17TH CENTURY ITALIAN DRAWINGS

IN THE METROPOLITAN MUSEUM OF ART

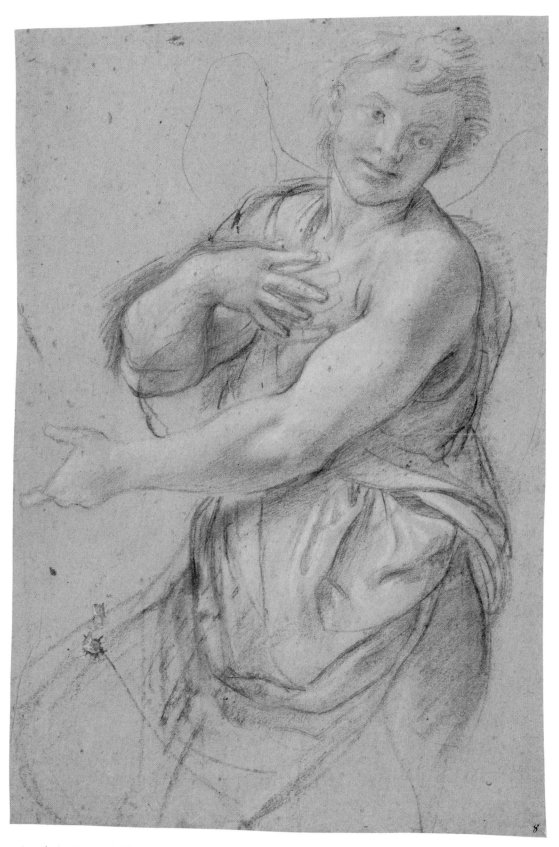

Annibale Carracci, No. 103

17TH CENTURY ITALIAN DRAWINGS

IN THE METROPOLITAN MUSEUM OF ART

JACOB BEAN

The Metropolitan Museum of Art
New York 1979
DISTRIBUTED BY Harry N. Abrams, Inc., Publishers, New York

LIBRARY OF CONGRESS CATALOGING IN PUBLICATION DATA

New York. Metropolitan Museum of Art.
 17th Century Italian drawings in the Metropolitan Museum of
Art.

 Includes bibliographical references and indexes.
 1. Drawing, Italian—Catalogs. 2. Drawing—17th century—
Italy—Catalogs. 3. Drawing—New York (City)—Catalogs. 4. New
York (City). Metropolitan Museum of Art—Catalogs. I. Bean,
Jacob. II. Title.
NC255.N45 1979 741.9'45'07401471 78-21502
ISBN 0-87099-183-3
ISBN 0-87099-184-1 pbk.
ISBN 0-8109-1628-2 Abrams

Contents

PREFACE 7

WORKS CITED IN ABBREVIATED FORM 9

Notices and Illustrations 15–287

Addendum 288

INDEX OF FORMER OWNERS 291

CONCORDANCE 295

INDEX OF ARTISTS 298

Preface

The exact chronological boundaries of the seventeenth century are overstepped in this illustrated inventory of Italian baroque draughtsmanship as it is represented in The Metropolitan Museum of Art. Innovative work of the Carracci, dating from the last two decades of the sixteenth century, qualifies for inclusion on stylistic grounds, as do drawings by late baroque masters—Marcantonio Franceschini, Benedetto Luti, Sebastiano Ricci, Francesco Solimena—that were produced in the early eighteenth century.

All drawings in the collection that I feel can be plausibly attributed to known artists of the period are described and reproduced, though some faint, hardly legible sketches by Francesco Allegrini have been omitted. Old copies and sheets of dubious authenticity have on the whole been excluded, but drawings probably produced in the studios of, or within the area of influence of major masters are included. A few drawings of puzzling traditional attribution are reproduced in the hope that their appearance here will elicit new solutions. For the same reason two still anonymous drawings of considerable interest are included at the end of the inventory.

An alphabetical rather than a chronological order has been adopted for convenience in consultation. This means, however, that rather monotonous lowlands—beginning with a dry exercise by Francesco Albani and continuing in the large group of sketches by Allegrini—must be crossed at the beginning of the book. But higher levels of quality and interest are soon attained and maintained. The Metropolitan Museum is fortunate in possessing the largest and, I believe, the most comprehensive group of Italian seventeenth-century drawings outside of Europe. The best draughtsmen of the period—Annibale Carracci, G. B. Castiglione, Pietro da Cortona, Carlo Maratti, Salvator Rosa—are brilliantly represented, and the absence of a drawing by Domenichino (who is rare outside of Windsor, but fortunately exemplified at the Pierpont Morgan Library in New York) might be said to be the exception that proves the rule.

A few statistics may elucidate the history of this part of the Metropolitan's collection of drawings. Of the 379 sheets illustrated in this inventory, 141 had been acquired (largely by gift and bequest) before 1961, when the Department of Drawings was established as a separate curatorial division of the museum. Many of these early acquisitions came as a gift in 1880 from Cornelius Vanderbilt, who purchased *en bloc* the large collection of drawings rather haphazardly put together by the American *marchand-amateur* James Jackson Jarves. A group of drawings was given in 1887 by the successful portrait painter Cephas Giovanni Thompson, who probably bought them in Rome, where he lived and worked from 1852 to 1859; then in

1917 Henry Walters presented an interesting group of Neapolitan drawings, part of a collection that had been formed in Naples by a member of the Spanish royal house in the mid-nineteenth century.

The Museum made its first purchase of Italian seventeenth-century drawings in 1908. Roger Fry chose the nine drawings, the most interesting of which was no doubt the Guercino study for the St. William altarpiece (No. 236). For the next half century baroque drawings were bought very sporadically indeed, and, of the twenty-four drawings purchased in those years, the Annibale Carracci landscape (No. 99, from the Pembroke sale in 1917) was perhaps the most distinguished. Since 1961 a particular effort has been made to enrich this aspect of our collection; thus more than half of the drawings in this inventory were acquired by purchase in the last eighteen years. The recent bequests of Walter C. Baker and Harry G. Sperling brought us some fine drawings, while Mr. Sperling's gift of funds for purchase should enable us further to enrich our collection.

Since the purpose of this publication is to illustrate a relatively little-known but important part of our collection of drawings, notices are brief, except where significant new information can be supplied. These entries offer essential bibliographical references and a record of provenance. Where an artist is represented by a substantial group of drawings, those that can be associated with datable paintings (or sculpture) are arranged in roughly chronological order, while those that are not connectible with finished works have been grouped according to traditional categories of subject matter—Old Testament, New Testament, ancient history, mythology, and so on—following the example of Adam Bartsch. However, exigencies of page layout have occasioned exceptions to this arrangement. A separate catalogue of the Robert Lehman Collection at the Metropolitan Museum is projected; therefore the few Italian seventeenth-century drawings in the Lehman Collection are not included in this inventory.

Lawrence Turčić has participated, as research assistant, in the preparation of this illustrated inventory since its inception; I owe him a great debt of gratitude for his careful verification of descriptions and references, as well as for innumerable pertinent suggestions. I also wish to thank Cynthia Ryan Lambros, assistant curator, for her constant and efficacious assistance. I am grateful to the many scholars whose suggestions and attributions are recorded in the entries that follow, but particular acknowledgment is due to the late Anthony M. Clark, to Dieter Graf, Ann Sutherland Harris, Catherine Johnston, Denis Mahon, Michael Mahoney, Jennifer Montagu, Philip Pouncey, and the late Walter Vitzthum.

JACOB BEAN
Curator of Drawings

Works Cited in Abbreviated Form

Bacou, 1967
Le Cabinet d'un grand amateur P.-J. Mariette, exhibition catalogue by Roseline Bacou, Françoise Viatte, and others, Musée du Louvre, Paris, 1967.

Baglione, 1642
Giovanni Baglione, Le vite de' pittori scultori et architetti. Dal pontificato di Gregorio XIII del 1572. In fino a' tempi di Papa Urbano Ottavo nel 1642, Rome, 1642.

Bartsch
Adam Bartsch, Le Peintre graveur, Vienna, 1803-1821. 21 vols.

Bean, 1964
Jacob Bean, 100 European Drawings in The Metropolitan Museum of Art, New York, 1964.

Bean, 1972
Drawings Recently Acquired, 1969-1971, exhibition catalogue by Jacob Bean, The Metropolitan Museum of Art, New York, 1972.

Bean, 1973
Drawings and Prints by the Carracci, exhibition catalogue by Jacob Bean, The Metropolitan Museum of Art, New York, 1973.

Bean, 1975-1976
European Drawings Recently Acquired, 1972-1975, exhibition catalogue by Jacob Bean, The Metropolitan Museum of Art, New York, 1975-1976.

Bean and Stampfle, 1971
Drawings from New York Collections, III, The 18th Century in Italy, exhibition catalogue by Jacob Bean and Felice Stampfle, New York, 1971.

Bellori
Giovan Pietro Bellori, Le vite de pittori, scultori e architetti moderni, edited by Evelina Borea, Turin, 1976.

Bettagno, 1966
Disegni di una collezione veneziana del Settecento, exhibition catalogue by Alessandro Bettagno, Fondazione Giorgio Cini, Venice, 1966.

Blunt, 1954
Anthony Blunt, The Drawings of G. B. Castiglione and Stefano Della Bella . . . at Windsor Castle, London, 1954.

Blunt, 1971
The German Drawings . . . at Windsor Castle by Edmund Schilling and Supplements to the Catalogues of Italian and French Drawings . . . by Anthony Blunt, London [1971].

Blunt and Cooke, 1960
Anthony Blunt and Hereward Lester Cooke, The Roman Drawings of the XVII and XVIII Centuries . . . at Windsor Castle, London, 1960.

Bologna, 1958
Ferdinando Bologna, Francesco Solimena, Naples, 1958.

Borenius and Wittkower, 1937
Tancred Borenius and Rudolf Wittkower, Catalogue of the Collection of Drawings by the Old Masters Formed by Sir Robert Mond . . ., London [1937].

Boschloo, 1974
A. W. A. Boschloo, Annibale Carracci in Bologna, Visible Reality in Art after the Council of Trent, Rome–The Hague, 1974. 2 vols.

Brauer and Wittkower, 1931
Heinrich Brauer and Rudolf Wittkower, Die Zeichnungen des Gianlorenzo Bernini, Berlin, 1931. 2 vols.

Byam Shaw, 1976
James Byam Shaw, Drawings by Old Masters at Christ Church, Oxford, Oxford, 1976. 2 vols.

Campbell, 1977
Malcolm Campbell, Pietro da Cortona at the Pitti Palace, a Study of the Planetary Rooms and Related Projects, Princeton, 1977.

Daniels, 1976
Jeffery Daniels, Sebastiano Ricci, Hove, Sussex, 1976.

De Dominici
Bernardo de Dominici, Vite de' pittori, scultori ed architetti napoletani, Naples, 1742. 3 vols.

Detroit, 1965
Art in Italy 1600-1700, exhibition organized by Frederick Cummings, introduction by Rudolf Wittkower, commentaries by Robert Enggass, Bertina Suida Manning, Robert Manning, Dwight C. Miller, Alfred Moir, Donald Posner, and Olga Raggio, The Detroit Institute of Arts, 1965.

De Vesme
Alexandre de Vesme, Stefano della Bella. Catalogue Raisonné, with introduction and additions by Phyllis Dearborn Massar, New York, 1971. 2 vols.

Dreyer, 1969
Römische Barockzeichnungen aus dem Berliner Kupferstichkabinett, exhibition catalogue by Peter Dreyer, Staatliche Museen Preussischer Kulturbesitz, Berlin-Dahlem, 1969.

Edinburgh, 1972
Italian 17th Century Drawings from British Private Collections, exhibition catalogue, Edinburgh, 1972.

Enggass, 1964
Robert Enggass, The Painting of Baciccio, University Park, Pennsylvania, 1964.

Ferrari and Scavizzi
 Oreste Ferrari and Giuseppe Scavizzi, *Luca Giordano,* Naples, 1966. 3 vols.

Gavazza, 1965
 Ezia Gavazza, *Lorenzo de Ferrari (1680-1744),* Milan, 1965.

Gibbons, 1977
 Felton Gibbons, *Catalogue of Italian Drawings in the Art Museum, Princeton University,* Princeton, 1977. 2 vols.

Graf, 1976
 Kataloge des Kunstmuseums Düsseldorf, Handzeichnungen, Band 2/1 und 2/2, Die Handzeichnungen von Guglielmo Cortese und Giovanni Battista Gaulli, edited by Dieter Graf, Düsseldorf, 1976. 2 vols.

Gregori, 1973
 Mina Gregori, *Gli affreschi della Certosa di Garegnano,* Milan [1973].

Harris, 1967
 Kataloge des Kunstmuseums Düsseldorf, Handzeichnungen, Band 1, Die Handzeichnungen von Andrea Sacchi und Carlo Maratta, edited by Ann Sutherland Harris (Sacchi) and Eckhard Schaar (Maratta), Düsseldorf, 1967.

Harris, 1977
 Ann Sutherland Harris, *Andrea Sacchi,* Oxford, 1977.

Harris, 1978
 Ann Sutherland Harris, "New Drawings by Andrea Sacchi: Addenda," *Burlington Magazine,* CXX, 1978, pp. 600-602.

Holland, 1961
 The Carracci, Drawings and Prints, exhibition catalogue by Ralph Holland, Newcastle upon Tyne, 1961.

Hollstein
 F. W. H. Hollstein, *Dutch and Flemish Etchings, Engravings and Woodcuts, ca. 1450-1700,* Amsterdam, 1949-1976. 19 vols. thus far.

Jacob, 1975
 Sabine Jacob, *Italienische Zeichnungen der Kunstbibliothek Berlin, Architektur und Dekoration 16. bis 18. Jahrhundert,* Berlin, 1975.

Johnston, 1971
 Catherine Johnston, *I disegni dei maestri, Il Seicento e il Settecento a Bologna,* Milan, 1971.

Johnston, 1973
 Mostra di disegni bolognesi dal XVI al XVIII secolo, exhibition catalogue by Catherine Johnston, Gabinetto Disegni e Stampe degli Uffizi, Florence, 1973.

Kurz, 1955
 Otto Kurz, *The Bolognese Drawings of the XVII and XVIII Centuries . . . at Windsor Castle,* London, 1955.

Lankheit, 1962
 Klaus Lankheit, *Florentinische Barockplastik. Die Kunst am Hofe der letzten Medici, 1670-1743,* Munich, 1962.

Le Blanc
 Ch. Le Blanc, *Manuel de l'amateur d'estampes,* Paris, 1854-1888. 4 vols.

Lugt
 Frits Lugt, *Les Marques de collections de dessins et d'estampes . . . ,* Amsterdam, 1921.

Lugt Supp.
 Frits Lugt, *Les Marques de collections de dessins et d'estampes . . . Supplément,* The Hague, 1956.

Mahon, 1963
 Mostra dei Carracci, Disegni, exhibition catalogue by Denis Mahon, Bologna, first edition, 1956, revised and corrected edition, 1963.

Mahon, 1968
 Mostra del Guercino, Dipinti, exhibition catalogue by Denis Mahon, Bologna, first edition, September 1968, revised and corrected edition, October 1968.

Mahon, 1969
 Mostra del Guercino, Disegni, exhibition catalogue by Denis Mahon, Bologna, exhibition 1968, catalogue 1969.

Mahoney, 1977
 Michael Mahoney, *The Drawings of Salvator Rosa,* New York and London, 1977. 2 vols.

Malafarina, 1976
 L'opera completa di Annibale Carracci, introduction by Patrick Cooney, critical catalogue by Gianfranco Malafarina, Milan, 1976.

Malvasia, 1686
 Carlo Cesare Malvasia, *Le pitture di Bologna, 1686,* edited by Andrea Emiliani, Bologna, 1969.

Malvasia, 1841
 Felsina pittrice. Vite de' pittori bolognesi, del conte Carlo Cesare Malvasia con aggiunte, correzioni e note inedite del medesimo autore di Giampietro Zanotti e di altri scrittori viventi, Bologna, 1841. 2 vols.

Mancigotti, 1975
 Mario Mancigotti, *Simone Cantarini il Pesarese,* Pesaro, 1975.

Marchini, 1960
 Giuseppe Marchini, *La pinacoteca comunale "Francesco Podesti" di Ancona,* Ancona, 1960.

Martin, 1965
 John Rupert Martin, *The Farnese Gallery,* Princeton, 1965.

Metropolitan Museum Hand-book, 1895
 The Metropolitan Museum of Art, Hand-book No. 8. Drawings, Water-Color Paintings, Photographs and Etchings, Tapestries etc., New York, 1895. (An unillustrated, summary checklist of the 882 European drawings then in the Museum's collection; they were all apparently at that time on exhibition. The introductory note warns that "the attributions of authorship are by former owners.")

Mezzetti, 1955
 Amalia Mezzetti, "Contributi a Carlo Maratti," *Rivista dell'Istituto Nazionale d'Archeologia e Storia dell'Arte,* n.s. IV, 1955, pp. 253-354.

Milkovich, 1964
Luca Giordano in America, Paintings, Drawings, Prints, exhibition catalogue by Michael Milkovich, Brooks Memorial Art Gallery, Memphis, Tennessee, 1964.

Monaci, 1977
Disegni di Giovan Battista Foggini (1652-1725), exhibition catalogue by Lucia Monaci, Gabinetto Disegni e Stampe degli Uffizi, Florence, 1977.

Montagu, 1978
Jennifer Montagu, "Bellori, Maratti, and the Palazzo Altieri," *Journal of the Warburg and Courtauld Institutes,* XLI, 1978, pp. 334-340.

Myers, 1975
Architectural and Ornamental Drawings: Juvarra, Vanvitelli, the Bibiena Family, and Other Italian Draughtsmen, exhibition catalogue by Mary L. Myers, The Metropolitan Museum of Art, New York, 1975.

Newcome, 1972
Genoese Baroque Drawings, exhibition catalogue by Mary Newcome, University Art Gallery, Binghamton, and Worcester Art Museum, 1972.

Newcome, 1977
Mary Newcome, "Paolo Gerolamo Piola," *Antologia di Belle Arti,* I, 1, 1977, pp. 37-56.

Noehles, 1970
Karl Noehles, *La Chiesa dei SS. Luca e Martina nell'opera di Pietro da Cortona,* Rome, 1970.

Parker II
K. T. Parker, *Catalogue of the Collection of Drawings in the Ashmolean Museum. Volume II. Italian Schools,* Oxford, 1956.

Pascoli, 1730
Lione Pascoli, *Vite de' pittori, scultori, ed architetti moderni,* I, Rome, 1730.

Percy, 1971
Giovanni Benedetto Castiglione, exhibition catalogue by Ann Percy, Philadelphia Museum of Art, 1971.

Posner, 1971
Donald Posner, *Annibale Carracci,* London, 1971. 2 vols.

Prachoff, 1906
Collection Adrien Prachoff. I. Dessins origineaux [sic] des maîtres anciens, St. Petersburg, 1906.

Ratti
Delle vite de' pittori, scultori, ed architetti genovesi, tomo secondo, scritto da Carlo Giuseppe Ratti . . . in continuazione dell' opera di Raffaello Soprani, Genoa, 1769.

Rizzi, 1975
Sebastiano Ricci disegnatore, exhibition catalogue by Aldo Rizzi, Udine, 1975.

Roli, 1967
Renato Roli, *Donato Creti,* Milan, 1967.

Roli, 1969
Renato Roli, *I disegni italiani del Seicento. Scuole emiliana, toscana, romana, marchigiana e umbra,* Treviso, 1969.

Roli, 1974
Renato Roli, "Disegni di Giuseppe Maria Crespi per la serie incisoria delle 'Storie di Bertoldo.'" *Atti et Memorie dell'Accademia Clementina di Bologna,* XI, 1974, pp. 1-6.

Salerno, 1963
Luigi Salerno, *Salvator Rosa,* Milan, 1963.

Salerno, 1975
L'opera completa di Salvator Rosa, introduction and critical catalogue by Luigi Salerno, Milan, 1975.

Sammlung Schloss Fachsenfeld, 1978
Sammlung Schloss Fachsenfeld, Zeichnungen, Bozzetti und Aquarelle aus fünf Jahrhunderten in Verwahrung der Staatsgalerie Stuttgart, exhibition catalogue edited by Gunther Thiem with entries by Ulrike Gauss, Heinrich Geissler, Volkmar Schauz, and Christel Thiem, Graphische Sammlung der Staatsgalerie, Stuttgart, 1978.

Schaar, 1967
Kataloge des Kunstmuseums Düsseldorf, Handzeichnungen, Band I. Die Handzeichnungen von Andrea Sacchi und Carlo Maratta, edited by Ann Sutherland Harris (Sacchi) and Eckhard Schaar (Maratta), Düsseldorf, 1967.

Schiavo
Armando Schiavo, *The Altieri Palace,* Rome [1965?].

Sestieri, 1972
Giancarlo Sestieri, "Per la conoscenza di Luigi Garzi," *Commentari,* XXIII, 1-2, 1972, pp. 89-111.

Stampfle and Bean, 1967
Drawings from New York Collections, II, The 17th Century in Italy, exhibition catalogue by Felice Stampfle and Jacob Bean, New York, 1967.

Stiftung Ratjen, 1977
Stiftung Ratjen, Italienische Zeichnungen des 16.-18. Jahrhunderts. Eine Ausstellung zum Andenken am Herbert List, exhibition catalogue, Munich, Berlin, Hamburg, Düsseldorf, Stuttgart, 1977-1978.

Strong, 1900
S. Arthur Strong, *Reproductions in Facsimile of Drawings by the Old Masters in the Collection of the Earl of Pembroke and Montgomery at Wilton House,* London, 1900.

Thiem, 1977
Christel Thiem, *Florentiner Zeichner des Frühbarock,* Munich, 1977.

Tietze, 1944
Hans Tietze and E. Tietze-Conrat, *The Drawings of the Venetian Painters in the 15th and 16th Centuries,* New York, 1944.

Van Regteren Altena, 1966
J. Q. van Regteren Altena, *Les Dessins italiens de la reine Christine de Suède,* Stockholm, 1966.

Venturi
A. Venturi, *Storia dell'arte italiana,* Milan, 1901-1939. 11 vols. from VI onward subdivided into parts.

Virch, 1962
Claus Virch, *Master Drawings in the Collection of Walter C. Baker,* New York, 1962.

Vitzthum, 1966
Disegni napoletani del Sei e del Settecento nel Museo di Capodimonte, exhibition catalogue by Walter Vitzthum, Naples, 1966.

Vitzthum, Florence, 1967
Cento disegni napoletani, sec. XVI-XVIII, exhibition catalogue by Walter Vitzthum, with Anna Maria Petrioli, Gabinetto Disegni e Stampe degli Uffizi, Florence, 1967.

Vitzthum, Paris, 1967
Le Dessin à Naples, du XVIe siècle au XVIIIe siècle, exhibition catalogue by Catherine Monbeig-Goguel and Walter Vitzthum, Cabinet des Dessins, Musée du Louvre, Paris, 1967.

Vitzthum, 1971
Walter Vitzthum, *I disegni dei maestri. Il barocco a Napoli e nell'Italia meridionale,* Milan, 1971.

Waterhouse, 1962
Ellis Waterhouse, *Italian Baroque Painting,* London, 1962.

Waterhouse, 1976
Ellis Waterhouse, *Roman Baroque Painting, A List of the Principal Painters and Their Works in and around Rome,* Oxford, 1976.

17TH CENTURY ITALIAN DRAWINGS
IN THE METROPOLITAN MUSEUM OF ART

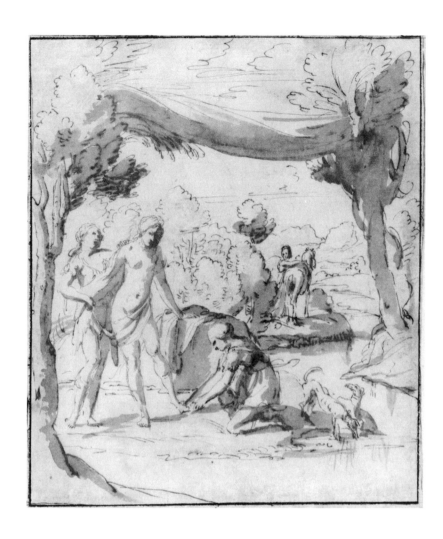

FRANCESCO ALBANI

Bologna 1578–Bologna 1660

1. *Diana Bathing*

Pen and brown ink, brown wash. 20.3 x 17.4 cm.

PROVENANCE: Gosuinus Uilenbroek; probably Uilenbroek sale, Amsterdam, October 23, 1741; purchased in London in 1961.

BIBLIOGRAPHY: B. Picart, *Impostures innocentes ou recueïl d'estampes d'après divers peintres illustres* . . ., Amsterdam, 1734, pl. 33; A. S. Harris, *Master Drawings*, VII, 2, 1969, p. 155, note 23, mentioned.

Purchase, 1961, Rogers Fund
61.162.2

This drawing was reproduced in reverse by Bernard Picart as the work of Domenichino when it figured in the "cabinet de Mr. Uilenbroek." At Chatsworth there is a related drawing, also traditionally attributed to Domenichino, in which the nude Diana is represented seated (no. 507; Courtauld Institute neg. 309/1/1). The Chatsworth drawing comes from the collection of N. A. Flink (Lugt 959), and thus, like our drawing, was in Amsterdam in the early eighteenth century. Both these drawings would seem to be the work of Albani. The rather dry penwork and the somewhat mannered elongation of the figures are paralleled in a *Death of Adonis* in the British Museum, traditionally attributed to Albani (repr. Johnston, 1971, fig. 20). Old copies of the Metropolitan Museum and the Chatsworth drawings are preserved in the Cabinet des Dessins at the Louvre (inv. 12,106 and 12,107, both as Albani).

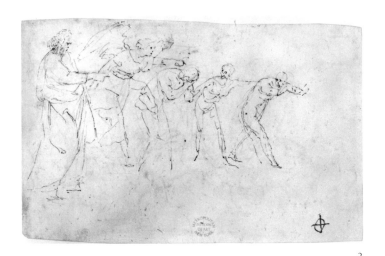

2

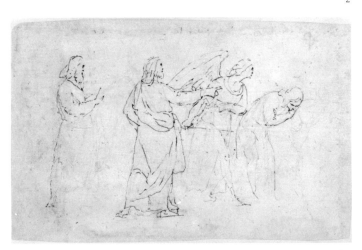

2 v.

FRANCESCO ALLEGRINI

Gubbio 1624– Rome 1663

2. *Adam and Eve Driven from Paradise*
VERSO. *Studies for the Same Composition*

Pen and brown ink, over red chalk. 10.4 x 17.0 cm.

Inscribed in pen and brown ink at lower right with a cross within a circle.

PROVENANCE: James Jackson Jarves; Cornelius Vanderbilt.

BIBLIOGRAPHY: *Metropolitan Museum Hand-book*, 1895, no. 138, as Pontormo.

Gift of Cornelius Vanderbilt, 1880
80.3.138

Francesco Allegrini was a prolific draughtsman, and his brittle, spidery pen and chalk figure notations are found on hundreds of sheets, usually quite small in size. Hermann Voss published drawings by Allegrini at Leipzig and Berlin (*Berliner Museen. Berichte aus den preussischer Kunstsammlungen,* XLV, 1924, pp. 15-19). Another sizable group is in Edinburgh (K. Andrews, *National Gallery of Scotland. Catalogue of Italian Drawings,* Cambridge, 1968, figs. 12-84). In addition, an album containing two hundred and twenty-four drawings said to come from the Odescalchi collection in Rome recently appeared in London (Christie's, March 20, 1973, no. 65; six of the drawings repr.).

The present group consists of seventy-three drawings of which twenty-one are so slight as to be almost illegible. The latter are not reproduced or described here. Though the whole group entered the Metropolitan's collection under a wide variety of highly speculative individual attributions, they may all have formed part of a series of some kind, for almost all have similar brown ink framing lines. Early in this century most of them were classified as school of the Carracci, and in 1958 Philip Pouncey suggested the convincing attribution to Francesco Allegrini for about half of these drawings. The rest were apparently not seen by him at that time, but I believe that he now agrees with the ascription of the whole group to Allegrini.

The subject of the recto and verso of this drawing, *Adam and Eve Driven from Paradise,* was also studied by Allegrini in a small sheet that was on the German art market in 1976 (sale, Berlin, Galerie Gerda Bassenge, Auktion 27, May 10-15, 1976, no. 5, repr.) said to be from the Odescalchi collection.

The cross within a circle inscribed in pen and brown ink on the recto of this sheet is very similar to a mark placed on drawings by G. L. Bernini, Salvator Rosa, and Pietro Testa from the Odescalchi collection, now in Haarlem, Leipzig, and elsewhere. A typical example of this "Odescalchi" mark can be seen on another drawing in this inventory—Salvator Rosa, No. 341. The mark seems to have been a symbol indicating the presence of a drawing on the reverse of the sheet (see Mahoney, 1977, I, pp. 17-30).

Three other drawings by Allegrini in the Metropolitan Museum (Nos. 10, 36, and 41, below) bear similar crosses within circles, presumably calling attention to slight pen sketches on the verso of each sheet.

3. *Cain Slaying Abel*

Pen and brown ink, brown wash. 8.0 x 6.1 cm. Framing lines in pen and brown ink. Tear at upper center. Lined.

PROVENANCE: James Jackson Jarves; Cornelius Vanderbilt.

BIBLIOGRAPHY: *Metropolitan Museum Hand-book*, 1895, no. 238, as unknown.

Gift of Cornelius Vanderbilt, 1880
80.3.238

4. *Lot and His Daughters*

Pen and brown ink, brown wash. 7.9 x 11.1 cm. Framing lines in red chalk, and in pen and brown ink on mount. Lined.

PROVENANCE: James Jackson Jarves; Cornelius Vanderbilt.

BIBLIOGRAPHY: *Metropolitan Museum Hand-book*, 1895, no. 99, as Antonio Tempesta.

Gift of Cornelius Vanderbilt, 1880
80.3.99

5. *Solomon Receiving the Queen of Sheba*

Pen and brown ink. 7.5 x 18.5 cm. Framing lines in pen and brown ink on mount. A number of brown stains. Lined.

Inscribed in pen and brown ink at lower center, *di L. Caracci.*

PROVENANCE: James Jackson Jarves; Cornelius Vanderbilt.

BIBLIOGRAPHY: *Metropolitan Museum Hand-book*, 1895, no. 256, as Ludovico Carracci.

Gift of Cornelius Vanderbilt, 1880
80.3.256

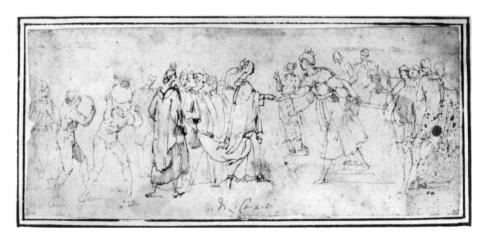

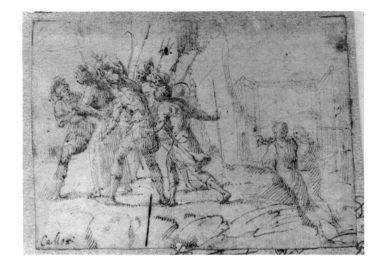

6. *The Arrest of Christ*

Pen and brown ink. 9.5 x 13.5 cm. Abrasion at upper center. Lined.

Inscribed in pen and brown ink at lower left, *Callott*.

PROVENANCE: James Jackson Jarves; Cornelius Vanderbilt.

BIBLIOGRAPHY: *Metropolitan Museum Hand-book*, 1895, no. 359, as Callot.

Gift of Cornelius Vanderbilt, 1880
80.3.539

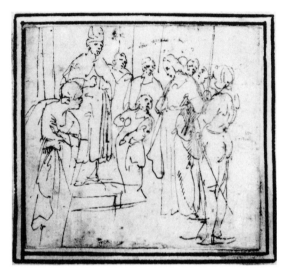

7. *Christ before the High Priest*

Pen and brown ink. 7.0 x 7.9 cm. Framing lines in pen and brown ink on mount. Lined.

PROVENANCE: James Jackson Jarves; Cornelius Vanderbilt.

BIBLIOGRAPHY: *Metropolitan Museum Hand-book*, 1895, no. 315, as Stefano della Bella.

Gift of Cornelius Vanderbilt, 1880
80.3.315

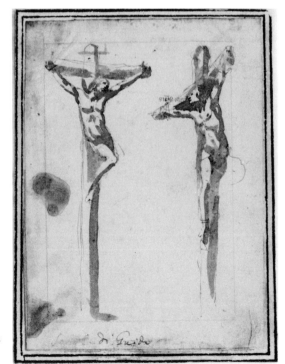

8. *Christ Crucified with the Good Thief*

Pen and brown ink, brown wash. 12.8 x 9.4 cm. Framing lines in red chalk, and in pen and brown ink on mount. Several stains. Lined.

Inscribed in pen and brown ink at lower margin, *Scuola di Guido;* at upper center, \overline{m}*sto mei* [?].

PROVENANCE: James Jackson Jarves; Cornelius Vanderbilt.

BIBLIOGRAPHY: *Metropolitan Museum Hand-book*, 1895, no. 326, as Guido Reni.

Gift of Cornelius Vanderbilt, 1880
80.3.326

9. *Group of Figures Copied from Michelangelo's Last Judgment*

Pen and brown ink, over a little black chalk. 9.5 x 13.5 cm. Framing
lines in pen and brown ink on mount. Lined.

PROVENANCE: James Jackson Jarves; Cornelius Vanderbilt.

BIBLIOGRAPHY: *Metropolitan Museum Hand-book*, 1895, no. 67, as
Daniele da Volterra.

Gift of Cornelius Vanderbilt, 1880
80.3.67

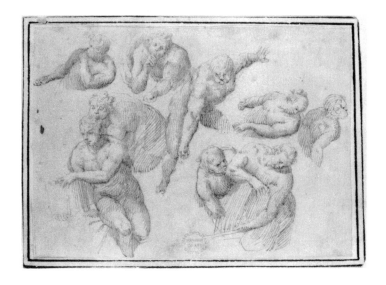

10. *The Martyrdom of St. Sebastian*

Pen and brown ink. Half figure of a bearded old man blessing, in pen
and brown ink on verso. 9.3 x 12.7 cm.

Inscribed in pen and brown ink at lower right with a cross within a
circle (see No. 2, above); at lower left, *Sᵒ di Guido*.

PROVENANCE: James Jackson Jarves; Cornelius Vanderbilt.

BIBLIOGRAPHY: *Metropolitan Museum Hand-book*, 1895, no. 285, as
Giovanni da Bologna.

Gift of Cornelius Vanderbilt, 1880
80.3.285

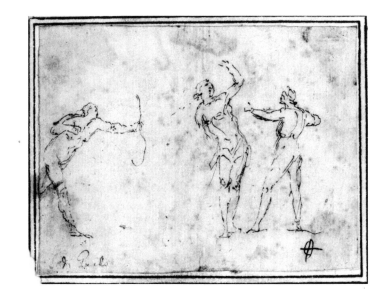

11. *Two Monastic Figures Standing before a Church*

Pen and brown ink. 6.4 x 7.9 cm. Framing lines in pen and brown
ink. Several stains. Lined.

PROVENANCE: James Jackson Jarves; Cornelius Vanderbilt.

BIBLIOGRAPHY: *Metropolitan Museum Hand-book*, 1895, no. 102, as
Antonio Tempesta.

Gift of Cornelius Vanderbilt, 1880
80.3.102

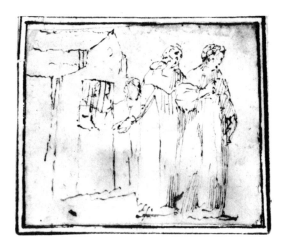

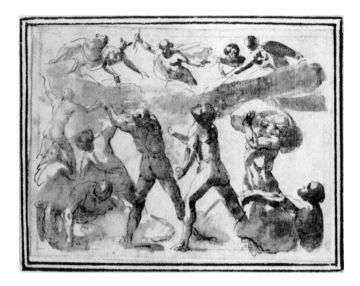

12. *Battle of the Titans*

Pen and brown ink, brown wash. 8.8 x 12.2 cm. Framing lines in black chalk, and in pen and brown ink on mount. Lined.

PROVENANCE: James Jackson Jarves; Cornelius Vanderbilt.

BIBLIOGRAPHY: *Metropolitan Museum Hand-book,* 1895, no. 273, as school of the Carracci.

Gift of Cornelius Vanderbilt, 1880
80.3.273

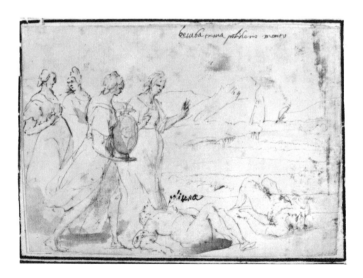

13. *The Rape of Europa*

Pen and brown ink. 9.1 x 12.0 cm. Framing lines in pen and brown ink on mount. Several stains. Lined.

PROVENANCE: James Jackson Jarves; Cornelius Vanderbilt.

BIBLIOGRAPHY: *Metropolitan Museum Hand-book,* 1895, no. 85, as Antonio Tempesta.

Gift of Cornelius Vanderbilt, 1880
80.3.85

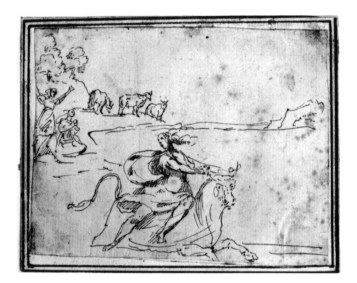

14. *The Death of Polyxena*

Pen and brown ink, brown wash. 8.9 x 12.9 cm. Framing lines in pen and brown ink on mount. Several stains. Lined.

Inscribed in pen and brown ink at upper margin, *hecuba trova polisena morta;* at lower center, *polisena.*

PROVENANCE: James Jackson Jarves; Cornelius Vanderbilt.

BIBLIOGRAPHY: *Metropolitan Museum Hand-book,* 1895, no. 252, as Ludovico Carracci.

Gift of Cornelius Vanderbilt, 1880
80.3.252

15. *Aeneas Carrying Anchises from Burning Troy*

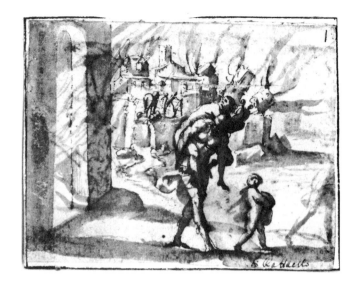

Pen and brown ink, brown wash. 9.7 x 13.0 cm. Framing lines in pen and brown ink on mount. Several stains. Lined.

Inscribed in pen and brown ink at lower right, *di Raffaello;* numbered at upper right, *1.*

PROVENANCE: James Jackson Jarves; Cornelius Vanderbilt.

BIBLIOGRAPHY: *Metropolitan Museum Hand-book.* 1895, no. 98, as Salvator Rosa, after Raphael.

Gift of Cornelius Vanderbilt, 1880
80.3.98

16. *Aeneas and Achates Entering Dido's Palace in a Cloud*

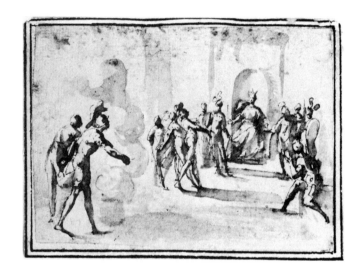

Pen and brown ink, brown wash, over black chalk. 8.9 x 12.8 cm. Framing lines in pen and brown ink on mount. Several stains. Lined.

PROVENANCE: James Jackson Jarves; Cornelius Vanderbilt.

BIBLIOGRAPHY: *Metropolitan Museum Hand-book.* 1895, no. 87, as Antonio Tempesta.

Gift of Cornelius Vanderbilt, 1880
80.3.87

17. *The Departure of Aeneas Announced to Dido?*

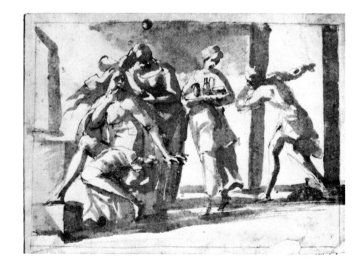

Pen and brown ink, brown wash, over black chalk. 8.3 x 11.7 cm. Framing lines in red chalk. Losses at lower margin. Lined.

PROVENANCE: James Jackson Jarves; Cornelius Vanderbilt.

BIBLIOGRAPHY: *Metropolitan Museum Hand-book.* 1895, no. 7, as Perino del Vaga.

Gift of Cornelius Vanderbilt, 1880
80.3.7

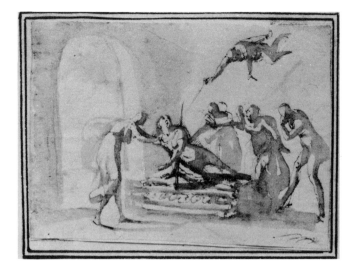

18. *The Death of Dido*

Pen and brown ink, brown wash, over black chalk. 9.4 x 13.5 cm. Framing lines in pen and brown ink on mount. Lined.

PROVENANCE: James Jackson Jarves; Cornelius Vanderbilt.

BIBLIOGRAPHY: *Metropolitan Museum Hand-book*, 1895, no. 89, as Antonio Tempesta.

Gift of Cornelius Vanderbilt, 1880
80.3.89

19. *Landscape with Figures: The Silver Age*

Pen and brown ink, brown wash. 8.7 x 11.8 cm. Framing lines in black chalk, and in pen and brown ink on mount. Lined.

Inscribed in pen and brown ink at upper left margin, *aetas argentea;* at lower center, *tempesta*.

PROVENANCE: James Jackson Jarves; Cornelius Vanderbilt.

BIBLIOGRAPHY: *Metropolitan Museum Hand-book*, 1895, no. 84, as Antonio Tempesta.

Gift of Cornelius Vanderbilt, 1880
80.3.84

20. *Scene of Sacrifice*

Pen and brown ink, brown wash. 10.3 x 15.5 cm. Framing lines in black chalk, and in pen and brown ink on mount. Several stains. Lined.

Numbered in pen and brown ink at upper margin, 6.

PROVENANCE: James Jackson Jarves; Cornelius Vanderbilt.

BIBLIOGRAPHY: *Metropolitan Museum Hand-book*, 1895, no. 284, as Pellegrino Tibaldi.

Gift of Cornelius Vanderbilt, 1880
80.3.284

21. *Group of Five Allegorical Figures*

Pen and brown ink. 15.3 x 13.4 cm. Framing lines in pen and brown ink. Lined.

Inscribed in pen and brown ink at lower margin, *Guido.*

PROVENANCE: James Jackson Jarves; Cornelius Vanderbilt.

BIBLIOGRAPHY: *Metropolitan Museum Hand-book,* 1895, no. 254, as school of the Carracci.

Gift of Cornelius Vanderbilt, 1880
80.3.254

22. *The Rape of the Sabines*

Pen and brown ink, over a little black chalk. 8.0 x 17.9 cm. Framing lines in pen and brown ink on mount. Lined.

PROVENANCE: James Jackson Jarves; Cornelius Vanderbilt.

BIBLIOGRAPHY: *Metropolitan Museum Hand-book,* 1895, no. 530, as Callot.

Gift of Cornelius Vanderbilt, 1880
80.3.530

23. *The Death of Lucretia?*

Pen and brown ink, brown wash. 9.8 x 17.1 cm. Framing lines in pen and brown ink on mount. Lined.

Inscribed in pen and brown ink at lower right, *Scuola Bolog.ᵉ*

PROVENANCE: James Jackson Jarves; Cornelius Vanderbilt.

BIBLIOGRAPHY: *Metropolitan Museum Hand-book,* 1895, no. 259, as school of the Carracci.

Gift of Cornelius Vanderbilt, 1880
80.3.259

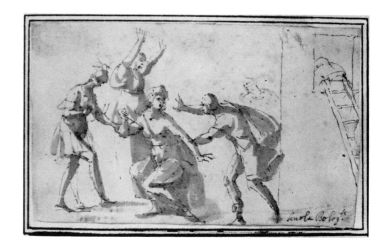

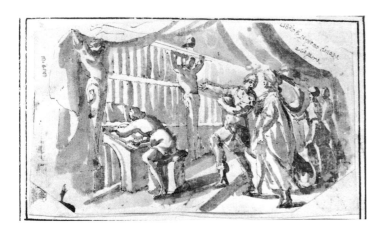

24. *The Library of Pergamum Given to Cleopatra*

Pen and brown ink, brown wash. 9.4 x 16.5 cm. Framing lines in pen and brown ink on mount. Several stains. All four corners cut off. Lined.

Inscribed in pen and brown ink at upper right, *Libris di pergomo donata/a clopatra.*

PROVENANCE: James Jackson Jarves; Cornelius Vanderbilt.

BIBLIOGRAPHY: *Metropolitan Museum Hand-book*, 1895, no. 267, as school of the Carracci.

Gift of Cornelius Vanderbilt, 1880
80.3.267

25. *Two Standing Male Figures in Antique Military Costume*

Pen and brown ink, brown and blue wash. 8.6 x 7.0 cm. Framing lines in pen and brown ink on mount. Lined.

Inscribed in pen and brown ink at upper left, *alesandro e . . . ione.*

PROVENANCE: James Jackson Jarves; Cornelius Vanderbilt.

BIBLIOGRAPHY: *Metropolitan Museum Hand-book*, 1895, no. 257, as Ludovico Carracci.

Gift of Cornelius Vanderbilt, 1880
80.3.257

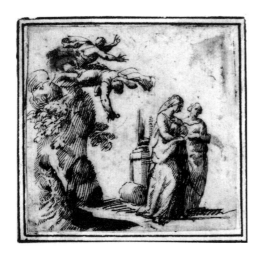

26. *Unidentified Subject: Two Falling Figures and Two Standing Women in a Landscape*

Pen and brown ink. 8.5 x 8.9 cm. Framing lines in pen and brown ink on mount. Several stains. Lined.

PROVENANCE: James Jackson Jarves; Cornelius Vanderbilt.

BIBLIOGRAPHY: *Metropolitan Museum Hand-book*, 1895, no. 100, as Antonio Tempesta.

Gift of Cornelius Vanderbilt, 1880
80.3.100

27. *Group of Gesticulating Figures*

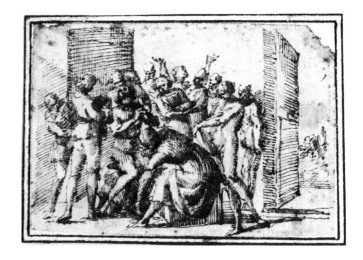

Pen and brown ink. 7.9 x 11.7 cm. Framing lines in black chalk, and in pen and brown ink on mount. Several stains. Upper right corner cut away. Lined.

PROVENANCE: James Jackson Jarves; Cornelius Vanderbilt.

BIBLIOGRAPHY: *Metropolitan Museum Hand-book*, 1895, no. 24, as Antonio Tempesta.

Gift of Cornelius Vanderbilt, 1880
80.3.24

28. *Unidentified Scene: Figures in a Landscape*

Pen and brown ink. 7.8 x 11.5 cm. Framing lines in pen and brown ink. Lined.

PROVENANCE: James Jackson Jarves; Cornelius Vanderbilt.

BIBLIOGRAPHY: *Metropolitan Museum Hand-book*, 1895, no. 23, as Antonio Tempesta.

Gift of Cornelius Vanderbilt, 1880
80.3.23

29. *Enthroned Warrior Distributing Crowns*

Pen and brown ink, brown wash. 9.0 x 12.8 cm. Framing lines in pen and brown ink. Several stains. Lined.

Inscribed in pen and brown ink at lower left, *Scuola di Caracci*.

PROVENANCE: James Jackson Jarves; Cornelius Vanderbilt.

BIBLIOGRAPHY: *Metropolitan Museum Hand-book*, 1895, no. 275, as school of the Carracci.

Gift of Cornelius Vanderbilt, 1880
80.3.275

30. *Supplicants before an Enthroned King and Queen*

Pen and brown ink. 13.4 x 10.7 cm. Several stains. Lined.

PROVENANCE: James Jackson Jarves; Cornelius Vanderbilt.

BIBLIOGRAPHY: *Metropolitan Museum Hand-book,* 1895, no. 463, as unknown.

Gift of Cornelius Vanderbilt, 1880
80.3.463

31. *Unidentified Subject: Figures before a Palace or Temple*

Pen and brown ink, brown wash, over a little red chalk. 13.4 x 17.9 cm. Framing lines in pen and brown ink on mount. Several stains. Lined.

PROVENANCE: James Jackson Jarves; Cornelius Vanderbilt.

BIBLIOGRAPHY: *Metropolitan Museum Hand-book,* 1895, no. 554, as Poussin.

Gift of Cornelius Vanderbilt, 1880
80.3.554

32. *Unidentified Scene: Nine Figures and a Horse*

Pen and brown ink, over red chalk. 6.4 x 10.2 cm. Framing lines in pen and brown ink on mount. Several stains. Lined.

PROVENANCE: James Jackson Jarves; Cornelius Vanderbilt.

BIBLIOGRAPHY: *Metropolitan Museum Hand-book,* 1895, no. 103, as Antonio Tempesta.

Gift of Cornelius Vanderbilt, 1880
80.3.103

33. *Procession of Musicians*

Pen and brown ink. 6.6 x 14.5 cm. Lined.

PROVENANCE: James Jackson Jarves; Cornelius Vanderbilt.

BIBLIOGRAPHY: *Metropolitan Museum Hand-book,* 1895, no. 113, as Lorenzo Ghiberti?

Gift of Cornelius Vanderbilt, 1880
80.3.113

34. *Group of Standing and Seated Female Figures*

Red chalk. Pen sketch of a costumed female figure on verso. 10.4 x 14.1 cm. Several stains.

PROVENANCE: James Jackson Jarves; Cornelius Vanderbilt.

BIBLIOGRAPHY: *Metropolitan Museum Hand-book,* 1895, no. 327, as Guido Reni.

Gift of Cornelius Vanderbilt, 1880
80.3.327

35. *Four Figure Studies, One of a Standing Archer*

Pen and brown ink. 11.7 x 8.4 cm. Framing lines in pen and brown ink on mount. Lined.

Inscribed in pen and brown ink at lower margin, *di Guido.*

PROVENANCE: James Jackson Jarves; Cornelius Vanderbilt.

BIBLIOGRAPHY: *Metropolitan Museum Hand-book,* 1895, no. 287, as Giovanni da Bologna.

Gift of Cornelius Vanderbilt, 1880
80.3.287

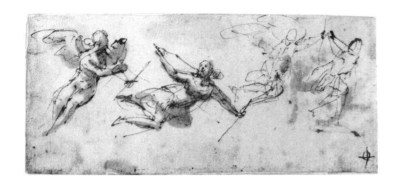

36. *Four Flying Angels*

Pen and brown ink, brown wash. Two flying figures in pen and brown ink on verso. 6.3 x 14.5 cm. Several stains.

Inscribed in pen and brown ink at lower right with a cross within a circle (see No. 2, above).

PROVENANCE: James Jackson Jarves; Cornelius Vanderbilt.

BIBLIOGRAPHY: *Metropolitan Museum Hand-book*, 1895, no. 112, as Lorenzo Ghiberti?

Gift of Cornelius Vanderbilt, 1880
80.3.112

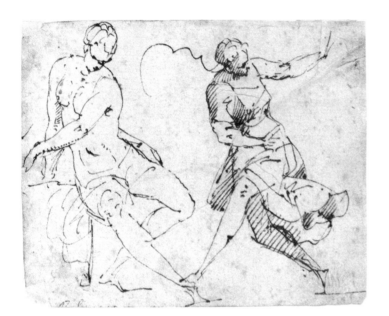

37. *Seated Female Nude and Dancing Female Figure*

Pen and brown ink. 9.7 x 12.3 cm.

PROVENANCE: James Jackson Jarves; Cornelius Vanderbilt.

BIBLIOGRAPHY: *Metropolitan Museum Hand-book*, 1895, no. 8, as school of Raphael.

Gift of Cornelius Vanderbilt, 1880
80.3.8

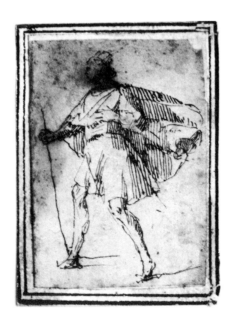

38. *Standing Male Figure with Cloak and Staff*

Pen and brown ink. 7.8 x 5.7 cm. Framing lines in pen and brown ink on mount. Stain at upper right. Lined.

PROVENANCE: James Jackson Jarves; Cornelius Vanderbilt.

BIBLIOGRAPHY: *Metropolitan Museum Hand-book*, 1895, no. 20, as unknown.

Gift of Cornelius Vanderbilt, 1880
80.3.20

39. *Battle Scene*

Pen and brown ink, red chalk and red wash. 13.5 x 20.1 cm. Framing lines in pen and brown ink on mount. Margins torn irregularly. Lined.

PROVENANCE: James Jackson Jarves; Cornelius Vanderbilt.

BIBLIOGRAPHY: *Metropolitan Museum Hand-book*, 1895, no. 5, as school of Giulio Romano.

Gift of Cornelius Vanderbilt, 1880
80.3.5

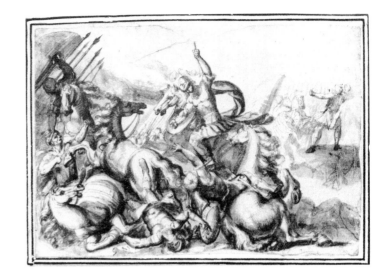

40. *Cavalry Engagement*

Pen and brown ink. 9.0 x 12.8 cm. Framing lines in pen and brown ink on mount. Much stained. Lined.

PROVENANCE: James Jackson Jarves; Cornelius Vanderbilt.

BIBLIOGRAPHY: *Metropolitan Museum Hand-book*, 1895, no. 27, as Giulio Romano.

Gift of Cornelius Vanderbilt, 1880
80.3.27

41. *Cavalry Engagement*

Pen and brown ink. Faint pen and brown ink sketch of an angelic concert on verso. 12.7 x 18.4 cm.

Inscribed in pen and brown ink at lower left, *P. Giac. Borgognone 1621-1676;* at lower right with a cross within a circle (see No. 2, above).

PROVENANCE: James Jackson Jarves; Cornelius Vanderbilt.

BIBLIOGRAPHY: *Metropolitan Museum Hand-book*, 1895, no. 509, as Borgognone.

Gift of Cornelius Vanderbilt, 1880
80.3.509

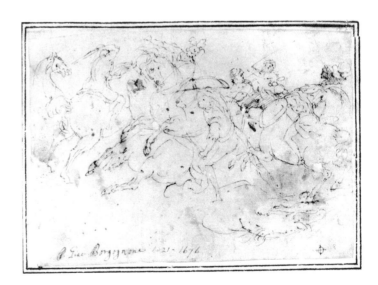

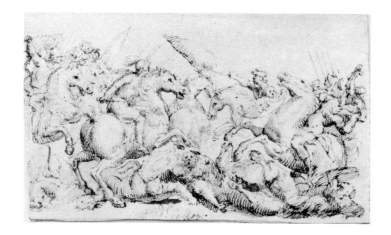

FRANCESCO ALLEGRINI

42. *Cavalry Engagement*

Pen and brown ink. 7.9 x 13.6 cm. Lined.

Inscribed in pen and brown ink at lower center, *d.ᶦ Callott*.

PROVENANCE: James Jackson Jarves; Cornelius Vanderbilt.

BIBLIOGRAPHY: *Metropolitan Museum Hand-book*, 1895, no. 535, as Callot.

Gift of Cornelius Vanderbilt, 1880
80.3.535

43. *Four Horsemen in Battle*

Pen and brown ink, brown wash. 10.1 x 13.3 cm. Framing lines in pen and brown ink on mount. Lined.

PROVENANCE: James Jackson Jarves; Cornelius Vanderbilt.

BIBLIOGRAPHY: *Metropolitan Museum Hand-book,* 1895, no. 459, as unknown.

Gift of Cornelius Vanderbilt, 1880
80.3.459

44. *Horseman and Three Foot Soldiers in Battle*

Pen and brown ink, brown wash. 9.5 x 13.3 cm. Lined.

PROVENANCE: James Jackson Jarves; Cornelius Vanderbilt.

BIBLIOGRAPHY: *Metropolitan Museum Hand-book,* 1895, no. 461, as unknown.

Gift of Cornelius Vanderbilt, 1880
80.3.461

45. *Four Nude Warriors*

Pen and brown ink, brown wash. 13.8 x 10.0 cm. Framing lines in pen and brown ink on mount. Lined.

PROVENANCE: James Jackson Jarves; Cornelius Vanderbilt.

BIBLIOGRAPHY: *Metropolitan Museum Hand-book*, 1895, no. 519, as Callot.

Gift of Cornelius Vanderbilt, 1880
80.3.519

46. *Group of Horsemen*

Pen and brown ink. 8.0 x 11.5 cm. Framing lines in pen and brown ink on mount. Several stains. Lined.

PROVENANCE: James Jackson Jarves; Cornelius Vanderbilt.

BIBLIOGRAPHY: *Metropolitan Museum Hand-book*, 1895, no. 251, as Ludovico Carracci?

Gift of Cornelius Vanderbilt, 1880
80.3.251

47. *Mounted Figure and Attendant*

Pen and brown ink. 7.9 x 8.4 cm. Framing lines in pen and brown ink on mount. Several stains. Lined.

PROVENANCE: James Jackson Jarves; Cornelius Vanderbilt.

BIBLIOGRAPHY: *Metropolitan Museum Hand-book*, 1895, no. 311, as Stefano della Bella.

Gift of Cornelius Vanderbilt, 1880
80.3.311

48. *Boar Hunt*

Pen and brown ink. 5.4 x 11.8 cm. Framing lines in pen and brown ink on mount. Stain at upper left. Lined.

Inscribed in pen and brown ink at lower margin, *Callott*.

PROVENANCE: James Jackson Jarves; Cornelius Vanderbilt.

BIBLIOGRAPHY: *Metropolitan Museum Hand-book*, 1895, no. 536, as Callot.

Gift of Cornelius Vanderbilt, 1880
80.3.536

49. *Horsemen Hunting*

Pen and brown ink, brown wash. 6.8 x 12.5 cm. Lined.

PROVENANCE: James Jackson Jarves; Cornelius Vanderbilt.

BIBLIOGRAPHY: *Metropolitan Museum Hand-book*, 1895, no. 538, as Callot.

Gift of Cornelius Vanderbilt, 1880
80.3.538

50. *Two Horses*

Pen and brown ink. 11.7 x 11.7 cm. Framing lines in pen and brown ink on mount. Several stains. Lined.

Inscribed in pen and brown ink at lower right, *Tempesta*.

PROVENANCE: James Jackson Jarves; Cornelius Vanderbilt.

BIBLIOGRAPHY: *Metropolitan Museum Hand-book*, 1895, no. 143, as Antonio Tempesta.

Gift of Cornelius Vanderbilt, 1880
80.3.143

FRANCESCO ALLEGRINI

51. *Six Horses*

Pen and brown ink. 7.5 x 24.7 cm. Framing lines in pen and brown ink on mount. Several stains. Lined.

PROVENANCE: James Jackson Jarves; Cornelius Vanderbilt.

BIBLIOGRAPHY: *Metropolitan Museum Hand-book*, 1895, no. 319, as Stefano della Bella.

Gift of Cornelius Vanderbilt, 1880
80.3.319

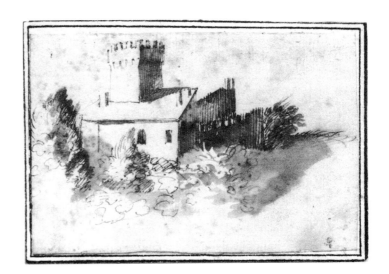

52. *Landscape with a Fortified Building*

Pen and brown ink, brown wash. 7.4 x 11.6 cm. Framing lines in pen and brown ink on mount. Several stains. Lined.

PROVENANCE: James Jackson Jarves; Cornelius Vanderbilt.

BIBLIOGRAPHY: *Metropolitan Museum Hand-book*, 1895, no. 66, as unknown.

Gift of Cornelius Vanderbilt, 1880
80.3.66

53. *Landscape with a Ruined Temple*

Brush and brown wash. 12.5 x 19.2 cm. Framing lines in pen and brown ink on mount. Lined.

PROVENANCE: James Jackson Jarves; Cornelius Vanderbilt.

BIBLIOGRAPHY: *Metropolitan Museum Hand-book*, 1895, no. 269, as unknown.

Gift of Cornelius Vanderbilt, 1880
80.3.269

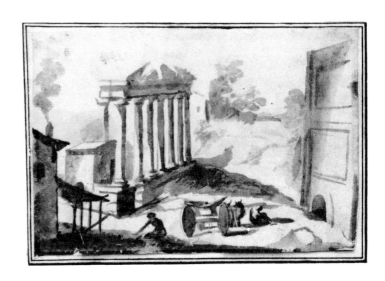

54

GIOVANNI BAGLIONE

Rome 1571 – Rome 1644

54. *Group of Nude Male Figures Kneeling and Standing in Supplication*

Pen and brown ink, brown wash. Squared in red chalk. 17.7 x 19.8 cm.

Inscribed faintly in pencil at lower margin, *Zuccaro* [?].

PROVENANCE: Purchased in London in 1965.

Purchase, 1965, Rogers Fund
65.66.2

The nude figures on the right in the drawing are posed in a way that announces the grouping of the saints attendant upon Cardinal Sfondrati in a painting in the Gesù in Rome, representing that prelate in the company of saints whose bodies were disinterred during excavations in 1599. Indeed, the drawing may be an early composition study for the painting, which was attributed to Baglione by Stephen Pepper (*Paragone,* XVIII, 211, 1967, p. 70, fig. 57).

55. *Rinaldo and Armida*

Pen and brown ink, brown wash, heightened with white, on brownish paper. 31.2 x 23.5 cm. Many losses. Lined.

Inscribed in pencil at lower right, *Cav.e Baglioni;* numbered in pen and brown ink, 99.

PROVENANCE: Harry G. Friedman, New York.

Gift of Harry G. Friedman, 1960
60.66.1

An old, much damaged, but possibly autograph replica of a drawing by Baglione in the Cabinet des Dessins, Musée du Louvre (inv. 2840). The Louvre drawing is a study, with minor variations, for Baglione's ceiling fresco in the Casino dell'Aurora, Palazzo Pallavicini-Rospigliosi, Rome, for which the artist was paid in 1614 (repr. *Bollettino d'Arte,* XXXIX, 1954, p. 319, fig. 13). Baglione himself describes the subject of the fresco as "la favola d'Armida, quando trovò Rinaldo addormentato, e sopra il suo incantato Carro il ripose" (Baglione, 1642, p. 403).

56. *Return of the Holy Family from Egypt*
VERSO. *Studies for the Return from Egypt*

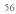
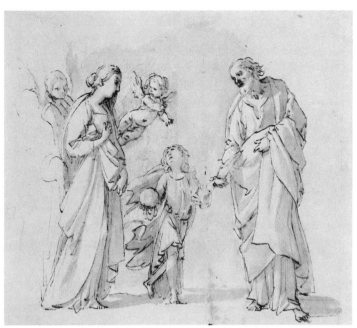

56

Pen and brown ink, brown wash, over black chalk (recto and verso).
17.5 x 20.6 cm.

PROVENANCE: Purchased in New York in 1962.

BIBLIOGRAPHY: W. Vitzthum, *Master Drawings,* I, 3, 1963, p. 60,
pl. 43b.

Purchase, 1962, Rogers Fund
62.237

Vitzthum related this drawing to two other studies by
Baglione of the same subject: one at the Accademia
Carrara in Bergamo, formerly attributed to Albani, and
another in the F. Lugt Collection, Institut Néerlandais,
Paris, once attributed to Guido Reni. Baglione makes no
mention of such a composition in the list of his own
painted work (Baglione, 1642, pp. 401-405).

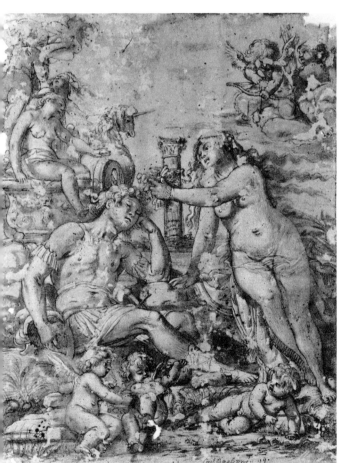

55

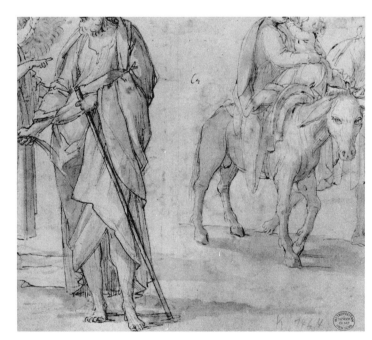

56 v.

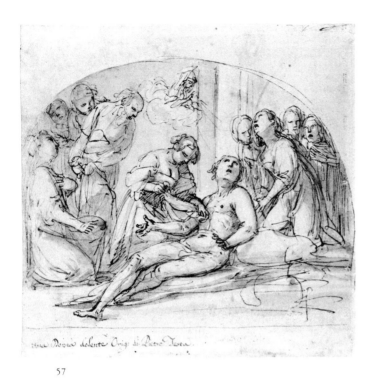

57

57 v.

GIOVANNI BAGLIONE

57. *The Miraculous Healing of a Young Man through the Intervention of the Virgin or a Female Saint* VERSO. *Studies of Sibyls and Angels*

Pen and brown ink, brown wash, over black chalk (recto); pen and brown ink, over black chalk (verso). 19.4 x 20.6 cm.

Inscribed in pen and brown ink at lower left on recto, *Una Donna dolente Orig: di Pietro Testa.*

PROVENANCE: Adrien Prachoff, St. Petersburg; Walter C. Baker, New York.

BIBLIOGRAPHY: Prachoff, 1906, no. 94, recto repr. p. 33, as Pietro Testa.

Gift of Walter C. Baker, 1961
61.72

The old attribution to Pietro Testa is certainly incorrect; the facial types on both recto and verso are typical of Baglione.

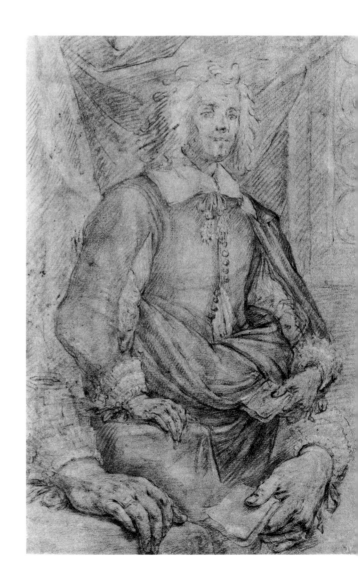

58

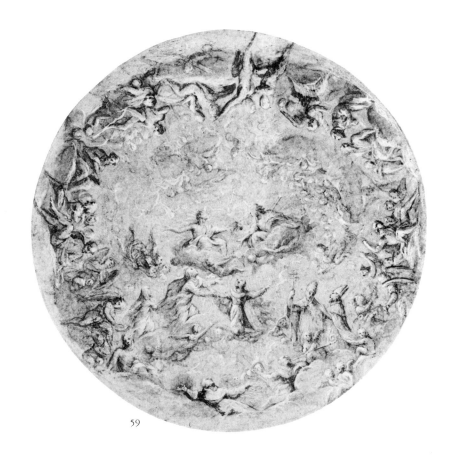

59

MARIO BALASSI

Florence 1604–Florence 1667

58. *Study for a Three-Quarter-Length Portrait of a Gentleman*

Red chalk, heightened with white, on red-washed paper. Black chalk studies of drapery on verso which is washed in blue. 37.1 x 24.2 cm. Surface abraded.

Inscribed in pen and brown ink on verso, *mario Balassi*.

PROVENANCE: Harry G. Sperling, New York.

Bequest of Harry G. Sperling, 1975
1975.131.3

The old inscription *mario Balassi* on the verso is in the same hand as that on a drawing by Balassi in Darmstadt (AE 1649; repr. Thiem, 1977, no. 173). Christel Thiem has identified the Darmstadt drawing as a study for the figure of Peter in a painting by Balassi representing St. Peter in prison, which is known through an engraving in *L'Etruria pittrice* (1795). In style the two drawings are very similar.

LAZZARO BALDI, attributed to

Pistoia ca. 1624–Rome 1703

59. *Monastic Saint Presented to the Holy Trinity by the Virgin, Study for a Circular Ceiling Decoration*

Brush and brown wash, heightened with white, over black chalk, on brown-washed paper. Diameter 25.2 cm. Lined.

PROVENANCE: J. G. H. Winckler (the mount bears a stamp with the same quarterings as Lugt 2702, but with a different ornamental surround); purchased in New York in 1961.

Purchase, 1961, The Elisha Whittelsey Fund
61.256

The soft, painterly, Cortonesque manner of this drawing is suggestive of Baldi, but it cannot be associated with any surviving painted work.

MARCANTONIO BASSETTI

Verona 1588 – Verona 1630

60. *Nymphs Bathing*

Brush and brown wash, heightened with white oil paint, on brown-washed paper. 14.5 x 19.2 cm. Lined.

Inscribed in pen and gold ink on old mount, *Tintorett.*

PROVENANCE: Robert Udny (Lugt 2248); P. Huart? (Lugt 2084); sale, London, Christie's, November 21, 1967, no. 49, repr., purchased by the Metropolitan Museum.

Purchase, 1967, Rogers Fund
68.39

A typical example of Bassetti's coarse but vigorous figure style, with the usual lavish applications of white paint used to heighten the forms. The largest group of Bassetti's drawings is at Windsor Castle (see A. Blunt and E. Croft-Murray, *Venetian Drawings . . . at Windsor Castle,* London, 1957, nos. 1-21); the landscape background in the present drawing is similar to that in a composition study of uncertain subject in the Weld collection at Lulworth Manor, Dorset (Courtauld Institute neg. 504/57/19).

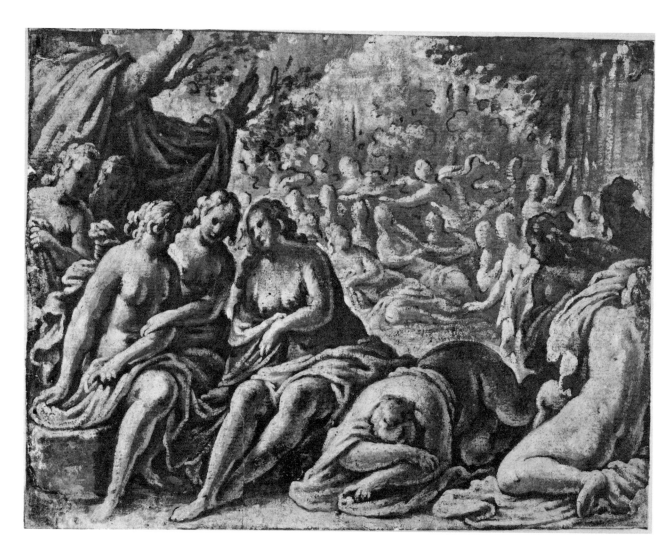

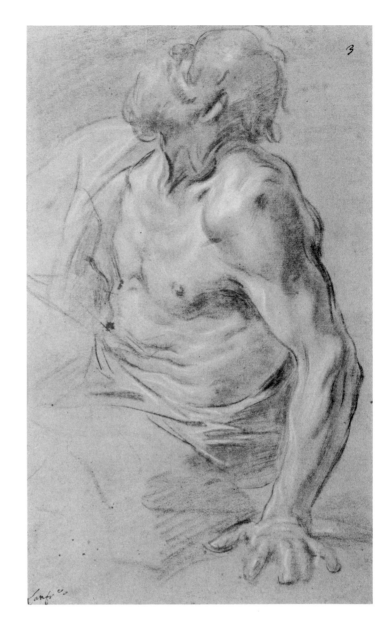

GIOVANNI BATTISTA BEINASCHI

Fossano 1636 – Naples 1688

61. *Seated Bearded Male Figure Looking to Upper Left*

Black and brown chalk, heightened with white, on blue-gray paper. 38.1 x 23.4 cm. Lined.

Inscribed in pen and brown ink at lower left corner, *Lanfr.co;* numbered at upper right corner, *3.*

PROVENANCE: Purchased in London in 1966.

Purchase, 1966, Rogers Fund
66.49

The old and erroneous inscription to Lanfranco is recorded in the same old hand that is found on a number of Beinaschi drawings once mistakenly given to Lanfranco. A good example is a black chalk study of a standing female figure in the British Museum (Pp 4-51, from the collection of Sir Joshua Reynolds). These sheets bear numbers up to 72, and may have been part of a sketchbook. The confusion between the drawing styles of Lanfranco and Beinaschi is long standing, and De Dominici (1742) says that "Forestieri anche Professori"– especially the English– were guilty of this mistake. The drawing styles of Lanfranco and Beinaschi have been discussed by J. Bean and W. Vitzthum (*Bollettino d'Arte,* XLVI, 1961, pp. 106-122).

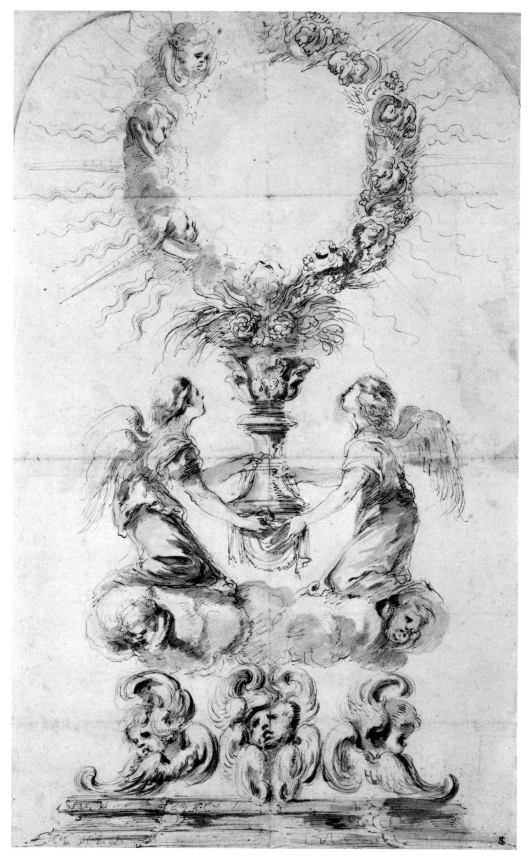

STEFANO DELLA BELLA

Florence 1610 – Florence 1664

62. *Design for a Monstrance*

Pen and brown ink, gray wash, over black chalk. 39.1 x 24.2 cm. Upper corners rounded; one vertical and two horizontal creases. Lined.

PROVENANCE: Earl Spencer (Lugt 1530); Spencer sale, London, T. Philipe, June 10-17, 1811, no. 236 or 237; Dr. Barry Delany (Lugt 350); purchased in London in 1961.

BIBLIOGRAPHY: Stampfle and Bean, 1967, no. 91, repr. (with previous bibliography).

Purchase, 1961, Rogers Fund
61.131.1

This design for a monstrance is unusually large and complete. At Windsor there is a free pen sketch for a similar monstrance, supported by three angels with upraised arms (Blunt, 1954, p. 95, no. 44).

63. *Design for a Cartouche*
VERSO. *Designs for Frames*

Pen and brown ink, over red chalk (recto); pen and brown ink, over black chalk (verso). 25.2 x 18.6 cm.

Inscribed in pen and brown ink on verso, . . .*di 28 di Gennaio/1656;* a number of mathematical calculations, and the word *Ama* in reverse.

PROVENANCE: Edwin S. Chapin, New York (according to vendor); purchased in New York in 1975.

BIBLIOGRAPHY: Bean, 1975-1976, no. 4.

Purchase, 1975, Phyllis Dearborn Massar and Robert J. Massar Gift and Harry G. Sperling Fund
1975.123

This drawing is only loosely related to the cartouche designs that figure in Stefano's *Raccolta di varii cappricii et nove inventioni di cartelle et ornamenti* of 1646 (De Vesme, nos. 1027-1044). The free penwork suggests a later date, and indeed the verso of the sheet bears the date January 28, 1656, in the artist's hand.

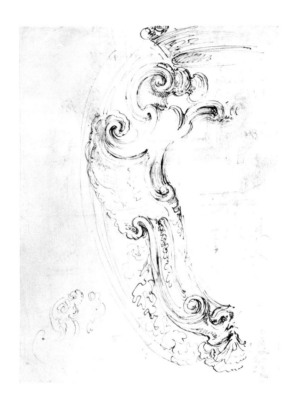

63

63 v.

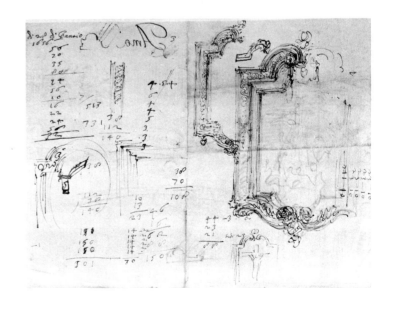

41

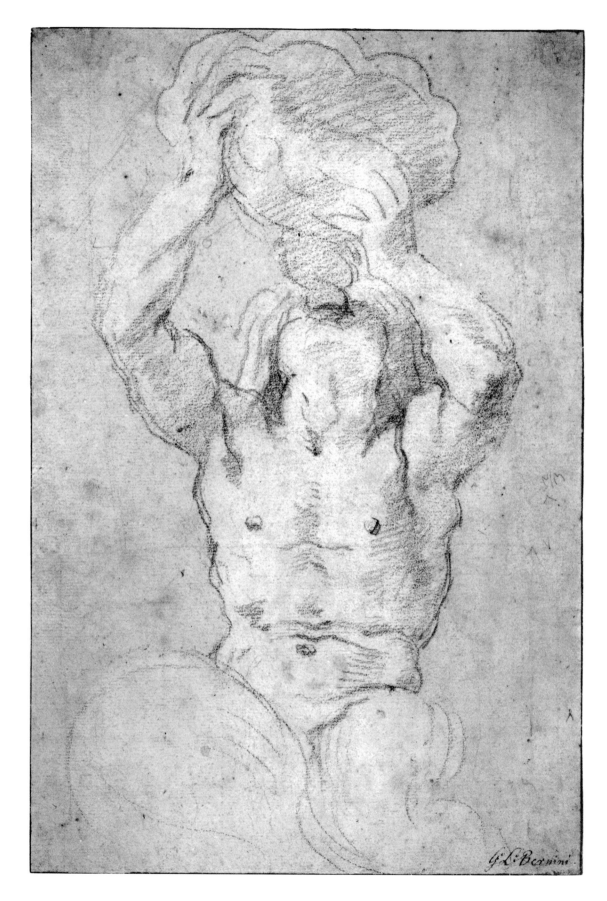

GIAN LORENZO BERNINI

Naples 1598 – Rome 1680

64. *Study for a Triton*
VERSO. *Anatomical Studies?*

Red chalk, the background tinted with an almost imperceptible pale brown wash, framing lines in pen and brown ink (recto); black chalk (verso). 36.4 x 24.5 cm.

Inscribed in pen and brown ink at lower right of recto, *G. L. Bernini;* at upper center of verso, *Lorenzo Bernini.*

PROVENANCE: Georges Haumont, Paris; Haumont sale, Paris, Hôtel Drouot, March 22, 1928, no. 43, repr., as Bernini for the Fontana del Tritone; purchased in Rome in 1973.

BIBLIOGRAPHY: Bean, 1975-1976, no. 6, recto repr.; A. S. Harris, *Selected Drawings of Gian Lorenzo Bernini,* New York, 1977, no. 37, recto repr.

Purchase, 1973, Harry G. Sperling Fund
1973.265

This recently rediscovered drawing is the only surviving study in Bernini's own hand for the Fontana del Tritone in the Piazza Barberini, Rome, datable 1642-1643. A pen and wash design at Windsor (Brauer and Wittkower, 1931, pl. 152c; Blunt and Cooke, 1960, no. 38) appears to be a studio production.

65

GIAN LORENZO BERNINI, school of

65. *Seated Figures of St. Ursula and St. Cecilia*

Pen and brown ink, brown wash. 17.2 x 12.5 cm. Arched top; much abraded. Lined.

Inscribed in pencil at lower margin of old mount, *Julio Romano.*

PROVENANCE: Cephas G. Thompson.

BIBLIOGRAPHY: *Metropolitan Museum Hand-book,* 1895, no. 783, as Giulio Romano.

Gift of Cephas G. Thompson, 1887
87.12.113

Lawrence Turčić identified this drawing, once attributed to Giulio Romano and then classed among the anonymous Italian material, as a work of the Bernini studio to be associated with the stucco figures of saints that surmount the arches of the nave of S. Maria del Popolo, Rome. These figures were executed by Bernini's assistants between August and December of 1655. The saints represented here, Ursula and Cecilia, are reversed in the stucco decoration. A black chalk study for the figure of Ursula, by Bernini himself, is preserved in Leipzig (repr. Brauer and Wittkower, 1931, pl. 41).

64 v.

BARTOLOMEO BISCAINO

Genoa ca. 1632 – Genoa 1657

66. *St. Michael the Archangel and Another Figure Recommending a Soul to the Virgin and Child*

Red chalk and brown wash. 29.2 x 20.2 cm. Lined.

Inscribed in red chalk at lower right corner on recto, *A.S.*; in pencil on reverse of old mount, *Bartolomeo Biscaino*.

PROVENANCE: Cephas G. Thompson.

BIBLIOGRAPHY: *Metropolitan Museum Hand-book*, 1895, no. 695, as Andrea Sacchi.

Gift of Cephas G. Thompson, 1887
87.12.25

FAUSTINO BOCCHI

Brescia 1659 – Brescia 1742

67. *The Mock Visit of Ceremony*

Pen and brown ink, brown and gray wash, over black chalk. Squared in black chalk. 29.1 x 29.1 cm.

Numbered in pen and brown ink at lower right margin, *1300, 1511, 1592....*

PROVENANCE: Purchased in London in 1962.

BIBLIOGRAPHY: Bean and Stampfle, 1971, no. 4, repr.

Purchase, 1962, Rogers Fund
62.119.1

The Brescian Faustino Bocchi made a specialty of comic genre scenes, often of circular format, featuring absurdly costumed dwarfs and hunchbacks. Other drawings, preparatory for such pictures, are in the collection of David Rust in Washington and in the Kunsthaus, Zurich (inv. 1943/10, as P. L. Ghezzi).

SEBASTIANO BOMBELLI, attributed to

Udine 1635 – Venice 1716

68. *Standing Figure in Oriental Costume*

Pen and brown ink, gray wash. 34.2 x 21.2 cm. Upper margin cut irregularly.

Inscribed in pen and brown ink at lower right corner on recto, *Bombelli;* on verso, *326* and *Bombelli.*

PROVENANCE: Giuseppe Vallardi (Lugt 1223); purchased in London in 1976.

BIBLIOGRAPHY: *Old Master Drawings. Armando Neerman,* exhibition catalogue, London, 1976, no. 21, repr.

Purchase, 1976, Harry G. Sperling Fund
1976.187.2

The old attribution to Bombelli, who is an unknown quantity as draughtsman, is rather surprising, but should not be dismissed as implausible. The mannered, somewhat theatrical pose of the heavily draped and turbaned figure recalls Claude Vignon's *Femmes Fortes,* engraved by Jean Mariette as illustrations for a book by Père Pierre Le Moyne that appeared in 1647, and indeed these figures may have inspired the draughtsman here. However, the fine penwork and the transparent gray washes have a distinctly Venetian air to them, foretelling in some ways the drawing style of Francesco Guardi.

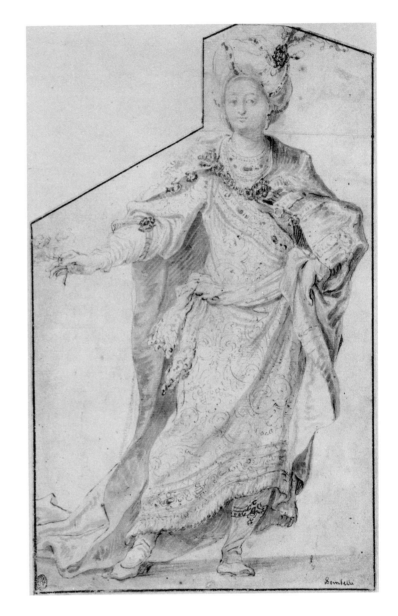

FABRIZIO BOSCHI

Florence ca. 1570 – Florence 1642

69. *Scheme for an Architectural Decoration with a Standing Male Figure in a Niche*

Black and red chalk. 26.6 x 12.8 cm. Stained at upper margin. Lined.

PROVENANCE: James Jackson Jarves; Cornelius Vanderbilt.

BIBLIOGRAPHY: *Metropolitan Museum Hand-book,* 1895, no. 119, as school of Michelangelo.

Gift of Cornelius Vanderbilt, 1880
80.3.119

The attribution to Fabrizio Boschi of this and the following drawing, both formerly classified as anonymous Italian, was made by Philip Pouncey in 1965.

70. *St. Matthew Seated in a Niche*

Black chalk. 25.4 x 12.9 cm. Lined.

A partially effaced and illegible inscription in pen and brown ink at lower center.

PROVENANCE: James Jackson Jarves; Cornelius Vanderbilt.

BIBLIOGRAPHY: *Metropolitan Museum Hand-book,* 1895, no. 120, as school of Michelangelo.

Gift of Cornelius Vanderbilt, 1880
80.3.120

See No. 69 above.

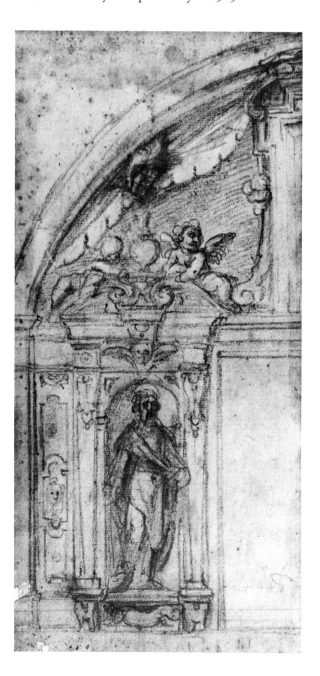

GIAN ANTONIO BURRINI

Bologna 1656 – Bologna 1727

71. *The Descent from the Cross*

Pen and brown ink, brown and red wash, over red chalk. 41.7 x 27.9 cm. Lined.

Drawing fixed to a Mariette mount inscribed, *ANTONIUS BUR-RINI.*

PROVENANCE: Count Albergati, Bologna (?); M. Chuberé, Paris; Pierre-Jean Mariette (Lugt 2097); Mariette sale, Paris, 1775-1776, part of no. 238; purchased in London in 1961.

BIBLIOGRAPHY: Stampfle and Bean, 1967, no. 139, repr. (with previous bibliography).

Purchase, 1961, Rogers Fund
61.123.4

According to Mariette (*Abécédario,* Paris, 1851-1853, I, p. 236), who owned this drawing, it formed part of a series of twelve studies for paintings on copper executed by Burrini for a certain Count C.P.A.; "Je crois Alber-gati, pour lequel Burini a beaucoup travaillé," comments Mariette. "Ces dessins lui font assurément honneur. Ils sont pleins de feu. M. Chuberé les avoit apportés à Paris et j'en ai eu quatre à son inventaire, dont je fais cas." In addition to the present drawing, Mariette's group of four included a *Birth of the Virgin,* now in the Louvre (inv. 7067), an *Adoration of the Shepherds,* and a *Presentation in the Temple,* both now in the Hessisches Landesmuseum, Darmstadt (AE 1252 and AE 1253, respectively). Crozat owned an *Adoration of the Magi* from the original series of twelve, and an *Arrest of Christ* in the Einar Perman collection in Stockholm may well have formed part of the set.

GIAN ANTONIO BURRINI

72. *Landscape with Figures near a Tomb*

Pen and brown ink. 26.1 x 20.8 cm. Lined.

Inscribed in the hand of Jonathan Richardson, Jr., in pen and brown ink on verso of old mount, *Ant. Burino. Bolog.^{se} Scolaro di Dom.^{co} Maria Canuti. nato 1660.*

PROVENANCE: Jonathan Richardson, Jr. (Lugt 2170 and 2997); H. M. Calmann, London.

Gift of H. M. Calmann, 1964
64.223

Jonathan Richardson, Jr., attributed this drawing to Burrini, and indeed the style suits the time and place—even the raised sarcophagus has Bolognese prototypes. No other landscape drawings by Burrini seem to have survived, so we must trust the younger Richardson's connoisseurship. He certainly knew Burrini's style as a figure draughtsman and owned a drawing by the master representing the Miraculous Appearance of the Image of St. Dominic at Soriano, now in the Cabinet des Dessins of the Louvre (inv. 7071).

GUIDO CAGNACCI
S. Arcangelo di Romagna 1601–Vienna 1663

73. *Standing Nude Female Figure* VERSO. *Studies of a Kneeling Nude Female Figure and of a Man's Head*

Red chalk on beige paper (recto and verso). 49.4 x 32.0 cm. Horizontal crease at center, several brown stains.

PROVENANCE: Earl Spencer (Lugt 1530); Sir Charles Greville (Lugt 549); Earl of Warwick (Lugt 2600); Hugh N. Squire, London; purchased in London in 1962.

Purchase, 1962, Gustavus A. Pfeiffer Fund
62.120.9

The attribution to Cagnacci, who is almost unknown as a draughtsman, is apparently traditional. However, it has not been possible to identify the drawing in records of the Spencer, Greville, and Warwick collections in which it figured, judging from the collectors' marks on the recto and verso of the sheet. The physical type and the smooth chalk treatment are rather what one might expect of Cagnacci.

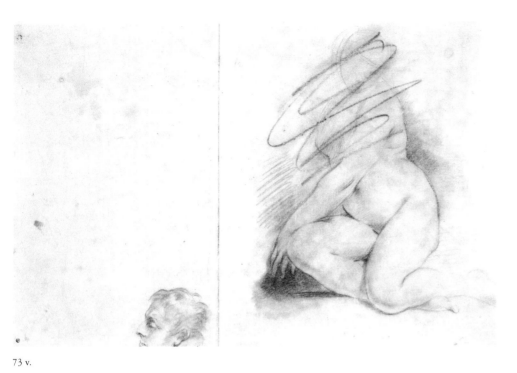

73 v.

GIACINTO CALANDRUCCI

Palermo 1646 – Palermo 1707

74. *The Vision of St. John of Matha*

Pen and brown ink, black and red chalk, some corrections in white.
36.2 x 26.5 cm.

PROVENANCE: Sale, London, Sotheby's, March 26, 1976, no. 152;
purchased in London in 1977.

Purchase, 1977, Mr. and Mrs. Carl Selden Gift
1977.128

Domitilla d'Ormesson points out that this design by
Calandrucci was engraved (in reverse) by Benoît Farjat
(Lyon 1646– Rome ca. 1720). An impression of Farjat's
print, which is not listed by Le Blanc, is in the Cabinet
d'Estampes of the Bibliothèque Nationale, Paris; in the
caption Calandrucci is credited as the inventor of the
design. Mademoiselle d'Ormesson has found another
pen composition study in the Cabinet des Dessins of
the Louvre (inv. 15349, as anonymous Italian). The Met-
ropolitan's drawing is blackened on the reverse of the
sheet for transfer to the engraver's plate, but there are
some minor variations between the drawing and the

print. In the latter, a biretta replaces the crown on the ground.

On the day of the celebration of his first Mass in Paris, John of Matha, who had been born in Provence in 1160, is said to have had the vision of an angel dressed in white with a cross of red and blue, breaking the chains of two slaves. This inspired him to dedicate his life to the freeing of slaves, and with this intention he founded with Felix of Valois the Order of the Holy Trinity. John of Matha died in Rome in 1213 and was canonized by Urban VIII in 1632.

75

50

ANDREA CAMASSEI
Bevagna near Foligno 1602 – Rome 1649

75. *St. Sebastian Clubbed to Death*

Red chalk. 46.0 x 30.5 cm. Various small spots and tears.

Inscribed in pen and brown ink at lower margin, *Giordano* . . . [rest illegible].

PROVENANCE: Pierre-Jean Mariette (Lugt 1852); Mariette sale, Paris, 1775-1776, part of no. 398, as Falcone; Marquis de Lagoy (Lugt 1710); unidentified collector's mark (Lugt 2508); purchased in Amsterdam in 1965.

BIBLIOGRAPHY: Stampfle and Bean, 1967, no. 74, repr., as Falcone; Vitzthum, Florence, 1967, mentioned p. 41, as Falcone; Vitzthum, Paris, 1967, mentioned p. 16, as Camassei; A. S. Harris, *Art Bulletin,* LII, 1970, p. 55, the painting fig. 12.

Purchase, 1965, Rogers Fund
65.137

P.-J. Mariette attributed this drawing to Aniello Falcone, perhaps influenced by De Dominici's comment that Falcone's drawing style was sometimes mistaken for that of Andrea Sacchi. Sacchi's classicizing influence is indeed evident in this drawing, which, as Ann Sutherland Harris has pointed out, is Andrea Camassei's study for a painting in the church of S. Sebastiano alla Polveriera, Rome, for which the artist was paid in 1633. In the painting the nude body of Sebastian bears the arrows of the first phase of his martyrdom; in both the painting and the drawing the Colosseum appears in the right background approximately where it actually stands in relation to the church, which is on the Palatine.

GIOVANNI ANGELO CANINI
Rome 1617 – Rome 1666

76. *Scene of Martyrdom*

Pen and brown ink, gray-brown wash, over red chalk. Illegible red chalk notations on verso. 18.7 x 12.7 cm.

Inscribed in pen and brown ink at lower left, *io: Agelus Caninius inventor*.

PROVENANCE: C. S. Sartoris, Wollaton Bingham; P. G. A. Bucknall (according to Christie's); sale, London, Christie's, March 25, 1969, part of no. 143; purchased in London in 1970.

Purchase, 1970, Rogers Fund
1970.113.1

The scene may represent the clubbing to death of St. Sebastian, but no such composition by Canini is recorded. He did, however, paint a martyrdom of St. Stephen in S. Martino ai Monti, Rome. There seems no reason to doubt the accuracy of the obviously old attribution, though the penwork is exceptionally free and has something of Lanfranco and Mola about it. The facial types are strikingly similar to those in Canini's pen sketches for his title page of the 1648 edition of Vasari's *Vite*; these drawings are at the Teyler Museum in Haarlem and the Bode Museum in East Berlin (see W. Vitzthum, *Master Drawings,* IV, 3, 1966, p. 304).

Ann Percy points out that in the Pennsylvania Academy Collection at the Philadelphia Museum of Art there is another pen sketch for the same composition and by the same hand (P.A.F.A. 120).

77. *The Virgin and Child Appearing to St. Anthony of Padua and a Hermit*

Red chalk and red wash. 34.6 x 23.1 cm.

Inscribed in pen and brown ink at lower left, *Ang. Canini*.

PROVENANCE: Howard C. Levis (Lugt 565); Alexander Lowenthal, Pittsburgh; Mary Lowenthal Felstiner, Stanford, California.

Gift of Mrs. Mary Lowenthal Felstiner, 1973
1973.126

The physical types and the rather brittle treatment of the drapery may be compared to those in an allegorical composition preserved at Darmstadt, also with a traditional attribution to G. A. Canini (AE 1713).

76

77

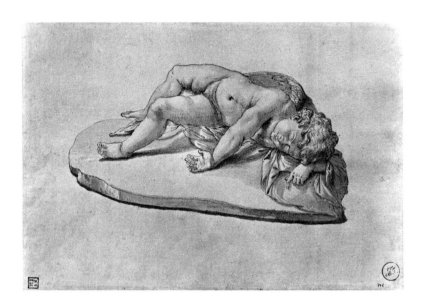

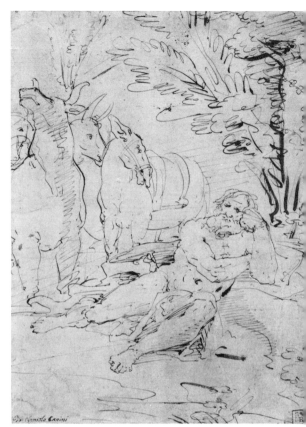

GIOVANNI ANGELO CANINI

78. *Sleeping Eros, after an Antique Sculpture*

Pen and brown ink, brown wash. 21.8 x 32.1 cm.

Numbered in pen and brown ink at lower right corner, *171*. Inscribed in pencil on old mount, *G. Canini*.

PROVENANCE: Sir Joshua Reynolds (Lugt 2364); Thomas Banks (Lugt 2423); Ambrose Poynter (Lugt 161); purchased in 1945.

Purchase, 1945, Rogers Fund
45.36

The traditional attribution to Canini is not implausible, for the artist made a specialty of drawn copies of classical antiquities. An ambitious project for a corpus of classical antiquities commissioned by Colbert for Louis XIV was cut short by Canini's death, though a good many drawings by Canini after medals and cameos were engraved by Etienne Picart (*Images des héros et des grands hommes de l'antiquité dessinées sur des médailles, des pierres antiques et autres anciens monuments par Jean-Ange Canini, gravées par Picart Le Romain,* Amsterdam, 1731).

79. *Unidentified Subject: Reclining Nude Male Figure and Cattle*

Pen and brown ink. Illegible black chalk notations on verso. 25.2 x 18.5 cm.

Inscribed in pen and brown ink at lower left, *Gio Agniolo Canini*.

PROVENANCE: Sir Joshua Reynolds (Lugt 2364); Carel Emil Duits (Lugt Supp. 533a); Eric Wunsch, New York.

Gift of Eric Wunsch, 1971
1971.130

The attribution is old and not impossible.

52

REMIGIO CANTAGALLINA

Borgo S. Sepolcro? ca. 1580 – Florence after 1635

80. *Three Figures by a Rustic Dwelling*

Pen and brown ink, over a little black chalk. 20.8 x 17.6 cm.
Lower half of drawing, 11.4 cm. in height, pasted on to larger sheet.

Numbered in pen and brown ink at upper right corner, *15*.

PROVENANCE: John and Alice Steiner, Larchmont, New York.

Gift of John and Alice Steiner, 1972
1972.271

81. *Landscape with a Farm House and a Bell Tower*

Pen and brown ink. 14.8 x 21.8 cm. Framing lines in pen and brown
ink, probably by the artist himself.

Inscribed in pen and brown ink at lower margin, *A di 17 7bre 1632
RC*.

PROVENANCE: Prof. John Isaacs; sale, London, Sotheby's, January
28, 1965, no. 147; Harry G. Sperling, New York.

Bequest of Harry G. Sperling, 1975
1975.131.15

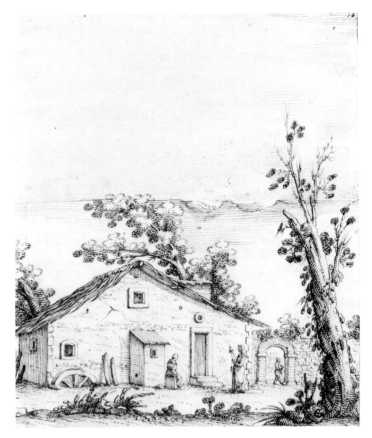

80

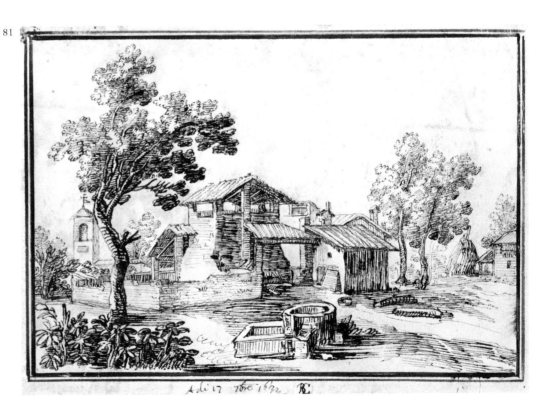

81

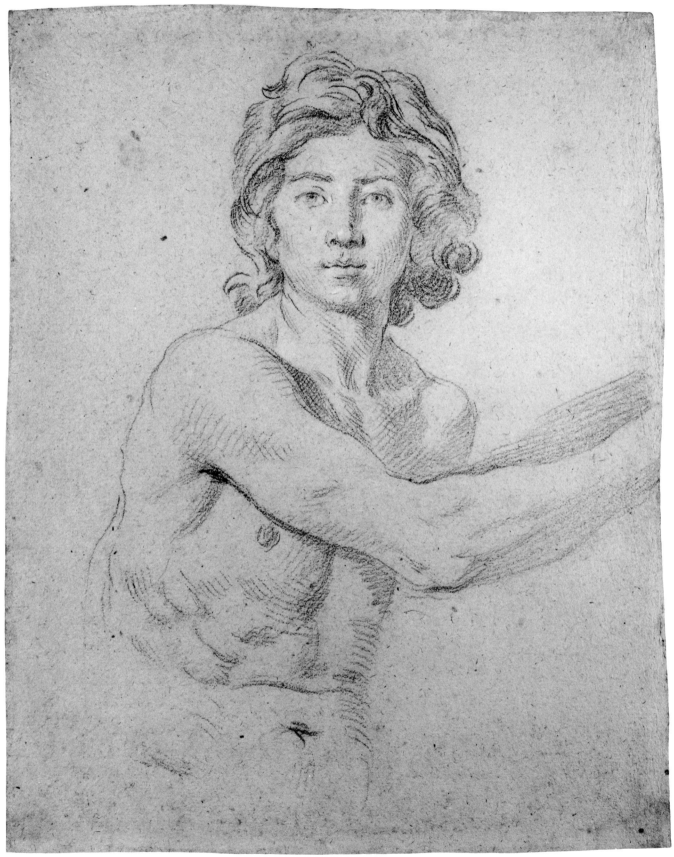

SIMONE CANTARINI

Pesaro 1612 – Verona 1648

82. *Half-Figure of a Youth with His Right Arm Raised*

Red chalk, a few white highlights, on beige paper. 33.8 x 26.7 cm.

PROVENANCE: Purchased in London in 1969.

BIBLIOGRAPHY: Mancigotti, 1975, fig. 136.

Purchase, 1969, Rogers Fund
69.1

The high finish of this drawing from life is exceptional for Cantarini. The same model in a similar pose is drawn in a much freer fashion on a sheet at Christ Church, Oxford, which is clearly a study for a seated, youthful John the Baptist (Byam Shaw, 1976, no. 1017, pl. 612). Both these studies may be preparatory for Cantarini's painting, the *Baptist Preaching in the Wilderness,* in the Pinacoteca at Bologna (repr. Mancigotti, 1975, pl. III, fig. 24).

83. *The Holy Family with Angels Bearing Symbols of the Passion*

Red chalk. 16.1 x 21.6 cm. Lined.

Inscribed in pen and brown ink at lower right corner of old mount, *Guido Reni.*

PROVENANCE: James Jackson Jarves; Cornelius Vanderbilt.

BIBLIOGRAPHY: *Metropolitan Museum Hand-book,* 1895, no. 313, as Guido Reni; Mancigotti, 1975, fig. 160.

Gift of Cornelius Vanderbilt, 1880
80.3.313

Though this and the following drawing (No. 84) were in the past attributed to Guido Reni, they are typical examples of the loose red chalk style of Cantarini.

84. *The Mystic Marriage of St. Catherine*

Red chalk. 11.9 x 10.8 cm. Upper left corner replaced. Lined.

Numbered in pencil at lower left corner, 2; inscribed in pen and brown ink at lower left corner of old mount, *G. Reni.*

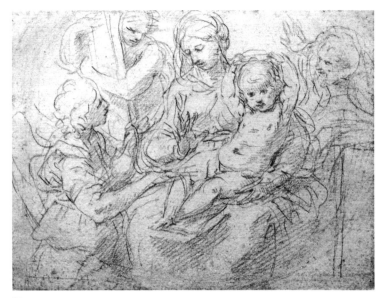

83

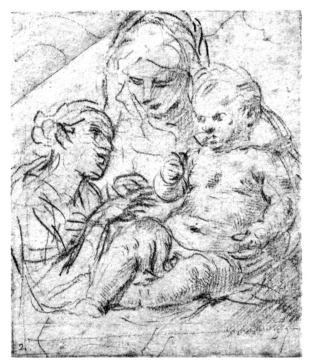

84

PROVENANCE: James Jackson Jarves; Cornelius Vanderbilt.

BIBLIOGRAPHY: *Metropolitan Museum Hand-book,* 1895, no. 331, as Guido Reni.

Gift of Cornelius Vanderbilt, 1880
80.3.331

See No. 83 above.

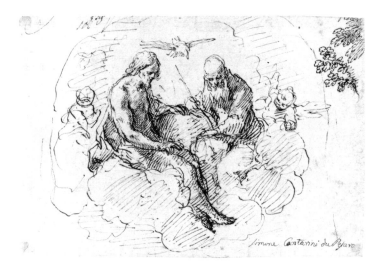

SIMONE CANTARINI

85. *The Holy Trinity in Glory*

Pen and brown ink. 13.3 x 20.2 cm. Lined.

Inscribed in pen and brown ink at lower right, *Simone Cantarini da Pesaro.*

PROVENANCE: Cephas G. Thompson.

BIBLIOGRAPHY: *Metropolitan Museum Hand-book,* 1895, no. 772, as Simone Cantarini; Mancigotti, 1975, fig. 162.

Gift of Cephas G. Thompson, 1887
87.12.102

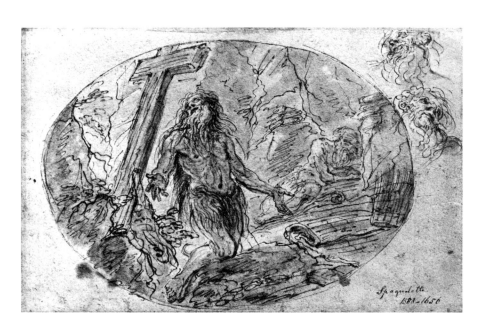

DOMENICO MARIA CANUTI

Bologna 1620 – Bologna 1684

86. *Two Hermits in the Wilderness*

Pen and brown ink, brown wash, on beige paper. 16.5 x 26.7 cm. Stains at lower left and right.

Inscribed in pen and brown ink at lower right corner, *Spagnoletto/ 1588-1650.*

PROVENANCE: James Jackson Jarves; Cornelius Vanderbilt.

BIBLIOGRAPHY: *Metropolitan Museum Hand-book,* 1895, no. 339, as Lo Spagnoletto; Blunt, 1971, p. 59, under no. 81.

Gift of Cornelius Vanderbilt, 1880
80.3.339

The convincing attribution to Canuti was made by Philip Pouncey in 1965. An almost identical drawing in the Royal Collection at Windsor (inv. 6756; Blunt, 1971, p. 59, no. 81) is considered by Ebria Feinblatt to be an old copy of the present sheet. Anthony Blunt refers to a third version in the Prado, but Manuela B. Mena Marqués informs me that this drawing cannot presently be found in Madrid.

GIOVANNI ANDREA CARLONE

Genoa 1639–Genoa 1697

87. *Old Testament Scene*

Pen and brown ink, brown wash, over black chalk. Squared in black chalk. 28.5 x 35.9 cm. Lower left corner made up.

Inscribed in pen and brown ink on a strip of paper pasted at lower left corner, *Gio Andrea Carlone*.

PROVENANCE: Sale, London, Sotheby's, December 10, 1968, no. 10, repr., purchased by the Metropolitan Museum.

BIBLIOGRAPHY: Newcome, 1972, no. 107, repr.

Purchase, 1968, Rogers Fund
68.193

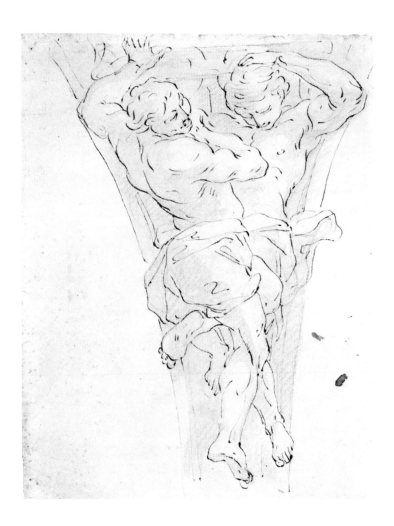

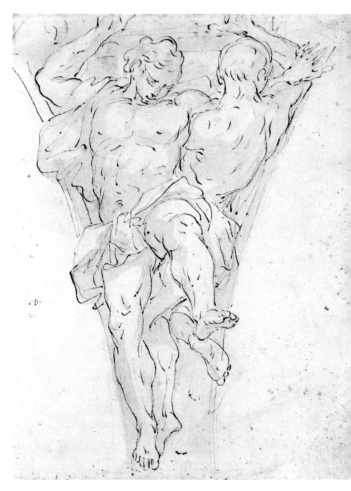

GIOVANNI BATTISTA CARLONE,
attributed to Genoa 1603–Turin 1677?

88. *Two Partially Draped Male Figures in a Pendentive*

Pen and brown ink, pale gray wash, over black chalk. 29.0 x 23.3 cm.

PROVENANCE: Mrs. Richard Krautheimer.

Gift of Mrs. Richard Krautheimer, 1970
1970.294.1

Trude Krautheimer was the first to point out that, in slapdash figure style, this and the following drawing (No. 89) are strikingly similar to the three angel caryatids studied on a sheet in the Janos Scholz collection. The Scholz drawing was first attributed to Giovanni Battista Carlone by the collector himself, and this attribution was maintained by Mary Newcome (repr. Newcome, 1972, p. 22, no. 52).

89. *Two Partially Draped Male Figures in a Pendentive*

Pen and brown ink, pale gray wash, over black chalk. 28.7 x 22.5 cm.

PROVENANCE: Mrs. Richard Krautheimer.

Gift of Mrs. Richard Krautheimer, 1970
1970.294.2

See No. 88 above.

GIULIO CARPIONI

Venice 1613–Vicenza 1678

90. *Bacchanalian Group with*
Children Drinking

Pen and brown ink, brown wash. 14.5 x 9.9 cm.

PROVENANCE: Marquis de Lagoy (Lugt 1710); Count Moriz von
Fries (Lugt 2903); unidentified collector's initials in purple ink on
mount, *J.I.K.*; Anton Schmid, Vienna; purchased in Zurich in 1969.

Purchase, 1969, Rogers Fund
69.126.1

91. *Figure Studies: Standing Nude Figure,*
Putti, and a Man's Head
VERSO. *Figure Studies: A Flying and*
a Standing Man

Red chalk (recto and verso). 27.7 x 19.5 cm.

PROVENANCE: Purchased in London in 1967.

Purchase, 1967, Rogers Fund
67.95.2

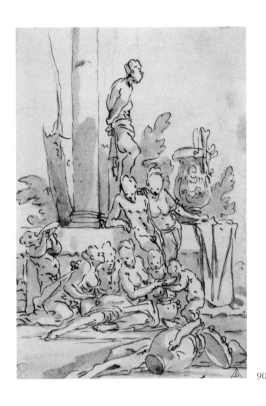

90

91

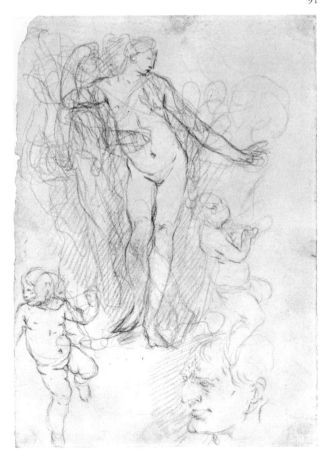

91 v.

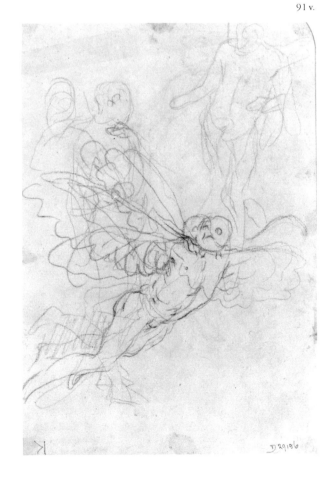

92. *Figure Studies: Men Standing by a Large Vase, a Falling Nude Figure, and Other Figures*

Red chalk. 23.5 x 16.0 cm.

Inscribed in pen and brown ink at lower left corner, *Salvator Rosa*.

PROVENANCE: Purchased in London in 1970.

BIBLIOGRAPHY: *Old Master Drawings and Paintings. Yvonne Tan Bunzl*. exhibition catalogue, London, 1970, no. 17, repr.; Bean, 1972, no. 4.

Purchase, 1970, Rogers Fund
1970.113.3

The oldish attribution to Rosa may be disregarded; the red chalk style is characteristic of Carpioni.

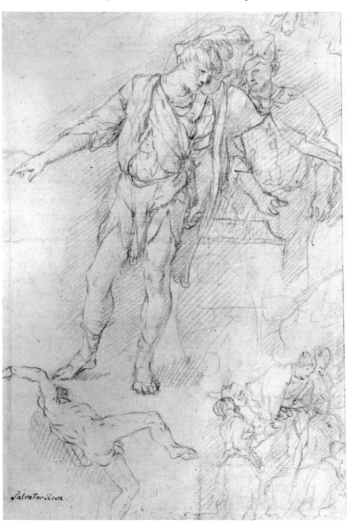

Salvator Rosa.

AGOSTINO CARRACCI

Bologna 1557 – Parma 1602

93. *Figure Studies for Frescoes in the Palazzo del Giardino*
VERSO. *Three Amors in the Garden of Venus*

Pen and brown ink, over a little red chalk (recto); pen and brown ink, gray-blue wash (verso). 28.2 x 39.9 cm. Partial lining masks all but the center of the verso with the drawing of the Amors (14.1 x 18.8 cm.).

Numbered in pen and brown ink at lower right corner on recto, *100*.

PROVENANCE: Pierre-Jean Mariette (Lugt 2097); Sir Thomas Lawrence (Lugt 2445); Lord Francis Egerton, 1st Earl of Ellesmere (Lugt Supp. 2710b); 6th Duke of Sutherland; sale, London, Sotheby's, July 11, 1972, no. 34, recto and verso repr., purchased by the Metropolitan Museum.

BIBLIOGRAPHY: Holland, 1961, no. 49, recto pl. XIII; Mahon, 1963, no. 62, recto pl. 31 (with full bibliography); Bacou, 1967, no. 24, recto repr.; Bean, 1973, no. 6; Bean, 1975-1976, no. 8.

Purchase, 1972, Harris Brisbane Dick Fund and Rogers Fund
1972.133.1

The lively pen sketches on the recto are studies for figures in the representation of the story of Peleus and Thetis painted in fresco on the vault of a room in the Palazzo del Giardino, Parma, by Agostino Carracci in the last two years of his life. The reclining female is studied for Thetis as she guides the Argo between Scylla and Charybdis. The male profile at the upper left of the sheet is a study for the figure of Peleus in the Marriage of Peleus and Thetis. There are further pen studies for these frescoes in the Albertina and at Windsor Castle (see Mahon, 1963, nos. 63-64), and the Kunsthalle in Hamburg recently acquired a double-faced sheet of pen sketches by Agostino, with studies for Thetis riding a dolphin (inv. no. 1974/68; repr. *Jahrbuch der Hamburger Kunstsammlungen*, 20, 1975, p. 138).

93

93 v.

94

94. *Figure Studies: Frontal Standing Male Nude, Male Heads, Seated Monkey, and a Long-Beaked Bird*

VERSO. *Figure Studies: Back View of Standing Male Nude, Male and Female Heads, a Flying Long-Beaked Bird, etc.*

Pen and brown ink (recto and verso). 27.0 x 19.4 cm.

PROVENANCE: Harry G. Sperling, New York.

Bequest of Harry G. Sperling, 1975
1975.131.16

A characteristic example of Agostino's study sheets, where motifs are artfully scattered on the page.

ANNIBALE CARRACCI
Bologna 1560 – Rome 1609

95. *A Domestic Scene*

Pen and black ink, gray and brown wash. 29.0 x 23.3 cm. A horizontal strip 3.4 x 23.3 cm. has been added at upper margin and drawing of drapery (?) continued in another hand. Lined and mounted on a blue Mariette surround from which the cartouche has been cut away.

Inscribed in pencil on reverse of old mount, *Collections of C. degli Occhialli, Crozat, Mariette, Count Fries, D'Argenville.*

PROVENANCE: Carlo degli Occhiali; Pierre Crozat (according to Mariette—see Mahon, 1963, p. 152); Pierre-Jean Mariette (Lugt 2097); Count Moriz von Fries (Lugt 2903); Sir Thomas Lawrence (Lugt 2445); Lord Francis Egerton, 1st Earl of Ellesmere; 6th Duke of Sutherland; sale, London, Sotheby's, July 11, 1972, no. 46, repr., purchased by the Metropolitan Museum.

BIBLIOGRAPHY: Holland, 1961, no. 75, pl. XVIII; Mahon, 1963, no. 225, pl. 106 (with full bibliography); Bacou, 1967, no. 26, repr.; Posner, 1971, I, p. 18, fig. 21; Bean, 1973, no. 11; Boschloo, 1974, I, p. 34, II, fig 129; Bean, 1975-1976, no. 9; Malafarina, 1976, no. III of appendix, repr.

Purchase, 1972, Mrs. Vincent Astor and Mrs. Charles Payson Gift, Harris Brisbane Dick Fund and Rogers Fund
1972.133.2

This tenderly observed scene of family life with a mother warming her child's nightdress before a small fire proba-

94 v.

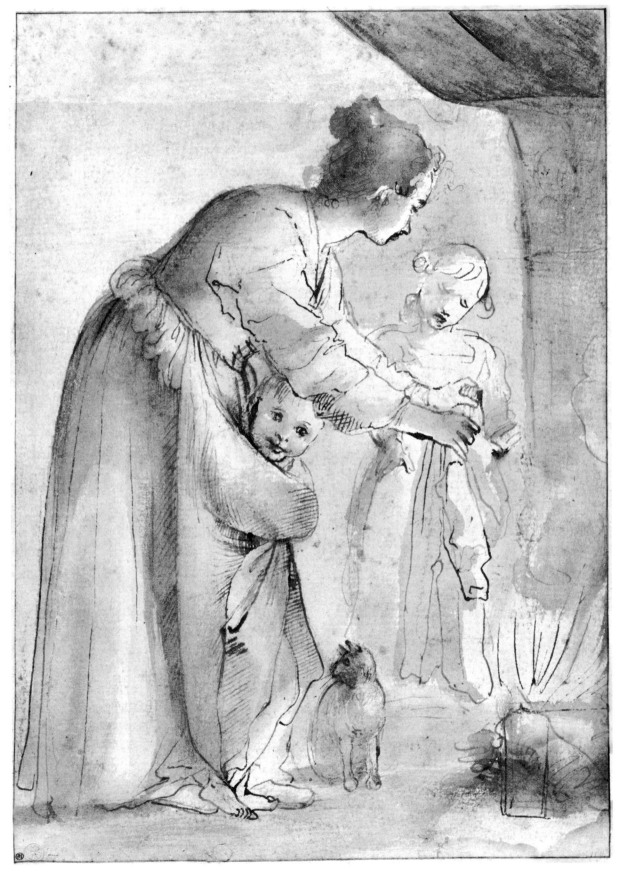

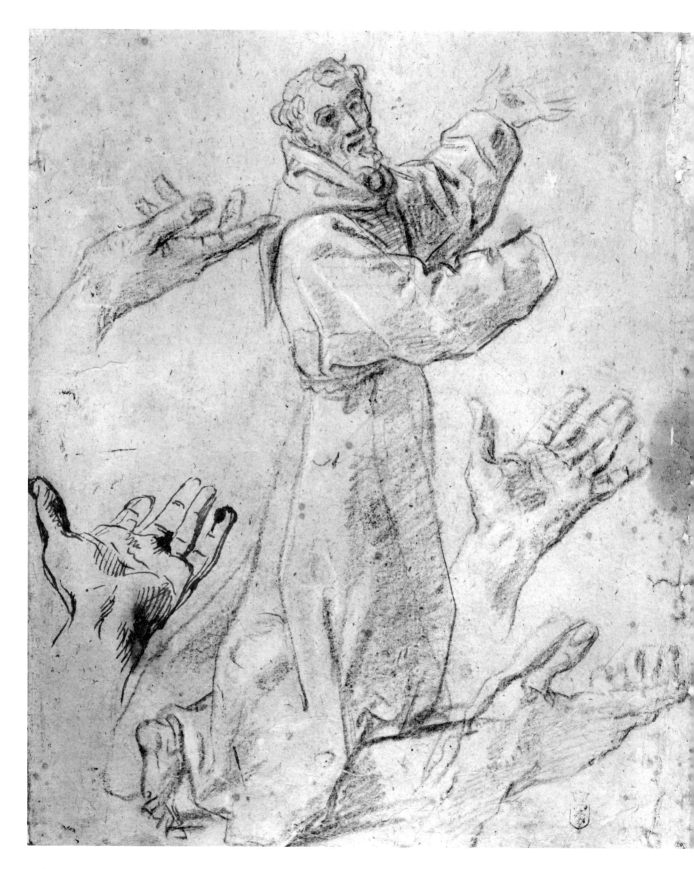

64

bly dates from the early 1580s. When the drawing was in Mariette's collection it was reproduced in reverse by Vincenzo Vangelisti in a mixed-method engraving and etching printed in bistre. An impression of this bearing the collector's marks of Moriz von Fries and Thomas Lawrence, two previous owners of the drawing itself, is in the Metropolitan Museum (1972.133.2a). The attribution to Annibale is traditional and entirely convincing. It was once exhibited, in Leicester in 1954, with an attribution to Bartolomeo Schedoni proposed by E. K. Waterhouse. This suggestion has not found acceptance.

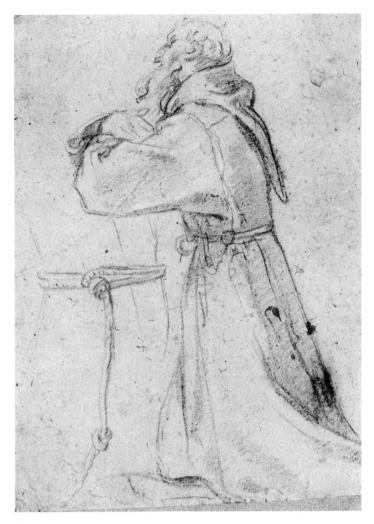

96 v.

96. *Kneeling Figures of St. Francis and Four Studies of His Hands* VERSO. *Kneeling Figure of St. Francis and a Study of the Cord at His Waist*

Red chalk for the figure and three of the hands, pen and brown ink for the hand at the lower left (recto); red chalk (verso). 33.5 x 28.3 cm.

PROVENANCE: Marquis de Lagoy (Lugt 1710); Sir Thomas Lawrence (Lugt 2445); Lord Francis Egerton, 1st Earl of Ellesmere (Lugt Supp. 2710b); 6th Duke of Sutherland; sale, London, Sotheby's, July 11, 1972, no. 49, recto and verso repr., purchased by the Metropolitan Museum.

BIBLIOGRAPHY: Holland, 1961, no. 146; Mahon, 1963, no. 91 (with full bibliography); Posner, 1971, II, p. 13, fig. 24c; Bean, 1973, no. 10; Bean, 1975-1976, no. 11; Malafarina, 1976, no. 23², repr.

Purchase, 1972, Rogers Fund
1972.137.1

The sketches on the recto are studies for the kneeling figure of St. Francis, with his arms extended toward the dead Christ but looking out at the spectator, as he appears at the lower left foreground of the *Pietà with Saints,* an altarpiece painted by Annibale in 1585 for the church of the Capuchin Fathers in Parma and now in the Galleria Nazionale of that city (repr. Posner, 1971, II, pl. 24a). The drawing on the verso shows a kneeling monk with arms crossed; it may be an earlier sketch for the figure of Francis. A red chalk study for the figure of the dead Christ in the center of the picture is preserved in the Uffizi (12418 F; repr. Posner, 1971, II, pl. 24b).

97. *Two Studies of a Boy and Two of a Girl*

Red chalk, heightened with white, on beige paper. Studies of legs in black and red chalk on verso. 22.8 x 32.1 cm.

PROVENANCE: Marquis de Lagoy (Lugt 1710); Thomas Dimsdale (Lugt 2426); Sir Thomas Lawrence (Lugt 2445); Lord Francis Egerton, 1st Earl of Ellesmere (Lugt Supp. 2710b); 6th Duke of Sutherland; sale, London, Sotheby's, July 11, 1972, no. 51, recto and verso repr., purchased by the Metropolitan Museum.

BIBLIOGRAPHY: Holland, 1961, no. 74, pl. XIX; Mahon, 1963, no. 229, pl. 108 (with full bibliography); Bean, 1973, no. 13; Bean, 1975-1976, no. 10, repr.; Malafarina, 1976, no. VII of appendix, repr.

Purchase, 1972, Harris Brisbane Dick Fund and Rogers Fund 1972.133.3

The directness of Annibale's vision and the economy of his use of red chalk give to this marvelously beautiful sheet a strikingly modern air. The drawing probably dates from the late 1580s.

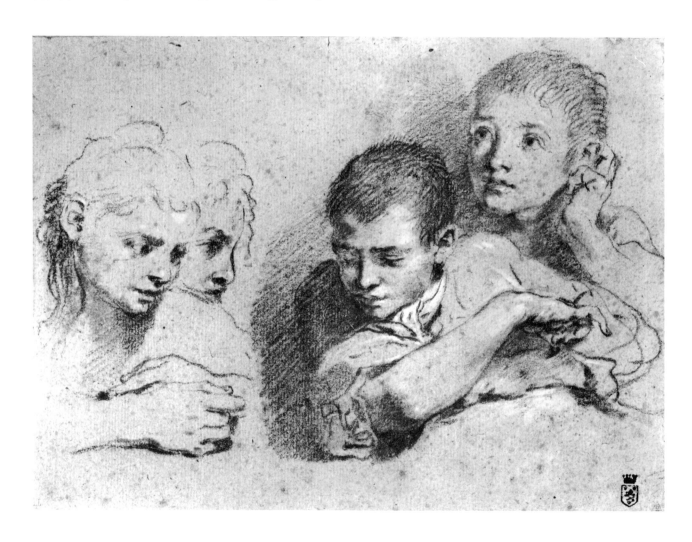

98. *The Monster Cacus*

Black chalk, heightened with white, on faded blue paper. 38.1 x 49.6 cm. Vertical creases at center; scattered oil and water stains and repairs. Lined with canvas.

PROVENANCE: Walter C. Baker, New York.

BIBLIOGRAPHY: Stampfle and Bean, 1967, no. 9, repr. (with previous bibliography and exhibition listings); Posner, 1971, II, p. 33; Bean, 1973, no. 14; Malafarina, 1976, under no. 74.

Bequest of Walter C. Baker, 1972

Study for the figure of Cacus in a fresco representing Hercules slaying the brigand monster, painted by Annibale above a fireplace in the Palazzo Sampieri-Talon in Bologna about 1593-1594 (repr. Posner, 1971, II, pl. 79). This vigorous drawing was once, not surprisingly, attributed to Rubens, but was correctly returned to Annibale as a study for the Bologna fresco by Michael Jaffé.

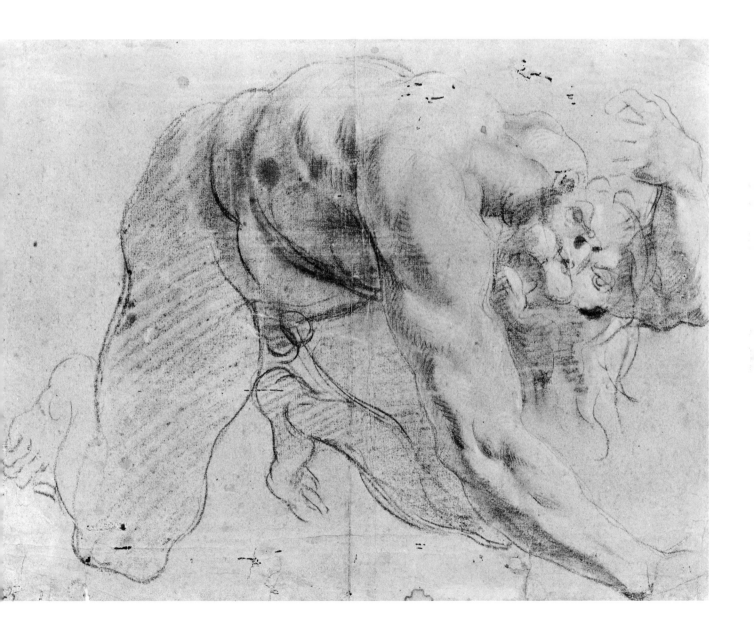

ANNIBALE CARRACCI

99. *Landscape with Jacob Sleeping*

Pen and brown ink, brown wash, over a little black chalk. 41.3 x 26.2 cm.

Numbered in pen and brown ink at upper right, 2; inscribed in pen and brown ink at lower right, *di mano di Anniballe Carracci* (the original inscription in a pale brown ink has been gone over in a darker ink); in pen and brown ink at lower right of verso, *An: Carrattio;* in pen and brown ink on the old mount (now detached from the drawing), *Jacob asleep y.ᵉ ladder with angels at a great distance.*

PROVENANCE: Sir Peter Lely (Lugt 2092); Earls of Pembroke; Pembroke sale, London, Sotheby's, July 5-6, 9-10, 1917, no. 376, purchased by the Metropolitan Museum.

BIBLIOGRAPHY: Stampfle and Bean, 1967, no. 10, repr. (with previous bibliography and exhibition listings); Bean, 1973, no. 23; Boschloo, 1974, I, p. 37; II, fig. 142.

Purchase, 1917, Hewitt Fund
19.76.14

But for the light indication, added perhaps as an afterthought, of a ladder rising up to heaven in the background, which identifies the sleeping youth as Jacob, this delightful drawing could be treated as a pure landscape. The verticality of the composition and the pre-dominance given to the foreground place the sheet among Annibale's Bolognese experiments in landscape. Another version of this composition with a youth asleep at the foot of a clump of trees, but without the ladder and with a considerable number of variations, is in a private collection in Brookline, Massachusetts; that sheet, formerly in the Ellesmere collection, is dated 1595 (repr. sale catalogue, London, Sotheby's, July 11, 1972, no. 58).

100. *Perseus Beheading Medusa* VERSO. *Study of a Child and of Decorative Motifs*

Pen and brown ink, brown wash, scribbles in a darker brown ink at upper right (recto); pen and brown ink, a little brown wash (verso). 12.7 x 23.9 cm. Cut to the shape of a lunette, the corners made up.

PROVENANCE: Purchased in London in 1962.

BIBLIOGRAPHY: R. Bacou, *Master Drawings*, II, 1, 1964, pp. 40-44, recto pl. 32, verso pl. 33; Martin, 1965, p. 246, no. 30, recto fig. 133, verso fig. 103; Bean, 1973, no. 15.

Purchase, 1962, Rogers Fund
62.204.3

100 v.

ANNIBALE CARRACCI (NO. 100)

Before undertaking in 1597 the frescoes of the Gallery of the Palazzo Farnese, Annibale decorated the Camerino, Cardinal Odoardo Farnese's own study in the family palace. The scheme of this ceiling decoration is Virtue, explained allegorically in scenes from classical mythology. In one of the lunettes beneath the cove vaulting Annibale represented in fresco the fable of Perseus and Medusa. The hero, nude except for the helmet of invisibility and the winged sandals lent him by Mercury, is about to decapitate Medusa, and he looks back at her head reflected in Minerva's shield. Mercury watches in the left background, and Medusa's two sisters are seen sleeping at the right. This very rough sketch corresponds in all essentials to the fresco as executed (repr. Martin, 1965, fig. 23). The doodling pen lines at upper right are probably related to the monochrome arabesques in the grisaille ornament of sections of the vault; these arabesques appear on the verso of this sheet.

101. *Anteros Victorious*

Red chalk. 22.2 x 15.7 cm. Oil stain at top of sheet. Lined.

Inscribed in pen and brown ink at lower left, *annibale Caracci.*

PROVENANCE: Lionel Lucas (Lugt Supp. 1733a); Claude Lucas; Lucas sale, London, Christie's, December 9, 1949, part of no. 67, as L. Carracci; Hugh N. Squire; purchased in London in 1962.

BIBLIOGRAPHY: Stampfle and Bean, 1967, no. 11, repr. (with previous bibliography and exhibition listings); Bean, 1973, no. 16; Malafarina, 1976, no. 104Z[1], repr.

Purchase, 1962, Gustavus A. Pfeiffer Fund
62.120.2

At the four corners of the cove vault of the Farnese Gallery the painted architecture opens to reveal triangular glimpses of painted sky, against which are silhouetted pairs of putti standing on balustrades. These putti are combined to represent contrasts between spiritual and sensuous loves. In one corner Cupid and Anteros are represented struggling for the palm branch; a black chalk drawing in the Louvre is a study for this group (inv. 7305, repr. Martin, 1965, pl. 242). The Metropolitan Museum's drawing represents an early stage of the artist's planning for this corner, a stage at which the artist thought of representing the victorious Anteros holding aloft the disputed palm branch and being carried by two putti.

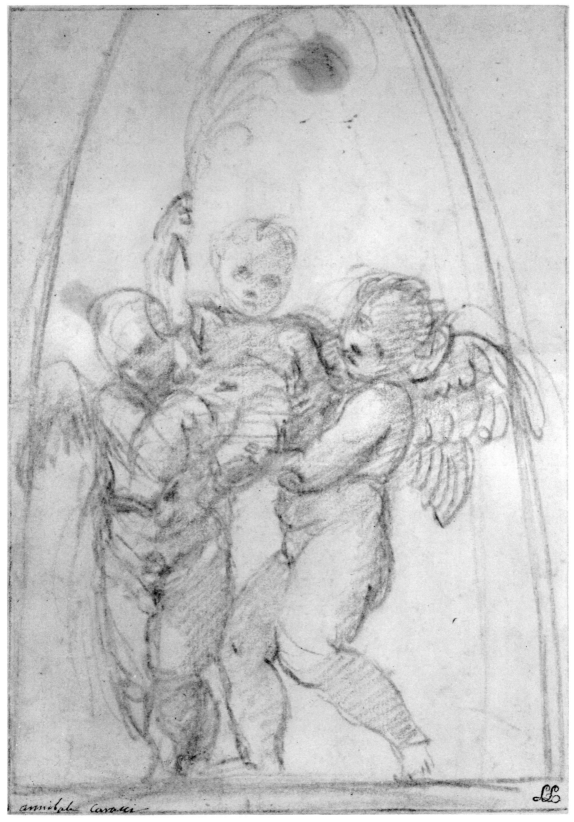

annibale Caracci

101

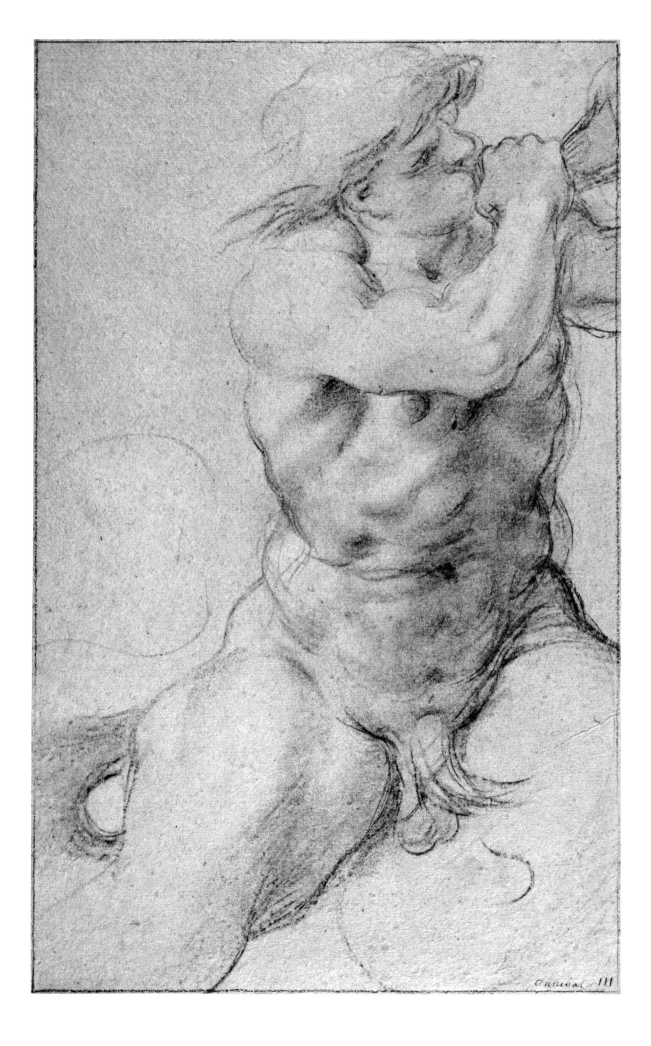

102. *Triton Sounding a Conch Shell*

Black chalk on blue paper. 38.6 x 24.3 cm.

Inscribed in pen and brown ink at lower right, *Annibal;* numbered in pen and brown ink, *111* (pagination of one of the Angeloni-Mignard-Crozart albums of Carracci drawings).

PROVENANCE: Francesco Angeloni, Rome; Pierre Mignard, Rome and Paris; Pierre Crozat, Paris; Victor Winthrop Newman, New York; sale, New York, American Art Association, May 8, 1923, no. 103; Dr. A. P. McMahon, New York; Mrs. A. P. McMahon; purchased in New York in 1970.

BIBLIOGRAPHY: W. Gernsheim and J. Lauke, *Carracci. Punkte eines Programms*, Florence, 1956, p. 16, listed; J. Bean, *Master Drawings*, VIII, 4, 1970, pp. 390-391, pl. 28; *Metropolitan Museum of Art Bulletin*, October 1970, p. 71, repr.; M. Levey, *National Gallery Catalogues, The Seventeenth and Eighteenth Century Italian Schools*, London, 1971, p. 60; Posner, 1971, II, p. 49; Bean, 1973, no. 18.

Purchase, 1970, Rogers Fund
1970.15

A recently rediscovered study for the triton that appears in the so-called Galatea composition on the ceiling of the Gallery of the Palazzo Farnese in Rome, where work on the frescoed decorations began in 1597. The cartoons and the finished fresco are the work of Annibale Carracci's less talented elder brother Agostino, but the invention of this robustly baroque figure is Annibale's, whose hand is here recognizable, as it is in a further study for the triton in the John Winter collection, London.

Technically and stylistically the Metropolitan Museum and the Winter drawings are very close. In fact, they were drawn on the same sheet of paper, for at the upper left margin of the verso of the Winter drawing we find the triton's left forearm and the tip of the conch shell that have been trimmed off the right margin of the sheet in the Metropolitan Museum. The large sheet was no doubt cut in half to produce two figure drawings when the Angeloni-Mignard albums of Carracci drawings were made up. Both sheets have drawn margin lines and are numbered in the fashion characteristic of the drawings that figured in these albums; the Winter sheet is inscribed 25, the New York drawing *111*. On the latter, the old inscription *Annibal* is further evidence of a French provenance. For this visual evidence see *Master Drawings*, VIII, 4, 1970, p. 391, fig. 1, pl. 27.

The subject of the "Galatea" fresco has been a riddle for art historians since Bellori's time, but quite recently Charles Dempsey has identified the composition as a representation of Thetis Borne to the Wedding Chamber of Peleus.

103. *Study of an Angel*
VERSO. *Study of a Cushion*

Black chalk, heightened with white, on blue paper. Several spots of rose-colored paint at lower left (recto); black chalk (verso). 37.2 x 24.4 cm. Margins somewhat irregular and masked by old inlay.

Numbered in pen and brown ink at lower right, *8* (pagination of one of the Angeloni-Mignard-Crozat albums of Carracci drawings).

PROVENANCE: Francesco Angeloni, Rome; Pierre Mignard, Rome and Paris; Pierre Crozat, Paris; Hugh N. Squire, London; purchased in London in 1962.

BIBLIOGRAPHY: Stampfle and Bean, 1967, no. 13, repr. (with previous bibliography and exhibition listing); Bean, 1973, no. 20.

Purchase, 1962, Gustavus A. Pfeiffer Fund
62.120.1

This drawing, a study from a young model in the studio, with wings indicated above his shoulders, was made in preparation for the figure of an angel that appears on the right in an altarpiece representing St. Gregory Praying for the Souls in Purgatory, commissioned from Annibale by Cardinal Antonio Maria Salviati in the very first years of the seventeenth century. The picture was painted for a chapel in the church of S. Gregorio Magno, Rome, and found its way to Bridgewater House in London, where it was destroyed during World War II (repr. Posner, 1971, II, pl. 130a).

Composition studies for this painting are preserved at Chatsworth and at Windsor Castle (repr. Posner, 1971, II, pls. 130b and 130d). Recently David McTavish has published a sheet in the Musée des Beaux-Arts at Dijon with studies of the standing angel's head and left arm (*Master Drawings*, XIII, 4, 1975, pp. 372-374, pls. 22a, 22b).

103 v.

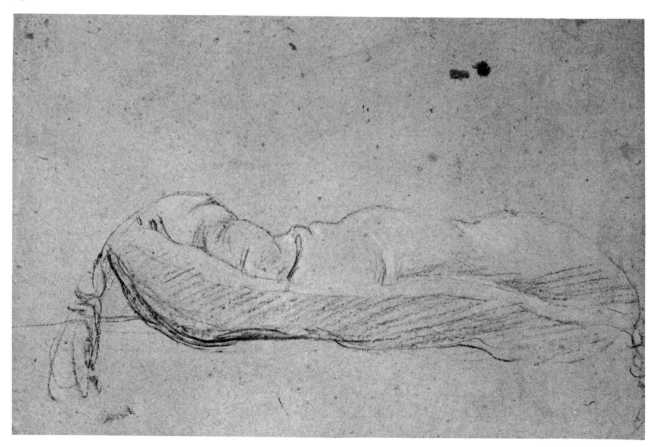

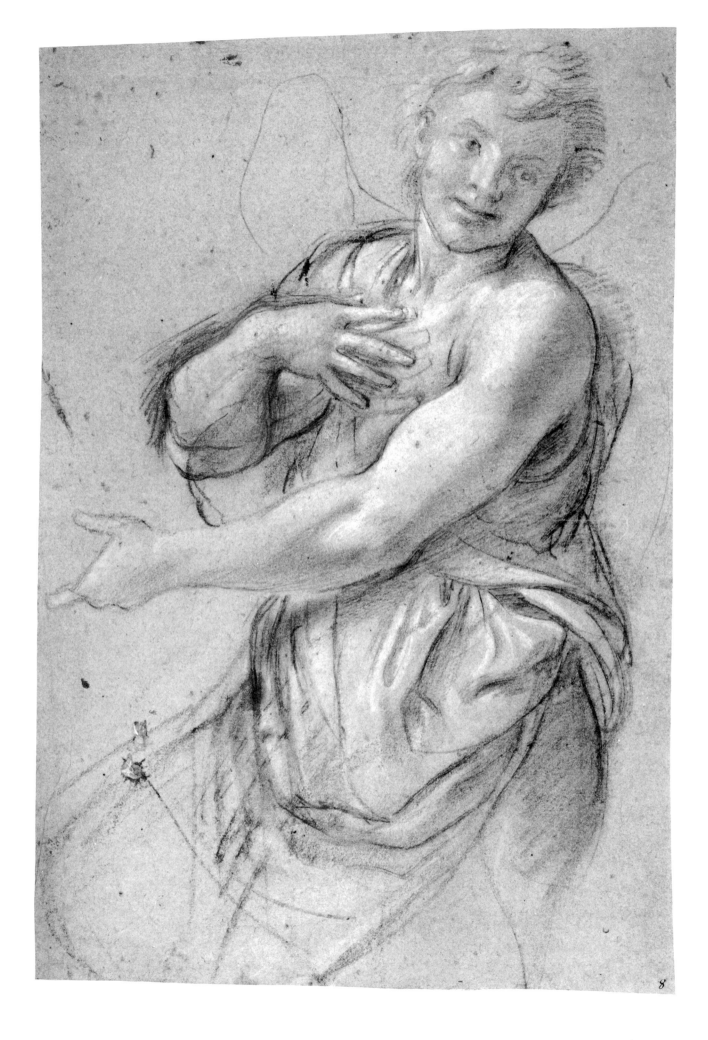

8

104. *The Drunken Silenus: Design for the Tazza Farnese*

Pen and brown ink, brown wash, over traces of black chalk. Diameter 25.5 cm. Some water staining at left margin. Lined.

Inscribed in pen and brown ink at lower margin, *Annibale Caracci.*

PROVENANCE: Boutin (according to manuscript inventory of the Lagoy collection); Marquis de Lagoy (Lugt 1710); Sir Thomas Lawrence (Lugt 2445); Lord Francis Egerton, 1st Earl of Ellesmere (Lugt Supp. 2710b); 6th Duke of Sutherland; sale, London, Sotheby's, July 11, 1972, no. 69, repr., purchased by the Metropolitan Museum.

BIBLIOGRAPHY: Holland, 1961, no. 124; Mahon, 1963, no. 113 (with full bibliography); Posner, 1971, II, p. 50; Bean, 1973, no. 19; Bean, 1975-1976, no. 12.

Purchase, 1972, Harris Brisbane Dick Fund and Rogers Fund 1972.133.4

Finished design for a silver plaque engraved by Annibale himself for his patron Cardinal Odoardo Farnese and intended to be used to decorate the bowl of a standing silver dish, the *Tazza Farnese.* This plaque, which survives in the Museo Nazionale, Naples, was used for printmaking, and pulls from it were taken from a fairly early date. It was Otto Kurz who rediscovered the silver plaque in Naples, separated from the *tazza,* which has disappeared (*Burlington Magazine,* XCVII, 1955, pp. 282-287). However, it is interesting to note that the Marquis de Lagoy in the manuscript inventory of his collection (drawn up before 1829) says of the present drawing: "il a été fait pour une soucoupe qui a appartenu à la maison farnèse et se trouve actuellement à Naples."

Two other studies by Annibale for this silver plaque have survived; one in the British Museum, the other formerly in the Ellesmere collection (see Kurz, *op. cit.,* figs. 14, 22). They represent earlier stages of the design, while the present drawing is reproduced on the plaque with only minor changes.

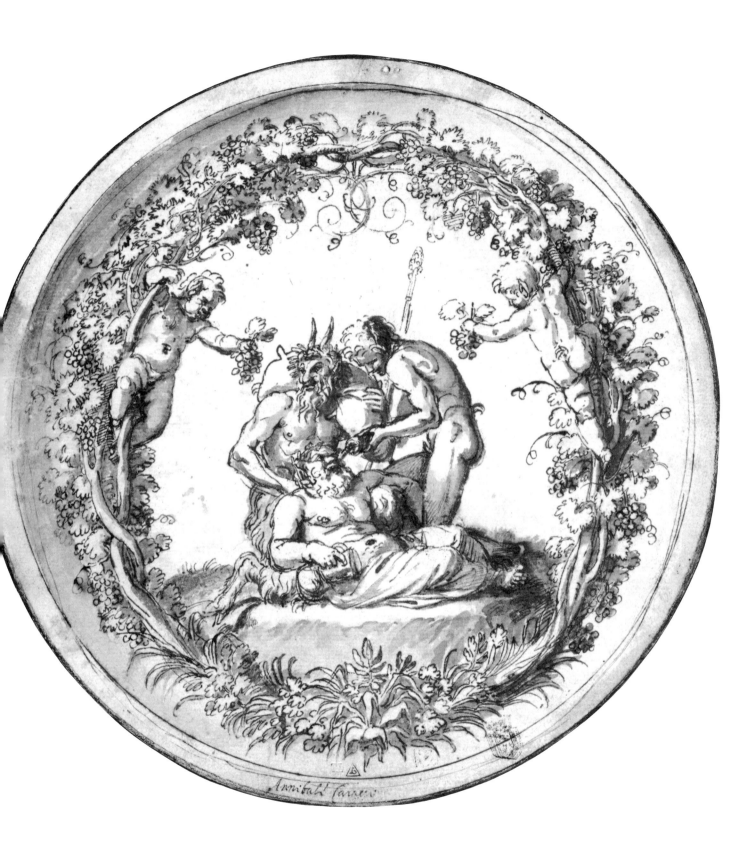

Annibale Carnero

77

105. *The Virgin and Child Resting Near a City Gate*

Pen and brown ink, a little brown wash, on beige paper. 18.7 x 21.5 cm. Lined and mounted on a blue Mariette surround from which the cartouche has been cut away.

Numbered in pen and dark brown ink at lower right, 93 (a Crozat number?).

PROVENANCE: Count Malvasia; Pierre Crozat (according to *Lawrence Gallery, Sixth Exhibition,* 1836, p. 22, no. 56); Pierre-Jean Mariette (Lugt 2097); Count Moriz von Fries (Lugt 2903); Sir Thomas Lawrence (Lugt 2445); Lord Francis Egerton, 1st Earl of Ellesmere (Lugt Supp. 2710b); 6th Duke of Sutherland; sale, London, Sotheby's, July 11, 1972, no. 72, repr., purchased by the Metropolitan Museum.

BIBLIOGRAPHY: Holland, 1961, no. 151; Mahon, 1963, no. 207 (with full bibliography); Bean, 1973, no. 26; Boschloo, 1974, I, pp. 30, 68, II, fig. 106; Bean, 1975-1976, no. 13; Malafarina, 1976, no. XX of appendix.

Purchase, 1972, Rogers Fund
1972.137.2

The Virgin is seated on the ground in a position of humility. A. W. A. Boschloo suggests that Annibale may have been inspired by Martin Schongauer's engraving *The Virgin Seated in a Courtyard* (Bartsch, VI, p. 134, no. 32), where Mary is seated on the ground before walls that converge at right angles behind her.

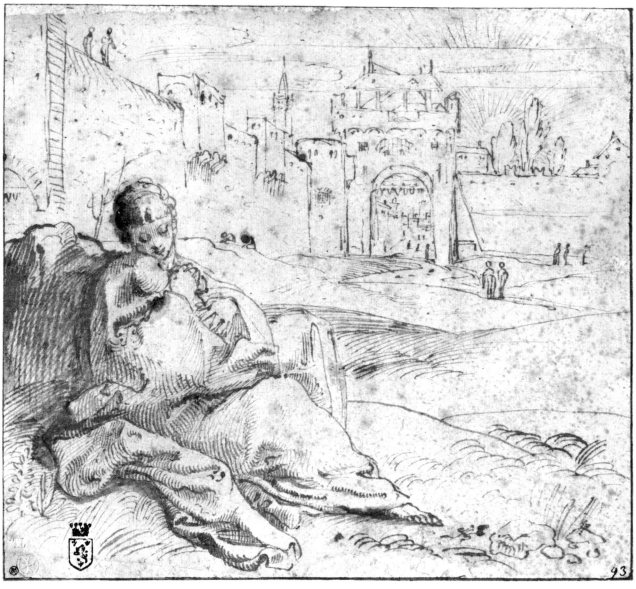

106. *Back View of a Seated Nude Youth Facing Right*

Red chalk. 28.1 x 30.1 cm.

Inscribed in pen and brown ink at lower right on recto, *Anibale Caracci*; numbered in red chalk in lower right corner on recto, *60*; inscribed in pen and brown ink on verso, *d'Annibale originale, ma non . . .* [rest cut off].

PROVENANCE: Cephas G. Thompson.

BIBLIOGRAPHY: *Metropolitan Museum Hand-book*, 1895, no. 753, as Annibale Carracci.

Gift of Cephas G. Thompson, 1887
87.12.83

The old attribution to Annibale deserves respect; the drawing has the vigor of his early studies from life.

107. *Back View of a Seated Nude Youth Facing Left*

Red chalk. 31.2 x 22.7 cm. All four corners cut. Lined.

Inscribed in pen and red-brown ink at lower margin of Richardson mount, *Annibale*.

PROVENANCE: Jonathan Richardson, Sr. (Lugt 2183 and 2983); Hon. Edward Bouverie (Lugt 325); Lord Ronald Sutherland Gower; Sutherland Gower sale, London, Christie's, January 28, 1911, part of no. 17, as A. Carracci, purchased by the Metropolitan Museum.

Purchase, 1911, Rogers Fund
11.66.6

The attribution to Annibale goes back at least to the time of Richardson, Sr., and is very plausible. The drawing comes from the collection of Lord Ronald Sutherland Gower and was in his sale in 1911 in the same lot as the well-known red chalk study of a putto attributed to Giorgione by P.-J. Mariette. This lot was purchased by Langton Douglas acting for the Metropolitan Museum. The Giorgione drawing from Mariette's collection bears the accession number 11.66.5.

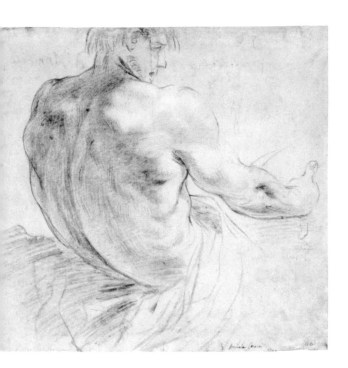

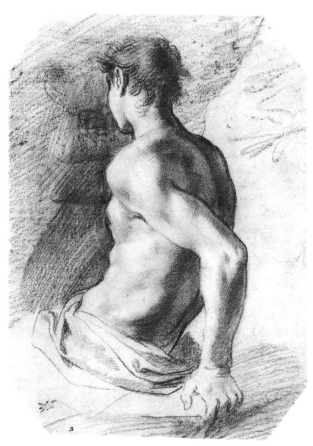

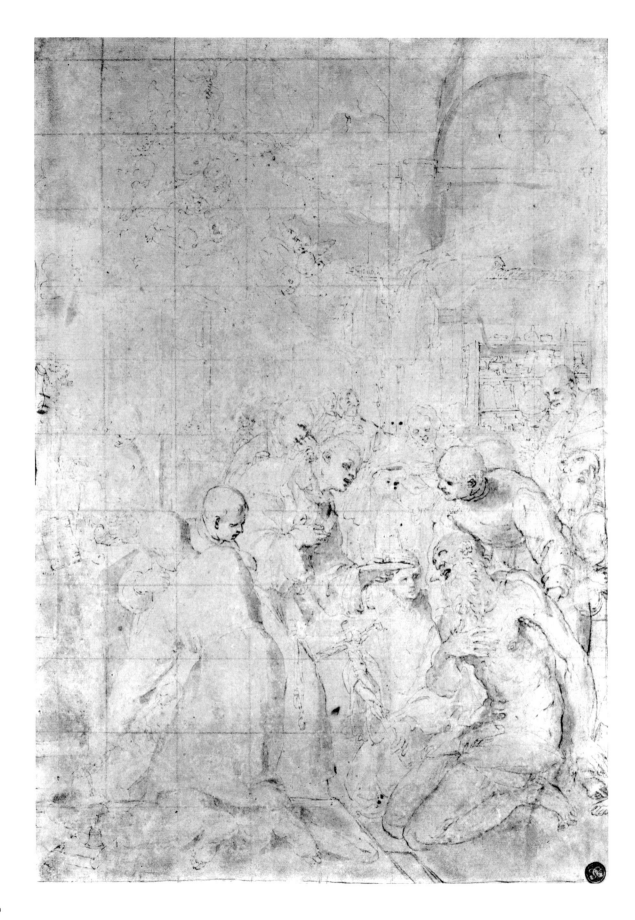

LUDOVICO CARRACCI

Bologna 1555–Bologna 1619

108. *The Last Communion of St. Jerome*

Pen and brown ink, brown wash, over traces of black chalk. Squared in red chalk. 41.5 x 29.1 cm. Surface abraded, repairs at lower left corner; small brown spots at center. Lined.

PROVENANCE: Unidentified collector (Lugt 1156); purchased in London in 1965.

BIBLIOGRAPHY: Stampfle and Bean, 1967, no. 4, repr,; Posner, 1971, I, p. 161, note 30; Bean, 1973, no. 1.

Purchase, 1965, Rogers Fund
65.111.1

It was Ludovico's cousin Agostino Carracci who received the commission to paint for the Bolognese church of S. Girolamo della Certosa the *Last Communion of St. Jerome,* now in the Bologna Pinacoteca, but both Ludovico and Annibale Carracci seem to have made a try at obtaining this important assignment. Malvasia (1841, I, p. 284) tells us that Annibale supplied a design for the projected picture, and Ludovico, who in 1592 painted a *Baptist Preaching* that was hung opposite Agostino's *Last Communion,* may have made the present drawing in competition with his cousins. Donald Posner has published a drawing in the Louvre as a study by Ludovico for the Certosa *St. Jerome (Paragone,* XI, 131, 1960, p. 53, pl. 38a), but his attribution has been questioned by Roseline Bacou and Denis Mahon, for whom the drawing is one of Annibale's sketches for the Certosa commission (*Dessins des Carrache,* exhibition catalogue, Musée du Louvre, Paris, 1961, p. 16). The present drawing, though unfortunately damaged, seems unmistakably to be the work of Ludovico. His manner is apparent in the facial types and in the supple pen line, and these characteristics may also be observed in the Louvre drawing. In Agostino's stately and rather static picture the kneeling St. Jerome receives the last rites in a setting of classical architecture, with a glimpse of landscape beyond. Ludovico here proposes a more animated and informal solution, with a crowd of onlookers gathered in the saint's study. In the Louvre drawing, which is narrower in format, the action takes place against a background of classical columns; below, St. Jerome is seen taking communion, and above he is carried up to heaven by angels.

LUDOVICO CARRACCI, attributed to

109. *Head of a Woman Looking to Upper Left*

Charcoal, heightened with white, on beige paper. 42.7 x 35.4 cm. Repaired tears and creases at right margin. Horizontal crease just above center. Lined.

Inscribed in pen and brown ink at lower left, *L. Carrache.*

PROVENANCE: Lionel Lucas (Lugt Supp. 1733a); Claude Lucas; Lucas sale, London, Christie's, December 9, 1949, part of no. 67, as L. Carracci; purchased in London in 1950.

Purchase, 1950, Rogers Fund
50.56

The broad treatment and the scale of this monumental head suggests that it may be a cartoon, and the traditional attribution to Ludovico is not implausible.

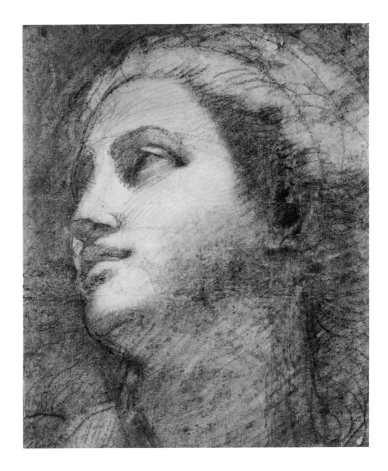

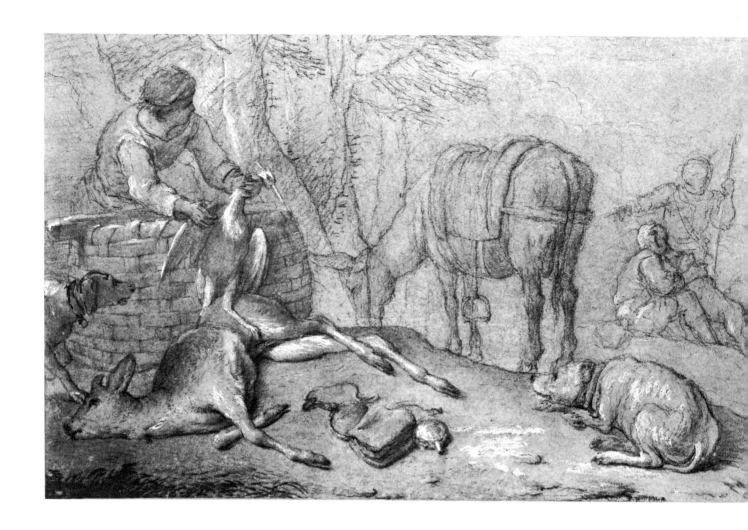

GIOVANNI AGOSTINO CASSANA

Genoa 1658 – Genoa 1720

or

GIOVANNI BATTISTA CASSANA

Genoa 1668 – Genoa 1738

110. *Hunters with Dead Game in a Landscape*

Black and red chalk, heightened with colored gouache, on blue paper. 24.8 x 40.1 cm. Lined.

Inscribed in pen and brown ink on lower margin of old mount, *Cassanini*.

PROVENANCE: George Knapton; sale, London, T. Philipe, May 25-June 5, 1807, part of no. 225, as Casanova; Sir Thomas Lawrence (Lugt 2446); the Hon. Mrs. J. Borthwick; sale, London, Sotheby's, November 28, 1962, no. 26, as Italian school, 17th century; purchased in London in 1963.

Purchase, 1963, Rogers Fund
63.103.1

The old inscription *Cassanini* may be a diminutive referring to one of the three sons of Giovanni Francesco Cassana. According to Ratti both Giovanni Agostino and Giovanni Battista, the youngest of the brothers, specialized in animal subjects (Ratti, 1769, II, pp. 16-17). In any case the drawing is very much in a Genoese tradition that looks back to the example of Giovanni Benedetto Castiglione. This drawing figured in the Knapton sale in 1807, under the name of Casanova, along with two drawings similar in subject, style, and technique now in the Pierpont Morgan Library (IV, 152 and IV, 152a; the former reproduced in C. Fairfax Murray, *J. Pierpont Morgan Collection of Drawings by the Old Masters Formed by C. Fairfax Murray*, London, 1912, IV, pl. 152, as Francesco Casanova). Another drawing from the Knapton group, "a shepherdess with sheep, an ass, and three piping boys in a landscape," was sold at Sotheby's on November 28, 1962, no. 27, and described, like the present sheet, as Italian school, seventeenth century. That drawing was recently on the art market (*Disegni Antichi. Galleria del Giudice*, exhibition catalogue, Genoa, 1970, no. 5, repr.).

VALERIO CASTELLO

Genoa 1624–Genoa 1659

111. *Judith Decapitating Holofernes*

Pen and brown ink, brown wash, over black chalk. 18.0 x 14.2 cm.
Lined.

Inscribed in pencil at lower right, *Salvator Rosa.*

PROVENANCE: Purchased in London in 1908.

BIBLIOGRAPHY: M. Newcome, *Master Drawings,* XIII, 1, 1975, p.
36, no. 16, pl. 20.

Purchase, 1908, Rogers Fund
08.227.7

Formerly attributed to Salvator Rosa, this drawing
was recognized as a characteristic example of the
draughtsmanship of Valerio Castello by Philip Pouncey
in 1961.

112. *Presentation of the Virgin
in the Temple*

83

Pen and brown ink, brown wash. 18.2 x 20.1 cm. All four corners cut away.

Inscribed in pencil on verso, *L'admission de la Vierge au temple, Ecole italienne XVI^e siècle, plume et bistre.*

PROVENANCE: Harry G. Sperling, New York.

Bequest of Harry G. Sperling, 1975
1975.131.17

The attribution to Valerio Castello was suggested by the compiler of this inventory at the time the drawing was acquired by Harry G. Sperling in 1966, and it entered the collection of the Metropolitan Museum with this attribution in 1975.

FRANCESCO CASTIGLIONE
Genoa ? ca. 1641 – Genoa 1716

113. *Young Hunter with His Dogs in a Landscape*

Pen and brown ink, watercolor. 21.1 x 30.6 cm. Lined.

Inscribed in pen and brown ink at lower margin, *Francesco Castiglione Genovese.*; in pencil at lower center of old mount, *B. West's.*

PROVENANCE: "Reliable Venetian Hand" (Lugt Supp. 3005c-d); Benjamin West (according to inscription on old mount); William Esdaile (Lugt 2617); purchased in London in 1908.

BIBLIOGRAPHY: Bettagno, 1966, no. 49, repr. (exhibited); Stampfle and Bean, 1967, mentioned p. 77; Percy, 1971, p. 129, no. 120, repr.

Purchase, 1908, Rogers Fund
08.227.24

The convincing attribution of this and the following drawing to Francesco Castiglione, Giovanni Benedetto's son and assistant, is in the "Reliable Venetian Hand."

114. *A Congress of Animals*

Pen and brown ink, watercolor, over a little black chalk. 20.7 x 30.8 cm. Lined.

Inscribed in pen and brown ink at lower margin, *Francesco Castiglione Genovese.*; in pencil at lower margin of old mount, *B. West's.*

PROVENANCE: "Reliable Venetian Hand" (Lugt Supp. 3005c-d); Benjamin West (according to inscription on old mount); William Esdaile (Lugt 2617); purchased in London in 1908.

BIBLIOGRAPHY: Bettagno, 1966, no. 50, repr. (not exhibited); Stampfle and Bean, 1967, no. 118, repr.; Percy, 1971, pp. 129-130, no. 121, repr.

Purchase, 1908, Rogers Fund
08.227.25

See No. 113 above.

Francesco Castiglione Genovese.

GIOVANNI BENEDETTO CASTIGLIONE

Genoa 1609 – Mantua 1665

115. *Youth Playing a Pipe for a Satyr*

Brush, brown, red, green, and blue paint, on beige paper. 40.6 x 53.5 cm. Vertical crease at center. Lined.

PROVENANCE: Sir William Richard Drake (Lugt 736); Drake sale, London, Christie's, May 24-25, 1892, part of no. 415; Dr. Francis Springell; Springell sale, London, Sotheby's, June 28, 1962, no. 39, repr.; purchased by the Metropolitan Museum.

BIBLIOGRAPHY: Stampfle and Bean, 1967, no. 77, repr. (with previous bibliography and exhibition listings); Percy, 1971, pp. 96-97, no. 64, repr., entitled "Marsyas teaching Olympos the Various Musical Modes."

Purchase, 1962, Gustavus A. Pfeiffer Fund
62.126

The drawing is dated around 1650 by Ann Percy.

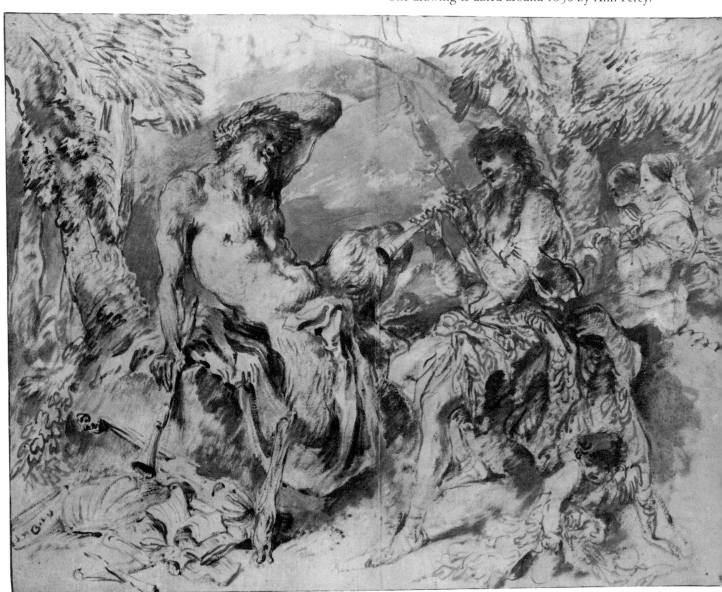

116. *Noah Entering the Ark*

Brush, red-brown and blue paint, on beige paper. Framing lines in
black chalk. 40.3 x 55.3 cm. Vertical crease at center.

Inscribed in pencil at lower left, *B. Castiglione fece.*

PROVENANCE: Giuseppe Vallardi (Lugt 1223); Giuseppe Pacini
(Lugt 2011); purchased in Paris in 1962.

BIBLIOGRAPHY: Detroit, 1965, no. 171, repr. (with previous bib-
liography); Percy, 1971, pp. 120-121, no. 109, repr.

Purchase, 1962, Rogers Fund
62.121.1

Ann Percy dates this drawing in the early 1660s.

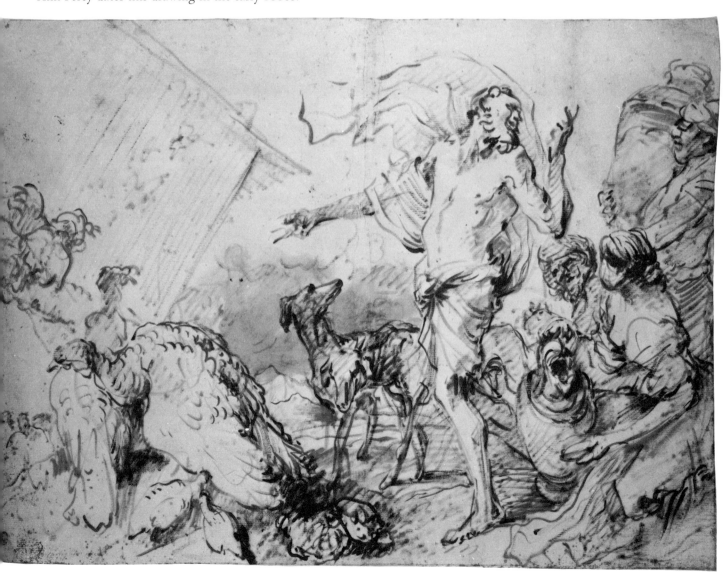

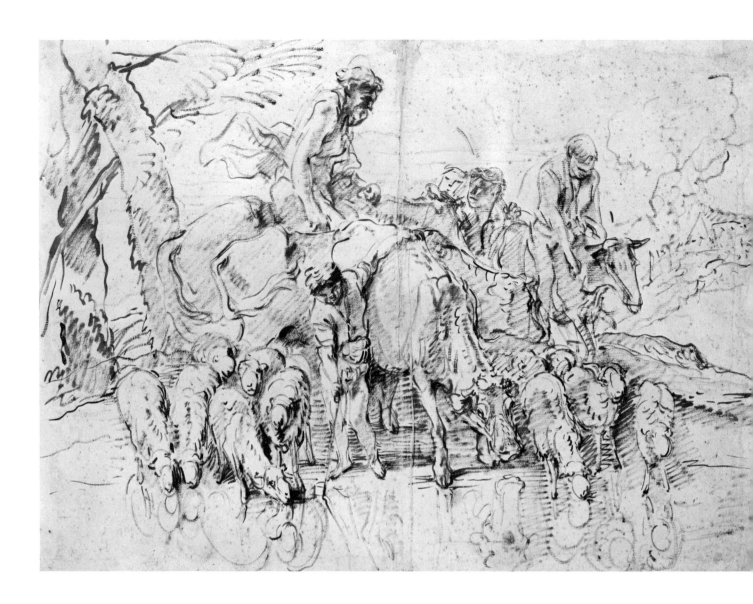

GIOVANNI BENEDETTO CASTIGLIONE

117. *Pastoral Journey with Flocks and Herds at a Stream*

Brush and red-brown paint. 40.2 x 57.6 cm. Lined. Vertical crease at center. Some foxing at upper right.

PROVENANCE: Walter C. Baker, New York.

BIBLIOGRAPHY: Virch, 1962, no. 34, repr.; Percy, 1971, p. 125, no. 114, repr.

Bequest of Walter C. Baker, 1972

Ann Percy dates this drawing in the early 1660s.

GIOVANNI BENEDETTO CASTIGLIONE

118. *God the Father Appearing to Jacob*

Brush, red, red-brown, blue, green, and white paint, on beige paper.
38.6 x 52.3 cm. Vertical crease at center; diagonal crease left of
center. All four corners replaced. Lined.

PROVENANCE: Unidentified collector's mark at lower right corner;
purchased in London in 1965.

BIBLIOGRAPHY: Stampfle and Bean, 1967, no. 76, repr.; Percy,
1971, p. 69, no. 19, repr.

Purchase, 1965, Robert Lehman Foundation Gift
65.176

Ann Percy points out that the subject is taken from
Genesis 35:9 and represents God appearing to Jacob,
Rachel, and Leah and some of their children at Bethel.
There are other versions of the same subject in the West
Berlin Print Room (KdZ 12511) and at Windsor Castle
(Blunt, 1954, no. 61, with mention of a version formerly
in the Misme collection, Paris).

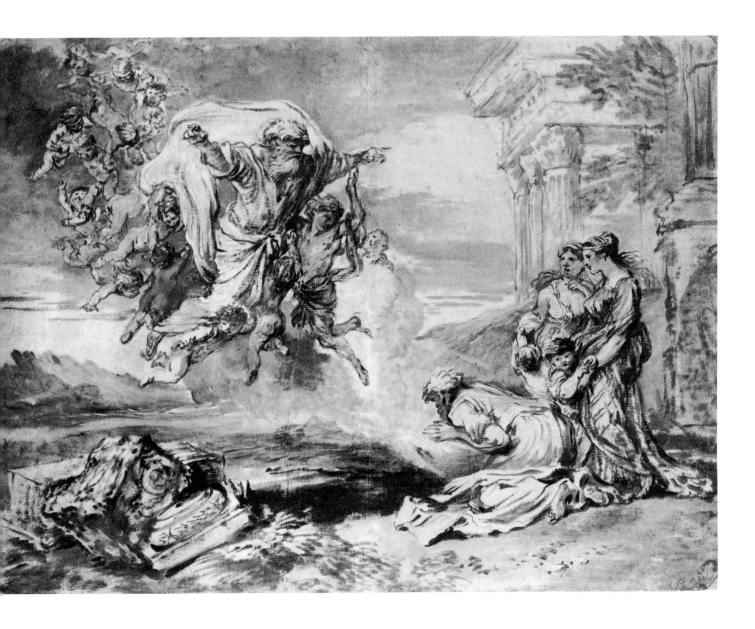

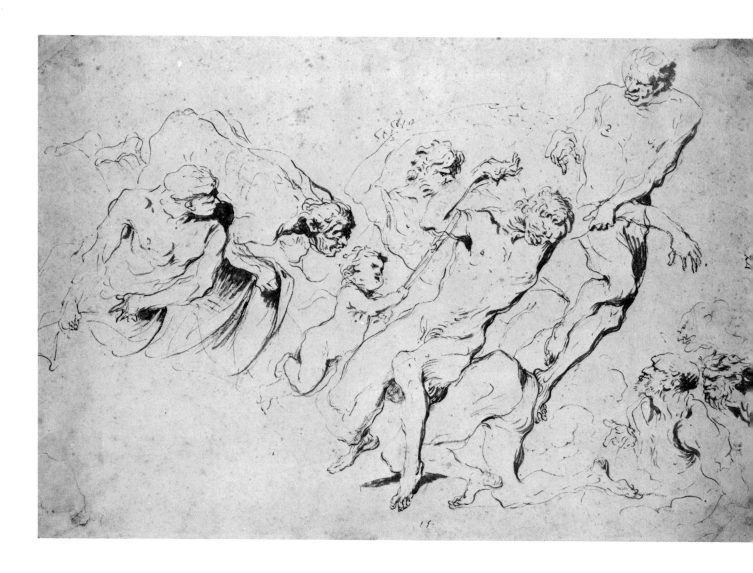

GIOVANNI BENEDETTO CASTIGLIONE

119. *Fantastic Subject: Five Nude Male Figures Punishing Another*

Pen and brown ink, brown wash, on beige paper. 25.8 x 38.4 cm. Upper left and lower right corners replaced; repairs at lower left.

Numbered in pen and brown ink at lower center, *15*; in another hand at right margin, *24*.

PROVENANCE: Purchased in London in 1965.

BIBLIOGRAPHY: Stampfle and Bean, 1967, no. 78, repr.; A. Percy, *Master Drawings*, VI, 2, 1968, p. 147, pl. 38a; Percy, 1971, pp. 72-73, no. 22, repr.

Purchase, 1965, Rogers Fund
65.112.4

This drawing is one of a series that may have figured in an album or sketchbook of pen drawings by G. B. Castiglione. Thirteen of these sheets have been identified by Ann Percy; they are numbered in pen and ink at the center of the lower margin, and the highest number recorded is 95. The subjects in this series are landscapes and fantastic allegorical or mythological scenes.

GIOVANNI BENEDETTO
CASTIGLIONE, circle of

120. *Nativity with Angels*

Brush, red, blue, and brown paint, on beige paper. 39.3 x 27.0 cm. Many badly restored losses at margins, lower right corner missing. Lined.

Inscribed in pencil on verso of old mount, *Vandyck.*

PROVENANCE: James Jackson Jarves; Cornelius Vanderbilt.

BIBLIOGRAPHY: *Metropolitan Museum Hand-book,* 1895, no. 458, as Van Dyck; Percy, 1971, p. 88, under no. 48.

Gift of Cornelius Vanderbilt, 1880
80.3.458

Ann Percy convincingly suggests that this is a production of the studio of G. B. Castiglione; it is related in composition to a drawing by Giovanni Benedetto himself in the Nationalmuseum, Stockholm (1605/1863; repr. A. Percy, 1971, no. 48). In the Stockholm drawing the Virgin looks down at the infant Jesus, rather than upward at the angel as she does in the present drawing. The old attribution to Van Dyck is not surprising, since that Flemish artist, who worked in Genoa, had a decisive influence on Castiglione.

121. *Animals and Figures before the Ark*

Brush, red-brown, brown, and blue paint. 24.4 x 36.9 cm. Lined.
PROVENANCE: Harry G. Sperling, New York.

Bequest of Harry G. Sperling, 1975
1975.131.18

122. *Pastoral Scene: Nomads with Sheep and Cattle*

Brush, brown, red-brown, blue, and white paint, on brownish paper. 25.6 x 36.2 cm. Lined.

Numbered in pen and brown ink at lower right, *42* [?].

PROVENANCE: Sir James Knowles; Knowles sale, London, Christie's, May 27, 1908, part of no. 134; purchased in London in 1908.

Purchase, 1908, Rogers Fund
08.227.22

Another version of this composition is preserved in Dresden (repr. *Die Albertina und das Dresdner Kupferstich-Kabinett,* Dresden, 1978, no. 43).

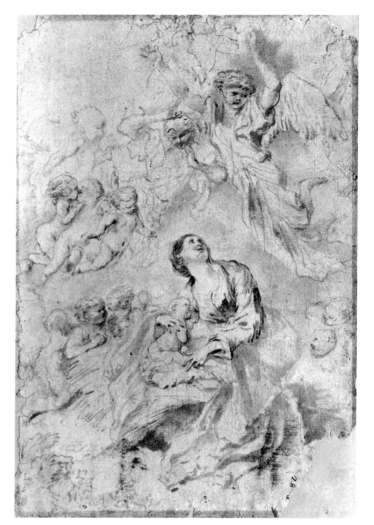

120

123. *Pastoral Scene: Shepherds and Their Flock*

Brush, brown, red-brown, blue, green, and white paint, on beige paper. 27.3 x 40.8 cm. Lined.

Inscribed in pen and brown ink at lower right, *Benedette.*

PROVENANCE: Pierre Crozat? (1406 with a paraph: Lugt 2951); François Renaud (Lugt Supp. 1042); Sir James Knowles; Knowles sale, London, Christie's, May 27, 1908, part of no. 134; purchased in London in 1908.

Purchase, 1908, Rogers Fund
08.227.23

Lawrence Turčić points out that there is another studio (?) version of this composition in the Genoese municipal collection (repr. G. Grosso and A. Pettorelli, *I disegni di Palazzo Bianco,* Milan, 1910, pl. 55).

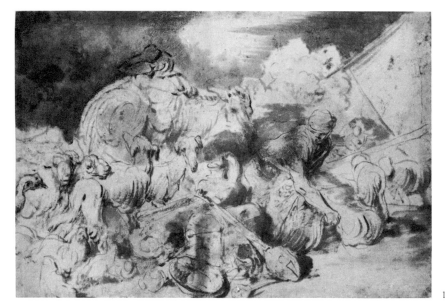

121

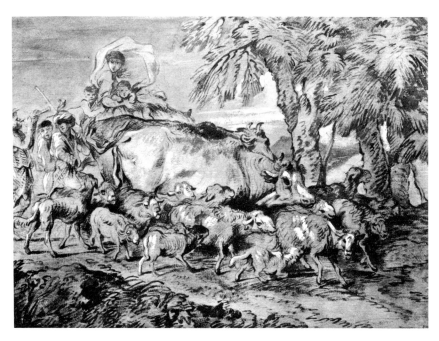

122

123

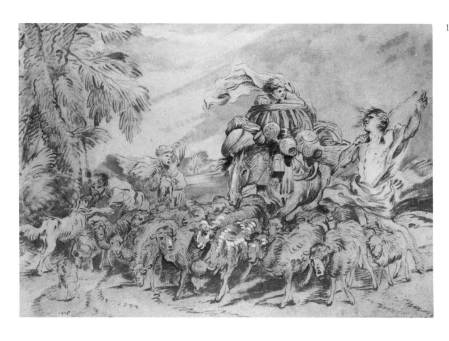

SIGISMONDO CAULA

Modena 1637 – Modena 1713?

124. *Two Seated Bearded Male Figures*

Brush, red-brown and white paint. Varnished. 26.4 x 19.9 cm. Repaired tear at upper right margin.

PROVENANCE: Purchased in Paris in 1961.

Purchase, 1961, Rogers Fund
61.143

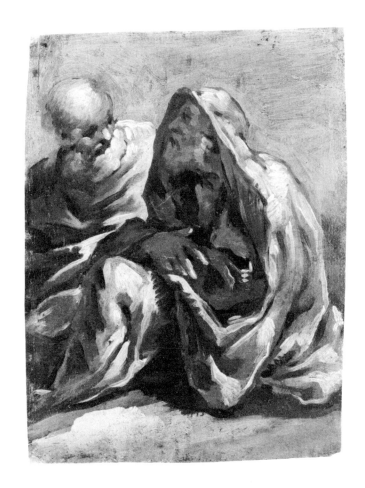

The attribution to the Modenese Sigismondo Caula is apparently traditional, and the brushwork, the figure types, and the drapery style are closely paralleled in other drawings with old attributions to this artist. Particular mention should be made of a group of drawings formerly in the Benno Geiger collection (B. Geiger, *Handzeichnungen alter Meister,* Vienna, 1948, pls. 58-61; pl. 60 is now in the British Museum, 1920-12-20-1) and a drawing of two males figures wrestling, in the Ecole des Beaux-Arts, Paris (Ancien fonds no. 99).

GIACOMO CAVEDONE

Sassuolo (Modena) 1577 – Bologna 1660

125. *The Virgin and Child with Two Male Saints*

Charcoal, brush and brown wash, white oil paint, on brown paper. 30.7 x 22.3 cm. Lined.

PROVENANCE: Jonathan Richardson, Sr. (Lugt 2184 and 2983-84); Sir Joshua Reynolds (Lugt 2364); J. B. S. Morritt, Rokeby Park, Yorkshire; purchased in London in 1973.

BIBLIOGRAPHY: Edinburgh, 1972, no. 34, repr. (with previous bibliography and exhibition listing); Bean, 1975-1976, no. 14.

Purchase, 1973, Rogers Fund
1973.12

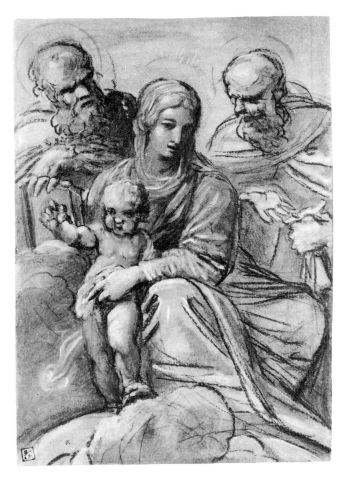

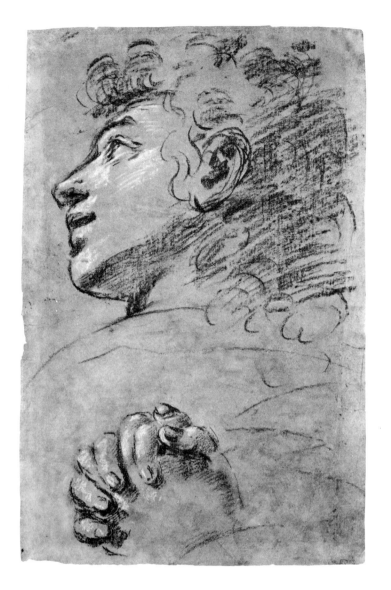

GIACOMO CAVEDONE, attributed to

126. *Profile Head of a Youth Looking to Upper Left, and Study of Clasped Hands*

Charcoal, heightened with white, on brownish paper. 41.8 x 27.3 cm.

PROVENANCE: Earls of Pembroke; Pembroke sale, London, Sotheby's, July 5-6, 9-10, 1917, no. 538, as Jacopo Bassano, purchased by the Metropolitan Museum.

BIBLIOGRAPHY: Strong, 1900, part II, no. 13, repr., as Venetian school; Tietze, 1944, p. 57, no. A228, "certainly by Carlo Francesco Nuvolone."

Purchase, 1917, Hewitt Fund
19.76.16

Strong in his publication of the Wilton House drawings gave this chalk study to the Venetian school, and suggested that Tintoretto or "his imitator Leandro Bassano" might be the artist.

For the Tietzes, the drawing was "certainly by Carlo Francesco Nuvolone"; they based this implausible attribution on a suggested but unconvincing connection with a head in Nuvolone's *The Painter and His Family* in the Brera, Milan. A. E. Popham suggested, much more convincingly, the name of Giacomo Cavedone for this coarse yet vigorous black chalk drawing that is rather clumsily heightened with white chalk in a manner characteristic of this Bolognese artist.

The Tietzes said that the drawing came from the collection of the Marquis de Lagoy, but it bears no trace of the Lagoy mark.

ANDREA CELESTI

Venice 1637 – Venice 1706

127. *Allegory of Venetian Power*

Pen and brown ink, brown wash, over red chalk. Design proper 37.0 x 28.5 cm.; entire sheet, including an engraved border, not reproduced, 54.5 x 40.0 cm.

Inscribed in pen and brown ink at lower left of design, *Celesti inventor.*

PROVENANCE: Purchased in London in 1964.

BIBLIOGRAPHY: Stampfle and Bean, 1967, no. 129, repr.

Purchase, 1964, Rogers Fund
64.13

Eighteenth-century guidebooks to the city of Brescia describe a now vanished picture that hung in one of the principal rooms of the Palazzo Municipale (La Loggia). In this composition Venice, Queen of the Seas, was represented riding over the waves in a silver conch shell encircled by tribute-bearing figures, with Justice, holding scales, close at hand. This recently rediscovered drawing corresponds in almost every detail with the old descriptions, and may well be a preparatory study for the lost picture. The scale of the design and the fact that the artist has used a sheet bearing an engraved architectural border suggest that the drawing may have been made as a *modello* to be shown to the commissioner of the picture. The arms on the breast of the seated figure of Venice are those of the Contarini; the reference is either to Domenico Contarini, doge from 1659 to 1675, or to Alvise Contarini, doge from 1676 to 1684.

IL CERANO
(Giovanni Battista Crespi)

Cerano near Novara ca. 1557 – Milan 1633

128. *St. Charles Borromeo*

Pen and brown ink, brown wash, heightened with white, on brown-washed paper. 46.1 x 26.9 cm. Lined with silk.

Inscribed in pen and brown ink at lower right, *Jean Baptise Cerani / de Milan;* in pen and brown ink on verso, *Jean Baptiste Crespi, dit il Cerano. nom d'un village pres de / Novara. del'Estat de Milan. bon peintre et architecte / et tres Entendu dans la prespective. il avoit voyagé a / Rome. et a Venise et est mort en 1633:* and *Il Cavaliere Cerani Milanese . . .* [rest illegible].

PROVENANCE: Pierre Crozat; Crozat sale, Paris, 1741, part of no. 628 or no. 629, "Ecoles de Milan, de Cremone, de Bresse, et autres Villes de Lombardie. Le Gaudentio, Bernard et Aurelio Luini, le Lomazzo, Figini, Morazone, Cerano, Crespi, et autres peintres milanois."; Count Carl-Gustav Tessin, Stockholm; Baron Jean-Gabriel Sack, Bergshammar (brother-in-law of Count Carl-Gustav Tessin); Baron C. Sack, Bergshammar; Prof. Einar Perman, Stockholm; purchased in Stockholm in 1967.

BIBLIOGRAPHY: O. Sirén, *Dessins et tableaux de la renaissance italienne dans les collections de Suède.* Stockholm, 1902, pp. 73-74; N. W. Neilson, *Master Drawings.* IX, 4, 1971, pp. 364-366, pl. 12.

Purchase, 1967, Rogers Fund
67.97

Identified by Nancy Ward Neilson as Cerano's study for the colossal statue of St. Charles Borromeo at Arona on Lago Maggiore. The *San Carlone* is seventy feet in height, and stands on a pedestal forty-two feet high. Cerano had designed it by 1614, but the statue was erected only at the very end of the seventeenth century.

129. *Portrait of a Man: Self Portrait ?*

Black chalk. Oval, 11.4 x 9.0 cm.

Faint inscription in black chalk around upper margin, of which only the word *Cerano* can be deciphered; inscribed in pen and brown ink at lower margin of old mount in the hand of J. Richardson, Sr., *Cav: Giovanni Batta: Crespi.*

PROVENANCE: Padre Sebastiano Resta; John, Lord Somers (Lugt 2981; *e 62* as Cerano—Lansdowne Ms., *Cav. Gio: Batta Crespi detto il Cerano Milanese gran Competitore de Procaccini. fù maestro del Gerardini e del lento e soave Cornaro*); Jonathan Richardson, Sr. (Lugt 2983-84); purchased in London in 1966.

Purchase, 1966, Rogers Fund
66.134.4

Nancy Ward Neilson suggests that the drawing is a self-portrait, and indeed the distinguished, rather ascetic face is close to that in the painted self-portrait in the Testori collection, Milan (repr. *Mostra del Cerano,* exhibition catalogue, Novara, 1964, fig. 190). The refinement of this chalk study is exceptional in Cerano's work, but is in a Milanese tradition that includes the fine portrait drawings of Giovanni Ambrogio Figino.

130

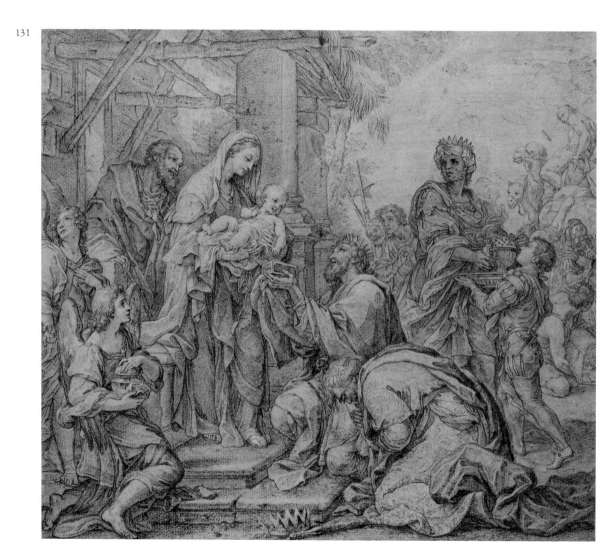

131

98

MICHELANGELO CERQUOZZI,
attributed to

Rome 1602 – Rome 1660

130. *Four Boats*

Pen and brown ink, brown wash, over a little black chalk. 19.2 x 27.0 cm. Lined.

Inscribed in pen and red and brown ink at lower margin of old mount, *Michel'Angelo Querquozzi /Romano. detto delle Battaglie scritto nel catalogo dell'Academia di S. Luca /nel 1650.*

PROVENANCE: Pierre Crozat? (*165* with a paraph, Lugt 2951); Sir Bruce S. Ingram (Lugt Supp. 1405a); Carl Winter (his mark "C.W." on reverse of mount, not described in Lugt); sale, London, Sotheby's, November 21, 1974, no. 71, repr.; purchased in New York in 1975.

Purchase, 1975, Rogers Fund
1975.190

The attribution to Cerquozzi, who is very rare as a draughtsman, is old and certainly plausible for this *bambocciante* artist.

GIUSEPPE CHIARI

Rome 1654 – Rome 1727

131. *The Adoration of the Magi*

Red chalk. 28.4 x 32.3 cm.

Inscribed at lower left in red chalk, *IOSEPH CLARUS PINGEBAT ANNO MDCCXIV*.

PROVENANCE: Purchased in London in 1966.

Purchase, 1966, Rogers Fund
66.135

A fairly exact and much reduced copy, very possibly by Giuseppe Chiari himself, after the *Adoration of the Magi*, a painting signed and dated 1714 by Chiari, now in Dresden (Gemäldegalerie, no. 444). This drawing was etched in the same direction by Benoît Farjat (1646– ca. 1720).

BACCIO CIARPI

Barga (Lucca) 1578 – Rome ca. 1644

132. *The Virgin and Child with St. John the Baptist, Pope St. Dionysius, and Two Other Saints*

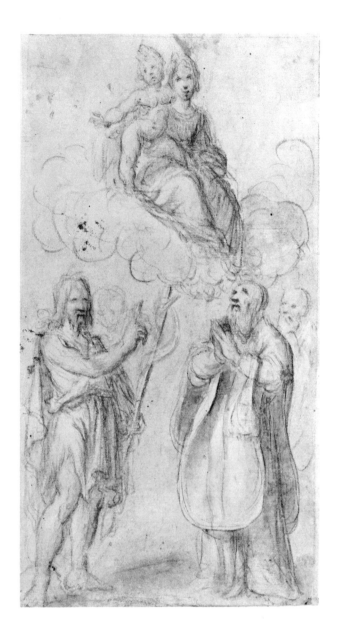

Black chalk, heightened with blue wash. 24.9 x 13.4 cm. A number of brown stains. Lined.

PROVENANCE: Count Lanfranco di Campello, Rome; A. Branson, London (according to vendor); purchased in London in 1965.

Purchase, 1965, Rogers Fund
65.66.3

Philip Pouncey, in 1965, identified this drawing as Baccio Ciarpi's preparatory study for an altarpiece in S. Silvestro in Capite, Rome. In the painting, which is datable before 1622, St. Louis, king of France, appears to the left of the Baptist, and Filippo Neri (not yet canonized) appears behind and to the right of St. Dionysius (see J. S. Gaynor and I. Toesca, *San Silvestro in Capite,* Rome, 1963, pp. 90-93, the painting fig. 25).

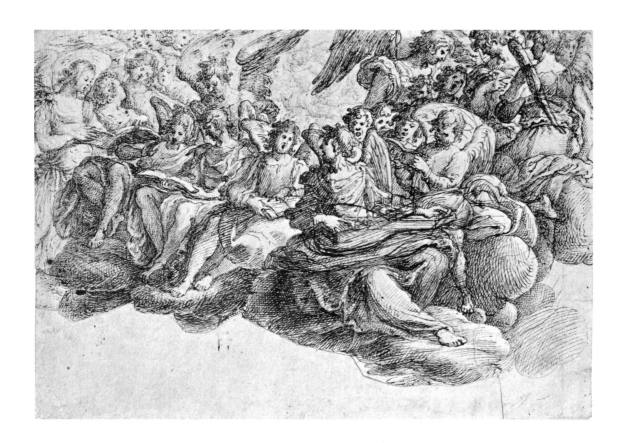

ANDREA COMMODI

Florence 1560 – Florence 1638

133. *Music-Making Angels Seated on Clouds*

Pen and brown ink, on beige paper. 18.1 x 27.4 cm. Lower margin of clouds cut out and silhouetted. Lined.

Inscribed in pen and brown ink at upper margin of old mount, *Caval.º Gasparo Celio fece.*

PROVENANCE: Hugo Sonnenschein, Chicago; sale, London, Sotheby's, March 23, 1971, no. 15, purchased by the Metropolitan Museum.

BIBLIOGRAPHY: Bean, 1972, no. 8

Purchase, 1971, Rogers Fund
1971.66.2

An inscription on the old mount erroneously gives this sheet to Gaspare Celio, but in 1971 Philip Pouncey identified the drawing as the work of the idiosyncratic late Florentine mannerist Commodi. Other drawings by the same spirited hand traditionally attributed to Commodi are in the Louvre, the British Museum, the Uffizi, and the Farnesina in Rome. Many of these pen drawings are studies for a Last Judgment (see *Disegni fiorentini 1560-1640 dalle collezioni del Gabinetto Nazionale delle Stampe,* exhibition catalogue by Simonetta Prosperi Valenti Rodinò, Rome, 1977, no. 56).

PIETRO DA CORTONA (Pietro Berrettini)

Cortona 1596 – Rome 1669

134. *The Triumph of Nature over Art*

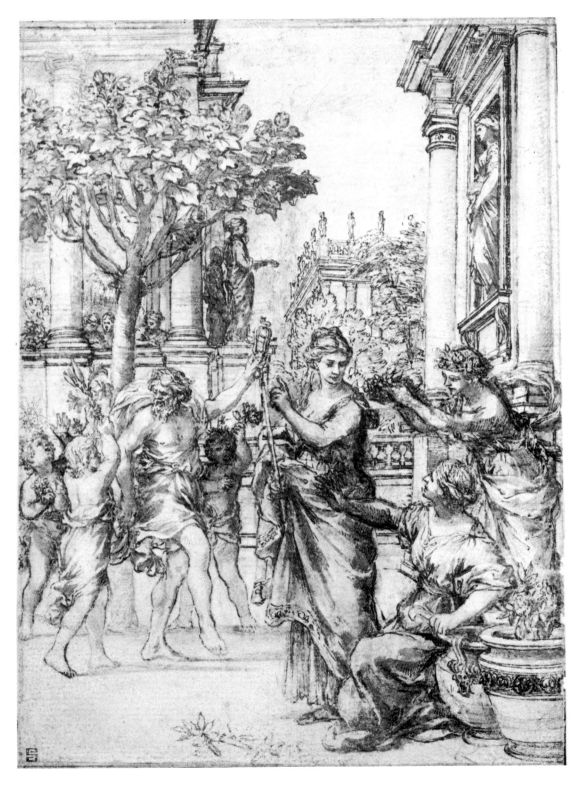

Pen and brown ink, brown wash, over black chalk. 19.9 x 14.6 cm.

PROVENANCE: Dr. A. Ritter von Wurzbach-Tannenberg, Vienna (Lugt 2587); Anton Schmid, Vienna (Lugt Supp. 2330b); sale, Munich, Karl and Faber, May 17-18, 1956, no. 30; Mathias Komor, New York (Lugt Supp. 1882a); purchased in New York in 1961.

BIBLIOGRAPHY: Stampfle and Bean, 1967, no. 57, repr. (with previous bibliography).

Purchase, 1960, Rogers Fund
61.2.1

Design for one of the illustrations for a treatise on gardening by a Jesuit professor, Giovanni Battista Ferrari. The book, *De Florum Cultura,* appeared in Rome in 1633, with this design engraved in reverse by Johann Friedrich Greuter. The artist illustrates an allegorical passage in Ferrari's text that tells of a contest between Nature and Art. Art, kneeling at the right with grafting knife in hand, has produced a rosebush with flowers of three colors, but Flora is about to crown Nature, who stands pointing at the miracle of her own doing. As if by magic a Chinese rose tree has sprung from the ground. Vertumnus dances holding a sistrum aloft, and three boys, Lucifer, Meriggio, and Hesper (identified respectively by a lily branch, a rose, and a bleeding heart, and representing Dawn, Noon, and Evening) circle the tree while its flowers change from white, to pink, to scarlet, as they are said to do in the course of a day. The wonders of Nature are seen to be more marvelous than those of Art. Drawings by Cortona for other illustrations in Ferrari's book are in the P. and N. de Boer Collection, Amsterdam (*Cybele before the Council of the Gods*), and in the Museo del Prado, Madrid (*Allegorical Scene with Barberini Bees*; repr. Blunt and Cooke, 1960, p. 76, fig. 57).

135. *Allegory in Honor of Cardinal Antonio Barberini the Younger*

Pen and brown ink, brown wash, heightened with white, over black chalk, on brown paper. 52.0 x 77.2 cm. Drawing made up of two sheets of paper joined vertically at left of center; pasted corrections at left (including figure of Mercury) and at right (including old man holding book). Repaired hole at lower center; vertical crease at center.

Inscribed in pen and brown ink at lower left, *Incidat* [and illegible monogram]; at lower right, *Incidatur commutato Regno* . . . [rest illegible].

PROVENANCE: Helen Elizabeth Harrison, Maiano, near Florence (purchased by her in S. Gimignano, about 1925); Gilbert Barker, Twyford, Berkshire (inherited from his aunt, Miss Harrison, at her death in 1958); purchased in London in 1964.

BIBLIOGRAPHY: Stampfle and Bean, 1967, no. 58, repr.; Noehles, 1970, p. 6, note 22.

Purchase, 1964, Rogers Fund
64.50

The high finish of this drawing, as well as the two inscriptions beginning *Incidat...,* in the hand of an ecclesiastical censor, indicate that it was intended for the engraver, and indeed the design was reproduced in the same dimensions but in reverse by a Dutch contemporary of Cortona, Theodor Matham, who was in Rome in the mid-1630s, a date that accords well with the style of Cortona's drawing (repr. Noehles, 1970, p. 18, fig. 2). Unfortunately, the engraving does not bear a dedicatory inscription that might help us in the interpretation of the allegorical message of the subject. Hollstein (XI, p. 252, no. 28) supplies an obviously incorrect title, *The Three Fates in a Colonnade,* but the always knowledgeable Mariette, in a manuscript description of the Albertina's impression of the print, has given us the key to the subject: "Des femmes représentant les diverses parties des Mathématiques venant faire hommage de leurs Sciences dans un Temple où au milieu une femme qui a près d'elle les armes de la famille Barberini est assise au-dessus d'un piédestal au pied duquel sont deux figures de Fleuves qui désignent le Tibre et l'Arno; pièce allégorique à la gloire du cardinal Antoine Barberini dont le portrait est soutenu en l'air par des enfants." In the drawing it is difficult to identify the portrait head, a generic Cortonesque type, but in Matham's engraving the medallion contains an easily recognizable portrait of Antonio Barberini the Younger as a man in his late twenties (for portraits of Antonio, created cardinal in 1627 at the age of nineteen by his uncle, Urban VIII, see A. Nava Cellini, *Paragone,* XVII, 191, 1966). For Karl Noehles the female figure seated on the pedestal is Sapienza-Minerva—at once the Magna Mater and an allegorical figure of Rome. The reclining figures of the Tiber (with Romulus and Remus) and the Arno (with the Florentine lion, *il marzocco*) are allusions to the Tuscan past and Roman present of the Barberini family whose arms appear on the shield above. In this Temple of Wisdom are statues of Mercury (because all forms of knowledge and art have need of the persuasive force of his eloquence) and of female figures representing the virtues.

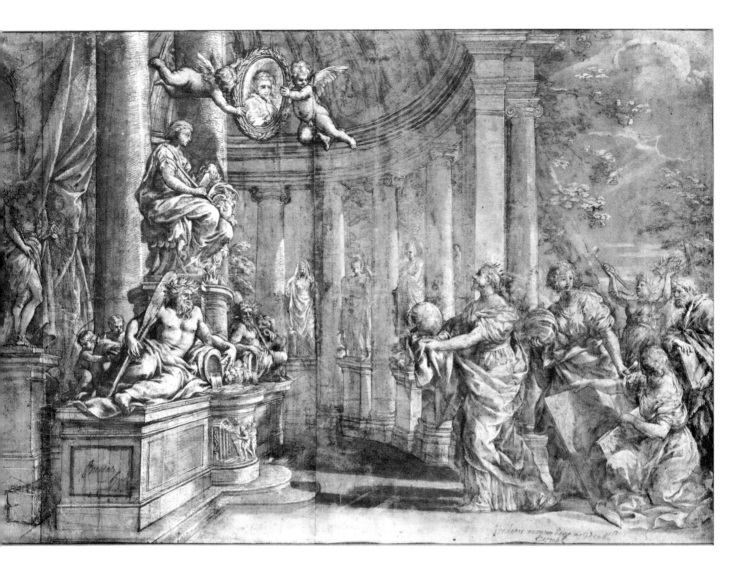

The scientific equipment carried by the figures on the right is more readily identifiable in the engraving: the woman leading the procession holds a celestial sphere, her follower bears an armillary sphere, the kneeling female holds tablets inscribed with terrestrial maps, while the old man holds a tablet bearing what appear to be the measurements of a column. Behind them stands Fame, holding a trumpet and a crown of foliage.

This large drawing is made up of two sheets joined vertically somewhat to the left of center. The white highlights employed in the two sections differ; on the right they are softer, on the left harder. It should be noted that the wing and the legs of the flying putto that project over the vertical joining have been reworked in the whites used otherwise only in the left section. This

suggests that, the client or ecclesiastical censor having found the original left section of the design unsatisfactory, it was cut off, a new solution supplied, and the joining of the two sheets smoothed over by the reworking of the putto in the white used in the new left half. Such a revision and reconsolidation of the design would account for the presence of the ecclesiastical permissions to engrave that appear at both lower left and lower right.

Volkmar Schauz has recently discovered and published a lively, small red chalk preparatory sketch for the *Allegory in Honor of Antonio Barberini* that differs in many ways from the definitive composition (*Jahrbuch der Staatlichen Kunstsammlungen in Baden-Württemberg,* XV, 1978).

136. *Study of Two Figures for the Age of Gold*

Black chalk. 32.3 x 24.7 cm. Several repaired holes and small tears; a few oil stains. Lined.

PROVENANCE: Sir Joshua Reynolds (Lugt 2364); William Mayor (Lugt 2799); Henry Oppenheimer, London; Oppenheimer sale, London, Christie's, July 10-14, 1936, no. 76; Earl of Harewood; sale, London, Christie's, July 6, 1965, no. 124, repr.; Walter C. Baker, New York.

BIBLIOGRAPHY: Stampfle and Bean, 1967, no. 60, repr. (with previous bibliography); Campbell, 1977, pp. 33, 264, no. 21, fig. 7.

Bequest of Walter C. Baker, 1972

In June 1637, Pietro da Cortona, taking a leave of absence from his work on the Barberini ceiling, arrived in Florence and almost immediately began a fresco cycle commissioned by the Grand Duke of Tuscany, Ferdinando II, for the Camera della Stufa in the Palazzo Pitti. The subject of the frescoes, said to have been devised by Michelangelo Buonarroti the Younger, is the Four Ages of Man as recounted in Ovid's *Metamorphoses*. However, the pessimistic Ovidian sequence, which moves from the delights of the Age of Gold, through the Silver and Bronze, to the horrors of the Age of Iron, has been reversed in the iconographical program employed by Cortona. History moves forward from the pagan Age of Iron to the Age of Gold; the latter fresco contains a number of symbolic references to a contemporary Florentine event, the marriage of Ferdinando II de' Medici to Vittoria della Rovere. Only two of the frescoes, the Ages of Gold and Silver, were completed when Cortona left Florence for Venice in the fall of 1637, but the surviving preparatory drawings for all four of the frescoes form a relatively coherent stylistic group, and the whole cycle may have been planned in detail during the summer of that year. The execution of the frescoes representing the Age of Bronze and the Age of Iron had to await Cortona's return to Florence in 1641, the year in which he began work on the decoration of the state rooms along the façade of the Palazzo Pitti.

This drawing is a study for the couple seated at the left in the *Age of Gold*. In this fresco the young woman crowns the seated youth with a laurel crown of victory, an allusion to the name Vittoria, while putti, laden with branches of oak (*rovere*), advance without disturbing a docile lion (the Florentine *marzocco*)—further references to the Medici-della Rovere marriage symbolized by the youthful couple. In addition to two composition studies, a great many chalk studies for figures in the Ages of Gold and Silver have survived, and they are among the finest Italian figure drawings of the seventeenth century.

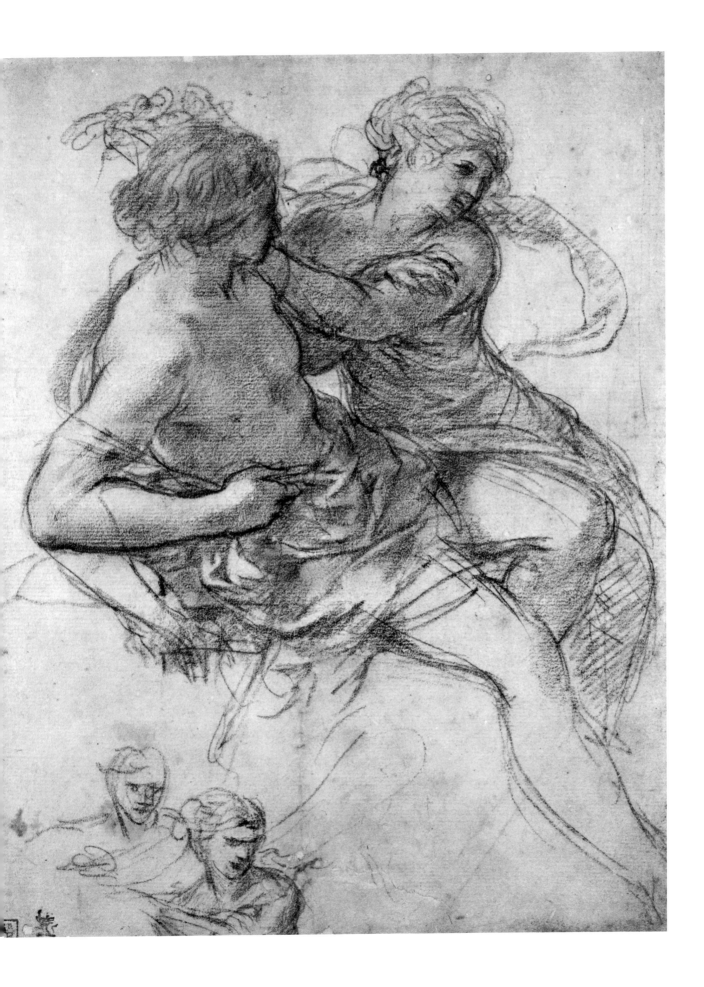

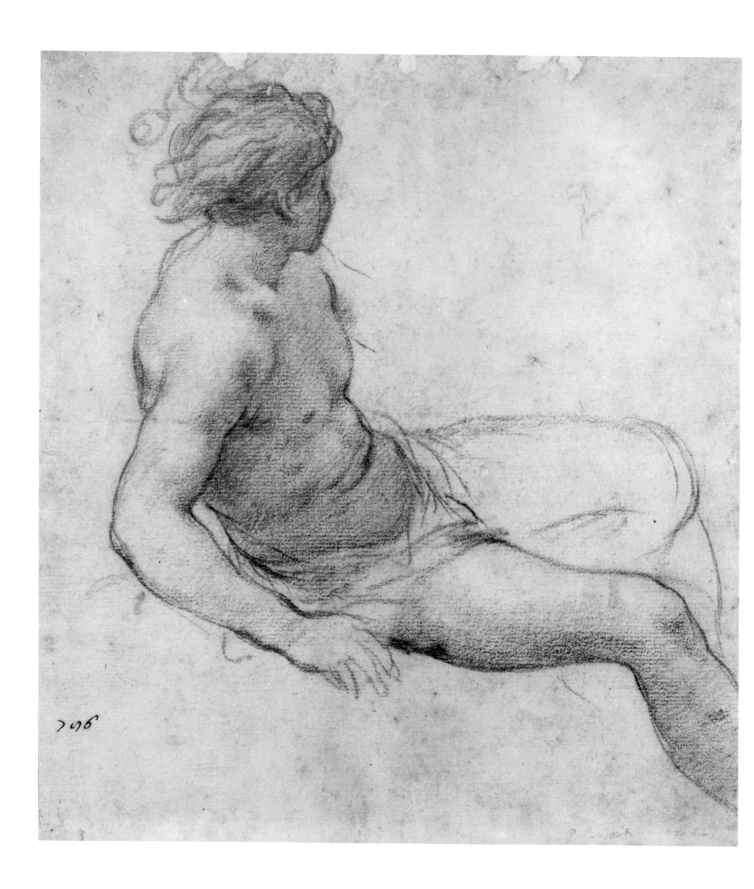

137. *Study of a Seated Youth for the Age of Gold*

Black chalk. 28.6 x 26.0 cm. Losses at upper margin. Lined.

Inscribed in black chalk at lower right, *P. Cortona;* numbered in pen and brown ink at lower left, 756 [?].

PROVENANCE: John Skippe; his descendants, the Martin family, including Mrs. A. D. Rayner-Wood; Edward Holland-Martin; Skippe sale, London, Christie's, November 20-21, 1958, no. 40, pl. 6; Walter C. Baker, New York.

BIBLIOGRAPHY: Stampfle and Bean, 1967, no. 61, repr. (with previous bibliography and exhibition listings); Campbell, 1977, p. 264, no. 22.

Bequest of Walter C. Baker, 1972

Preparatory study for the youth seated on the left in Cortona's fresco representing the Age of Gold (see No. 136 above). The position of the youth's right arm is closer in the previous drawing to the solution adopted in the fresco, but in both figure studies his left arm (here only lightly indicated) is raised, while in the fresco it rests across his chest.

138. *Study for the Age of Bronze*

Pen and brown ink, over black chalk. 23.3 x 17.2 cm. Lined.

Numbered in pen and brown ink at lower margin, *n⁰* 57 [?], in the same hand as the number 22 on No. 145; in pencil at lower margin of old mount, *Pietro da Cortona.*

PROVENANCE: Prof. John Isaacs, London; Isaacs sale, London, Sotheby's, February 27, 1964, part of no. 64, purchased by the Metropolitan Museum.

BIBLIOGRAPHY: Stampfle and Bean, 1967, no. 62, repr. (with previous bibliography); Campbell, 1977, pp. 49, 53-55, 268, no. 45, fig 17.

Purchase, 1964, Rogers Fund
64.48.2

Pietro da Cortona's *Age of Bronze* in the Camera della Stufa of the Palazzo Pitti at Florence represents a scene of Roman military triumph. The composition is dominated at the right by an enthroned general, who from a high pedestal distributes crowns to victorious legionaries. In the left foreground three enchained prison-

ers crouch dejectedly, while behind them a bearded figure explains the meaning of an inscribed tablet to onlookers gathered before a circular temple that shelters a statue of Christ blessing.

Six composition studies by Cortona for this fresco have been identified, five of them fairly recently. All of them, on stylistic grounds, seem to date from 1637, during Cortona's first campaign in the Camera della Stufa, and not from 1641, when the *Age of Bronze* was finally painted (see No. 136 above). If we follow the artist's progress from first ideas to the nearly final solution, the sequence of the six drawings would seem to be: a pen sketch in an album of drawings by Cortona and Ciro Ferri on the New York art market a decade ago (repr. Campbell, 1977, fig. 13); a drawing in the Uffizi on the verso of a sketch of the partially completed Roman church of SS. Luca e Martina (repr. *op. cit.*, fig. 14); drawings in Munich and Prague (repr. *op. cit.*, figs. 15 and 16, respectively); the present drawing; then the following drawing (No.139). The present sheet deals only with the principal figures in the composition, the general distributing crowns to soldiers. There are three conspicuous variations between drawing and fresco: in the latter the general is seated, not standing; the soldier

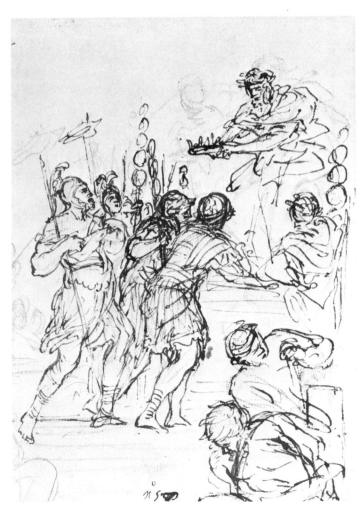

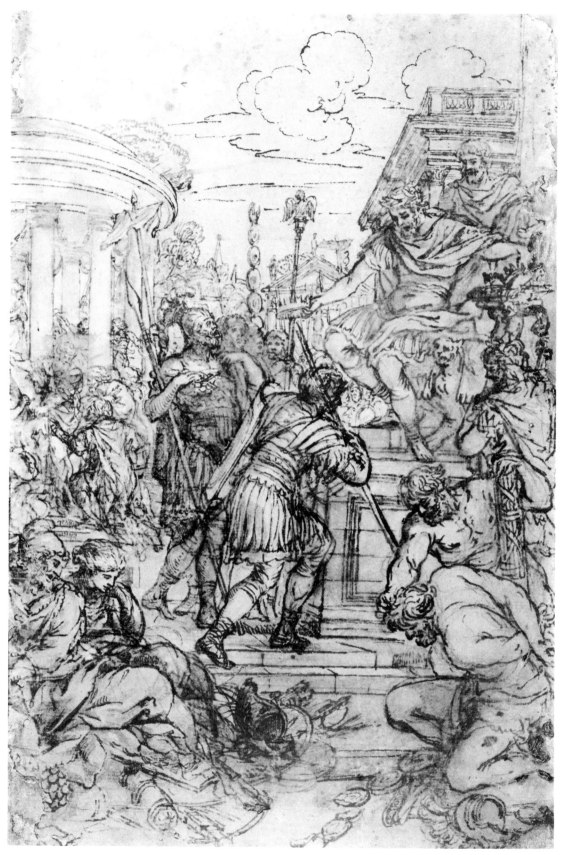

PIETRO DA CORTONA (NO. 138)

at the center raises his arms to seize the offered crown instead of bending forward humbly; and the captive at the right foreground has been suppressed.

In the following drawing (No. 139), a design for the whole composition, we still encounter the modest attitude of the central soldier and the captive guarded by a lictor in the right foreground, both motifs that disappear in the fresco, but the general is already enthroned, and the seated captives seen at the left in the fresco make their appearance for the first time. In the fresco Cortona made a number of changes in the grouping of the figures and in architectural details. Even more advanced composition drawings must have existed, but for the present No. 139 brings us as close as we can come, in the sequence of drawings, to the finished work.

139. *Study for the Age of Bronze*

Pen and brown ink, brown wash, over black chalk. 40.5 x 27.0 cm. All four corners replaced; repairs at left and right margins; scattered repaired holes and tears. Lined.

PROVENANCE: Walter C. Baker, New York.

BIBLIOGRAPHY: Stampfle and Bean, 1967, no. 63, repr. (with previous bibliography); Campbell, 1977, pp. 49, 53-55, 267-268, no. 44, fig. 18.

Bequest of Walter C. Baker, 1972

See No. 138 above.

140. *A Wind God*

Black chalk, heightened with white, on brownish paper. 18.9 x 33.3 cm. The irregular edges of the sheet have been filled in on all sides. Lined.

PROVENANCE: George Hibbert; Nathaniel Hibbert; Sir Henry Thurston Holland, 1st Viscount Knutsford, and his heirs; sale, London, Sotheby's, April 11, 1935, no. 78; L. G. Duke, London; purchased in London in 1961.

BIBLIOGRAPHY: Stampfle and Bean, 1967, no. 64, repr. (with previous bibliography and exhibition listings); Campbell, 1977, pp. 118, 276, no. 98, fig. 79.

Purchase, 1961, The Elisha Whittelsey Fund
61.129.1

A study for the figure of a wind god who appears at the edge of the central oval of the frescoed ceiling in the Sala di Apollo, Palazzo Pitti, Florence. It was in 1641 that Pietro da Cortona undertook the decoration of the state rooms of the Pitti, using an iconographic program that dedicated each room to a planet symbolic of the virtues required of a prince, from youth through old age. The Sala di Venere was the first to be finished, then the Sala di Giove and the Sala di Marte. How far work on the elaborate stucco ornament for the Sala di Apollo had come when Cortona left for Rome in 1647 is uncertain, but the frescoes had hardly been begun. Cortona himself was never able to return to Florence to complete the task, and the decoration was finished by his principal assistant, Ciro Ferri, as late as 1661.

The chronology and the respective roles of Cortona and Ferri in the elaboration of the design of the central fresco in the Sala di Apollo is somewhat unclear, but this figure of a wind god was certainly conceived and drawn by Cortona himself. Further studies of the wind god are reproduced by Malcolm Campbell: a small sheet of pen sketches in a private collection (his fig. 77); and a chalk sketch in the Farnesina (inv. 124347 verso; his fig. 78 – Walter Vitzthum attributed the sketch to Cortona, while Campbell retains its old attribution to Ferri).

141. *Satyrs Supporting an Ornamental Motif*

Pen and brown ink. 16.7 x 18.6 cm. Lined.

PROVENANCE: Fagan ? (Lugt Supp. 919c, the name inscribed in pen and brown ink on recto and verso of old mount); purchased in London in 1962.

Purchase, 1962, Rogers Fund
62.119.2

The free penwork is very similar to that of Cortona's sketches for the ornamentation in the state rooms of the Palazzo Pitti, and the satyr caryatids and the *mascaron* decorating the pediment are motifs that are found in the stucco decoration of these rooms. This sheet may be compared with a study in the Uffizi that involves a comparable pediment with *mascaron,* satyrs, and garlands; the Uffizi drawing is a study for the stucco ornamentation of the Sala di Apollo (no. 18 Orn.; repr. Campbell, 1977, fig. 70). Malcolm Campbell in his work on Cortona at the Pitti Palace makes no mention of the present drawing.

142. *The Virgin and Child with St. Martina, Another Study of St. Martina, Studies of a Head, and of an Arcade*

Pen and brown ink, over black chalk. 16.3 x 18.6 cm. Figure studies in brush and brown wash on verso can be seen in transparency at right on recto. Lined.

Inscribed in blue pencil on verso of old mount, *Giulio Romano.*

PROVENANCE: James Jackson Jarves; Cornelius Vanderbilt.

BIBLIOGRAPHY: *Metropolitan Museum Hand-book,* 1895, no. 52, as Giulio Romano.

Gift of Cornelius Vanderbilt, 1880
80.3.52

Once attributed to Giulio Romano, then to the circle of Correggio, this drawing was recognized in 1958 as the work of Pietro da Cortona by Philip Pouncey. The Roman martyr St. Martina, kneeling before the Virgin and about to receive a flower from the Christ Child, was a subject several times painted by Cortona. It was in the course of excavations for the crypt of the church of the Academy of St. Luke in Rome that the body of St. Martina was discovered. Cortona was the architect of the church built on that site between 1635 and 1650 (which was eventually dedicated to both Luke and Martina), and the architectural sketches at the top of the sheet may be related to Cortona's plans for SS. Luca e Martina.

141

142

PIETRO DA CORTONA

143. *God the Father with Angels Holding Symbols of the Passion*

Black chalk. 46.4 x 36.2 cm. Lined.

Inscribed in black chalk on verso, *cirus ferrus*.

PROVENANCE: Purchased in London in 1971.

BIBLIOGRAPHY: Bean, 1972, no. 9; J. Bean, *Master Drawings*, XI, 3, 1973, p. 294, pl. 42.

Purchase, 1971, Rogers Fund
1971.146

Recently rediscovered study for part of the central group of figures in Cortona's fresco decoration of the cupola of S. Maria in Vallicella, the Chiesa Nuova, Rome. This fresco was begun in 1647 and unveiled in 1651. The subject is the Trinity in Glory and the Glorification of the Instruments of the Passion. There are many variations between the finished fresco and this preparatory drawing in which angels hold palm branches, Veronica's veil, and the column of the Flagellation.

Walter Vitzthum identified pen and chalk drawings by Cortona for the cupola in Edinburgh, Vienna, and Paris (*L'Oeil*, 83, 1961, pp. 62 ff.). Eckhard Schaar has found a study for the figure of God the Father at Düsseldorf (*Italienische Handzeichnungen des Barock*, Kunstmuseum, Düsseldorf, 1964, no. 34, fig. 8). More recently Nicholas Turner has suggested that a pen sketch in a private collection in London is a study for the figures of Abraham, Isaac, and Adam in the cupola fresco (*Prospettiva*, 10, 1977, pp. 62-63, fig. 3).

PIETRO DA CORTONA

144. *Angels Sealing the Foreheads of the Children of Israel*

Brush and gray wash, heightened with white, over black chalk, on brownish paper. 42.6 x 113.2 cm. The drawing is made up of five sheets of paper joined vertically.

PROVENANCE: Sale, London, Sotheby's, March 13, 1957, no. 16; sale, London, Sotheby's, July 7, 1966, no. 2, repr., purchased by the Metropolitan Museum.

BIBLIOGRAPHY: Stampfle and Bean, 1967, no. 66, repr.; W. Vitzthum, *I disegni dei maestri. Il barocco a Roma,* Milan, 1971, p. 83, color pl. XVII.

Purchase, 1966, Rogers Fund
66.134.1a-c

In 1652 Cortona was at work on cartoons for the mosaic decoration of the first three bays in the right nave of St. Peter's. For the elliptical cupolas of these bays he supplied scenes from the Apocalypse—the mosaic of the third cupola representing the Incensing of the Fiery Altar, that of the second the Adoration of the Lamb. These two mosaics had been completed by the time he began, in 1668, the cartoons for the cupola of the first bay, representing Angels Sealing the Foreheads of the Children of Israel (Revelation 7), but the mosaic of this last subject was finished only after Cortona's death, under the supervision of Ciro Ferri (G. Briganti, *Pietro da Cortona,* Florence, 1962, pp. 252-253). This large drawing, made up of several sheets of paper joined vertically, gives us the essential narrative passages of Cortona's dramatic rendering of the apocalyptic vision, and the opening of the oval lantern is indicated in black chalk at the upper center of the design. Here, at the end of his career, the artist abandons pen and chalk; brush with wash suffices to indicate the surging movement of the figures. An engraving of the mosaic cupola in the first bay by F. Aquila, published in 1695, names Ciro Ferri as the designer of the composition, but the testimony of this drawing, certainly by Cortona, makes it clear that Ferri's role was probably limited to supervising the completion of his master's project. However, Nicholas Turner has recently identified in Siena (Biblioteca Comunale, vol. S. II. 5, folio 46, recto) a black chalk drawing in Ciro Ferri's typical, scribbly hand that is a study for a group of figures in the mosaic. Ferri's figures come closer to the finished mosaic than to the Cortona project at the Metropolitan Museum.

PIETRO DA CORTONA

145. *Half-Figure of a Bacchante with Outstretched Right Arm*

Red chalk. 12.2 x 18.0 cm. Lower corners missing. Lined.

Numbered in pen and brown ink by the "Double-numbering" collector, *34,* and *trenta quattro;* at lower right, *n⁰ 22* in the same hand as the number 57 on No. 138.

PROVENANCE: "Double-numbering" collector; Prof. John Isaacs, London; Isaacs sale, London, Sotheby's, February 27, 1964, part of no. 65; purchased in London in 1964.

Purchase, 1964, Rogers Fund
64.197.3

Not associable with any surviving work by Cortona, but a typical example of his chalk figure draughtsmanship at its freest.

146. *Sea Battle*

Brush and brown wash. Illegible red chalk notations on verso. 12.1 x 18.0 cm.

Inscribed in pencil on verso, *P. da Cortona.*

PROVENANCE: Nathaniel Hone (Lugt 2793); Sir Thomas Lawrence (Lugt 2445); Prof. John Isaacs, London; Isaacs sale, London, Sotheby's, February 27, 1964, part of no. 65; purchased in London in 1964.

Purchase, 1964, Rogers Fund
64.197.4

The loose brushwork of this drawing suggests quite a late date in Cortona's career. It may be compared with the designs for mosaics in St. Peter's; see No. 144.

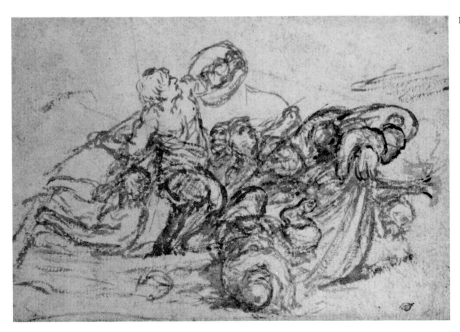

DANIELE CRESPI

Busto Arsizio ca. 1598 – Milan 1630

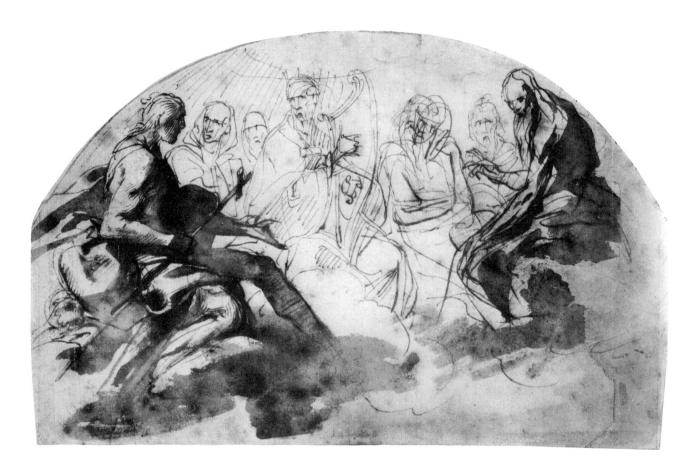

147. *St. John the Baptist, St. Benedict, King David, and Other Seated Figures*

Pen and brown ink, brown wash. 17.8 x 28.7 cm. Arched top. Losses at top right and at right margin; the sheet made up in both these areas.

PROVENANCE: Purchased in London in 1978.

BIBLIOGRAPHY: *Dessins de maîtres anciens, Galerie de Bayser,* exhibition catalogue, Paris, 1977, no. 14, repr.

Purchase, 1978, Harry G. Sperling Fund
1978.133

Study for the heavenly witnesses who assist, from a bank of clouds, as St. Hugh of Grenoble blesses the newly founded Grande Chartreuse. This is one of the events in the life of St. Bruno painted by Crespi, at the end of his life, in the Certosa di Garegnano, Milan. The narrative scene, one of six lunette-shaped compositions in the church of the Certosa, occurs on the wall of the nave, immediately to the left of the high altar (repr. Gregori, 1973, pl. XXI). In the Ambrosiana there is a pen study for the whole composition (repr. Gregori, 1973, fig. 27).

GIUSEPPE MARIA CRESPI

Bologna 1665 – Bologna 1747

148. *The Massacre of the Innocents*

Red chalk, over traces of black chalk. 43.7 x 59.3 cm.

PROVENANCE: Unidentified collector's mark, D.F., in violet at left margin of verso (not in Lugt); purchased in Paris in 1970.

BIBLIOGRAPHY: Bean, 1972, no. 10; Johnston, 1973, p. 96.

Purchase, 1970, Rogers Fund
1970.258

This drawing was recognized as the work of G. M. Crespi by Luigi Dania; it is very closely related to Crespi's painting of the *Massacre of the Innocents* presented by the artist to Ferdinando de' Medici and now in the Uffizi in Florence. The elaborate, rather academic draughtsmanship of this large sheet is characteristic of G. M. Crespi, and it may well be the artist's study for an etching to be made after the painting. Crespi painted at least three other representations of the Massacre of the Innocents, each differing in some way from the Uffizi picture (Ferratini collection, Bologna; Alte Pinakothek, Munich; National Gallery of Ireland, Dublin), and yet another version is recorded in an etching after G. M. Crespi by Ludovico Mattioli (Bartsch, XIX, pp. 398-399, no. 4).

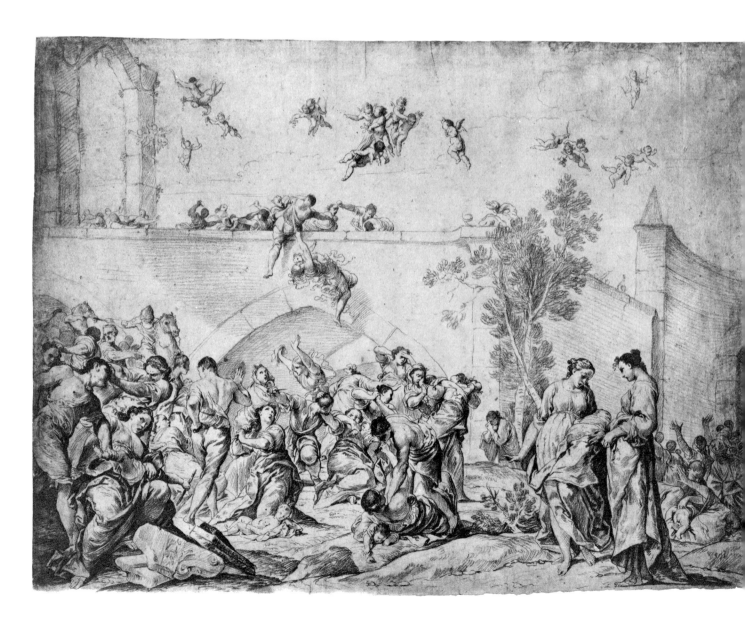

149. *Marcolfa Discovers Bertoldino Trying to Hatch Eggs*

Red chalk. Faint black chalk sketch of Bertoldino on verso. 22.6 x 14.6 cm.

PROVENANCE: Purchased in London in 1953; transferred from the Department of Prints, 1976.

BIBLIOGRAPHY: J. Bean, *Master Drawings*, IV, 4, 1966, p. 421; Roli, 1974, fig. 18a.

Purchase, 1953, The Elisha Whittelsey Fund
1976.57.1

A study for one of Crespi's twenty etchings (in this case Bartsch, XIX, p. 408, no. 31, in reverse) illustrating the old Bolognese burlesque histories of Bertoldo, Bertoldino, and Cacasenno. The Metropolitan Museum possesses two further studies for these etchings: see Nos. 150 and 151 below. In the Musée des Beaux-Arts in Orléans, are preserved red chalk studies for four further illustrations: Bartsch, 23, 29, 36, and 40 (repr. Roli, 1974, figs. 15a, 15b, 16a, and 16b). Unpublished studies for Bartsch 35 and 41 are in the Kunsthalle, Hamburg (inv. 52450 and 52449, respectively). A series of twenty watercolor drawings attributed to G. M. Crespi, corresponding in reverse to the etchings but with a number of variations, appeared on the Italian art market in 1973. They were acquired by the Cassa di Risparmio in Bologna and are reproduced in color in Andrea Emiliani's catalogue, *Le collezioni d'arte della Cassa di Risparmio in Bologna. I disegni. I. dal Cinquecento al Neoclassicismo*, Bologna, 1973.

GIUSEPPE MARIA CRESPI

150. *Menghina Coming from the Garden Meets Cacasenno*

Red chalk. 19.3 x 14.0 cm. The sheet made up of two pieces of paper joined horizontally 2.8 cm. from the lower margin.

PROVENANCE: Purchased in London in 1953; transferred from the Department of Prints, 1976.

BIBLIOGRAPHY: J. Bean, *Master Drawings,* IV, 4, 1966, p. 421; Roli, 1974, fig. 17a.

Purchase, 1953, The Elisha Whittelsey Fund
1976.57.2

Study for Bartsch, XIX, p. 409, no. 37, which is in reverse. See No. 149 above.

151. *Marcolfa Persuades Cacasenno to Mount a Horse*

Red chalk. 20.1 x 14.6 cm.

PROVENANCE: Purchased in London in 1953; transferred from the Department of Prints, 1976.

BIBLIOGRAPHY: A. H. Mayor, *Metropolitan Museum of Art Bulletin,* November 1953, p. 77, repr.; J. Bean, *Master Drawings,* IV, 4, 1966, pp. 420-421, pl. 36; Bean and Stampfle, 1971, no. 11, repr.; Roli, 1974, fig. 17b.

Purchase, 1953, The Elisha Whittelsey Fund
1976.57.3

Study for Bartsch, XIX, p. 409, no. 39, which is in reverse. See No. 149 above.

DONATO CRETI

Cremona 1671 – Bologna 1749

152. *Thetis Dipping the Infant Achilles into the Waters of the Styx*

Pen and brown ink. 16.9 x 27.6 cm. Lined.

PROVENANCE: James Jackson Jarves; Cornelius Vanderbilt.

BIBLIOGRAPHY: *Metropolitan Museum Hand-book*, 1895, no. 369, as Tiepolo; Roli, 1967, p. 109, listed; R. Roli, *Master Drawings*, XI, 1, 1973, pp. 28-29, pl. 18.

Gift of Cornelius Vanderbilt, 1880
80.3.369

Renato Roli identified this drawing as a preparatory study for a painting of the same subject in the Pinacoteca Nazionale, Bologna, a painting that he dates in the second decade of the eighteenth century (repr. Roli, 1967, no. 36, fig. 45, pl. VI).

153. *The Virgin Bringing the Habit to the Seven Founding Fathers of the Servite Order*

Pen and brown ink. 29.1 x 20.9 cm. Brown and green stains. Lined.

Inscribed in pen and brown ink at lower left corner of old mount, *Donato Creti.*

PROVENANCE: Purchased in London in 1967.

BIBLIOGRAPHY: Roli, 1967, p. 109, listed; R. Roli, *Master Drawings*, XI, 1, 1973, p. 29, pl. 22.

Purchase, 1967, Rogers Fund
67.95.1

Renato Roli has suggested that a small painting in the convent of S. Maria dei Servi, Bologna, representing the Virgin Bringing the Black Habit to the Servites (repr. *Master Drawings,* XI, 1, 1973, p. 29, fig. 1) is a reduced copy of a lost and unrecorded original by Creti, and that the present drawing is Creti's study for the composition.

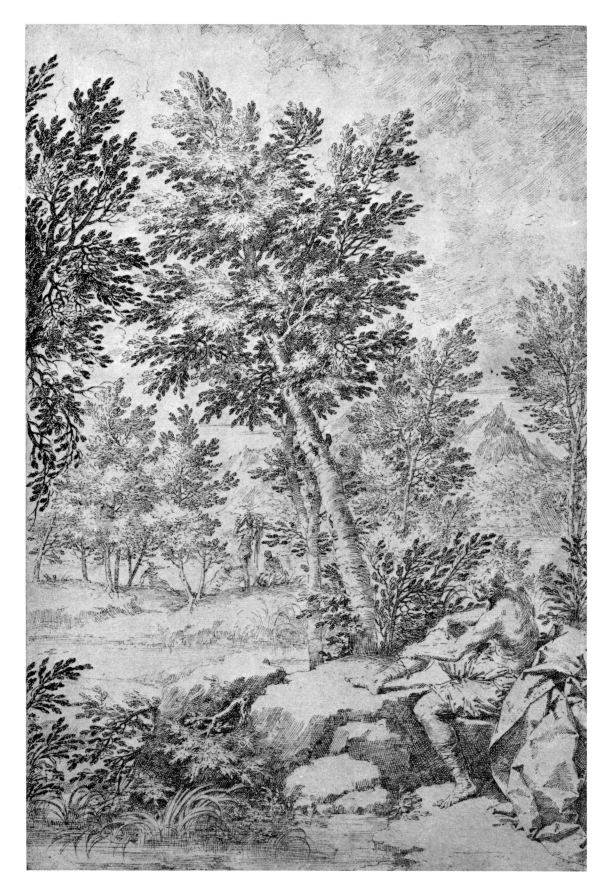

DONATO CRETI

154. *Bathers in a Wooded Landscape*

Pen and two shades of brown ink. 35.6 x 24.0 cm. Lined.

PROVENANCE: William Russell (Lugt 2648); Sir James Knowles, London; Samuel Wagstaff, New York; David Hutchinson, New York; purchased in New York in 1971.

BIBLIOGRAPHY: Bean, 1972, no. 11.

Purchase, 1971, Rogers Fund
1971.58

The seated youth in the foreground also appears in a landscape drawing at Windsor that was attributed by Otto Kurz to Domenico Maria Fratta but which appears to be the work of Fratta's master, Creti (Kurz, 1955, no. 268; repr. L. van Puyvelde, *The Flemish Drawings . . . at Windsor Castle,* London, 1942, no. 269, attributed there to Gillis Neyts).

PIETRO DAMINI
Castelfranco 1592 – Padua 1631

155. *St. Louis of France, St. Francis, and a Female Monastic Saint*

Pen and brown ink, brown wash. 21.6 x 14.8 cm. Arched top. Lined.

Inscribed in pen and brown ink at lower right, *di Pietro Damini;* in another hand, *1592-1631.*

PROVENANCE: James Jackson Jarves; Cornelius Vanderbilt.

BIBLIOGRAPHY: *Metropolitan Museum Hand-book,* 1895, no. 182, as Pietro Damini; Tietze, 1944, no. 690.

Gift of Cornelius Vanderbilt, 1880
80.3.182

The old inscription to Pietro Damini is certainly plausible, and the drawing may be usefully compared to a sheet in the British Museum representing the Virgin and Child with Angels, given to Damini by the "Reliable Venetian Hand" (Pp.4-64; repr. Bettagno, 1966, fig. 23).

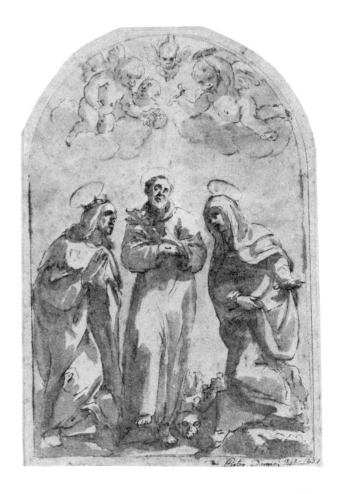

CESARE DANDINI

Florence 1596 – Florence 1656

156. *Allegorical Figure of Painting*

Pen and brown ink, over red chalk. 26.1 x 27.5 cm.

Inscribed in pen and brown ink at lower margin, *C.D.*

PROVENANCE: Eric Wunsch, New York.

BIBLIOGRAPHY: Thiem, 1977, no. 158, repr.

Gift of Eric Wunsch, 1970
1970.244.1

The monogram *C.D.* occurs on many of Cesare Dandini's drawings. This figure of Painting is related to, and perhaps inspired by, that allegorical figure in *La Pittura e la Poesia,* a painting by Francesco Furini, signed and dated 1626, in the Reserves of the Uffizi in Florence. Interestingly enough, the painting was engraved as the work of Cesare Dandini for *L'Etruria pittrice* (II, Florence, 1795, pl. LXXXXII; the engraving repr. in Thiem, 1977, fig. 297).

157. *Standing Draped Male Figure, His Left Arm Resting on a Pedestal*

Black chalk, a little lead pencil, on dark brown washed paper. 40.0 x 26.2 cm. Lined.

Inscribed in pen and brown ink at lower left, *Dandini;* in lead pencil, *Cesare Dandini;* inscribed in black chalk on verso of old mount, *Cesare Dandini.*

PROVENANCE: Cephas G. Thompson.

BIBLIOGRAPHY: *Metropolitan Museum Hand-book,* 1895, no. 793, as Cesare Dandini.

Gift of Cephas G. Thompson, 1887
87.12.123

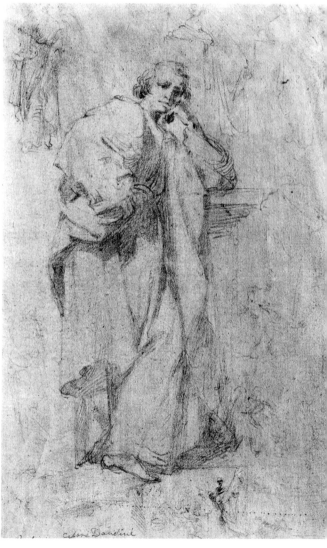

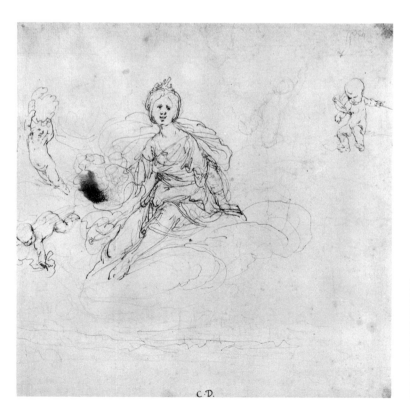

PIETRO DANDINI

Florence 1646 – Florence 1712

158. *Design for a Ceiling Decoration with Neptune and the Four Continents*

Pen and brown ink, over black chalk. 24.8 x 39.2 cm. A number of brown stains.

Inscribed in pen and brown ink at lower margin, *E.Europa/N. Nettunno/A Americha/AF Africha/AS Asia* (the letters appear above the corresponding figures in the composition); in lead pencil at lower margin, *P.D.*

PROVENANCE: James Hazen Hyde (a smaller version of Lugt 1320 is stamped in black on the verso).

Gift of the Estate of James Hazen Hyde, 1959
59.208.93

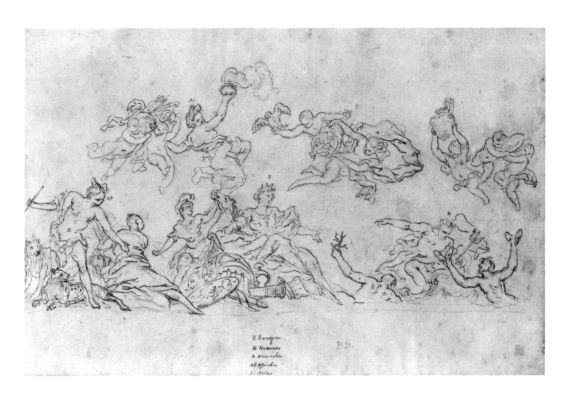

The monogram *P.D.* and stylistic evidence give weight to the traditional attribution of this drawing to Pietro Dandini.

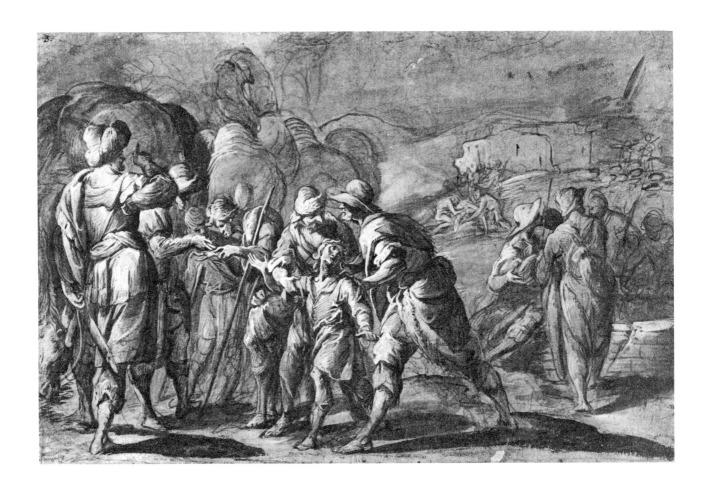

GIOVANNI BATTISTA DISCEPOLI

Castagnola 1590 – Milan ? 1660

159. *Joseph Sold by His Brethren*

Brush and red wash, heightened with white, over red chalk, on red-washed paper. 28.2 x 43.6 cm.

Inscribed in pen and brown ink at lower left, *G.b. discepoli f.;* numbered in pen and black ink at upper left corner, *3*; inscribed on verso, *Batt^a Disepoli detto . . . [Zop]po di Lugano.*

PROVENANCE: Giuseppe Vallardi (Lugt 1223); James Jackson Jarves; Cornelius Vanderbilt.

BIBLIOGRAPHY: *Metropolitan Museum Hand-book*, 1895, no. 333, as Giovanni Battista Discepoli; Stampfle and Bean, 1967, no. 35, repr.

Gift of Cornelius Vanderbilt, 1880
80.3.333

Few examples of Discepoli's draughtsmanship have survived; those attributed to him in the Ambrosiana (see E. Spina Barelli, *Disegni di maestri lombardi del primo seicento,*

Milan, 1959, nos. 84-87) are slight, while the present drawing shows him to be a vigorous if somewhat *retardataire* practitioner of a mannerist tradition that in Lombardy was prolonged well into the seventeenth century.

PIETRO FACCINI

Bologna 1562 – Bologna 1602

160. *Seated Female Figure*

Brush and red wash, over red chalk. Framing lines in pen and brown ink. 34.1 x 26.0 cm. A number of brown and white stains. Lined.

Inscribed in pen and brown ink at lower right, *f. Barotius.*

PROVENANCE: Purchased in London in 1975.

BIBLIOGRAPHY: Bean, 1975-1976, no. 15.

Purchase, 1975, Harry G. Sperling Fund and Rogers Fund
1975.130

Study for the central figure of the Virgin in Faccini's altarpiece, *Virgin and Child Enthroned with Saints,* from the Pellicani chapel in S. Francesco, Bologna (Malvasia, 1686, pp. 120-121), and now in the Pinacoteca of that city (repr. Venturi, IX, 6, fig. 477). Red-washed studies for the whole composition are preserved in the Ashmolean Museum, Oxford (Parker II, no. 218, pl. LIII) and the British Museum (1938-11-4-1).

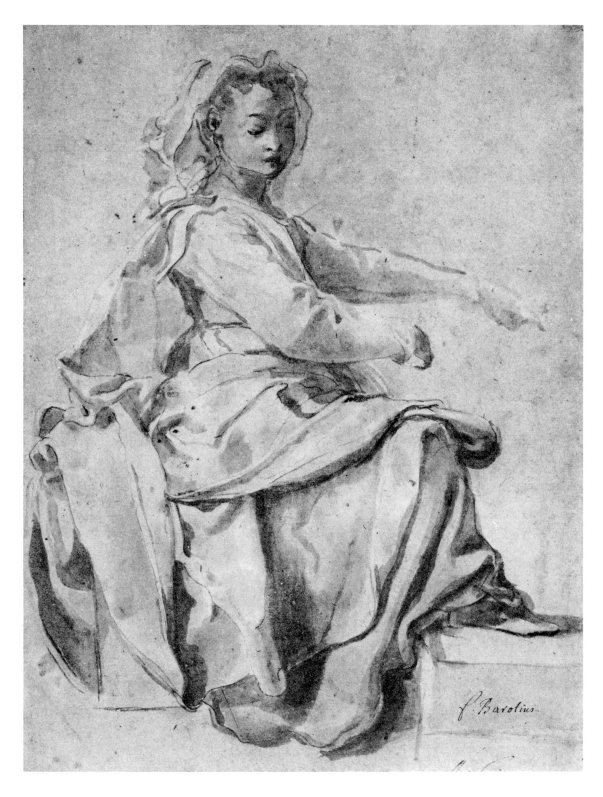

PIETRO FACCINI

161. *Christ and the Virgin Appearing to St. Francis*

Pen and brown ink, brown wash, heightened with white, on gray-green paper. 40.7 x 26.0 cm. A number of repaired tears and holes. Spots of red pigment. Lined.

Inscribed in pen and brown ink at lower right margin, *Pietro Facino a Cento* (in part trimmed away); in pencil on reverse of old mount, *Ciro de Conegliano* [sic].

PROVENANCE: Sir Peter Lely (Lugt 2092); Jonathan Richardson, Sr. (Lugt 2184); Thomas Hudson (Lugt 2432); mark mistakenly associated with Pierre Crozat (Lugt 474); Sir Charles Greville (Lugt 549); Earl of Warwick (Lugt 2600); Warwick sale, London, Christie's, May 20-21, 1896, probably part of no. 130, "Sketch for a Saint Anthony of Padua, by Facini"; sale, Paris, Hôtel Drouot, February 25, 1924, no. 7, repr., as "Ciro de Conegliano"; purchased in Paris in 1964.

Purchase, 1964, Rogers Fund
64.132.1

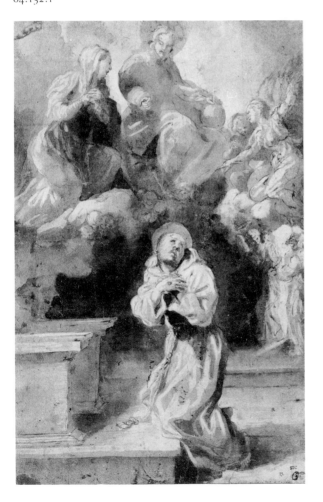

The old attribution to Faccini is entirely convincing, and how it came to be given to "Ciro de Conegliano" in a 1924 sale in Paris defies explanation. The composition was utilized with slight variations in a small painting on panel in the Louvre that Pierre Rosenberg has recently attributed to Faccini. The painting had previously figured in Louvre inventories under the name of Annibale Carracci, then of Ludovico Carracci, and more recently as G. A. Donducci (L. Hautecoeur, *Musée National du Louvre. Catalogue des peintures . . . II. Ecole italienne et école espagnole,* Paris, 1926, p. 55, no. 1271).

ANIELLO FALCONE
Naples 1607 – Naples 1656

162. *Ruth and Boaz*

Red chalk and red wash. 16.7 x 17.4 cm. Cut irregularly to a kidney shape. Several brown stains. Lined.

Inscribed in pen and brown ink at lower margin, *A F.*; on recto of old mount, *Aniello Falcone/Maestro di Sal. Rosa, d'Andrea/de lione, del Coppola e d'altri bat/ taglisti;* numbered at upper right corner of old mount, *16* [?].

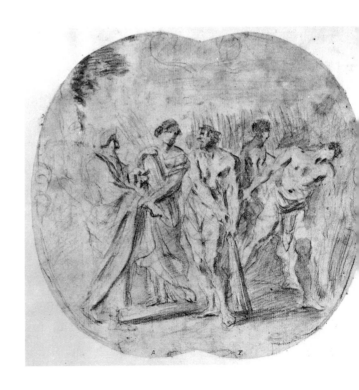

PROVENANCE: Don Gaspar Méndez de Haro y Guzmán, Marchese del Carpio e Helice, Viceroy of Naples, 1682-1687; sale, London, Christie's, March 20, 1973, no. 35, repr.; purchased by the Metropolitan Museum.

Purchase, 1973, Rogers Fund
1973.71

The drawing was identified at the time of its sale at Christie's in 1973 as a study for Falcone's fresco, representing Ruth and Boaz, in the dome of the St. Agatha chapel in S. Paolo Maggiore, Naples. F. Saxl has discussed Falcone's decorations in this chapel, which can be dated 1640 (*Journal of the Warburg and Courtauld Institutes*, III, 1939-1940, pp. 78-80). Vitzthum identified a red chalk drawing at Windsor, formerly attributed to Sacchi, as Falcone's study for the oval fresco in the chapel dome representing Deborah and Barak (Blunt, 1971, p. 82, no. 169). Saxl had already identified a red chalk drawing in the Museo di Capodimonte, Naples, as a study for the head of Barak (repr. Vitzthum, 1966, cat. 15, fig. 11).

163. *Ruins of the Roman Arena at Pozzuoli*

Pen and brown ink, brown wash. 18.8 x 27.0 cm. A number of brown spots. Lined.

Inscribed in pen and brown ink at lower left, *A. Fa Pozzuolo;* on the old mount, *falcone;* numbered on the old mount, 69 [?].

PROVENANCE: Don Gaspar Méndez de Haro y Guzmán, Marchese del Carpio e Helice, Viceroy of Naples, 1682-1687; sale, London, Christie's, March 20, 1973, no. 29, repr.; purchased by the Metropolitan Museum.

BIBLIOGRAPHY: Bean, 1975-1976, no. 16.

Purchase, 1973, Rogers Fund
1973.72

This landscape is rare in being executed in pen; all Falcone's other surviving landscape studies are in red chalk. H. M. Calmann possesses a red chalk view of the ruins of the arena at Pozzuoli seen from the same point of view (repr. Christie's sale catalogue, London, March 20, 1973, no. 28).

A. Fa Pozzuolo

164. *Male Nude with Left Arm Upraised, and a Further Study of His Head*

Red chalk. 26.7 x 16.9 cm. A good many repaired losses. The heel of the left foot has been drawn in by another hand.

Inscribed in pencil on verso, *A. Sachi 0.*

PROVENANCE: Don Sebastien Gabriel de Borbón y Braganza (1811-1875); Don Pedro Alcántara de Borbón y Borbón, Duke of Dúrcal (1862-1892); Dúrcal sale, New York, American Art Galleries, April 10, 1889, part of no. 249, as Sacchi; Henry Walters.

BIBLIOGRAPHY: Vitzthum, Paris, 1967, p. 15, mentioned and attributed to Falcone.

Gift of Henry Walters, 1917
17.236.19

This academy figured in the Dúrcal collection under the name of Andrea Sacchi, but was given to Falcone by Walter Vitzthum, who connected it with a group of red chalk figure studies in the Louvre and in West Berlin. Lawrence Turčić points out that another red chalk figure study also from the Dúrcal collection, but now in the

National Collection of Fine Arts, Washington, D.C. (*Hercules Holding a Club,* attributed to Giuseppe Cesari, 1926.7.188, gift of John Gellatly), is very probably by the same hand as the present drawing.

GREGORIO DE FERRARI

Porto Maurizio 1647 – Genoa 1726

165. *The Assumption of the Virgin*

Black chalk, a little pen and brown ink. Architectural notations in black chalk on verso. 28.2 x 20.3 cm. Brown stain at upper margin.

Inscribed in pen and brown ink at lower left, *Gregorio D. Ferrari.*

PROVENANCE: Purchased in London in 1962.

BIBLIOGRAPHY: E. Gavazza, in *Arte in Europa. Scritti de storia dell'arte in onore di Edoardo Arslan.* Milan, n.d., I, p. 725, mentioned; repr. II, pl. 473.

Purchase, 1962, Rogers Fund
62.119.3

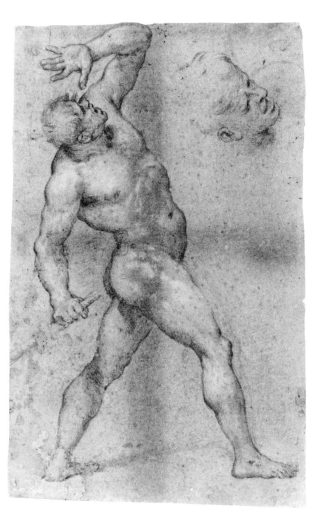

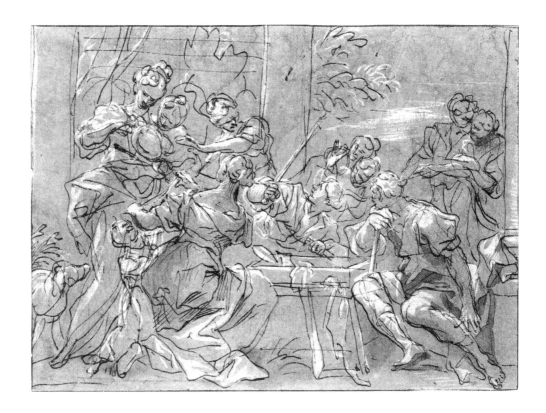

GREGORIO DE FERRARI

166. *Achilles and the Daughters of Lycomedes*

Pen and brown ink, heightened with white, over black chalk, on brownish paper. 24.5 x 34.4 cm.

PROVENANCE: Purchased in London in 1964.

BIBLIOGRAPHY: *Drawings of Five Centuries. Peter Claas,* exhibition catalogue, London, 1964, no. 25, pl. 14.

Purchase, 1964, Rogers Fund
64.284

167. *Design for an Overdoor Decoration*

Pen and brown ink, brown wash, over a little black chalk; *rinceaux* in red chalk on verso. 28.8 x 20.4 cm. A number of brown stains.

PROVENANCE: Purchased in London in 1967.

Purchase, 1967, Rogers Fund
67.95.9

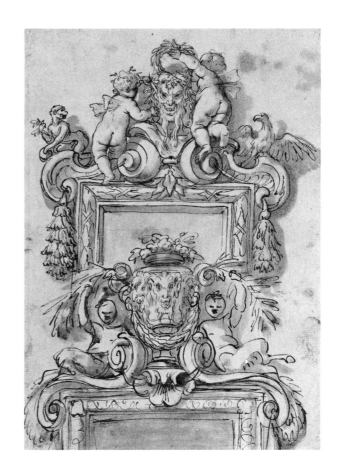

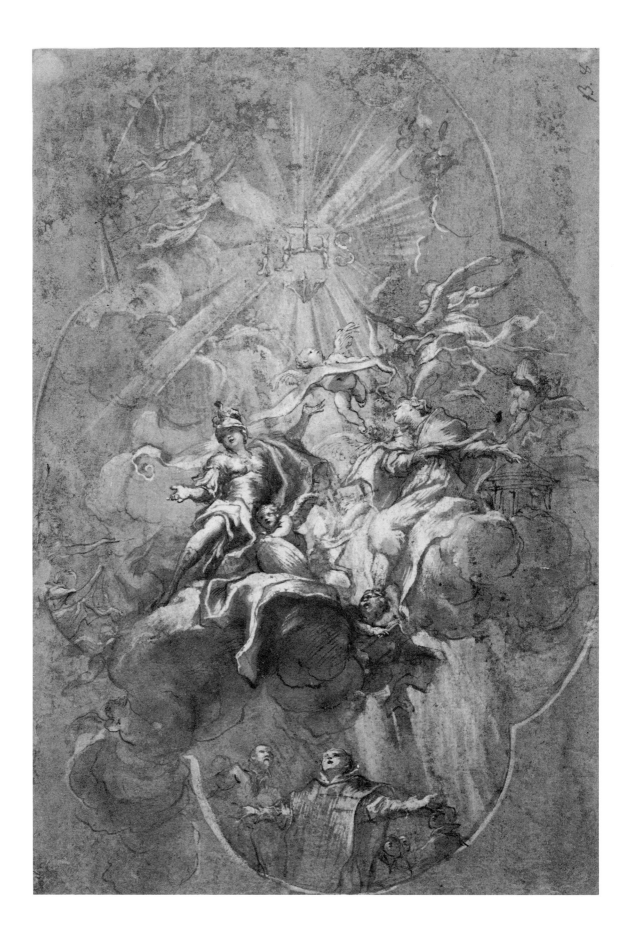

168. *Glorification of the Name of Jesus*
VERSO. *Aurora and Cephalus*

Pen and brown ink, brown wash, heightened with white, on blue-gray paper (recto); pen and brown ink, brown wash, heightened with white, over black chalk (verso). 38.8 x 26.3 cm.

Inscribed in pen and brown ink at upper right corner of recto, *B. 8*; in pencil on verso, *G. Ferrari;* and No *54*.

PROVENANCE: Purchased in London in 1962.

BIBLIOGRAPHY: Gavazza, 1965, pp. 38-39, 93-94, verso fig. 39, as Lorenzo de Ferrari; Newcome, 1972, no. 143, the verso exhibited and repr. as Lorenzo de Ferrari.

Purchase, 1962, Rogers Fund
62.119.11

The drawing on the recto, with the Glorification of the Sacred Monogram, which owes a good deal to the example of Gaulli's Gesù ceiling in Rome, is a very spirited example of the draughtsmanship of Gregorio de Ferrari. On the other hand, the drawing on the verso of the sheet, somewhat awkward and dry, has been given by Ezia Gavazza to Gregorio's son Lorenzo and connected with the latter's fresco of the Hunt of Diana on the ceiling of the Salotto con la Caccia di Diana in the Palazzo Grimaldi, Piazza S. Luca, Genoa (repr. Gavazza, 1965, fig. 36). The same author identified a pen drawing in the Uffizi as a further study by Lorenzo for the Cephalus and Aurora group (*op. cit.*, fig. 37).

169

169. *Ceiling Design with the Presentation in the Temple*

Pen and brown ink, brown wash, heightened with white, on blue-gray paper. 52.7 x 41.3 cm.

BIBLIOGRAPHY: J. Bean, *Master Drawings,* XI, 3, 1973, p. 294, pl. 41; Myers, 1975, pp. 19-20, no. 22, repr.

Purchase, 1955, The Elisha Whittelsey Fund
55.628.8 (Department of Prints and Photographs)

The attribution to Gregorio de Ferrari is due to Mary L. Myers, who discovered this design among the anonymous architectural drawings in the Print Department of the Metropolitan Museum.

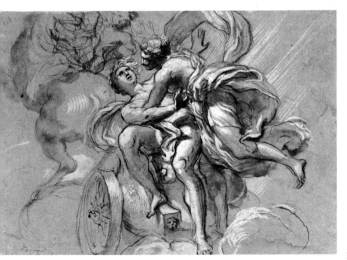

168 v.

GREGORIO DE FERRARI

170. *Heraclius Carrying the Cross into Jerusalem*

Pen and brown ink, brown wash, over black chalk. 37.3 x 51.9 cm. The design continued on a small fragment approximately 8.0 x 4.0 cm. attached to the right margin. Top margin arched; lower left and right corners cut away.

PROVENANCE: Rudolf Wien, Vienna and New York (according to vendor); purchased in New York in 1967.

BIBLIOGRAPHY: Newcome, 1972, p. 37, no. 100, repr.; M. Newcome, *Paragone,* XXIX, 335, 1978, pp. 66-67, pl. 73.

Purchase, 1967, Rogers Fund
67.205

Gregorio de Ferrari began the fresco decorations of the church of S. Croce e S. Camillo, Genoa, toward the end of his life; the work was finished only after his death by his son Lorenzo (Ratti, 1769, II, pp. 116-117, 264). This very spirited design for a composition that appears in a lunette above the altar of the church is surely in the hand of the more inventive Gregorio. Walter Vitzthum has pointed out that a drawing in the Palazzo Rosso, Genoa, for the same lunette composition is also by Gregorio, though it has an old attribution to Lorenzo (W. Vitz-

thum, *Master Drawings,* VI, 3, 1966, pp. 312-313, pl. 39). The lunette as executed by Lorenzo is a much staider composition, with fewer and larger figures (repr. Gavazza, 1965, fig. 3, where the author follows Ratti in mistakenly describing the subject as the *Invention of the Cross*). The present design was attributed by its previous owner to Sébastien Bourdon.

CIRO FERRI
Rome 1634 – Rome 1689

171. *The Last Supper*

Brush and brown wash, heightened with white, over black chalk, on brownish paper. 35.0 x 22.6 cm. Upper and lower margins cut to contours of the decorative cartouches. Lined.

Inscribed in pen and brown ink at lower margin of old mount, *Pietro da Cortona*.

PROVENANCE: Hon. Edward Bouverie (Lugt 325); sale, London, Christie's, July 20, 1859, no. 24, as Pietro da Cortona; sale, London, Christie's, November 21, 1967, no. 142, repr., as Pietro da Cortona, purchased by the Metropolitan Museum.

Purchase, 1967, Rogers Fund
68.38

Study for one of the illustrations in the missal of Alexander VII Chigi, published in Rome in 1662. Ferri's design was engraved in reverse by Cornelis Bloemaert without the decorative cartouche at the top and the Chigi arms below. The missal of Alexander VII has a frontispiece by Pietro da Cortona and fifteen full-page illustrations after designs by Carlo Cesi, Guglielmo Cortese, Pietro da Cortona, Ciro Ferri, Carlo Maratti, Jan Miel, and Pier Francesco Mola. Ferri, who made something of a specialty of designs intended for engraving, supplied five illustrations for the missal. In addition to the *Last Supper* he drew the *Circumcision,* the *Crucifixion,* the *Resurrection,* and *Peter and Paul in Prison.* Ferri's drawing for the *Circumcision* is in a private collection in New York (Stampfle and Bean, 1967, no. 126, repr.), and an old studio copy of this latter drawing is preserved in the Metropolitan Museum (61.166.2).

in the Farnesina in Rome (nos. 124465 and 124469; Langheit, 1962, pp. 107, 213, note 166). Another episode from the life of Francis Xavier, *The Baptism of the Heathen,* was drawn or painted by Ciro Ferri; this scene was engraved by Jean Mariette (not listed by Le Blanc; an impression is in the Print Department of the Metropolitan Museum).

Manuela B. Mena Marqués points out that in the Roberto Longhi Archives in Florence there is a photograph, classed as school of Maratti, of a painting that corresponds in almost every detail, including the arched top, to the Metropolitan drawing. In the painting, however, two male spectators appear behind the standing turbaned figure on the right.

Though the drawing has no traditional attribution to Ferri, in style it is typical of him. Its high finish suggests it may be a study for an engraving, but the print does not seem to have been issued.

172. *The Death of St. Francis Xavier*

Black chalk. 51.0 x 32.0 cm. Arched top; all margins torn irregularly. Lined.

PROVENANCE: Purchased in Los Angeles in 1966.

Purchase, 1966, Mrs. Carl Selden and Florence and Carl Selden Foundation Gifts
66.9

The most celebrated seventeenth-century representation of the death of St. Francis Xavier is Carlo Maratti's painting (commissioned 1674, completed 1679) on the altar dedicated to that saint in the Gesù, Rome. The architectural and sculptural elements of this altar were designed by Pietro da Cortona, but work on the altar was not begun until three years after his death. Cortona's early involvement with this enterprise makes it possible that his principal assistant, Ciro Ferri, may have hoped to obtain the commission for the painted altarpiece. Though Maratti's composition has a square top and Ferri's a rounded one, they have a number of figural elements in common, especially the pose of the dying saint in the foreground, and it is hard to say if Ferri was influenced by Maratti or vice versa. Ferri's interest in this composition is evidenced in two rapid pen sketches for the figure of the dying Francis Xavier holding a cross

173. *The Virgin Immaculate Appearing to Four Saints*

Black chalk. Squared in black chalk. 27.3 x 21.8 cm. Considerable foxing. Lined.

Inscribed in pencil on reverse of old mount, *Carlo Maratti.*

PROVENANCE: Purchased in Zurich in 1962.

Purchase, 1962, Rogers Fund
62.129.4

The monastic saints kneeling at the right may be Carmelites (St. Angelus of Jerusalem and St. Mary Magdalen de' Pazzi ?), and the drawing could be a study for an oval relief. It should be remembered that Ciro Ferri was responsible for the design of the choir of the church of S. Maria Maddalena de' Pazzi in Florence (executed 1675-1701); however, no such composition occurs among the reliefs here.

A black chalk drawing by Ferri in the Kunstmuseum, Düsseldorf (II g 2), is a study for the same oval relief; the figures are posed in the same way, but there is a greater expanse of landscape background seen beyond the balustrade.

172

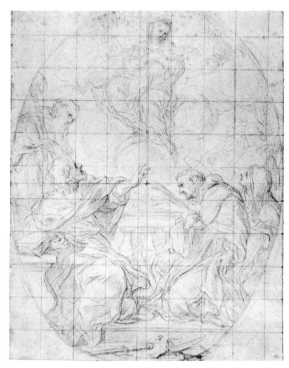

173

174. *Design for an Altar with Kneeling Angels Supporting a Crucifix*

Pen and brown ink, brown wash, over black chalk. 31.0 x 27.4 cm. Several brown stains.

Partially effaced inscription in pen and brown ink on verso, *Pietro da Cortona* [?].

PROVENANCE: Count Lanfranco di Campello, Rome; A. Branson, London (according to vendor); purchased in London in 1965.

BIBLIOGRAPHY: H.-W. Kruft, *Burlington Magazine*, CXII, 1970, p. 695, fig. 47.

Purchase, 1965, Rogers Fund
65.66.4

Hanno-Walter Kruft compared the kneeling angels and standing putti in this drawing with similar figures on a monumental silver and gilded bronze reliquary in the Museum of the Co-Cathedral of St. John, Valletta, Malta, which he convincingly argues was designed by Ciro Ferri.

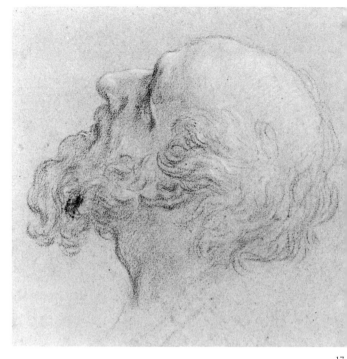

17

175. *Head of a Bearded Man Looking to Upper Left*

Black chalk, heightened with white, on blue paper. 22.0 x 22.9 cm. Brown stain at left of center. Lined.

Inscribed in black chalk at left margin of old mount, *Ciro Ferri*.

PROVENANCE: J. Byam Shaw, London.

Gift of J. Byam Shaw, 1962
62.149

176. *Head of a Bearded Man Looking to Upper Right*

Black chalk on blue paper. 17.5 x 15.8 cm. Lined.

Inscribed in pen and brown ink at lower margin of old mount, *Cirro Ferri;* in pen and brown ink in another hand on verso of old mount, *ciro Ferri in . . . Hon^{ble} Rob^t Bruce's Collect . . ./1726.*

PROVENANCE: Hon. Robert Bruce (according to old inscription); Curtis O. Baer, New Rochelle, New York.

Gift of Curtis O. Baer, 1963
63.118

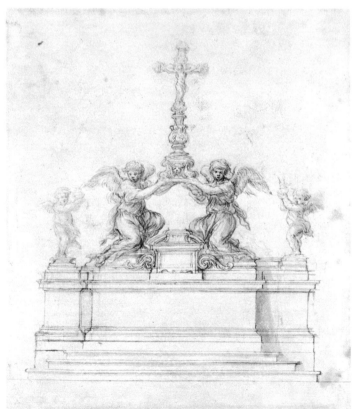

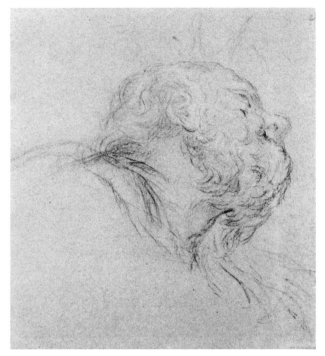

176

177. *Landscape with Mountains in the Distance*

Brush and gray wash, over a little black chalk. 22.6 x 35.1 cm. Considerably foxed, losses at lower left. Lined.

PROVENANCE: James Jackson Jarves; Cornelius Vanderbilt.

BIBLIOGRAPHY: *Metropolitan Museum Hand-book*, 1895, no. 266, as school of the Carracci.

Gift of Cornelius Vanderbilt, 1880
80.3.266

The same landscape composition, with the addition of a few figures and slightly different cloud formations, was etched by Francesco Bartolozzi and published by J. Boydell with the title, "From an Original Drawing by Pietro da Cortona" (A. de Vesme and A. Calabi, *Francesco Bartolozzi*, Milan, 1928, p. 608, no. 2498). The rather hesitant brushwork in the present drawing suggests Ciro Ferri rather than his master, and the drawing may well be a copy by Ferri after a lost original by Cortona. Other such copies exist—Walter Vitzthum has pointed out that a landscape drawing by Ferri at Haarlem is a copy after an original by Pietro da Cortona at Windsor Castle (the two drawings repr. *Master Drawings*, IV, 3, 1966, p. 303).

177

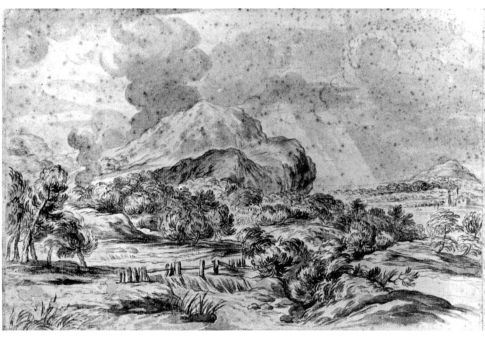

GIOVANNI BATTISTA FOGGINI

Florence 1652 – Florence 1725

179. *The Sabine Women Pleading for Peace*

Pen and brown ink, brown wash, over black chalk, on brownish paper. 40.1 x 55.6 cm. Vertical crease at center. Lined.

Inscribed in pen and brown ink on verso of old mount in Jonathan Richardson, Jr.'s hand (Lugt 2997), *Sabina Mulieres, quarum ex Injuriâ Bellum ortum erat. . . .* [passage from Livy identifying the subject]; in another hand, *Luca Giordano d^o Fa Presto per la volicità nel dipingere . . .*

PROVENANCE: Jonathan Richardson, Jr. (Lugt 2170); William Bates (Lugt 2604); David Rust; purchased in New York in 1961.

BIBLIOGRAPHY: Stampfle and Bean, 1967, no. 136, repr. (with previous bibliography); Monaci, 1977, mentioned under no. 13.

Purchase, 1961, Rogers Fund
61.52

The drawing was acquired with a traditional attribution to Luca Giordano, and it was Walter Vitzthum in 1965 who supplied the correct name, Foggini. There are two further studies for this composition at Windsor (Blunt, 1971, no. 174, pl. 60, and no. 175).

180. *Apollo and Coronis*

Pen and brown ink, brown wash, over black chalk. 26.5 x 34.6 cm. Several brown stains. Lined.

Inscribed in pen and brown ink at lower margin, *Ciro Ferri* (canceled); and *Gio: Batta. Foggini.*

PROVENANCE: Purchased in New York in 1961.

BIBLIOGRAPHY: J. Montagu in *The Twilight of the Medici, Late Baroque Art in Florence 1670-1743,* exhibition catalogue, Institute of Arts, Detroit, and Palazzo Pitti, Florence, 1974, p. 60, no. 22, repr. p. 61; L. Monaci in *Kunst des Barok in der Toskana,* Munich, 1976, p. 27; Monaci, 1977, pp. 31-32.

Purchase, 1961, The Elisha Whittelsey Fund
61.174

Jennifer Montagu has pointed out that a rough sketch for this composition is to be found in the Farnesina in Rome (128798; repr. Monaci, *op. cit.,* 1976, p. 28, fig. 7). The composition was used for a wax relief in the Museo di Doccia.

ORAZIO FIDANI

Florence ca. 1610 – Florence ? after 1656

178. *Bust of a Youth Looking to Upper Left*

Black and red chalk, on blue paper. Slight study of drapery (?) in black chalk on verso. 20.2 x 16.1 cm.

Inscribed in pen and brown ink at lower margin, *Di Orazio fidani.*

PROVENANCE: Purchased in New York in 1974.

BIBLIOGRAPHY: Thiem, 1977, no. 203, repr.

Purchase, 1974, Harry G. Sperling Fund
1974.270

The inscription *Di Orazio fidani* is in the same hand as that on a red and black chalk study of a child's head by Fidani in a private collection in Paris (Thiem, 1977, no. 202, repr.).

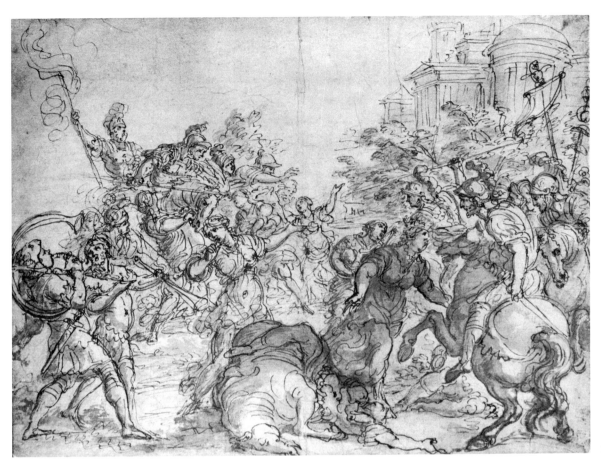

179

180

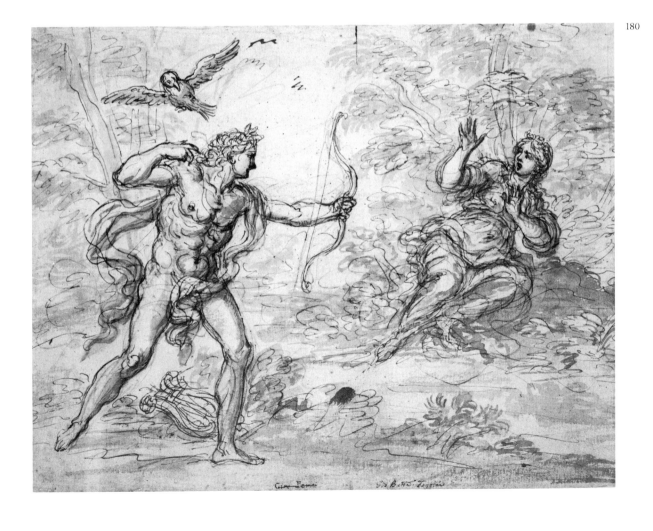

NOTE: Some sixty designs by Foggini for ornament and architecture are preserved in the Department of Prints and Photographs of the Metropolitan Museum. Nine of these drawings are reproduced by Mary L. Myers in her catalogue, *Architectural and Ornamental Drawings: Juvarra, Vanvitelli, the Bibiena Family, and Other Italian Draughtsmen,* The Metropolitan Museum of Art, New York, 1975, nos. 23a-28.

FRANCESCO FRACANZANO, attributed to

Monopoli 1612 – Naples 1656

181. *Abraham about to Sacrifice Isaac*

Pen and brown ink, over traces of black chalk. 20.6 x 28.5 cm. Lined.

Inscribed in pencil on reverse of old mount, *Fracanzana* (?—upper part of the first letters cut off).

PROVENANCE: Don Sebastien Gabriel de Borbón y Braganza (1811-1875); Don Pedro Alcántara de Borbón y Borbón, Duke of Dúrcal (1862-1892); Dúrcal sale, New York, American Art Galleries, April 10, 1889, lot no. undetermined; Henry Walters.

Gift of Henry Walters, 1917
17.236.49

The attribution to Fracanzano in the hand that correctly identifies so many of the artists from the Dúrcal collection should be seriously considered. The brittle, somewhat awkward penwork, which owes something to the example of Ribera, is paralleled in a study of two male figures in the British Museum traditionally attributed to Fracanzano (1965-4-10-1). Nonetheless, Fracanzano is rather elusive as a draughtsman; Walter Vitzthum lucidly summed up the situation in his exhibition catalogue of Neapolitan drawings at the Uffizi (Vitzthum, Florence, 1967, pp. 36-37).

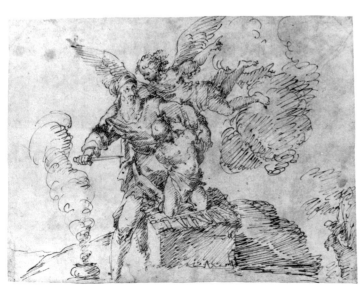

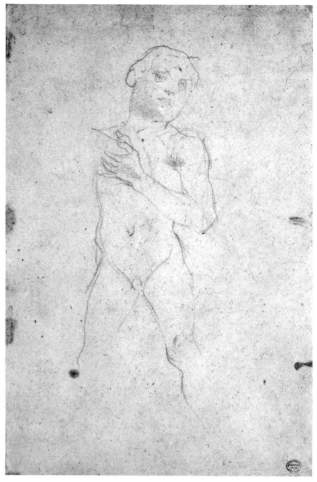

182 v.

BALDASSARE FRANCESCHINI, called Il Volterrano

Volterra 1611 – Florence 1689

182. *Allegorical Figure of Purity with a Unicorn and Putto* VERSO. *Study of a Nude Boy*

Red chalk on beige paper. 39.7 x 26.2 cm. Two brown stains.

Numbered in pencil at lower right corner of recto, 67.

PROVENANCE: Purchased in London in 1969.

BIBLIOGRAPHY: Bean, 1972, no. 19; J. Bean, *Master Drawings,* X, 2, 1972, p. 164, recto pl. 44a; J. P. Cooney, *Master Drawings,* XII, 4, 1974, pp. 373-374, verso pl. 39a.

Purchase, 1969, Rogers Fund
69.172

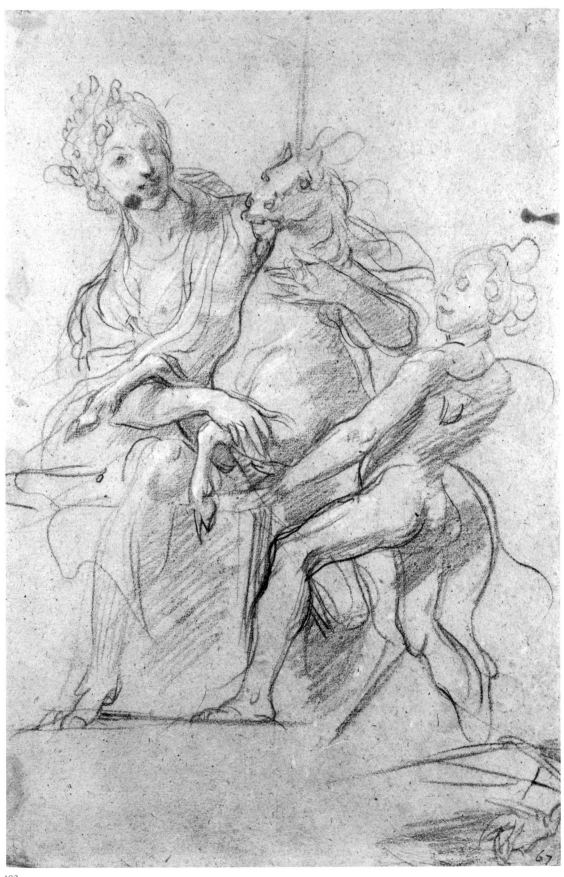

Study for the figure of Purity with a unicorn that appears to the right above the entrance arch of the Orlandini chapel in S. Maria Maggiore, Florence, the decoration of which Volterrano undertook in 1642.

The putto on the verso may be studied for one of the attendants of the figure of Humility that appears above the entrance arch to the left.

183. *Allegorical Figure of Purity with a Unicorn and Two Putti*

Red chalk and red wash, on beige paper. Faint red chalk sketches for the same group on verso. 25.7 x 26.3 cm. Some foxing.

Inscribed in pen and brown ink in Gabburri's hand on verso, *di Baldassar Franceschini detto il Volterrano | Originale de sua mano dell' opera da lui med.*[no] *| dipinta a Fresco nella. chiesa di Santa Maria | Maggiore dei P.P. Carmelitani della Congregazione | di Mantova della Città di Firenze;* numbered on verso, *n° 391;* in paler brown ink, *n° 5.*

PROVENANCE: F. M. N. Gabburri (Lugt Supp. 2992b); Sir Joshua Reynolds (Lugt 2364); Dr. Edward Peart (Lugt 891); sale, London, Christie's, June 23, 1970, no. 22. repr.; purchased in London in 1970.

BIBLIOGRAPHY: Bean, 1972, no. 18; J. Bean, *Master Drawings*, X, 2, 1972, p. 164, pl. 44b; J. P. Cooney, *Master Drawings*, XII, 4, 1974, p. 373.

Purchase, 1970, Rogers Fund
1970.282

Another study for the figure of Purity with a unicorn and attendant putti on the right side of the lunette-shaped fresco above the entrance arch of the Orlandini chapel in S. Maria Maggiore, Florence (see No. 182 above). This design comes very close to Volterrano's final solution, and the outline of the window that pierces the lunette is indicated at upper left. The connection between drawing and fresco was noted by Gabburri, who once owned the drawing. Further studies for the Purity group are in the Louvre and the Uffizi (see J. Patrick Cooney, *op. cit.*). Red chalk studies for the fresco on the vault of the chapel that represents Elijah in his Fiery Chariot are in the National Gallery of Scotland, Edinburgh (4937 and 4939; repr. Thiem, 1977, figs. 216 and 305, respectively).

184. *Allegorical Figure of Purity with a Unicorn*

Red chalk, heightened with white, on beige paper. 29.9 x 21.8 cm. Several brown stains. Lined.

PROVENANCE: J. Cantacuzène, Paris (on verso of old mount, mark *JC* in a circle, not described by Lugt); J.C[antacuzène] sale, Paris, Hôtel Drouot, June 4-6, 1969, no. 421; purchased by the Metropolitan Museum.

BIBLIOGRAPHY: Bean, 1972, no. 20; J. P. Cooney, *Master Drawings*, XII, 4, 1974, p. 375, pl. 45.

Purchase, 1969, Rogers Fund
69.115

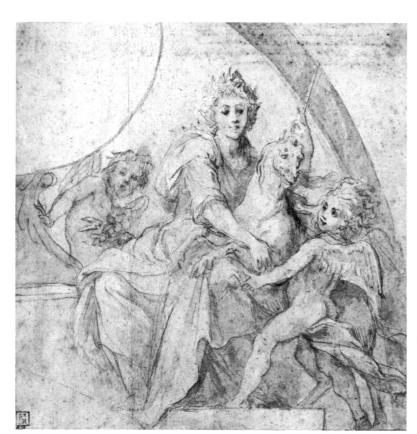

183

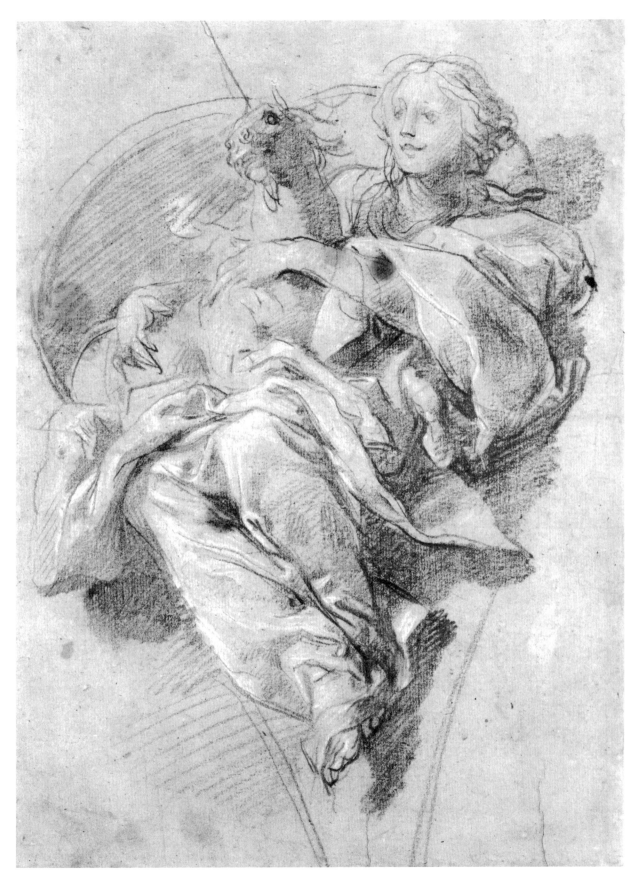

145

J. Patrick Cooney identified this drawing as a study for one of the frescoed pendentives in the chapel of St. Lucy in SS. Annunziata, Florence. He also identified a red chalk drawing of Faith in Vienna as a study for another pendentive in the chapel (Albertina, *Beschreibender Katalog*, III, 1932, no. 683). The decoration of this chapel was commissioned from Volterrano in 1650.

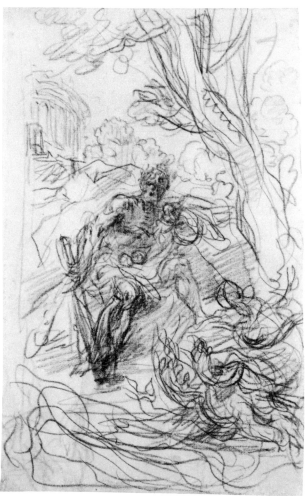

185

185. *Hercules in the Garden of the Hesperides*

Red chalk. 27.0 x 17.1 cm. Lined.

PROVENANCE: Mathias Komor (Lugt Supp. 1882a); Walter C. Baker, New York.

Gift of Walter C. Baker, 1961
61.6

The golden apples of the Hesperides that Hercules holds may allude to the *palle* of the Medici arms. A modern German inscription on the verso of the mount suggests that this is a study for Franceschini's decorations of the apartment of Vittoria della Rovere in the Palazzo Pitti, but no such composition occurs in these frescoes.

186. *Design for a Catafalque* VERSO. *Female Saint Kneeling on Clouds under an Arch, and a Design for the Pinnacle of the Catafalque*

Red chalk. 37.2 x 25.9 cm. (overall). A horizontal strip 8.2 cm. in height has been added at top, where the drawing is continued in the artist's hand.

Numbered in pencil at lower right corner, 94.

PROVENANCE: Sale, London, Christie's, March 26-27, 1974, no. 46, repr.; purchased in New York in 1975.

BIBLIOGRAPHY: Bean, 1975-1976, no. 17; S. J. Cooke in *Renaissance and Baroque Drawings from the Collections of John and Alice Steiner*, exhibition catalogue, Fogg Art Museum, Cambridge, Massachusetts, 1977, p. 100, mentioned.

Purchase, 1975, Harry G. Sperling Fund
1975.120

In the Albertina there is preserved a design by Volterrano for a sarcophagus supported by three kneeling figures, very similar to that in the present drawing. The Vienna drawing was identified by Klaus Lankheit as a study for the sarcophagus made for the canonization of St. Mary Magdalen de' Pazzi, which was celebrated in Florence in 1669 (Albertina, *Beschreibender Katalog*, III, 1932, no. 691; Lankheit, 1962, p. 43, p. 208, note 16). The final appearance of the catafalque for this *Theatrum Sacrum* is

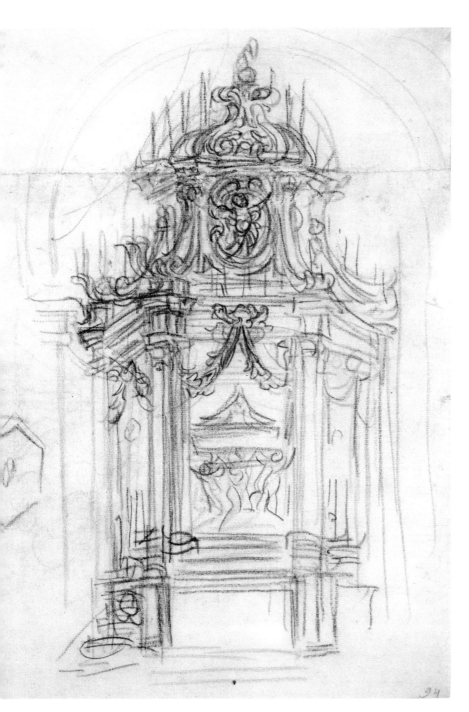

186 v. (detail)

BALDASSARE FRANCESCHINI

recorded in a print by Theodor Verkruys that illustrates Lodovico Adimari's *Prose sacre contenenti il compendio della vita di S. Maria Maddalena de'Pazzi . . . ,* Florence, 1706. There the sarcophagus is surmounted not by an elaborate architectural crown, as in the present design, but by an apparition of the saint kneeling on clouds. This solution

is in fact adumbrated in a sketch that appears on the verso of the drawing.

The sarcophagus and its architectural surround are also studied on a sheet in the Steiner collection which proposes solutions that come closer to the catafalque as executed (S. J. Cooke, *op. cit.,* no. 37, repr.).

147

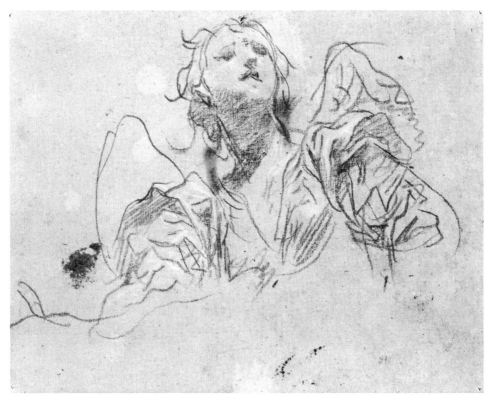

187

BALDASSARE FRANCESCHINI

187. *Half-Figure of an Angel Looking Upward*

Red chalk, on beige paper. 16.2 x 21.4 cm. Several brown stains.
Lined.

PROVENANCE: Purchased in London in 1964.

Purchase, 1964, Rogers Fund
64.197.5

188. *Studies of Architectural Moldings, of the Virgin and Child with a Kneeling Saint, and of Two Angels Supporting Frames*

Pen and brown ink, red chalk, a little black chalk. Further studies of
moldings in red chalk and pen and brown ink on verso. 28.5 x 20.7
cm.

PROVENANCE: Mrs. Richard Krautheimer.

Gift of Mrs. Richard Krautheimer, 1966
66.35

188

MARCANTONIO FRANCESCHINI

Bologna 1648 – Bologna 1729

189. *The Birth of Adonis*

Pen and brown ink, brown wash. 24.3 x 40.5 cm. Hole at right margin. Lined.

BIBLIOGRAPHY: D. Miller, *Master Drawings*, IX, 2, 1971, p. 127, pl. 8.

Gift of The Drawing Shop, 1961
61.156

Study for a small painting on copper now in the Staatliche Kunstsammlungen, Dresden (repr. D. Miller, *op. cit.*, fig. 5); in the painting the positions of the standing putto at left and of the infant Adonis at center differ from those in the drawing. Miller identifies the painting as one commissioned from Franceschini in October 1684. A reversed, red chalk copy of this drawing (and not of the painting) is in the Cabinet des Dessins at the Louvre (inv. 3292, as Filippo Lauri).

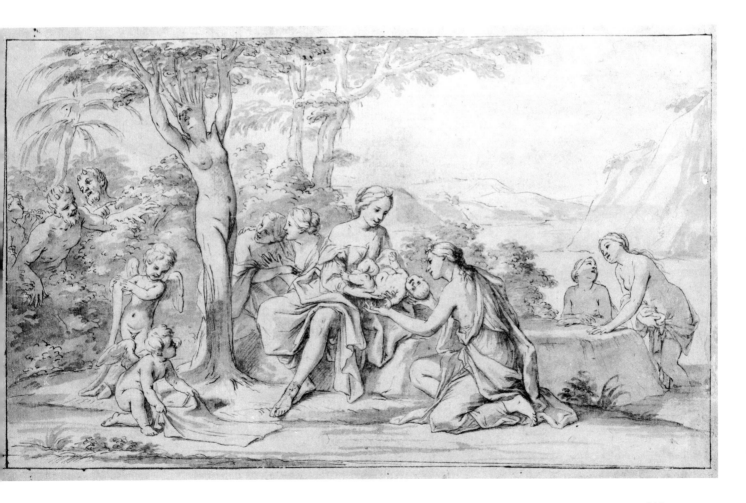

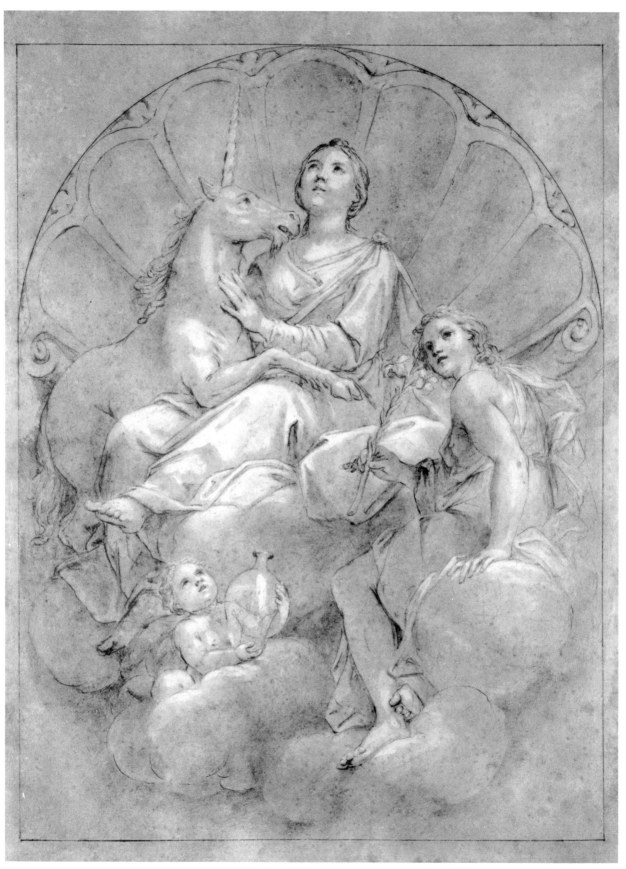

190

190. *Allegorical Figure of Purity with a Unicorn*

Pen and brown ink, gray wash, heightened with white, over black chalk, on brown-washed paper. 40.0 x 29.8 cm. Some foxing.

PROVENANCE: Purchased in London in 1963.

BIBLIOGRAPHY: Stampfle and Bean, 1967, no. 134, repr.; D. Miller, *Master Drawings,* IX, 2, 1971, p. 129.

Purchase, 1963, Rogers Fund
63.89

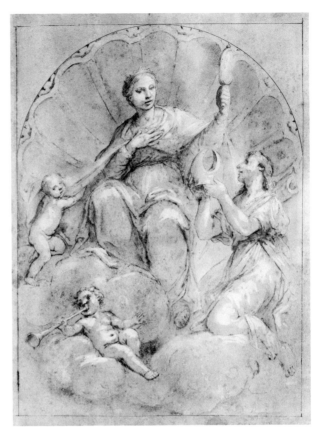

Like Nos. 191 and 192 below, a study for one of Marcantonio's now destroyed pendentives for the cathedral in Piacenza, which were finished by August 1689. Dwight Miller has published four drawings in the Davia-Bargellini Collection, Bologna, that are related to these pendentives (*Bollettino d'Arte,* XLI, 1956, pp. 318-325).

191. *Allegorical Figure of Faith*

Pen and brown ink, gray wash, heightened with white, on brown-washed paper. 39.8 x 29.8 cm. Considerable foxing.

PROVENANCE: Harry G. Sperling, New York, purchased by him in London ca. 1963.

BIBLIOGRAPHY: Stampfle and Bean, 1967, under no. 134; D. Miller, *Master Drawings,* IX, 2, 1971, p. 129.

Bequest of Harry G. Sperling, 1975
1975.131.26

See No. 190 above.

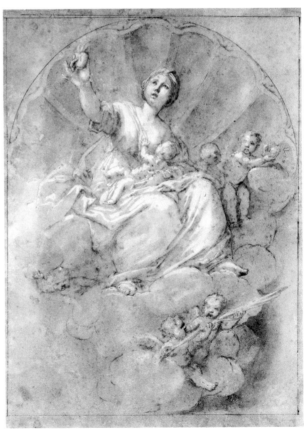

192. *Allegorical Figure of Charity*

Pen and brown ink, gray wash, heightened with white, on brown-washed paper. 40.2 x 29.8 cm. Considerable foxing.

PROVENANCE: Harry G. Sperling, New York, purchased by him in London ca. 1963.

BIBLIOGRAPHY: Stampfle and Bean, 1967, under no. 134; D. Miller, *Master Drawings,* IX, 2, 1971, p. 129.

Bequest of Harry G. Sperling, 1975
1975.131.27

This drawing and Nos. 190 and 191 above were part of a group of four studies for pendentives that were together on the London market in 1963; the present whereabouts of the fourth drawing, which represented Humility, is not known.

Another study for the Charity pendentive is at Windsor Castle (Kurz, 1955, no. 219, fig. 37).

193. *St. Lawrence Standing and Holding the Grill, Instrument of His Martyrdom*

Pen and brown ink, gray wash, heightened with white, on beige paper. Squared in black chalk. 35.6 x 19.1 cm. Lined.

Inscribed in pen and brown ink at lower left, *Francischini;* in another hand, *from vo! 1st: no. 40* (indicating the drawing's place in the Pembroke albums).

PROVENANCE: Earls of Pembroke; Pembroke sale, London, Sotheby's, July 5-6, 9-10, 1917, no. 423; sale, London, Sotheby's, November 15, 1961, no. 162; purchased in London in 1962.

Purchase, 1962, Rogers Fund
62.130.2

193

194

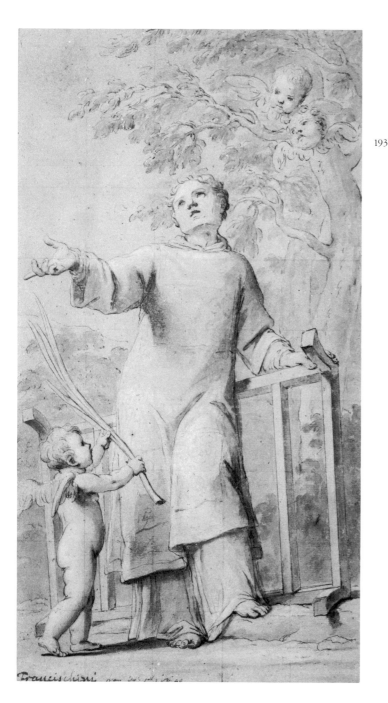

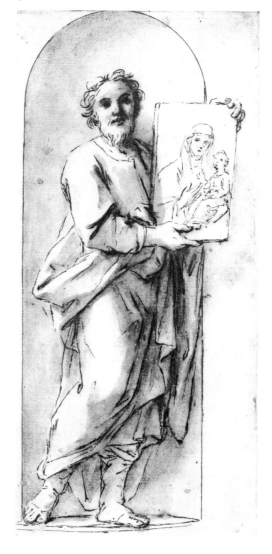

In 1963 Dwight Miller pointed out that this drawing
is a study for Marcantonio's altarpiece in the church of
S. Lorenzo, Turin. The painting, which follows the draw-
ing quite closely, is reproduced by Renato Roli who
dates it 1715 (*Pittura bolognese, 1650-1800, dal Cignani ai
Gandolfi,* Bologna, 1977, fig. 121d).

194. *St. Luke Holding a Painting*
of the Virgin and Child

Pen and brown ink, brown wash. 22.7 x 10.5 cm. Lined.

PROVENANCE: James Jackson Jarves; Cornelius Vanderbilt.

BIBLIOGRAPHY: *Metropolitan Museum Hand-book,* 1895, no. 168, as
unknown, perhaps Vanni.

Gift of Cornelius Vanderbilt, 1880
80.3.168

This drawing, formerly classed as anonymous Italian,
was attributed to Marcantonio Franceschini by Philip
Pouncey in 1965.

MARCANTONIO FRANCESCHINI,
attributed to

195. *Head of a Young Woman*

Brush and brown wash, heightened with white, over dotted contours
in black chalk. 45.9 x 35.4 cm. Made up of four pieces of paper joined
vertically and horizontally; losses at right center. Lined.

Inscribed in pen and brown ink at lower right, *Marc . . . Francischini.*

PROVENANCE: Sir Joshua Reynolds (Lugt 2364); purchased in New
York in 1966.

Purchase, 1966, Rogers Fund
66.14

The drawing was no doubt part of a cartoon. Dwight
Miller does not accept the apparently old attribution to
Marcantonio Franceschini. The artist could, however, be
Bolognese, and Lawrence Turčić points out a very strik-
ing similarity in facial type to the head of a young woman
in a drawing traditionally attributed to Carlo Cignani at
Chatsworth (repr. Roli, 1969, no. 55).

195

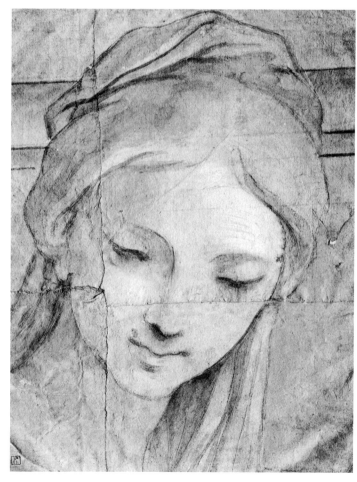

ANTON DOMENICO GABBIANI

Florence 1652 – Florence 1726

196. *Design for a Ceiling Decoration: A Gathering of Mythological Figures*

Pen and brown ink, over black chalk (recto). Faint red chalk design of a dancing satyr and two seated figures on verso. 36.0 x 29.7 cm.

PROVENANCE: Purchased in London in 1971.

BIBLIOGRAPHY: *Old Master Drawings, Yvonne Tan Bunzl,* exhibition catalogue, London, 1971, no. 21, pl. XI; Bean, 1972, no. 21.

Purchase, 1971, Rogers Fund
1971.222.1

Mina Gregori has identified this drawing as a study for a ceiling fresco by Gabbiani completed in 1697 in the Palazzo Orlandini, Florence (details repr. by L. Ginori Lisci, *I Palazzi di Firenze,* Florence, 1972, II, p. 831, and M. Mosco, *Itinerario di Firenze barocca,* Florence, 1974, p. 107). The drawing differs in many ways from the fresco, and most of the groups are reversed in the latter. In another pen study in the Uffizi (9931 F), most of the figures appear in the same direction as in the finished fresco.

197. *Flying Putto Supporting a Crown*

Red chalk. 27.0 x 18.9 cm. Repaired losses at upper left corner, and at center of left and right margins. Some foxing.

Inscribed in pen and brown ink on verso, *Gabbiani / n.º 997.*

PROVENANCE: Cephas G. Thompson.

BIBLIOGRAPHY: *Metropolitan Museum Hand-book,* 1895, no. 690, as Paolo Veronese.

Gift of Cephas G. Thompson, 1887
87.12.20

The old attribution to Gabbiani is quite acceptable, and in style the drawing may be compared to a black chalk study of a flying putto holding a sheaf of wheat in the Hessisches Landesmuseum, Darmstadt (AE 1944, from the collections of P.-J. Mariette and the Marquis de Lagoy). The Darmstadt drawing has an old attribution to Gabbiani in a hand very close to that on the verso of the present drawing.

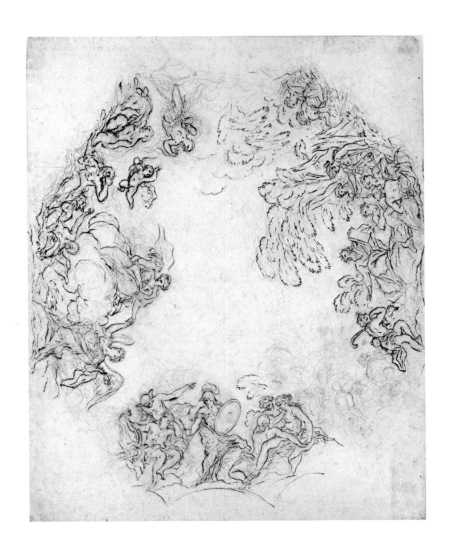

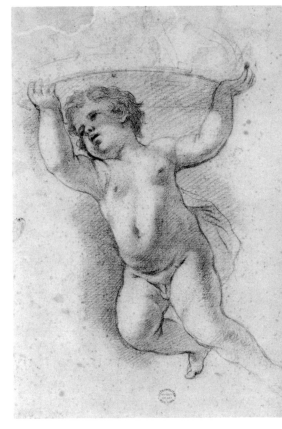

DOMENICO GARGIULO,
called Micco Spadaro

Naples 1612 – Naples 1675

198. *Sheet of Studies: A Horse Above, a Seated Man and a Reclining Man Below*

Pen and brown ink, brown and red-brown wash. 21.3 x 13.8 cm. Lower left corner replaced.

Dated on recto in pen and brown ink in shadow to right of horse, . . . *8bre 1639;* numbered at upper right on recto, 52; on verso, 25; inscribed in pencil on verso, *Franceschini.*

PROVENANCE: Don Sebastien Gabriel de Borbón y Braganza (1811-1875); Don Pedro Alcántara de Borbón y Borbón, Duke of Dúrcal (1862-1892); probably Dúrcal sale, New York, American Art Galleries, April 10, 1889, lot no. undetermined; Pratt Institute, Brooklyn; purchased in New York in 1964.

Purchase, 1964, Gustavus A. Pfeiffer Fund
64.136.7

This and No. 199 below appear to have formed part of a dismembered sketchbook containing rapid pen and wash notations of scenes of popular life. Other sheets from this sketchbook are in American collections: eight in the Cooper-Hewitt Museum, New York (1938.88.4425-4432; four of these drawings were reproduced in the catalogue of the exhibition *Baroque Painters of Naples*, Ringling Museums, Sarasota, 1961, nos. 53-56) and eight more in the National Collection of Fine Arts, Washington, D.C. (1929.7.151-158, gift of John Gellatly). Three of the drawings from the book are dated: Cooper-Hewitt 1938.88.4428 is dated *Xbre 1638* (repr. *Baroque Painters of Naples, op. cit.*, no. 55), National Collection of Fine Arts 1929.7.153, *maj. 1639,* and the present drawing, *8bre 1639.* All of the sheets are numbered at upper right; no number is repeated, and the highest is 74. All of the pages in the Cooper-Hewitt Museum and one in Washington were given to Micco Spadaro at least from the time they figured in the Dúrcal collection, and this provenance gives considerable weight to the attribution. The sheet in Washington just mentioned (1929.7.156) bears on the verso a seventeenth-century (?) inscription, *Spadaro* (Mahoney, 1977, II, fig. 3.1E). Furthermore, a sheet of red chalk sketches of low-life figures at the Cooper-Hewitt (1939.88.4437) that is close in style to the sketchbook pages, though not necessarily from the book, has an old

inscription, *m. Sp. fe:.* Though he did not know the present drawing or No. 199 below, the late Walter Vitzthum accepted the sketchbook pages at the Cooper-Hewitt and in Washington as early works by Micco Spadaro (Vitzthum, Paris, 1967, p. 24).

It is very probable that Nos. 198 and 199 came from the Dúrcal collection, but it is not possible to identify these two drawings in the catalogue of the 1889 Dúrcal sale in New York. In any case they have been in this city since at least the beginning of the century.

199. *Sheet of Studies: Three Figures Above, Studies of Horses Below*

Pen and brown ink, brown and a little red-brown wash. 21.2 x 13.7 cm. Numerous brown stains.

Numbered in pen and brown ink at upper right on recto, *51*[?]; on verso, *26.*

200

DOMENICO GARGIULO (NO. 199)

PROVENANCE: Don Sebastien Gabriel de Borbón y Braganza (1811-1875); Don Pedro Alcántara de Borbón y Borbón, Duke of Dúrcal (1862-1892); probably Dúrcal sale, New York, American Art Galleries, April 10, 1889, lot. no. undetermined; Pratt Institute, Brooklyn; purchased in New York in 1964.

Purchase, 1964, Gustavus A. Pfeiffer Fund
64.136.5

See No. 198 above.

200. *Two Standing Men*

Pen and brown ink, brown wash. 17.8 x 13.4 cm. Lined.

A pen inscription at lower margin has been canceled with pen and brown ink; inscribed on verso of old mount, *S. Rosa.*

PROVENANCE: Don Sebastien Gabriel de Borbón y Braganza (1811-1875); Don Pedro Alcántara de Borbón y Borbón, Duke of Dúrcal (1862-1892); Dúrcal sale, New York, American Art Galleries, April 10, 1889, part of no. 200, as Salvator Rosa; Henry Walters.

BIBLIOGRAPHY: Mahoney, 1977, II, p. 799, the old attribution to Salvator Rosa rejected.

Gift of Henry Walters, 1917
17.236.44

The scratchy penwork in these figure studies is close to that in Gargiulo's sketchbook sheets reproduced as Nos. 198 and 199 above. Furthermore, the inscription is canceled in the same way as that on one of the sketchbook sheets in Washington, D.C., at the National Collection of Fine Arts (1929.7.151). The latter drawing and six further sketchbook sheets in Washington (1929.7.152-155, 157-158) were all, like the present drawing, attributed to Salvator Rosa in nineteenth-century pencil inscriptions on the reverse of the old mounts. Michael Mahoney quite rightly rejects this attribution to Rosa.

This drawing is somewhat smaller than the pages of the Micco Spadaro sketchbook discussed above, and bears no characteristic page number at upper right. However, the sheet may have been trimmed down.

DOMENICO GARGIULO

201. *Two Nude Male Figures, One Seated and One Reclining*

Pen and brown ink. 13.0 x 18.9 cm. Upper left corner replaced; a number of brown stains at left.

Numbered in pen and brown ink at lower right, *9.*; inscribed in pencil on verso, *Spadaro.*

PROVENANCE: Don Sebastien Gabriel de Borbón y Braganza (1811-1875); Don Pedro Alcántara de Borbón y Borbón, Duke of Dúrcal (1862-1892); Dúrcal sale, New York, American Art Galleries, April 10, 1889, part of no. 195, as Domingo Gargiolo; Henry Walters.

Gift of Henry Walters, 1917
17.236.12

This drawing and the following fourteen pen sketches (Nos. 202-215 below) all figured in the collection of the Duke of Dúrcal under the name of Micco Spadaro. The loose, assured, and ornamental pen line of these sheets distinguishes them from the hesitant earlier drawings by Gargiulo reproduced above, and the present group must be works of the artist's maturity. Micco Spadaro was a prolific draughtsman, and pen drawings in this rapid and stylish manner are to be found in many other collections here and abroad. Walter Vitzthum identified a large group of them among the anonymous drawings in the Kupferstichkabinett in West Berlin; these come from the Pacetti collection, and one sheet found its way to the Berlin Kunstbibliothek (Vitzthum, 1971, p. 89, fig. 17; also S. Jacob, *Italienische Zeichnungen der Kunstbibliothek Berlin,* Berlin, 1975, no. 525, repr.); other drawings in this manner are in the Victoria and Albert Museum, the Cabinet des Dessins of the Louvre, the Copenhagen Print Room, the Uffizi, the Museo di Capodimonte in Naples, the National Collection of Fine Arts, Washington, D.C., the Cooper-Hewitt Museum, and the Janos Scholz collection in New York (see Vitzthum, Paris, 1967, pp. 24-25; also Stampfle and Bean, 1967, no. 103). The subjects of these drawings range from scenes of popular life to free copies after antique sculpture, and include religious compositions.

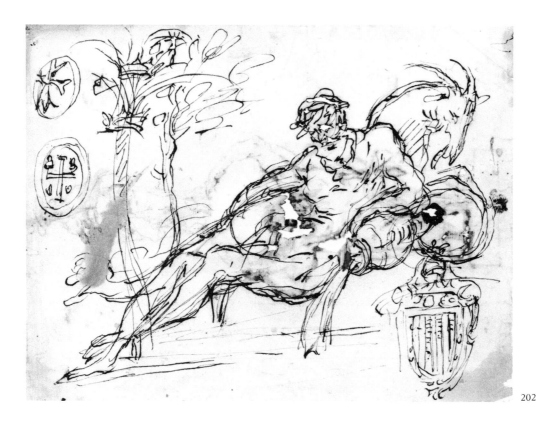

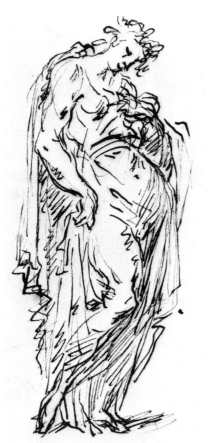

203

DOMENICO GARGIULO

202. *Reclining River God, a Goat's Head, and Studies of Heraldic Emblems*

Pen and brown ink. Pen study of cavalier standing on a globe supported by a kneeling giant on verso (this drawing visible through transparent lining). 19.6 x 26.7 cm. A number of repaired losses. Lined.

PROVENANCE: Don Sebastien Gabriel de Borbón y Braganza (1811-1875); Don Pedro Alcántara de Borbón y Borbón, Duke of Dúrcal (1862-1892); Dúrcal sale, New York, American Art Galleries, April 10, 1889, part of no. 193, as Domingo Gargiolo; Henry Walters.

BIBLIOGRAPHY: Mahoney, 1977, I, p. 148, II, fig. 3.1G.

Gift of Henry Walters, 1917
17.236.10

203. *Standing Draped Female Figure*

Pen and brown ink. 19.0 x 10.4 cm. Lined.

PROVENANCE: Don Sebastien Gabriel de Borbón y Braganza (1811-1875); Don Pedro Alcántara de Borbón y Borbón, Duke of Dúrcal (1862-1892); Dúrcal sale, New York, American Art Galleries, April 10, 1889, part of no. 193, as Domingo Gargiolo; Henry Walters.

Gift of Henry Walters, 1917
17.236.7

158

DOMENICO GARGIULO

204. *Male Figure Running*

Pen and brown ink. Three pen studies of male heads on verso. 25.6 x 18.4 cm. Upper right corner replaced; upper left corner torn off.

Inscribed in pencil on verso, *Spadaro*.

PROVENANCE: Don Sebastien Gabriel de Borbón y Braganza (1811-1875); Don Pedro Alcántara de Borbón y Borbón, Duke of Dúrcal (1862-1892); Dúrcal sale, New York, American Art Galleries, April 10, 1889, part of no. 194, as Domingo Gargiolo; Henry Walters.

Gift of Henry Walters, 1917
17.236.39

205. *Unidentified Subject: Scene of Martyrdom?*

Pen and brown ink. 24.2 x 19.1 cm. Small losses at upper right; stains at center and upper margin.

Numbered in pen and gray ink at lower left, 6.

PROVENANCE: Don Sebastien Gabriel de Borbón y Braganza (1811-1875); Don Pedro Alcántara de Borbón y Borbón, Duke of Dúrcal (1862-1892); Dúrcal sale, New York, American Art Galleries, April 10, 1889, part of no. 193, as Domingo Gargiolo; Henry Walters.

Gift of Henry Walters, 1917
17.236.6

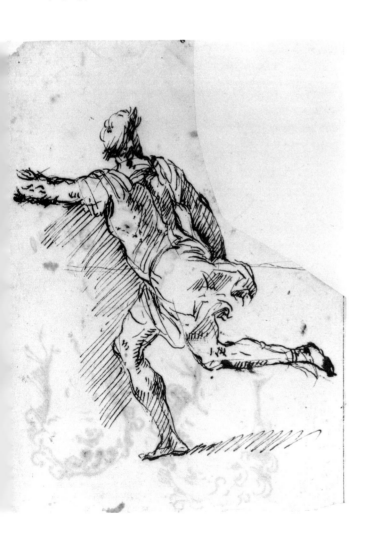

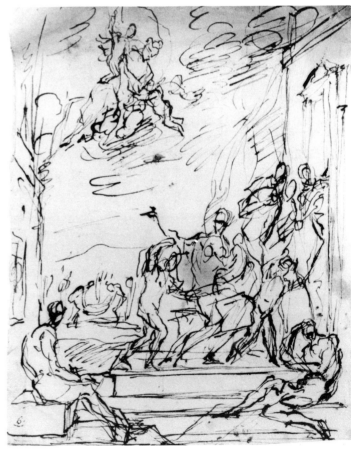

206. *Virgin and Child Appearing to St. Paul*

Pen and brown ink. 24.8 x 19.5 cm. Lower margins irregular. Lined.

PROVENANCE: Don Sebastien Gabriel de Borbón y Braganza (1811-1875); Don Pedro Alcántara de Borbón y Borbón, Duke of Dúrcal (1862-1892); Dúrcal sale, New York, American Art Galleries, April 10, 1889, part of no. 193, as Domingo Gargiolo; Henry Walters.

Gift of Henry Walters, 1917
17.236.8

207. *Nude Female Riding on a Triton's Back*

Pen and brown ink, brown wash, on brownish paper. 15.2 x 22.7 cm. Upper left corner replaced.

Inscribed in pencil on verso, *Micco Spadaro*, and *Arpino* (the latter crossed out).

PROVENANCE: Don Sebastien Gabriel de Borbón y Braganza (1811-1875); Don Pedro Alcántara de Borbón y Borbón, Duke of Dúrcal (1862-1892); Dúrcal sale, New York, American Art Galleries, April 10, 1889, part of no. 198, as Salvator Rosa; Henry Walters.

BIBLIOGRAPHY: Mahoney, 1977, II, p. 799.

Gift of Henry Walters, 1917
17.236.24

207

208. *Charioteer*

Pen and brown ink. 14.7 x 13.8 cm. Lined.

Inscribed in pencil on verso, *Spadaro*.

PROVENANCE: Don Sebastien Gabriel de Borbón y Braganza (1811-1875); Don Pedro Alcántara de Borbón y Borbón, Duke of Dúrcal (1862-1892); Dúrcal sale, New York, American Art Galleries, April 10, 1889, part of no. 194, as Domingo Gargiolo; Henry Walters.

Gift of Henry Walters, 1917
17.236.36

209. *A Crouching Man Defecating and a Standing Man Urinating*

Pen and brown ink, masking "corrections" in lighter brown ink. 15.2 x 18.4 cm.

Inscribed in pencil on verso, *Spadaro*.

PROVENANCE: Don Sebastien Gabriel de Borbón y Braganza (1811-1875); Don Pedro Alcántara de Borbón y Borbón, Duke of Dúrcal (1862-1892); Dúrcal sale, New York, American Art Galleries, April 10, 1889, part of no. 194, as Domingo Gargiolo; Henry Walters.

Gift of Henry Walters, 1917
17.236.32

210. *Standing Figure and Figures Bending Over*

Pen and brown ink, black chalk. 15.0 x 17.9 cm. Lined.

Inscribed in pencil on verso, *Spadaro*.

PROVENANCE: Don Sebastien Gabriel de Borbón y Braganza (1811-1875); Don Pedro Alcántara de Borbón y Borbón, Duke of Dúrcal (1862-1892); Dúrcal sale, New York, American Art Galleries, April 10, 1889, part of no. 195, as Domingo Gargiolo; Henry Walters.

Gift of Henry Walters, 1917
17.236.11

DOMENICO GARGIULO

211. *Abraham about to Sacrifice Isaac*

Pen and brown ink, violet wash. 13.8 x 25.6 cm.

PROVENANCE: Don Sebastien Gabriel de Borbón y Braganza (1811-1875); Don Pedro Alcántara de Borbón y Borbón, Duke of Dúrcal (1862-1892); Dúrcal sale, New York, American Art Galleries, April 10, 1889, part of no. 195, as Domingo Gargiolo; Henry Walters.

Gift of Henry Walters, 1917
17.236.13

212. *God the Father Appearing to a Kneeling Figure*

Pen and brown ink, violet wash. 13.8 x 25.7 cm.

PROVENANCE: Don Sebastien Gabriel de Borbón y Braganza (1811-1875); Don Pedro Alcántara de Borbón y Borbón, Duke of Dúrcal (1862-1892); Dúrcal sale, New York, American Art Galleries, April 10, 1889, part of no. 195, as Domingo Gargiolo; Henry Walters.

Gift of Henry Walters, 1917
17.236.14

211

212

DOMENICO GARGIULO

213. *Seated Figure Receiving an Object Presented by a Smaller Figure*

Pen and brown ink. 16.6 x 15.3 cm. Several losses (the head of the seated figure almost entirely gone). Lined.

PROVENANCE: Don Sebastien Gabriel de Borbón y Braganza (1811-1875); Don Pedro Alcántara de Borbón y Borbón, Duke of Dúrcal (1862-1892); Dúrcal sale, New York, American Art Galleries, April 10, 1889, part of no. 194, as Domingo Gargiolo; Henry Walters.

Gift of Henry Walters, 1917
17.236.51

214. *Studies of a Group of Seated Figures and of a Flying Figure*

Pen and brown ink. 19.2 x 25.3 cm. Losses at upper left and right; margins irregular. Lined.

PROVENANCE: Don Sebastien Gabriel de Borbón y Braganza (1811-1875); Don Pedro Alcántara de Borbón y Borbón, Duke of Dúrcal (1862-1892); Dúrcal sale, New York, American Art Galleries, April 10, 1889, part of no. 193, as Domingo Gargiolo; Henry Walters.

Gift of Henry Walters, 1917
17.236.9

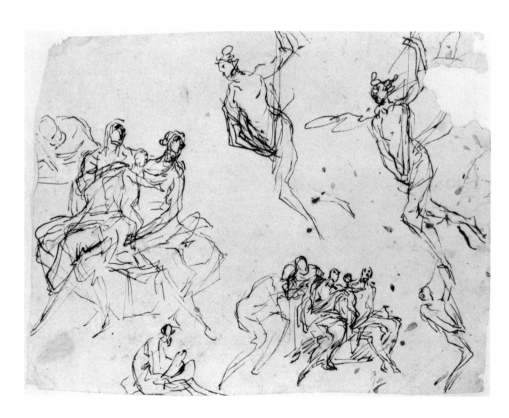

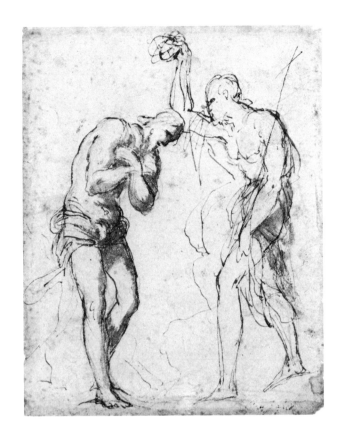

DOMENICO GARGIULO

215. *The Baptism of Christ*

Pen and brown ink, brown wash, over red chalk. Pen sketch of a kneeling figure (?) in a landscape on verso. 19.7 x 15.4 cm.

Partially effaced inscription at lower right of verso, . . . *anco*[?]; in pencil on verso *Spadaro* and *Ignoto* (the latter inscription crossed out).

PROVENANCE: Don Sebastien Gabriel de Borbón y Braganza (1811-1875); Don Pedro Alcántara de Borbón y Borbón, Duke of Dúrcal (1862-1892); Dúrcal sale, New York, American Art Galleries, April 10, 1889, probably part of no. 194, as Domingo Gargiolo; Henry Walters.

Gift of Henry Walters, 1917
17.236.31

216. *Standing Nude Putto and Study of a Helmeted Head*

Black chalk, heightened with white, on blue paper. 19.3 x 11.5 cm.

Inscribed in pencil on verso, *Micco Spadaro,* and *Cav^r Arpino* (the latter crossed out).

PROVENANCE: Don Sebastien Gabriel de Borbón y Braganza (1811-1875); Don Pedro Alcántara de Borbón y Borbón, Duke of Dúrcal (1862-1892); Dúrcal sale, New York, American Art Galleries, April 10, 1889, part of no. 197, as Domingo Gargiolo; Henry Walters.

Gift of Henry Walters, 1917
17.236.48

The old attribution to "Domingo Gargiolo" is acceptable on stylistic grounds, though the drawing is unusual in being executed in chalk. Something of the influence of the Cavaliere d'Arpino is evident here, and indeed his name has been inscribed on the reverse of the sheet and then crossed out.

LUIGI GARZI

Pistoia 1638 – Rome 1721

217. *Marcus Curtius Leaping into the Chasm*

Pen and brown ink, brown wash, heightened with white, on brownish paper (recto). Red chalk study of a seated, crowned female figure on verso. 27.7 x 42.8 cm. Lower left corner missing.

Inscribed in pen and brown ink on verso, *Luuigi* [sic] *Garzi*.

PROVENANCE: Purchased in New York in 1961.

BIBLIOGRAPHY: Sestieri, 1972, p. 108, fig. 21.

Purchase, 1961, The Elisha Whittelsey Fund
61.142

Study for a painting by Garzi now in the Glasgow Art Gallery and Museum (repr. Sestieri, 1972, p. 107, fig. 20). There are considerable variations between the drawing and painting, not only in the pose of figures, but in the architectural and landscape background.

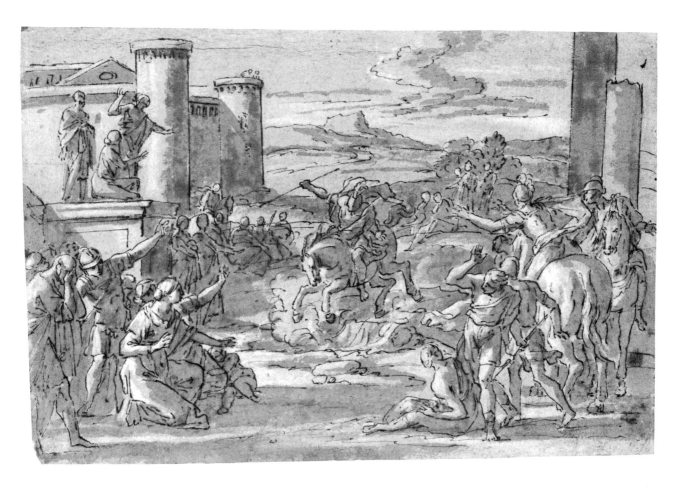

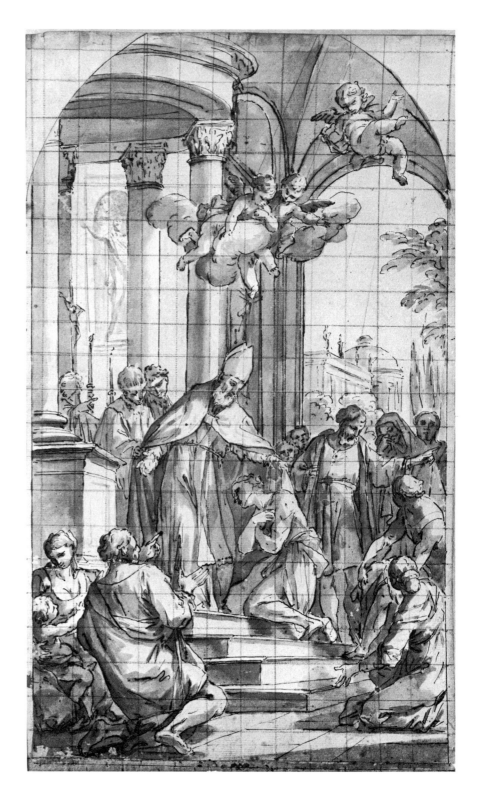

LUIGI GARZI

218. *St. Francis Renouncing
His Worldly Goods*

Pen and brown ink, brown wash. Squared in black chalk. 53.0 x 31.2 cm. Lined.

Inscribed in pencil at lower right, *Andrea Sacchi / D;* numbered in pencil at upper left, *102.*

PROVENANCE: Cephas G. Thompson.

BIBLIOGRAPHY: *Metropolitan Museum Hand-book*, 1895, no. 790, as Andrea Sacchi.

Gift of Cephas G. Thompson, 1887
87.12.120

This drawing came to the Metropolitan Museum in 1887 under the name of Garzi's master, Andrea Sacchi, and it was not until 1966 that the correct identification was supplied by Philip Pouncey. He recognized the drawing as a study for a painting by Luigi Garzi that forms part of the decoration of the Cappella di S. Francesco in S. Silvestro in Capite, Rome. The painting (repr. Sestieri, 1972, p. 97, fig. 8) differs in a number of details from this squared drawing, but it retains the arched top outlined here. Garzi supplied two lateral canvases for this chapel and painted the small cupola in fresco with a representation of St. Francis in Glory; payments for this work were made in 1695 and 1696. Pouncey also pointed out that at Holkham Hall there is a similarly large study for the other lateral canvas, which represents St. Francis Preaching (repr. Sestieri, 1972, the painting fig. 9, the drawing fig. 11).

219. *The Finding of Moses*

Pen and brown ink, brown wash, heightened with white, on gray-green paper. 26.2 x 27.8 cm. Lined.

PROVENANCE: William Bates (Lugt 2604); purchased in London in 1908.

Purchase, 1908, Rogers Fund
08.227.12

James Draper in 1968 recognized Garzi's manner in this drawing, which had previously been called anonymous. The artist painted several versions of the Finding of Moses, and in composition this drawing comes closest to a painting in the Reserves of the Uffizi, first published by Giancarlo Sestieri as the work of Garzi (Sestieri, 1972, p. 104, fig. 16; the painting had been previously attributed by Vittorio Moschini to Benedetto Luti). A red chalk drawing on blue paper in the collection of the late Herbert List (repr. *Stiftung Ratjen*, 1977, no. 89) may be related to the Uffizi painting; it differs in a number of details both from the picture and the Metropolitan's sketch. Our drawing is rather awkward in execution and may be an old copy of a design by Garzi.

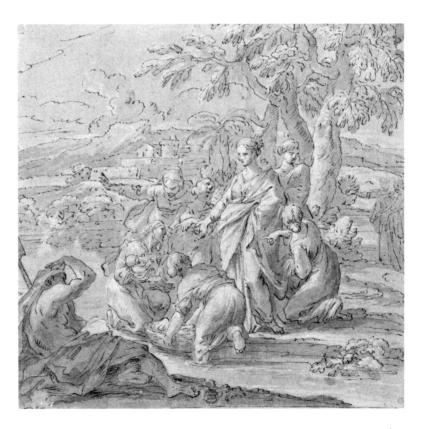

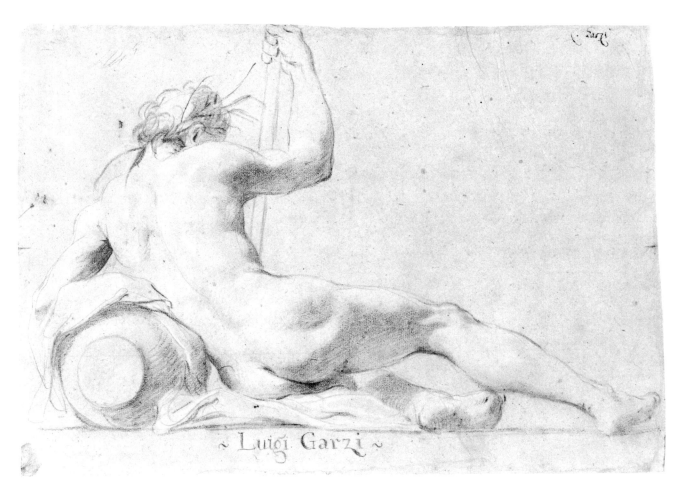

LUIGI GARZI

220. *Reclining River God*

Black chalk, heightened with white, on gray paper. 26.5 x 39.8 cm.
Lined.

Inscribed in black chalk at lower margin, *Luigi Garzi;* in pen and
brown ink at upper right corner, *L. Garzi;* in pencil on verso of old
mount, *Marquis of Aberdeen Collection.*

PROVENANCE: Marquess of Aberdeen (according to inscription on
verso of mount); purchased in New York in 1961.

Purchase, 1961, The Elisha Whittelsey Fund
61.215.1

221. *Sheet of Studies: Heads, Hands, and Doves*

Red chalk (the heads and hands) and black chalk (the doves), on blue
paper. 39.8 x 27.1 cm. Surface somewhat abraded. Lined.

Inscribed in pen and brown ink at lower right corner, *m 143.*

PROVENANCE: Purchased in London in 1966.

Purchase, 1966, Rogers Fund
66.54.2

This very Marattesque sheet of studies was on the Lon-
don market in 1966 with another similar sheet of studies
that bore an old and plausible attribution to Garzi. This
latter sheet was numbered *m 141,* while the present
drawing is numbered *m 143.* Anthony Clark pointed out
that such inventory (?) numbers preceded by a lower-case
m occur on drawings by Batoni, Cades, Ghezzi, Masucci,

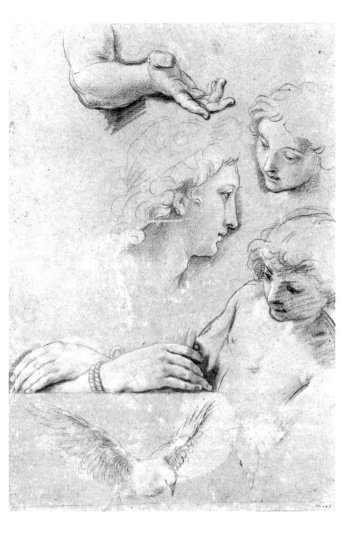

GIOVANNI BATTISTA GAULLI,
called Baciccio

Genoa 1639 – Rome 1709

222. *Allegorical Figure of Faith*

Pen and brown ink, brown wash, heightened with white, over a little black chalk, on brownish paper. 23.1 x 16.3 cm. The figure cut out in silhouette and pasted onto a sheet of brownish paper.

Inscribed in pen and brown ink at lower right corner, *il* [?] *Baciccia;* on verso of old mount, *Si da per discepolo del Cav.re Bernino.*

PROVENANCE: Count Lanfranco di Campello, Rome; purchased in London in 1965.

BIBLIOGRAPHY: M. V. Brugnoli, *Paragone,* XVII, 195, 1966, p. 72, fig. 64.

Purchase, 1965, Rogers Fund
65.131.2

The drawing was identified by Maria Vittoria Brugnoli as Gaulli's study for the figure of Faith that appears in a triangular section of the vaulting in the church of S. Marta al Collegio Romano in Rome. Gaulli was responsible for the overall design of the frescoes in the vault,

LUIGI GARZI (NO. 221)

and other eighteenth-century Roman artists; the highest number noted is *m 1014* on a drawing by Masucci. A pen study by Masucci, in the collection of the Metropolitan Museum (1972.118.12, Bequest of Walter C. Baker, 1972), for his *Education of the Virgin* in SS. Nome di Maria, Rome, is inscribed *m 231.*

GIOVANNI BATTISTA GAULLI (NO. 222)

but only executed the central tondo with St. Martha in
Glory and the Virtues in the four surrounding penden-
tives (ca. 1672). The two other tondos and the remaining
eight pendentives, including that with Faith, are said to
have been painted by Paolo Albertoni and Girolamo
Troppa (see Enggass, 1964, pp. 146-147, the frescoes
reproduced figs. 23-26). Visual evidence that Gaulli was
responsible for the design of the whole ceiling was
supplied by Maria Vittoria Brugnoli, who published a
sheet formerly in a private collection in Vienna with
sketches by Gaulli for all three of the circular compo-
sitions (*Paragone*, VII, 81, 1956, pp. 23-24, fig. 17a).
Other drawings by Gaulli for the S. Marta decorations
are in the Kupferstichkabinett in West Berlin (Dreyer,
1969, no. 78, pl. 41; no. 79).

223. *Prophets, Saints, and Music-Making Angels in Glory*

Pen and brown ink, gray wash over black chalk. 41.3 x 52.8 cm.
Vertical crease at center; losses at upper margin. Lined.

Several illegible, erased inscriptions at lower margin.

PROVENANCE: Antonio Barboza ? (collector's mark in red at lower
right corner which is close to Lugt 77); purchased in New York in
1961.

BIBLIOGRAPHY: D. Graf, *Pantheon*, XXXI, 2, 1973, p. 175, fig. 27;
Graf, 1976, I, p. 111.

Purchase, 1961, The Elisha Whittelsey Fund
61.178.1

Dieter Graf identified this drawing as a study for part of a scheme for the decoration of the cupola of S. Agnese, Piazza Navona, Rome, where Gaulli had already painted allegorical Virtues in the four principal pendentives (ca. 1666-1672). The cupola fresco, which was to represent the Virgin presenting St. Agnes to the Trinity in the presence of the Heavenly Host, was commissioned from Ciro Ferri in 1670, but it is not certain how far the project had advanced by Ferri's death in 1689. At that time Gaulli attempted to obtain the cupola commission and prepared a *bozzetto*, which is now in the Kunstmuseum, Düsseldorf (repr. Graf, *op. cit.*, 1973, p. 173), as are a number of preparatory drawings (repr. Graf, 1976, nos. 312-317). Gaulli's attempt to secure the commission was unsuccessful, and the frescoes were finished by a feeble follower of Ciro Ferri, Sebastiano Corbellini.

224. *Allegory of the Immaculate Conception*

Pen and brown ink, gray wash. Squared in black chalk. 24.7 x 15.1 cm. Lined.

Inscribed in pen and brown ink on old mount, *Baciccio.*

PROVENANCE: Sale, London, Sotheby's, December 10, 1968, no. 14, repr.; Peter Palumbo, Ascot, Berkshire.

BIBLIOGRAPHY: Edinburgh, 1972, no. 57, repr. p. 100.

Gift of Peter Palumbo, 1977
1977.13

The subject is unusual; St. Joachim kneels while God the Father appears to St. Anne and the youthful Virgin, who crushes a serpent writhing on top of a globe. No painting by Gaulli of this subject is recorded, but Lawrence Turčić points out that a very similar theme occurs in a painting by Guglielmo Cortese in S. Prassede, Rome, which Ellis Waterhouse dates 1661-1663. There, both St. Joachim and St. Anne kneel before an apparition of the girlish Virgin standing on a cresent moon, while God the Father appears above (Waterhouse, 1976, p. 69, fig. 22).

225. *Christ Giving the Host to a Holy Abbess*

Pen and brown ink, gray wash. Squared in black chalk. 39.9 x 23.3 cm. Lined.

PROVENANCE: Sale, London, Sotheby's, December 7, 1967, no. 5, repr.; purchased in London in 1968.

BIBLIOGRAPHY: Graf, 1976, I, p. 146, II, fig. 791.

Purchase, 1968, Rogers Fund
68.106.1

No painting of this subject has survived, but the style of the drawing is that of Baciccio's full maturity. Another pen and wash study for this composition, with a good many variations, was formerly in the collection of C. R. Rudolf (sale, London, Sotheby's, July 4, 1977, no. 119, repr.). Studies for the figure of Christ, for the kneeling abbess, for the angel kneeling at the right, and for the angel holding up a paten at left of center are in Düsseldorf (Graf, 1976, nos. 455-457, repr.). An old copy of the present drawing is preserved at the Metropolitan Museum (87.12.43, Gift of Cephas G. Thompson, 1887).

226. *Allegorical Composition: Music and Justice with the Spinola Arms*

Pen and brown ink, pale brown wash, heightened with white, over black chalk, on rose-washed paper. Framing lines in pen and brown ink. 19.9 x 13.5 cm. Repaired holes at upper left and lower right.

Inscribed in pencil at lower margin, *Design for the well known picture. A. Vandyck.*

PROVENANCE: Pierre-Jean Mariette (Lugt 2097); Mariette sale, Paris, 1775-1776, no. 431: "Jean-Baptiste Gauli, Un joli Sujet Allégorique, d'une composition très-agréable, où se voit la Justice, etc. fait à la plume et au bistre, rehaussé de blanc"; John Barnard (Lugt 1420); Dr. Barry Delany (Lugt 350); Lord Nathan of Churt; sale, London, Sotheby's, May 21, 1963, no. 148, as Flemish school, seventeenth century; purchased in London in 1963.

BIBLIOGRAPHY: Graf, 1976, I, p. 112.

Purchase, 1963, Rogers Fund
63.103.2

Robert Enggass pointed out in 1964 that this design was engraved in the same direction by Robert van Audenaerd, who credited Gaulli with the invention (Le Blanc, I, p. 68, no. 77). The drawing figured in the collection of P.-J. Mariette as the work of Gaulli, but at a later date Mariette's identifying cartouche was trimmed away, and the drawing acquired a fanciful attribution to Van Dyck, which it still carried when it appeared at Sotheby's in 1963. The smoking volcano in the background may be Vesuvius, and this composition, where Justice brandishes the arms of the Genoese Spinola family, could be an allegorical homage to Cardinal Giulio Spinola (created 1664) who was for a time Papal Nuncio in Naples. However, a cardinal's hat does not surmount the arms, and the allegorical allusion was perhaps intended for some other member of the Spinola family which actively patronized Gaulli.

Another design for this composition is at Düsseldorf (Graf, 1976, no. 320, repr.).

ALESSANDRO GHERARDINI

Florence 1655 – Livorno 1723

227. *Allegorical Homage to an Architect?*

Pen and brown ink, brown wash, over black chalk. Squared in black chalk. 27.0 x 19.0 cm. Lined.

Inscribed in pen and dark brown ink on banderole above medallion, *OMNIBUS UNA QUIES;* in pen and brown ink at lower left corner, *d Alessand.º Gherardini.*

PROVENANCE: Prof. John Isaacs, London (according to vendor); purchased in London in 1961.

Purchase, 1961, Rogers Fund
61.130.13

A female figure (Architecture?) is seated on a section of a fluted column and draws geometrical figures on a sheet held up by two putti. The winged and helmeted figure of *Virtù,* with the image of the sun on her breast, points upward at a portrait of an unidentified man and downward to the geometrical drawings. This may well be a design for an allegorical frontispiece, but the print does not seem to have been issued. On stylistic grounds the old attribution to Gherardini seems quite justifiable.

LUCA GIORDANO

Naples 1634 – Naples 1705

228. *The Abduction of Helen*

Pen and brown ink. 19.9 x 26.7 cm. Brown stains and a loss at lower center.

Inscribed in pencil at lower left, *Luca Giordano born 1626* [?].

PROVENANCE: Scottish private collection; purchased in London in 1977.

BIBLIOGRAPHY: Vitzthum, 1971, p. 85, pl. XXVII (with previous bibliography); Edinburgh, 1972, no. 62, repr. p. 116.

Purchase, 1977, Harry G. Sperling Fund
1977.127

On stylistic grounds the drawing may be said to antedate Giordano's departure for Spain; the line is free and meandering, rather decorative in comparison to the formal abbreviations of the drawings of Giordano's Spanish period.

229. *The Holy Trinity*

Red chalk. Faint red chalk studies of a seated female figure on verso. 26.6 x 38.4 cm. Vertical crease at center; scattered brown stains.

Inscribed in pen and brown ink at lower left corner, *L. Giordano;* on verso, *Appartiene ad Aless.º Maggiori il quale lo comprò in Roma nel 1809.*

PROVENANCE: Unidentified Neapolitan collector– the paraph *DL* in pen and brown ink at lower left also appears on No. 285 and No. 286 (Paolo de Matteis); Alessandro Maggiori (Lugt Supp. 3005b); sale, Geneva, Nicolas Rauch, June 18-19, 1962, no. 255; purchased in Zurich in 1962.

BIBLIOGRAPHY: Milkovich, 1964, no. 36, repr.; Ferrari and Scavizzi, 1966, I, p. 200, II, p. 266.

Purchase, 1962, Rogers Fund
62.129.1

Ferrari and Scavizzi consider this drawing to date from Giordano's first years in Spain.

228

229

175

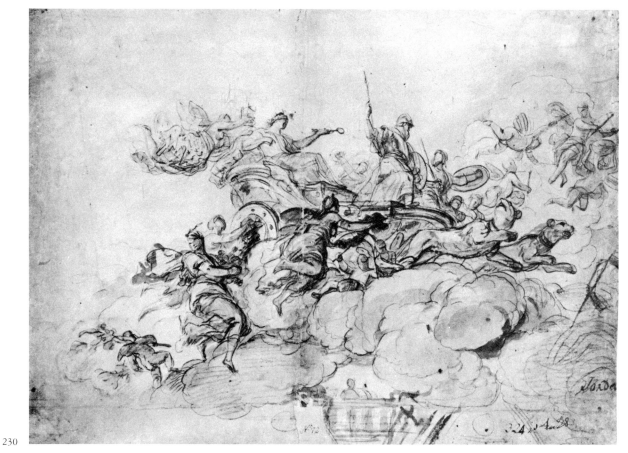

230

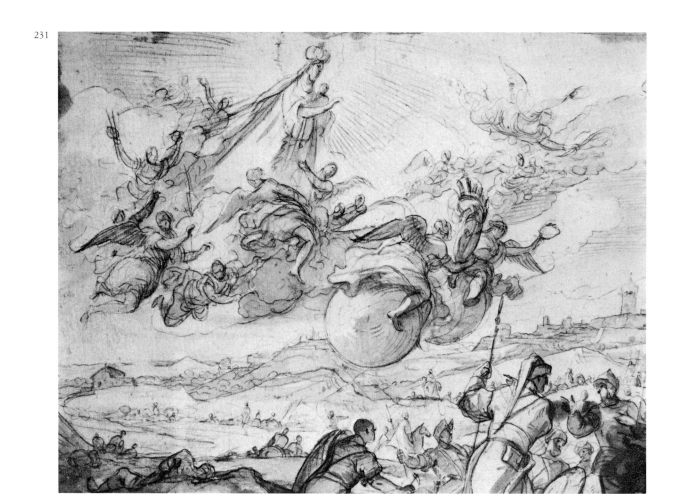

231

LUCA GIORDANO

230. *The Triumph of Cybele*

Brown wash over black chalk. 37.5 x 53.0 cm. Vertical crease just left of center; missing passage replaced at center of lower margin.

Inscribed in brush and gray wash at right margin, *Jorda . . .;* in pen and brown ink at lower margin, *N.º 72, 324P s, 4 . . . Rs* [?].

PROVENANCE: Sale, London, Sotheby's, February 27, 1963, part of no. 21, as Italian school, seventeenth century, purchased by the Metropolitan Museum.

BIBLIOGRAPHY: Bean, 1964, no. 38, repr.; Ferrari and Scavizzi, 1966, II, pp. 209, 266; Stampfle and Bean, 1967, no. 125, repr.

Purchase, 1963, Rogers Fund
63.76.4

It was Walter Vitzthum who identified this drawing as a study for part of Giordano's ceiling fresco celebrating the legend of the Order of the Golden Fleece, painted about 1697 in the Casón del Buen Retiro in Madrid (repr. Ferrari and Scavizzi, 1966, III, figs. 435-436).

231. *The Virgin Intervening during a Siege of Madrid*

Brown wash over black chalk. 26.6 x 35.6 cm. Brown stains at upper left and lower right.

PROVENANCE: Purchased in Zurich in 1962.

BIBLIOGRAPHY: Milkovich, 1964, no. 37, repr.; W. Vitzthum, *Master Drawings*, III, 2, 1965, p. 178; Ferrari and Scavizzi, 1966, I, p. 203, fig. XXXIII, II, pp. 266, 279.

Purchase, 1962, Rogers Fund
62.129.2

Walter Vitzthum pointed out that this drawing is a study for a now-lost painting by Giordano representing the Intervention of the Virgin of Atocha in a battle against the Moors, executed about 1699 for the old shrine of Our Lady of Atocha in Madrid. The standing bear attempting to climb a tree, a feature of the arms of the city of Madrid, is just discernible on the shield supported by angels above the city walls at the right in the drawing.

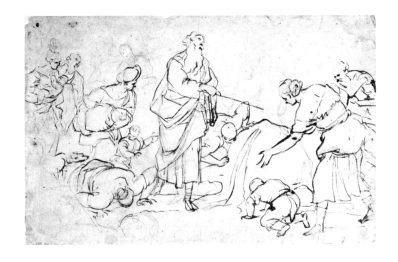

232. *Moses Striking the Rock*

Pen and brown ink, over black chalk. 25.7 x 41.2 cm. Losses at all margins. Lined.

Inscribed in pen and brown ink at lower right, *L. Gior. . . f* [?]; at lower left, *no 70*.

PROVENANCE: Purchased in London in 1967.

Purchase, 1967, Rogers Fund
67.99

233. *Prelate with Crosier Standing on a Cloud Supported by Putti*

Black chalk. 36.9 x 25.9 cm. Scattered brown stains.

Inscribed in pencil on verso, *Giordano.*

PROVENANCE: Don Sebastien Gabriel de Borbón y Braganza (1811-1875); Don Pedro Alcántara de Borbón y Borbón, Duke of Dúrcal (1862-1892); Dúrcal sale, New York, American Art Galleries, April 10, 1889, part of no. 169, as Luca Giordano; Henry Walters.

Gift of Henry Walters, 1917
17.236.21

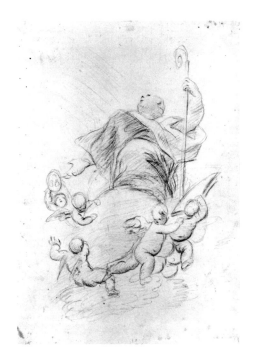

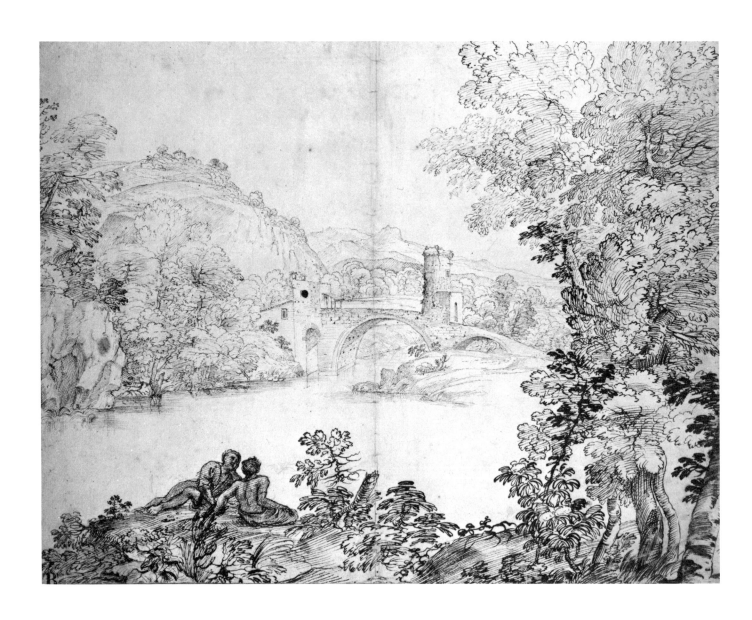

GIOVANNI FRANCESCO GRIMALDI

Bologna 1606 – Rome 1680

234. *Landscape with a Bridge and Two Figures*

Pen and brown ink, over a little black chalk. 33.8 x 44.4 cm. Vertical crease at center, several brown stains. Lined.

PROVENANCE: Unidentified English collector (Lugt Supp. 416a); purchased in London in 1962.

BIBLIOGRAPHY: Stampfle and Bean, 1967, no. 80, repr. (with previous bibliography).

Purchase, 1962, Rogers Fund
62.204.1

LUCA GIORDANO

230. *The Triumph of Cybele*

Brown wash over black chalk. 37.5 x 53.0 cm. Vertical crease just left of center; missing passage replaced at center of lower margin.

Inscribed in brush and gray wash at right margin, *Jorda . . .;* in pen and brown ink at lower margin, *N.º 72, 324P s, 4...Rs* [?].

PROVENANCE: Sale, London, Sotheby's, February 27, 1963, part of no. 21, as Italian school, seventeenth century, purchased by the Metropolitan Museum.

BIBLIOGRAPHY: Bean, 1964, no. 38, repr.; Ferrari and Scavizzi, 1966, II, pp. 209, 266; Stampfle and Bean, 1967, no. 125, repr.

Purchase, 1963, Rogers Fund
63.76.4

It was Walter Vitzthum who identified this drawing as a study for part of Giordano's ceiling fresco celebrating the legend of the Order of the Golden Fleece, painted about 1697 in the Casón del Buen Retiro in Madrid (repr. Ferrari and Scavizzi, 1966, III, figs. 435-436).

231. *The Virgin Intervening during a Siege of Madrid*

Brown wash over black chalk. 26.6 x 35.6 cm. Brown stains at upper left and lower right.

PROVENANCE: Purchased in Zurich in 1962.

BIBLIOGRAPHY: Milkovich, 1964, no. 37, repr.; W. Vitzthum, *Master Drawings.* III, 2, 1965, p. 178; Ferrari and Scavizzi, 1966, I, p. 203, fig. XXXIII, II, pp. 266, 279.

Purchase, 1962, Rogers Fund
62.129.2

Walter Vitzthum pointed out that this drawing is a study for a now-lost painting by Giordano representing the Intervention of the Virgin of Atocha in a battle against the Moors, executed about 1699 for the old shrine of Our Lady of Atocha in Madrid. The standing bear attempting to climb a tree, a feature of the arms of the city of Madrid, is just discernible on the shield supported by angels above the city walls at the right in the drawing.

232. *Moses Striking the Rock*

Pen and brown ink, over black chalk. 25.7 x 41.2 cm. Losses at all margins. Lined.

Inscribed in pen and brown ink at lower right, *L. Gior...f* [?]; at lower left, *no 70.*

PROVENANCE: Purchased in London in 1967.

Purchase, 1967, Rogers Fund
67.99

233. *Prelate with Crosier Standing on a Cloud Supported by Putti*

Black chalk. 36.9 x 25.9 cm. Scattered brown stains.

Inscribed in pencil on verso, *Giordano.*

PROVENANCE: Don Sebastien Gabriel de Borbón y Braganza (1811-1875); Don Pedro Alcántara de Borbón y Borbón, Duke of Dúrcal (1862-1892); Dúrcal sale, New York, American Art Galleries, April 10, 1889, part of no. 169, as Luca Giordano; Henry Walters.

Gift of Henry Walters, 1917
17.236.21

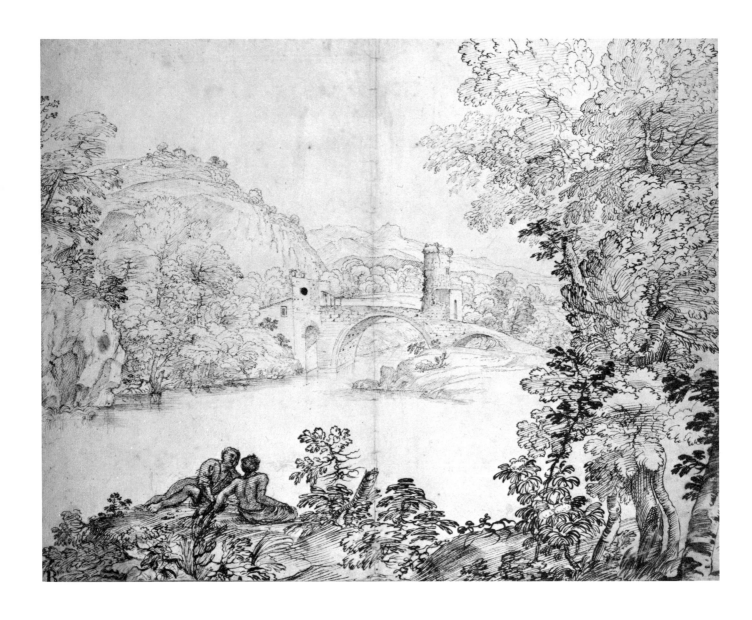

GIOVANNI FRANCESCO GRIMALDI

Bologna 1606 – Rome 1680

234. *Landscape with a Bridge and Two Figures*

Pen and brown ink, over a little black chalk. 33.8 x 44.4 cm. Vertical crease at center, several brown stains. Lined.

PROVENANCE: Unidentified English collector (Lugt Supp. 416a); purchased in London in 1962.

BIBLIOGRAPHY: Stampfle and Bean, 1967, no. 80, repr. (with previous bibliography).

Purchase, 1962, Rogers Fund
62.204.1

IL GUERCINO (Giovanni Francesco Barbieri)

Cento 1591 – Bologna 1666

235. *The Raising of Lazarus*

Pen and brown ink, brown wash. 20.0 x 27.0 cm. Considerable foxing. Lined.

PROVENANCE: Sir Peter Lely (Lugt 2092); Sir Robert Mond (Lugt Supp. 2813a); D. E. Brackley; sale, London, Sotheby's, December 1, 1966, no. 37; sale, London, Sotheby's, March 28, 1968, no. 43; purchased in New York in 1968.

BIBLIOGRAPHY: Borenius and Wittkower, p. 27, no. 103; Mahon, 1969, no. 45, repr.

Purchase, 1968, Fosburgh Fund, Inc., and Rogers Fund 68.68

Identified by Denis Mahon as one of Guercino's preparatory studies for the Louvre *Raising of Lazarus*, a painting he dates in 1619 (repr. Mahon, 1968, no. 35). Another composition study, with conspicuous differences from both this drawing and the finished painting, is in the Teyler Museum, Haarlem (no. H 45).

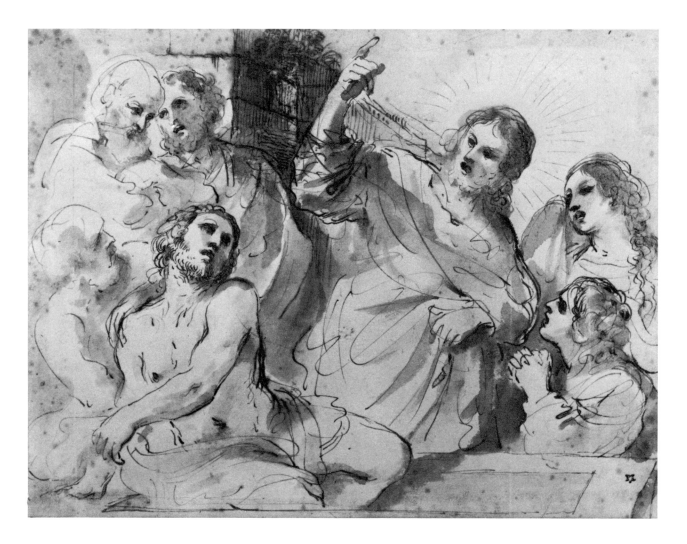

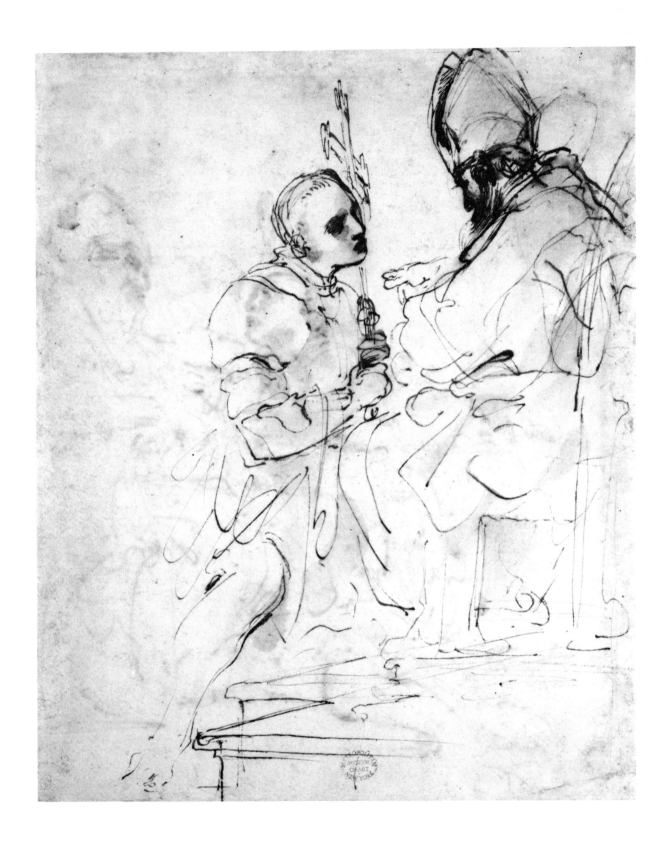

236. *Youth Kneeling before a Prelate*
VERSO. *Another Study of a Youth Kneeling before a Prelate*

Pen and brown ink. 23.5 x 19.1 cm.

PROVENANCE: William Russell (Lugt 2648); purchased in London in 1908.

BIBLIOGRAPHY: Stampfle and Bean, 1967, no. 37, repr. (with previous bibliography); Mahon, 1969, no. 63, recto and verso repr.

Purchase, 1908, Rogers Fund
08.227.29

A free sketch for the principal figures in Guercino's altarpiece representing St. William, Duke of Aquitaine, receiving the monastic habit, painted in 1620 for the church of S. Gregorio in Bologna and now in the Pinacoteca of the same city (repr. Waterhouse, 1962, fig. 96). Guercino's preparations for this justly celebrated early work are recorded in a number of composition sketches. In the painting, St. William, kneeling before St. Benedict of Aniane who is seated at the left, pulls a monastic cowl over his head; a drawing at Windsor (inv. 2475) gives this solution. In the three drawings at the Louvre (inv. 6884, 6885, 6886) and one in Frankfurt (Städel inv. 3922) St. William, kneeling or standing before the prelate, already wears the habit. On both the recto and verso of the Metropolitan sheet the kneeling saint, still clad in armor, holds a cross in hand, and this scheme is elaborated in reverse with the addition of other figures in a further Louvre drawing (inv. 6883); drawings in West Berlin (K.d.Z. 16362) and Dresden (inv. C 1913-7) show St. William, clad in armor, standing before the bishop. A complete composition study with notable variations that once belonged to Vivant Denon is now in the collection of Pierre Rosenberg, Paris. Denis Mahon has identified a number of studies for other figures and groups in this composition, including a beautiful black chalk study for the drapery of the Virgin in the Koenig-Fachsenfeld collection.

236 v.

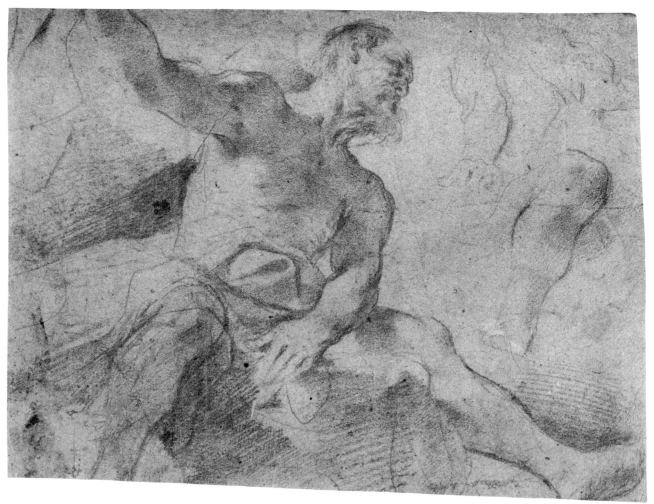

GUERCINO

237. *Seated Old Man with*
Right Arm Upraised
VERSO. *Seated Nude Youth*

Red chalk on blue paper. 23.3 x 31.7 cm. Lower margin cut diagonally; several brown stains.

PROVENANCE: Purchased in Florence in 1970.

BIBLIOGRAPHY: Mahon, 1969, p. 91; Johnston, 1971, p. 86, pl. XXIX; Bean, 1972, no. 25.

Purchase, 1970, Rogers Fund
1970.168

First recognized by Walter Vitzthum, when the drawing was on the art market in Florence in 1968, as a study for the figure of Tithonus, the aged and abandoned lover of Aurora, in Guercino's ceiling fresco in the Casino Ludovisi, Rome, which represents Aurora crossing the

182

237 v.

heavens in her chariot (repr. Waterhouse, 1962, fig. 98). The nude youth on the verso is no doubt studied for the figure of Day in a lunette below one end of the ceiling fresco (this detail repr. Mahon, 1968, fig. IV). These decorations date from the second half of 1621.

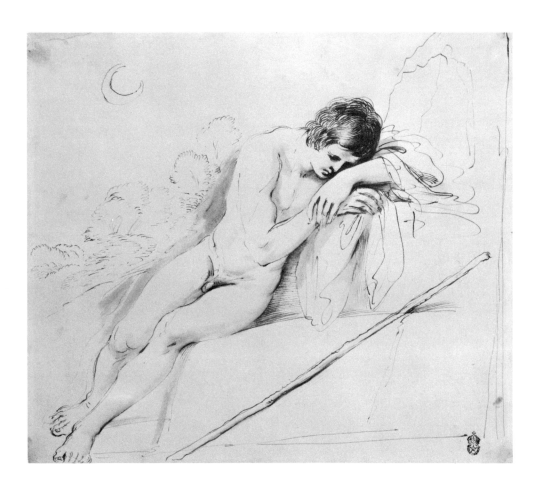

238. *Endymion Sleeping*

Pen and brown ink, brown wash. 21.1 x 24.8 cm. Lined.

PROVENANCE: 1st Earl of Gainsborough; sale, London, Christie's, July 27, 1822, lot no. uncertain; A. G. B. Russell (Lugt Supp. 2770a); purchased in New York in 1968.

BIBLIOGRAPHY: A. G. B. Russell, *Drawings by Guercino.* London, 1923, p. 34, pl. V; D. Mahon in *Omaggio al Guercino. Mostra di dipinti restaurati e dei disegni della collezione Denis Mahon di Londra,* exhibition catalogue, Cento, 1967, p. 8, note 11; J. Bean, *Metropolitan Museum of Art Bulletin,* February 1969, p. 315, repr.

Purchase, 1968, Rogers Fund
68.171

It was Denis Mahon who pointed out that this drawing is a study for the now lost "Endimione figura intera" painted for Don Antonio Ruffo of Messina, a painting that was paid for in March of 1650 (Malvasia, 1841, II, p. 331).

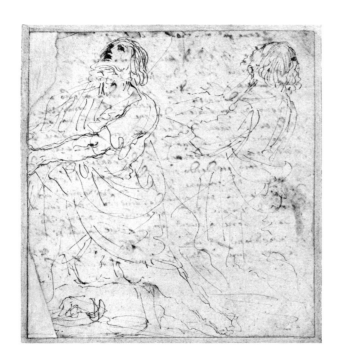

GUERCINO

239. *Two Studies of a Kneeling Male Figure*

Pen and brown ink. 17.7 x 16.9 cm. On the verso of the sheet is a letter which can be seen in transparency. Upper and lower left corners replaced. Lined.

PROVENANCE: Jonathan Richardson, Jr. (Lugt 2170); William Young Ottley (Lugt 2665); purchased in London in 1963.

Purchase, 1963, Rogers Fund
63.37

Denis Mahon has suggested that this figure may be studied for the kneeling St. Bartholomew in the 1652 *Madonna and Child with the Infant Baptist, John the Evangelist, and Bartholomew,* now in the Palazzo Rosso, Genoa (repr. N. Grimaldi, *Il Guercino,* Bologna, n.d., pl. 143). In the painting the apostle kneels like the figure at the right, and looks upward toward the enthroned Virgin. The apostle's attributes, a knife held to the chest in the right hand and a book in the left, are conspicuous features of the painting, but they do not occur in this very rough sketch.

184

240. *The Virgin Immaculate*

Pen and brown ink, brown wash. 26.0 x 12.3 cm. Lined.

PROVENANCE: MacDonald sale, near Rotherham, 1961; Dr. Jacob Bauer (according to Sotheby's); sale, London, Sotheby's, July 9, 1968, no. 30, repr., purchased by the Metropolitan Museum.

Purchase, 1968, Rogers Fund
68.172.2

Denis Mahon has identified the drawing as a study for the figure of the Virgin in Guercino's *Immaculate Conception,* now in the Pinacoteca Comunale at Ancona (repr. Marchini, 1960, p. 76). In the painting, payments for which are recorded in 1656 (Malvasia, 1841, II, p. 337), the Virgin attended by two putti glances downward, and God the Father appears above with outstretched arms.

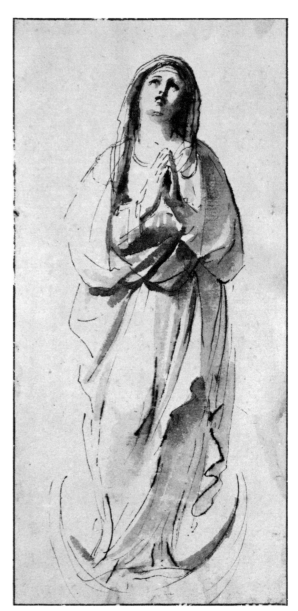

GUERCINO

241. *The Adoration of the Magi*

Pen and brown ink, brown wash. 27.1 x 34.6 cm.

PROVENANCE: Jean-Denis Lempereur (Lugt 1740); Lempereur sale, Paris, May 24, and following days, 1773, no. 173; Sir James Knowles; Knowles sale, London, Christie's, May 27, 1908, no. 145 or 146; purchased in London in 1908.

Purchase, 1908, Rogers Fund
08.227.30

On stylistic grounds this drawing may be assigned to the 1620s.

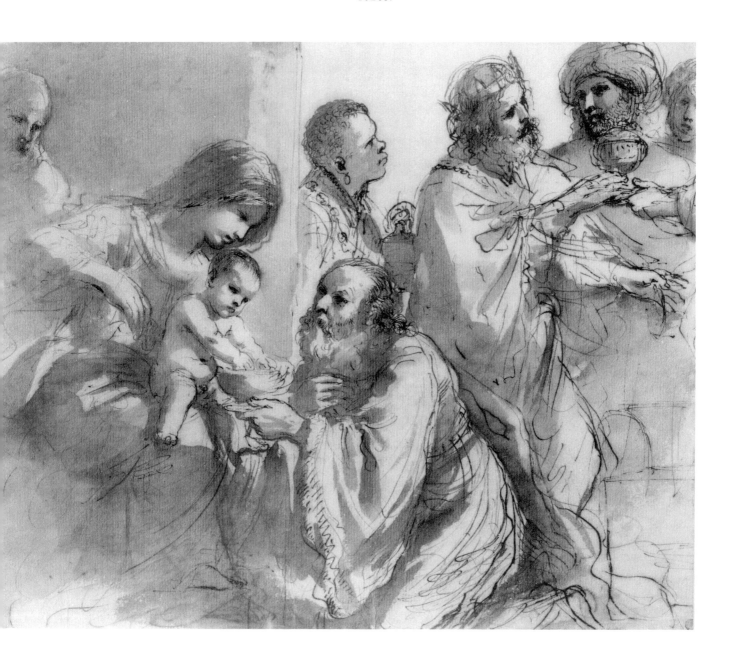

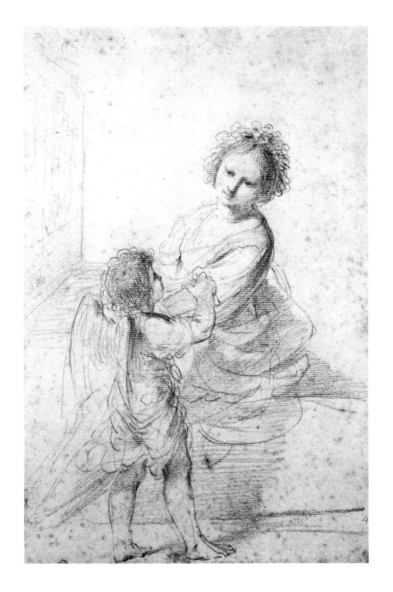

GUERCINO

242. *St. Cecilia Playing the Organ*

Red chalk. 29.0 x 19.1 cm. Lined.

PROVENANCE: Lady Lucas; sale, London, Sotheby's, June 29, 1926, no. 42; purchased in London in 1971.

BIBLIOGRAPHY: C. Rogers, *A Collection of Prints in Imitation of Drawings*, London, 1778, II, opposite p. 113 (facsimile by W. W. Ryland dated 1764, in the same direction as the drawing); Bean, 1972, no. 27.

Purchase, 1971, Rogers Fund
1971.221.1

243. *Youth in a Chariot with Attendant Young Woman*

Pen and brown ink, brown wash. 16.6 x 19.8 cm. The acidity of the ink has corroded the paper, and the heads may have been retouched in brown wash by a later hand. Lined.

PROVENANCE: James Jackson Jarves; Cornelius Vanderbilt.

BIBLIOGRAPHY: *Metropolitan Museum Hand-book*, 1895, no. 294, as Guercino.

Gift of Cornelius Vanderbilt, 1880
80.3.294

This sketch is perhaps connected with Guercino's planning for the ceiling painting in the Palazzo Costaguti, Rome, which represents the sleeping Rinaldo abducted by Armida in a chariot (Mahon, 1968, fig. VII). However, the youth in this drawing certainly does not appear to be asleep. A pen drawing in the Fitzwilliam Museum, Cambridge, has been identified by Denis Mahon as a study for the Palazzo Costaguti painting, which dates from the second half of 1621 (Mahon, 1969, no. 77, repr.). In style the Cambridge sketch is quite close to the present drawing.

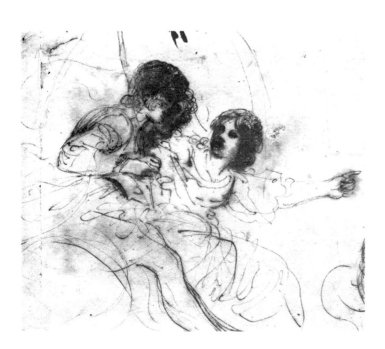

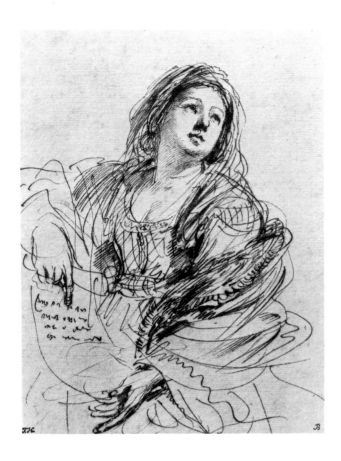

GUERCINO

244. *A Sibyl Holding a Scroll*

Pen and brown ink. 19.7 x 15.0 cm. Lined.

PROVENANCE: Thomas Hudson (Lugt 2432); Hon. Edward Bouverie (Lugt 325); J. P. Richter; purchased in London in 1912.

Purchase, 1912, Rogers Fund
12.56.11

245. *Standing Youth Holding a Bowl*

Red chalk. 26.5 x 18.9 cm. Glue stains at margins. Lined.

PROVENANCE: Hon. Edward Bouverie (Lugt 325); John, Lord Northwick; Northwick sale, London, Sotheby's, November 1-4, 1920, no. 14; sale, London, Sotheby's, March 12, 1963, no. 34, repr., purchased by the Metropolitan Museum.

BIBLIOGRAPHY: Stampfle and Bean, 1967, no. 46, repr. (with previous bibliography).

Purchase, 1963, Rogers Fund
63.75.2

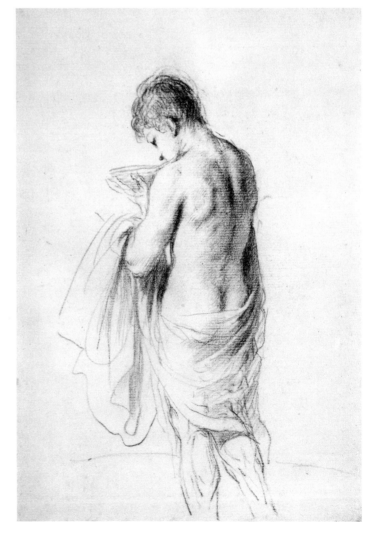

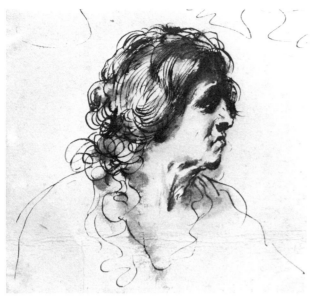

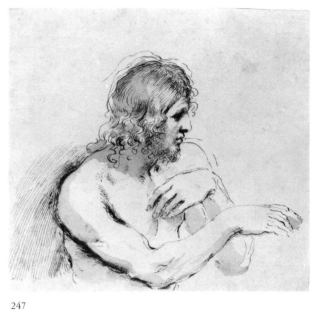

246 247

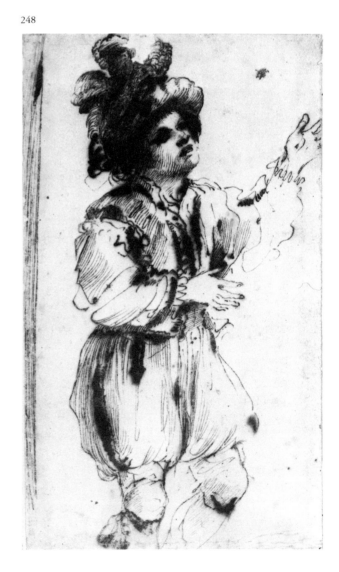

248

GUERCINO

246. *Bust of a Man Facing Right*

Pen and brown ink, brown wash. 13.7 x 15.2 cm.

Inscribed in pencil on verso of old mount, *Guercino/ B.23 – Parsons 1920.*

PROVENANCE: Dan Fellows Platt (Lugt Supp. 750a); purchased in New York in 1938.

Purchase, 1938, Harris Brisbane Dick Fund
38.179.4

247. *Half-Figure of a Nude Man Facing Right*

Pen and brown ink, brown wash. 16.2 x 18.3 cm.

Inscribed in pen and brown ink at lower left corner of "Casa Gennari" mount, *12 S Fo.* [?].

PROVENANCE: Casa Gennari (Lugt Supp. 2858c); Francesco Formi, Bologna; Hon. Edward Bouverie; Dr. A. P. McMahon, New York; Mrs. A. P. McMahon; purchased in New York in 1970.

BIBLIOGRAPHY: Bean, 1972, no. 26.

Purchase, 1970, Rogers Fund
1970.40

GUERCINO

248. *Boy Wearing a Plumed Hat, Arms Upraised*

Pen and brown ink. 19.4 x 11.1 cm. Losses at upper margin.

PROVENANCE: Walter C. Baker, New York.

BIBLIOGRAPHY: Virch, 1962, no. 31.

Bequest of Walter C. Baker, 1972

Claus Virch pointed out that what appears to be an old copy of the present drawing was in the Adrien Prachoff collection in St. Petersburg in 1906 (repr. Prachoff, 1906, pl. 46).

249. *Fireworks in a Piazza*

Pen and brown ink, brown wash. 18.5 x 26.4 cm.

PROVENANCE: Sir Charles Greville (Lugt 549); Earl of Warwick (Lugt 2600); J. P. Richter; purchased in London in 1912.

BIBLIOGRAPHY: Stampfle and Bean, 1967, no. 49, repr. (with previous bibliography); R. Roli, *I Fregi centesi del Guercino,* Bologna, 1968, pp. 75-76, pl. 24; Mahon, 1969, no. 191, repr.

Purchase, 1912, Rogers Fund
12.56.12

GUERCINO, attributed to

250. *St. Joseph with the Christ Child Holding a Flowering Rod*

Red chalk. 25.7 x 23.1 cm. Vertical ruled line in red chalk at left; considerable foxing. Lined.

PROVENANCE: James Jackson Jarves; Cornelius Vanderbilt.

BIBLIOGRAPHY: *Metropolitan Museum Hand-book*, 1895, no. 280, as Guercino.

Gift of Cornelius Vanderbilt, 1880
80.3.280

The draughtsmanship reveals certain weaknesses, but nonetheless the drawing may be autograph. Or it is an old copy of a lost drawing dating from Guercino's maturity.

251. *St. Jerome Writing*

Pen and brown ink, on brownish paper. 34.2 x 29.4 cm. (overall). A strip 2.7 cm. has been added at bottom and the design continued in the same (?) hand. Considerably abraded. Lined.

PROVENANCE: John, Lord Northwick; Northwick sale, London, Sotheby's, November 1-4, 1920, no. 16, as Guercino; Harry G. Friedman, New York.

Gift of Harry G. Friedman, 1960
60.66.9

The sheet has suffered considerably from abrasion, and the penwork has a rather mechanical quality. Nonetheless, the drawing probably emanates from the immediate circle of Guercino.

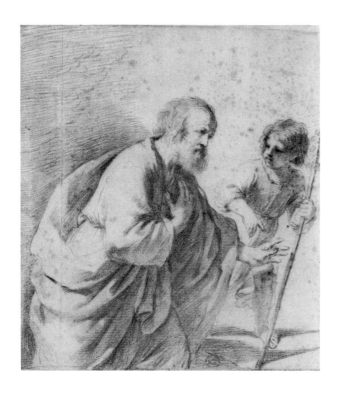

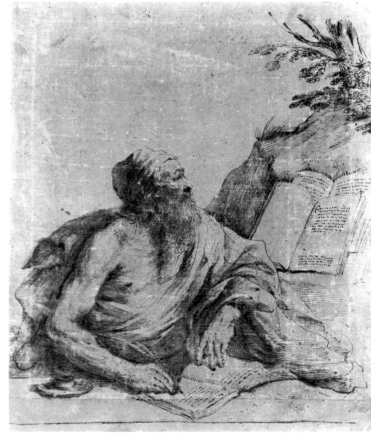

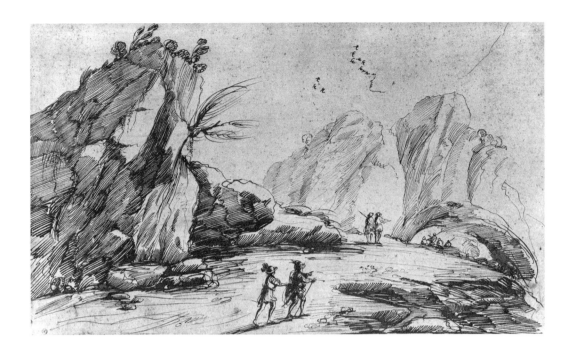

GUERCINO, imitator of

252. *Rocky Landscape with Eight Figures*

Pen and brown ink. 24.2 x 42.2. Lined.

Inscribed in pen and brown ink on reverse of old mount, *Barbieri (Giovanni Francesco) detto il Guercino né a Cento . . . Dessin acheté 20f à Paris le 25 avril 1860 . . . C. Gasc.*

PROVENANCE: Charles Gasc (Lugt 544 and 1068); James Jackson Jarves; Cornelius Vanderbilt.

BIBLIOGRAPHY: *Metropolitan Museum Hand-book*, 1895, no. 292, as Guercino.

Gift of Cornelius Vanderbilt, 1880
80.3.292

This landscape and the three following (Nos. 253-255) are typical and competent examples of the work of the forger or forgers of drawings by Guercino—especially of landscapes—who were presumably at work in Italy in the second half of the eighteenth century. All four are executed in a thick, pasty, dark red-brown ink that is the mark of such forgeries. Such drawings are sometimes direct copies after drawings by Guercino or facsimile reproductions thereof, but the four landscapes here seem rather to be *pastiches,* composite compositions utilizing motifs borrowed here and there from Guercino's landscapes.

253. *Landscape with Figures and a Two-Arched Bridge*

Pen and brown ink. 19.9 x 28.7 cm. Lined.

PROVENANCE: Commendatore Gelosi (Lugt 545); A. Donnadieu (Lugt 98).

Purchase, 1917, Harris Brisbane Dick Fund
17.97.17

253

GUERCINO, imitator of

254. *Landscape with Figures and a Farm House*

Pen and brown ink. 33.7 x 48.4 cm. Lined.

PROVENANCE: Marquis de Biron, Paris and Geneva; purchased in Geneva in 1937.

Purchase, 1937, Rogers Fund
37.165.99

255. *Landscape with Figures and Fortified Buildings*

Pen and brown ink. 35.8 x 47.3 cm. Lined.

PROVENANCE: Marquis de Biron, Paris and Geneva; purchased in Geneva in 1937.

Purchase, 1937, Rogers Fund
37.165.108

254

255

LUDOVICO LANA, attributed to

Codigoro near Ferrara 1597 – Modena 1646

256. *Allegory of Religion: God the Father above, Faith, Hope, and Charity below*

Pen and brown ink, brown and rose-brown wash, heightened with white, on brownish paper. 43.0 x 28.9 cm. The figure at upper right is on a separate sheet with irregular edges that has been pasted to the old support. Lined.

Inscribed in blue pencil on reverse of old mount, *L22-1/Lana– Modena*.

PROVENANCE: James Jackson Jarves; Cornelius Vanderbilt.

BIBLIOGRAPHY: *Metropolitan Museum Hand-book*, 1895, no. 152, as unknown, Modenese school.

Gift of Cornelius Vanderbilt, 1880
80.3.152

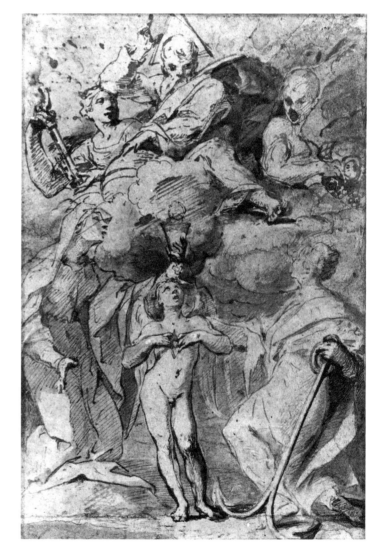

The nineteenth-century (?) attribution to Lana must be taken with a certain caution, since we have no point of reference for his style as a draughtsman. The figure types in his paintings and prints are quite different from those in this interesting drawing, which might well date from the second half of the seventeenth century. The figure style and the use of colored wash are paralleled in the work of another, later Modenese draughtsman, Sigis-mondo Caula (see No. 124 above).

The allegorical representation of Charity is unusual. The Virtue is represented as a winged, nude youth opening his chest to reveal his heart.

GIOVANNI LANFRANCO

Parma 1582 – Rome 1647

257. *Design for a Wall Decoration with the Sacrifice of Abraham and the Flight into Egypt*

Pen and brown ink, brown wash, over a little red chalk, heightened with white, on blue paper; architectural moldings above and below indicated in ruled black chalk lines. 15.9 x 40.6 cm. (overall). A piece of blue paper 9.8 cm. wide has been added at left.

Inscribed in pen and brown ink on a slip of white paper pasted to verso, *ducati 2 – | Lanfranco.*

PROVENANCE: W. Pitcairn Knowles (Lugt 2643); Dr. A. Ritter von Wurzbach-Tannenberg (Lugt 2587); purchased in Düsseldorf in 1968.

BIBLIOGRAPHY: E. Schleier, *Revue de l'Art*, VII, 1970, pp. 52-53 (with previous bibliography), figs. 9, 11.

Purchase, 1968, Walter C. Baker Gift
68.51

Identified by Eric Schleier as a project for the decoration of a section of the frieze in the Sala Regia of the Quirinal Palace. The drawing differs from the fresco, as executed by a team of artists including Agostino Tassi, Carlo Saraceni, Alessandro Turchi, and others. Lanfranco worked on this project in 1616-1617.

258. *Seated Apostles and Putti*

Red chalk. 13.1 x 24.5 cm. Lined.

Illegible inscription in pen and brown ink on verso.

PROVENANCE: Count Lanfranco di Campello, Rome; A. Branson, London (according to vendor); purchased in London in 1965.

BIBLIOGRAPHY: Stampfle and Bean, 1967, no. 33, repr.

Purchase, 1965, Rogers Fund
65.66.6

One of Lanfranco's major commissions in Naples was the painting in fresco of the rib-vaulted nave of the church of the Certosa di S. Martino. In the circular spaces along the center of the vault Lanfranco painted Christ appearing in a glory of angels, and in the triangular vaulted spaces above the windows he inserted groups of apostles, prophets, sibyls, and putti. Walter Vitzthum identified this drawing as a scheme for one of these triangular areas. The broad-based triangular composition takes into consideration the whole area to be painted, while the faint red chalk indications of a narrower triangle suggest the area of the steeply rising vault that would be visible to the viewer standing directly below.

257

258

GIOVANNI LANFRANCO

259. *The Martyrdom of the Apostle Matthias*

Pen and brown ink, brown wash, spots of red wash at upper right and left. 17.4 x 15.6 cm.

PROVENANCE: Walter Lowry, New York.

BIBLIOGRAPHY: Stampfle and Bean, 1967, no. 34, repr. (with previous bibliography).

Gift of Walter Lowry, 1956
56.219.4

Study for a fresco at the right of a window in the inner façade of SS. Apostoli, Naples. Lanfranco decorated the interior of this church with scenes of the Apostles' deaths by martyrdom. A good many preparatory drawings for this commission have survived, and at Capodimonte in Naples, Windsor Castle, and the Uffizi there are further studies for this particular scene, the Martyrdom of Matthias. See also No. 260 below.

GIOVANNI LANFRANCO

260. *Male Figure Running*

Pen and brown ink. 20.5 x 11.8 cm. Vertical and horizontal creases at center.

Numbered in pencil at lower right, *734*.

PROVENANCE: Cephas G. Thompson.

BIBLIOGRAPHY: *Metropolitan Museum Hand-book*, 1895, no. 734, as Raphael; Stampfle and Bean, 1967, under no. 34.

Gift of Cephas G. Thompson, 1887
87.12.64

261

Study for a terrified witness to the martyrdom of St. Matthias. This figure also appears, lightly indicated, at the upper right in No. 259 above, which is a study for Lanfranco's fresco of this subject in SS. Apostoli, Naples. At the Nationalmuseum in Stockholm there is a larger study for the same figure, very similar in pose, but different in technique (D 972, black and white chalk on faded blue paper; deposited at the Nationalmuseum by the Institut Tessin, Paris).

261. *The Miraculous Mass of St. Martin of Tours with the Apparition of a Ball of Fire above His Head*

Pen and brown ink. 18.2 x 10.5 cm.

Unidentified paraphs (?) in pen and brown ink at lower left and right.

PROVENANCE: King Philip V of Spain; sale, London, Christie's November 22, 1966, no. 102, as Carlo Maratta; Philip Pouncey, London; Eric Wunsch, New York.

BIBLIOGRAPHY: *Old Master Drawings. H. Schickman Gallery,* exhibition catalogue, New York, 1968, no. 15, repr.

Gift of Eric Wunsch, 1968
68.123.2

The correct attribution to Lanfranco of this drawing, which had been given in the past to Carlo Maratti, is that of Philip Pouncey. The abbreviated penwork of this drawing is typical of Lanfranco's mature, Neapolitan years; and indeed the subject, the Mass of St. Martin of Tours, would have been appropriate to the Certosa di S. Martino, where Lanfranco worked (see No. 258 above). He is not, however, recorded as having painted this subject.

262. *Putti and a Young Satyr at Play*

Red chalk. 18.7 x 25.7 cm. Vertical and horizontal creases at center; several brown stains. Lined.

Inscribed in pencil at lower left, *Lanfranco.*

PROVENANCE: Purchased in London in 1966.

Purchase, 1966, Rogers Fund
66.53.1

This drawing, which is Correggesque both in style and mood, may be a design for an engraved illustration. However, no such print seems to have been issued.

262

OTTAVIO LEONI

Rome ca. 1578 – Rome 1630

263. *Portrait of Giovanni Battista Rossa*

Black chalk, a little red and white chalk, on faded blue paper. 24.3 x 16.3 cm. A loss at lower left margin.

Inscribed in black chalk at lower left on recto, *157/aprile;* at lower center, *1620;* in pen and brown ink on verso, *Sr. Gio: Batta Rossa.*

PROVENANCE: Purchased in London in 1963.

Purchase, 1963, Rogers Fund
63.91.2

This and the following portrait (No. 264) are part of a series of more than four hundred portrait drawings that bear dates ranging from 1615 to 1629. The drawings are numbered at the lower left-hand corner; the lowest figure I have so far encountered is 6 (dated *genaio 1615*) and the highest 434 (dated *sitinbre 1629*). This numbering may be that of the enormous collection of Leoni's portrait drawings said to have belonged to Prince Borghese (Baglione, 1642, p. 321). P.-J. Mariette reported that the Borghese drawings passed to M. d'Aubigny and were sold in Paris in 1747. Mariette states that the d'Aubigny album contained a number of portraits of artists dated 1614, but 1615 is the earliest date noted in the series to which the present drawing and No. 264 belong.

Neither the subject of the present portrait nor that of No. 264 is a figure of any note at all, but then Mariette assures us that Leoni recorded a full social gamut, "depuis la tiare . . . jusqu'à la houlette."

264. *Portrait of Piermarino Bernabò*

Black chalk, heightened with white, on faded blue paper. 21.5 x 14.7 cm. Considerable foxing.

Inscribed in pen and brown ink at lower left on recto, *iio/giugno;* at lower center, *1618[?]*; on verso, *Piermarino Bernabò.*

PROVENANCE: Harry G. Sperling, New York.

Bequest of Harry G. Sperling, 1975
1975.131.34

See No. 263 above.

GIOVANNI MARIA LUFFOLI

Pesaro, notices 1665–1707

265. *Design for a Title Page*

Pen and brown ink, over red chalk. 23.3 x 14.8 cm.

Inscribed in pen and brown ink at lower left, *del Luffoli;* numbered on a sticker attached at upper left corner, *378*; inscribed on verso, *Bellis.ª*

PROVENANCE: Janos Scholz, New York; purchased in New York in 1952; transferred from the Department of Prints, 1977.

Purchase, 1952, The Elisha Whittelsey Fund
1977.311

A young ruler is shown enthroned, holding an orb in his right hand; around him are grouped, clockwise from upper right, allegorical figures of Justice, Wisdom, Charity, Magnanimity, Prudence, and Strength. An eagle with spread wings surmounts the empty cartouche.

Luffoli, recorded as a pupil of Simone Cantarini and active in Pesaro, is otherwise unknown as a draughtsman. The old attribution on the present sheet is plausible, since the scratchy but elegant penwork reflects the drawing style of his master Cantarini.

and Francis H. Dowley has suggested a connection with the artist's lost reception piece for the Roman Accademia di San Luca in 1695, which is recorded as representing "San Benedetto denudato nell'eremo." For Dowley the drawing is either an original by Luti, or a studio replica by some gifted pupil. Though the washes have faded and the white highlights may have been reworked, this rather elaborately finished drawing seems quite characteristic of Luti in style and handling.

267. *Pius V and the Ambassador of the King of Poland*

Black and red chalk, brown wash, heightened with white. 39.2 x 55.2 cm. Lined.

Inscribed in pen and brown ink on old mount, *Benedetto Luti.*

PROVENANCE: Thomas Brand Hollis; Mr. Disney and his descendants (according to Christie's); sale, London, Christie's, July 1, 1969, no. 128, repr., purchased by the Metropolitan Museum.

BIBLIOGRAPHY: Bean and Stampfle, 1971, no. 12, repr.

Purchase, 1969, Rogers Fund
69.169

The Dominican pope, St. Pius V, is here represented blessing a sample of the soil of Rome, to be taken as a relic to the King of Poland by his ambassador, who kneels before the pope. The late Anthony Clark pointed out that this elaborately finished sheet is very probably the drawn *modello* for a picture commissioned in 1712 by the master general of the Dominicans as a gift to Clement XI Albani, on the occasion of the canonization of Pius V. The picture, praised by Luti's biographer, Lione Pascoli, as "per verità superbissima" (Pascoli, 1730, p. 231), and pronounced a "chef-d'œuvre" by Dézallier d'Argenville, hung in the eighteenth century in the Palazzo Albani alle Quattro Fontane in Rome, but its present whereabouts is unknown (V. Moschini, *L'Arte*, XXVI, 1923, p. 112).

Luti has attempted an historically accurate representation of an event that took place a century and a half earlier during the reign of Pius V (1559-1565). The façade and square of St. Peter's are represented as they appeared in the 1560s; Lafreri's engraving in the *Speculum* was very possibly Luti's guide for this reconstruction. In the background, at right of upper center, may be discerned part of the dome of St. Peter's, still unfinished at Michelangelo's death in 1564.

BENEDETTO LUTI

Florence 1666 – Rome 1724

266. *St. Benedict on a Bed of Thorns*

Black chalk, brown wash, heightened with white, on brownish paper. 49.7 x 36.3 cm. Some foxing.

Numbered in pencil at lower left, 200; inscribed in pen and brown ink at lower right, *Benedetti Ludi;* on verso, *Benedetti Ludi.*

PROVENANCE: Jan Pietersz. Zoomer (Lugt 1511); Cephas G. Thompson.

BIBLIOGRAPHY: *Metropolitan Museum Hand-book*, 1895, no. 749, as Giampietro Zanotti; F. H. Dowley, *Art Bulletin*, XLIV, 1962, p. 223, fig. 16.

Gift of Cephas G. Thompson, 1887
87.12.79

The nineteenth-century attribution of this drawing to Giampietro Zanotti was based on a misreading of Zoomer's mark, *I.P.Z.*, as Zanotti's initials. The older attribution to Luti, on the other hand, is convincing,

267

BENEDETTO LUTI

268. *Portrait of a Man*

Red chalk. 42.8 x 33.2 cm. Horizontal crease at center. Lined.

Inscribed in pencil on reverse of old mount, *Marco Benefial—Autoritratto/Roma—1684—1764.*

PROVENANCE: Sale, London, Sotheby's, October 21, 1963, no. 108, as Marco Benefial; Harry G. Friedman, New York.

Gift of Harry G. Friedman, 1964
64.14

This drawing was at one time given to Benefial, but in 1964 Anthony Clark supplied the convincing attribution to Luti, suggesting that it *might* be a self-portrait.

Benedetto Luti

269

BENEDETTO LUTI

269. *Seated Nude Male Figure*

Red chalk. Slight red chalk sketch of a seated figure on verso. 53.4 x 39.8 cm. Made up of two sheets joined horizontally at center.

Inscribed in pen and brown ink at lower right, *Benedetto Luti;* on verso, *Bened.º Luti.*

PROVENANCE: Purchased in London in 1970.

Purchase, 1970, Rogers Fund
1970.108

There are comparable large chalk academies by Luti in the Uffizi, and at Christ Church, Oxford (Byam Shaw, 1976, nos. 662 and 663, pls. 377 and 376, respectively).

CARLO MARATTI

Camerano 1625 – Rome 1713

270. *Allegorical Figure of Divine Wisdom*

Red chalk. 44.7 x 36.7 cm. Lined.

Numbered in pen and brown ink at upper left, *no. 28*; inscribed on a piece of the old mount pasted onto the verso, *Carlo Maratti.*

PROVENANCE: Thomas Hudson (Lugt 2432); Sir Joshua Reynolds (Lugt 2364); Prince Wladimir Nikolaevitch Argoutinsky-Dolgoroukoff (according to inscription on verso of old mount); Alexandre Benoit, Paris (according to vendor); purchased in Paris in 1966.

BIBLIOGRAPHY: Stampfle and Bean, 1967, no. 111, repr.; Montagu, 1978, pp. 236, 339.

Purchase, 1966, Rogers Fund
66.137

During the pontificate of Clement X Altieri (1670-1676) the family palace on the Piazza del Gesù in Rome was enlarged and extensively redecorated. A major addition to the palace was the Great Hall on the *piano nobile,* and Maratti received the commission to decorate this room. Payments are recorded from 1674 to 1677 (Schiavo, pp. 98-99), but only the fresco that fills the rather long and narrow central section of the vault was executed. This central area is filled with an elaborate allegorical compo-

sition dominated by the figure of Clemency, an allusion to the name and virtue of Clement X (repr. Schiavo, pl. XXXIX). The rest of the vault – i.e. the steeply curved sections pierced by windows that run from the stucco frame of the allegory of Clemency down to the cornice – was left blank (see Schiavo, figs. 71-72), but we know from Bellori that Maratti intended to decorate these spaces. Bellori further tells us that he himself supplied Maratti with the subjects of these projected frescoes, and that the artist prepared drawings and cartoons for every part of the expanded scheme.

The undecorated portions of the vault are divided by real or feigned windows. According to Bellori's *Vita ed opera di pitture del Signor Carlo Maratti,* the four sections of the vaulting at the opposite ends of the Hall were to contain allegorical figures representing Religion, Faith, Divine Wisdom, and Evangelical Truth, respectively. The six spandrels between the windows on the two long sides of the room – three to a side – were to contain representations of Rome with the Tiber, Peace, Heroic Virtue, Europe, Africa, and Asia with America (Bellori, pp. 597-598).

In recent years some twenty-two drawings in collections here and abroad have been identified as preparatory studies by Maratti for the decoration of these spandrels; the most recent and complete listing of the drawings is supplied by Jennifer Montagu. Miss Montagu has also discovered in the Vatican Library a manuscript that gives full descriptions of the iconography of each one of the spandrel subjects. However, this text, which appears to be a scribe's copy of Bellori's original program, speaks of twelve spandrel spaces, giving to Asia and America separate spaces and allotting a fourth spandrel on the other side to a representation of Time. In spite of the miscalculation about the number of spaces available, this manuscript offers iconographic descriptions that are more complete than those in Bellori's life of Maratti.

In the Vatican text the present subject is described in the following way: "La Divina Sapienza starà sedendo stabile sopra un cubo; haverà il petto armato, e'l volto scintillante di raggi solari. Terrà nella destra il libro suggellato con li sette suggelli, di cui parla l'Apocalisse, interpretato per gli arcani della sapienza divina. Poserà l'altra mano, e'l braccio sopra un Agnello; poiche il principio della sapienza è il timore di Dio, e l'Innocenza. Sotto di essa apparirà l'Ignoranza fra' l'ombre, con un lume spento, con gli occhi chiusi, e con gli orecchi asinini" (Montagu, 1978, p. 338). On the other hand the subject is described in Bellori's *Vita* as follows:

"divina Sapienza . . . quella tiene lo scettro come gover-natrice dell' universo ed insieme il libro con i sette signacoli dell'Apocalisse continente i divini misterii, ed appresso di lei un amorino celeste in sembianza cruccioso discaccia l'Ignoranza infida" (Bellori, p. 598). The pres-ent composition involves elements mentioned in both descriptions; the lamb mentioned in the Vatican text can just be discerned at the right, and the angry putto described in Bellori's *Vita* appears at the left.

270

271. *Allegorical Figure of Peace*

Pen and brown ink, heightened with white, over red chalk, on brown washed paper (the form of the spandrel is indicated in brown wash). 24.1 x 23.1 cm. Lined.

Inscribed in pen and brown ink at upper left, *PAX;* in pen and brown ink at lower right, *N. 15.*; in pencil on reverse of old mount, *Design for a Spandril | "Peace" (Pax) | Original drawing by Domenichino.*

PROVENANCE: Sir Karl Parker; purchased in London in 1966.

BIBLIOGRAPHY: Stampfle and Bean, 1967, no. 114, repr.; Montagu, 1978, p. 340.

Purchase, 1966, Rogers Fund
66.53.3

Study for one of the projected but never executed spandrel frescoes in the Great Hall of the Palazzo Altieri. See No. 270 above. The following description of the subject is supplied in Bellori's life of Maratti: "Siegue la Pace apportato al mondo con l'umanità di Cristo, a' cui piedi gilace il Furore d'Averno incatenato; tiene ella in una mano il ramo dell'olivo e con l'altra addita un angiolo che spiega il motto: ET IN TERRA PAX" (Bellori, p. 598). This comes closer to the present drawing in iconographical terms than does the description in the Vatican manuscript, which reads: "Appresso si vedrà la Pace col caduceo in una mano; con l'altra estinguerà la face sopra un cumulo d'armi, e sotto di se terrà legato il Furore bendato, e cieco versando un vaso di sangue, fra teste tronche, e membra intrise; per simbolo dell' imperio della Chiesa fondato sù la Pace annunciata da Giesú X' po" (Montagu, 1978, p. 338).

272. *Virtue Crowned by Honor*

Pen and brown ink, over red chalk, heightened with white, on blue paper. 14.9 x 13.3 cm. Upper margin repaired. Lined.

Numbered in pen and brown ink at lower left, 9; inscribed in pencil on reverse of old mount, *La fermeté couronnée par l'Abondance;* in pen and brown ink, *1741*.

PROVENANCE: Richard Houlditch (Lugt 2214); purchased in London in 1961.

BIBLIOGRAPHY: Stampfle and Bean, 1967, no. 112, repr. (with previous bibliography); W. Vitzthum, *Burlington Magazine,* CIX, 1967, pp. 253-254; Montagu, 1978, pp. 337, 340.

Purchase, 1961, Rogers Fund
61.169

This and No. 273 below are studies for another of the projected spandrel frescoes in the Palazzo Altieri (see Nos. 270 and 271 above). The subject, *Virtue Crowned by Honor,* is elaborately described in the Vatican manuscript as "la Virtú, e l'Honore: questo giovine alato, e risplendente terrà con una mano il cornucopia, con l'altra porgerà una Corona, et un ramo di palma alla virtú; la quale si dipingerà armata con pelle di Leone sopra il capo, e con la destra mano stringerà la clava col sole à mezzo il petto, ed in terra legato il trifauce cane" (Montagu, 1978, pp. 338-339).

In the present drawing Virtue wears the lion's skin over her head, and Honor holds a cornucopia, as the text dictates. These features are missing in the second study, but there, lightly indicated in chalk at the bottom of the sheet, appears the "trifauce cane." Other studies for *Virtue Crowned by Honor* are in the Albertina in Vienna, the National Gallery of Scotland, Edinburgh, and the Academia de San Fernando, Madrid.

273. *Virtue Crowned by Honor*

Red chalk. 34.3 x 26.8 cm.

Inscribed in pen and brown ink at lower left, *Carlo Maratt.*

PROVENANCE: Sale, London, Sotheby's, December 1, 1964, no. 37, repr., purchased by the Metropolitan Museum.

BIBLIOGRAPHY: Stampfle and Bean, 1967, no. 113, repr. (with previous bibliography); W. Vitzthum, *Burlington Magazine,* CIX, 1967, p. 254; Montagu, 1978, p. 340.

Purchase, 1964, Joseph Pulitzer Bequest
64.295.1

See No. 272 above.

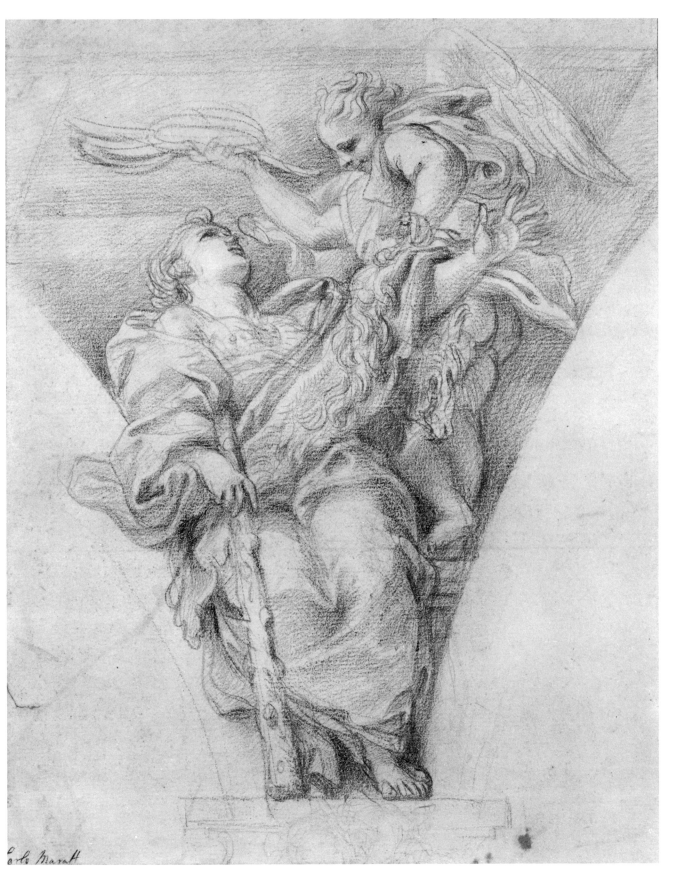

Carlo Maratt

207

CARLO MARATTI

274. *Nude Male Figures Supporting a Frame; Plan of a Ceiling*

Pen and brown ink, over black chalk. 18.9 x 25.7 cm.

PROVENANCE: Purchased in London in 1965.

BIBLIOGRAPHY: Stampfle and Bean, 1967, p. 75, under no. 114; Montagu, 1978, p. 339.

Purchase, 1965, Rogers Fund
65.206

It was in 1965 that Walter Vitzthum related the sketches on this sheet to Maratti's plan for the decoration of the vault of the Great Hall in the Palazzo Altieri; on the London market the drawing had been attributed to Pietro da Cortona. The nude male figures are studies for those that appear painted in *grisaille* and supporting the corners of the frame of the central fresco composition, the *Allegory of Clemency* (see Schiavo, pl. XXXIX). The frame of this central panel is indicated to the right, as are—in a very summary fashion—the spandrels of the vault.

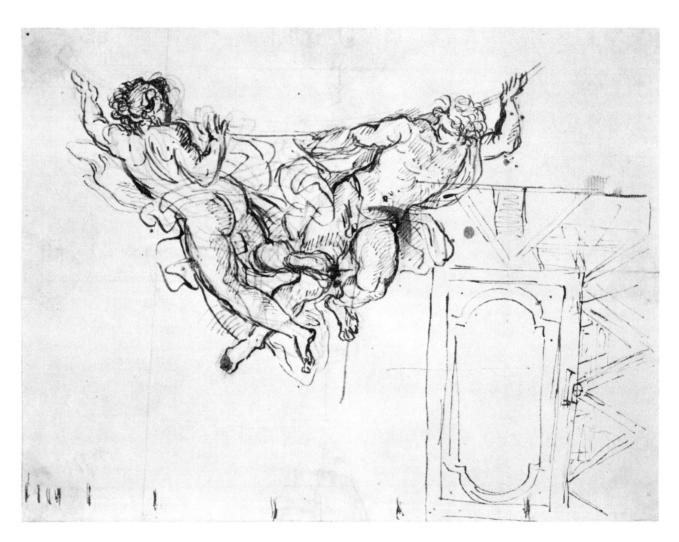

275. *Jael Slaying Sisera*

Red chalk, heightened with white, on blue paper. 22.3 x 27.2 cm. Lined.

PROVENANCE: John, Lord Northwick; Northwick sale, Sotheby's, London, November 1-4, 1920, no. 64; Henry Oppenheimer; Oppenheimer sale, London, Christie's, July 10-14, 1936, part of no. 120, purchased by the Metropolitan Museum.

BIBLIOGRAPHY: Stampfle and Bean, 1967, no. 115, repr. (with previous bibliography).

Purchase, 1936, Harris Brisbane Dick Fund
36.101.2

About 1677, Maratti was commissioned to supply cartoons for the mosaic decoration of the vault of the second bay of the left nave of St. Peter's in Rome, immediately adjacent to the chapel of the Presentation. Work on the cartoons and on the mosaics progressed slowly; the four pendentives with representations of Aaron, Noah, Gideon, and Isaiah, and the six half-lunettes representing Judith and Holofernes, Jael and Sisera, Joshua, Elijah, Moses, and Miriam were completed between 1686 and 1695. The cupola with its representation of St. John's vision of the Immaculate Conception was still unfin-

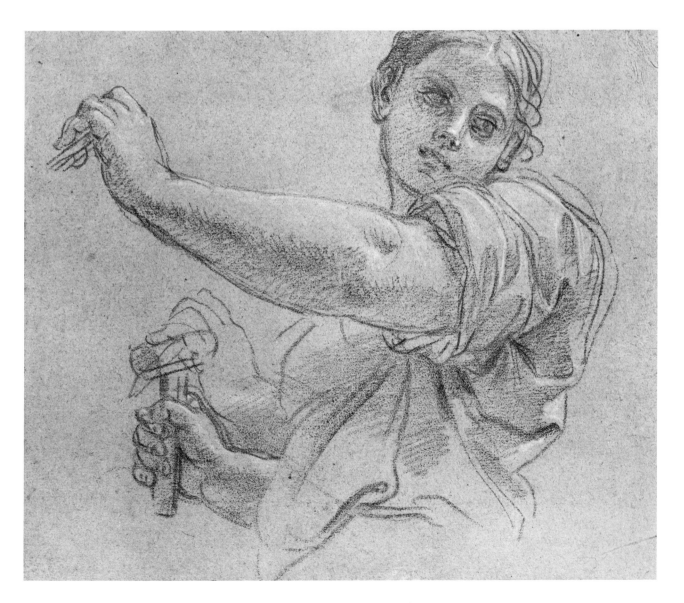

ished at Maratti's death in 1713 (Mezzetti, 1955, p. 344). The artist's cartoons for the six half-lunettes are preserved in the Loggia della Benedizione of St. Peter's. The cartoon for the Jael and Sisera composition (repr. Mezzetti, 1955, p. 288) reveals Maratti's final solution for the pose of the biblical heroine Jael: as in the present preparatory study, she holds the hammer in her right hand, but instead of holding up the tent spike in her left hand she points down at the body of the Canaanite general Sisera, whose head she has already pierced with the spike. Preparatory studies for the Jael and Sisera group, offering alternative compositional solutions, are to be found in West Berlin, Düsseldorf, the Academia de San Fernando, Madrid, in Melbourne, and at Windsor Castle.

276. *Judith Holding up the Head of Holofernes*

Pen and brown ink, over red chalk. 25.5 x 18.0 cm.

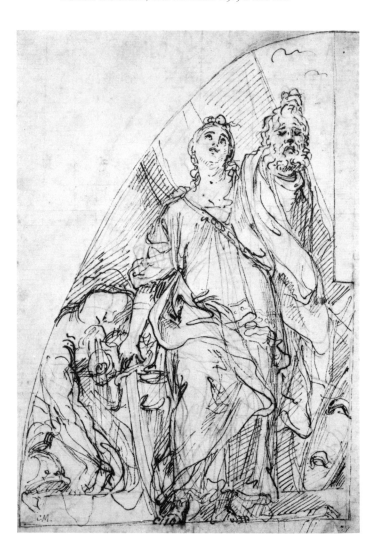

Inscribed in pencil on verso, *ch. maratte.*

PROVENANCE: Purchased in Geneva in 1962.

BIBLIOGRAPHY: W. Vitzthum, *Master Drawings*, III, 2, 1965, p. 175, pl. 37b; Stampfle and Bean, 1967, p. 76, mentioned under no. 115; Schaar, 1967, p. 117.

Purchase, 1962, Rogers Fund
62.133

Study for one of the mosaic half-lunettes in the second bay of the left nave of St. Peter's (see No. 275 above). In the finished cartoon, preserved in the Vatican, Judith looks downward at the headless body of Holofernes, which appears at the right, instead of gazing triumphantly upward as she does in this drawing. Many other studies for this composition have survived, and those at Düsseldorf and at the Academia de San Fernando in Madrid deserve particular notice.

277. *The Virgin Immaculate with Four Male Saints*

Pen and brown ink, red chalk, and a little red wash. 45.6 x 25.7 cm. Arched top, torn irregularly; slight repairs in bluish and gray wash at top of arch. Lined.

Inscribed in pen and brown ink at lower left, *C.º Maratti.*

PROVENANCE: William Mayor (Lugt 2799); C. R. Rudolf (Lugt Supp. 2811b).

BIBLIOGRAPHY: Stampfle and Bean, 1967, no. 117, repr. (with previous bibliography); Schaar, 1967, p. 126.

Purchase, 1963, Rogers Fund
63.18

For the Cybo chapel of S. Maria del Popolo in Rome, Carlo Maratti painted an altarpiece representing St. John the Evangelist, St. Gregory, St. John Chrysostom, and St. Augustine anachronistically grouped together and engaged in a discussion of the Immaculate Conception, which is symbolically represented above them. The painting was commissioned by Cardinal Alderano Cybo and was finished in 1686 (Mezzetti, 1955, p. 337, no. 110; repr. E. Lavagnino *et al., Altari barocchi in Roma,* Rome, 1959, p. 159).

In the finished painting St. John the Evangelist stands at the left, his right hand raised, while with his left he points to the open book held by the seated figure of St.

Gregory. Composition drawings that differ in many ways from the painting are preserved at Chatsworth, the Uffizi, the Academia de San Fernando, Madrid, at Düsseldorf and the Pierpont Morgan Library. The composition of the Morgan Library drawing is reversed in a red chalk drawing in the *Codice Resta* in the Ambrosiana, Milan, described by Resta himself as a copy by a certain Giuseppe Macagno after an original (*modello?*) by Maratti (repr. G. Bora, *I disegni del Codice Resta*, Milan, 1976, no. 250). Studies for individual figures in the altarpiece are in the British Museum, the Berlin Print Room, the Kunstmuseum at Düsseldorf, the Biblioteca Nacional, Madrid, and in the collection of Sir John Pope-Hennessy.

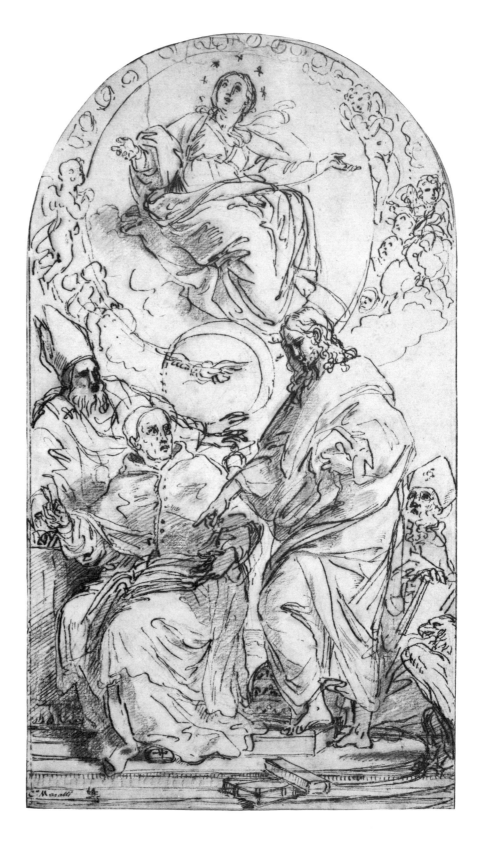

278. *The Virgin Immaculate and Four Male Saints*

Red chalk on beige paper. 36.5 x 20.7 cm.

PROVENANCE: Hereward Lester Cooke, Washington, D.C.; purchased in Washington in 1962.

BIBLIOGRAPHY: Blunt and Cooke, 1960, p. 56, mentioned under no. 286; Stampfle and Bean, 1967, p. 76, mentioned under no. 117; Schaar, 1967, p. 126.

Purchase, 1962, Rogers Fund
62.137

Another study for the altarpiece of the Cybo chapel, S. Maria del Popolo, Rome; see No. 277 above. The composition proposed here, with St. John the Evangelist pointing with his right hand to the book held by the seated St. Gregory on the left, is reversed with some changes in a red chalk composition sketch at Chatsworth (no. 569; Courtauld Institute neg. B 62/1059A).

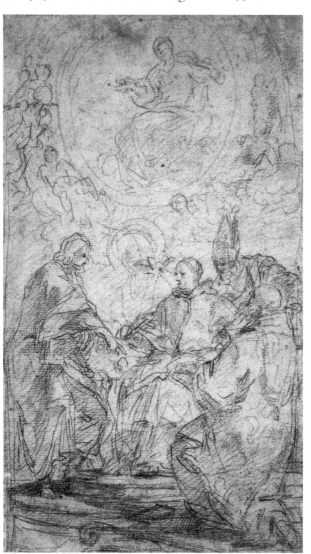

279. *The Virgin and St. Rosalia Interceding with Christ*

Pen and brown ink, over black chalk. 26.2 x 22.7 cm. Lined.

Inscribed in pen and brown ink at lower right border of the Mariette mount, *In disegni N. 130.*

PROVENANCE: Pierre-Jean Mariette (Lugt 2097), the cartouche on the Mariette mount inscribed, *CAROLUS MARATTA;* purchased in New York in 1961.

Purchase, 1961, The Elisha Whittelsey Fund
61.212.2

Christ, the Virgin, and St. Rosalia appear grouped in much the same way at the upper left in a drawing, also attributed to Maratti by P.-J. Mariette, preserved in the Cabinet des Dessins of the Louvre (inv. 3356, as Maratti). This compositional study represents St. Rosalia interceding for the city of Palermo. A flying angel with a sword (just discernible at the lower right margin of the present sketch) drives off figures of War and Pestilence. Protection is also invoked against earthquakes, symbolized by a subterranean god derived from Raphael. A view-plan of Palermo and its harbor with Mount Pellegrino appears in the left background of the Louvre design, which must be the project for a major altarpiece. There is no record of such a commission, which would have presumably come from Palermo. For that city, however, Maratti did, in the 1690s, paint a *Madonna del Rosario* for the Oratorio di S. Zita (Mezzetti, 1955, p. 331, no. 84) that has no connection with the composition in the Louvre drawing. Prince Maffeo Barberini commissioned from Maratti a painting for the church at Palestrina near Rome, representing St. Rosalia interceding for the plague-stricken of that town in 1656 (now in Florence, Corsini collection; Mezzetti, 1955, p. 323, no. 40); again the composition is quite different from that in the Louvre drawing.

Domitilla d'Ormesson calls attention to two drawings in Düsseldorf (FP 2044 and FP 2217), traditionally and convincingly attributed to Maratti's Palermitan disciple, Giacinto Calandrucci. These represent St. Rosalia interceding for Palermo and include some of the elements of the Louvre composition, notably the view of Palermo and the Raphael-inspired earthquake god. The Düsseldorf drawings are rather coarse in execution, and they lack the brilliance of the penwork of the Louvre

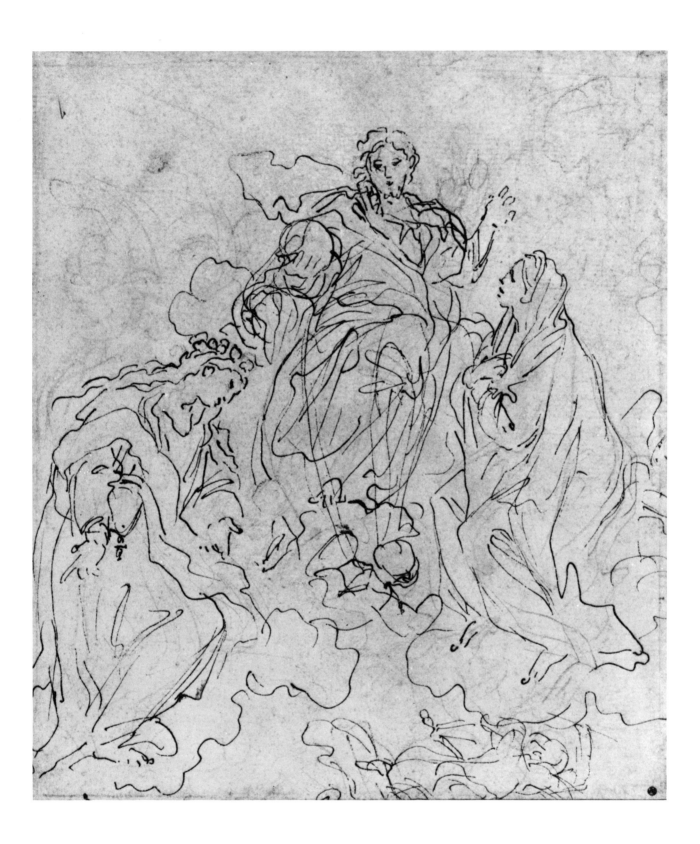

drawing and the present sketch. If the latter are the work of Calandrucci, they show him in an exceptionally brilliant and entirely Marattesque vein. We can find no trace of a painting of this subject by Calandrucci, and indeed the Düsseldorf drawings may be derivations from a scheme elaborated by Maratti.

280. *Allegory of the Old and New Dispensations*

Pen and brown ink, over black and red chalk, heightened with white, on beige paper. 30.2 x 21.1 cm. Lined.

PROVENANCE: Purchased in London in 1967.

BIBLIOGRAPHY: P. Dreyer, *Master Drawings,* VII, 1, 1969, pp. 24-25, pl. 12; Blunt, 1971, p. 96, under no. 290.

Purchase, 1967, Rogers Fund
67.95.10

Peter Dreyer identified this late drawing by Maratti as that reproduced in reverse by Giovanni Girolamo Frezza in an engraving dated 1708. A dry replica of the present drawing is in the Royal Collection at Windsor Castle (Dreyer, *op. cit.,* pl. 13). Dreyer published the Windsor drawing as an original by Maratti, but Anthony Blunt suggests that it is an old copy of the Metropolitan's sheet.

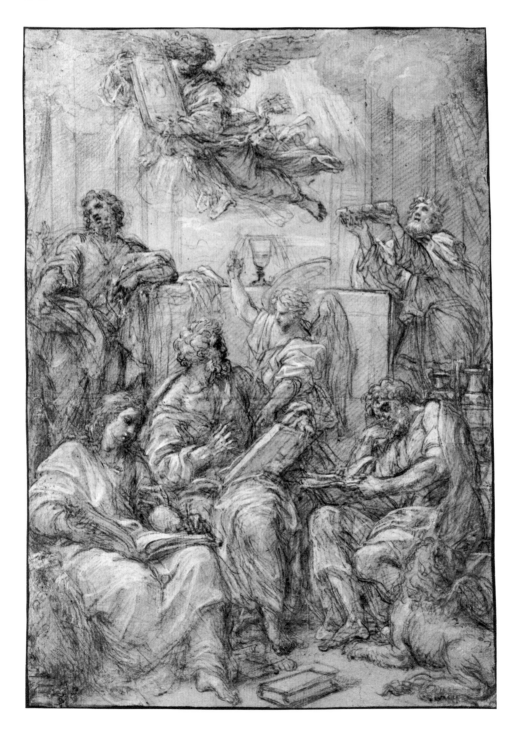

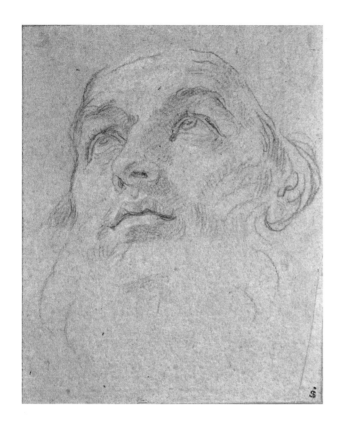

CARLO MARATTI

281. *Head of a Bearded Man Looking to Upper Left*

Red chalk on blue paper. 20.2 x 16.3 cm. Lower right corner replaced.

Inscribed in red ink at lower margin of old mount, *Carlo Maratti;* numbered in pen and brown ink on reverse of old mount, *G/n.º 52.*

PROVENANCE: Earl Spencer (Lugt 1531); Spencer sale, London, T. Philipe, June 10-17, 1811, part of no. 454; purchased in London in 1963.

BIBLIOGRAPHY: *Old Master Drawings. W. R. Jeudwine,* exhibition catalogue, London, 1963, no. 12.

Purchase, 1963, Rogers Fund
63.98.2

Study for the head of St. Ambrose in an altarpiece representing the Virgin with Sts. Francis of Sales, Nicholas of Myra, and Ambrose, painted by Maratti during a visit to the Marches in 1672 and intended for the high altar of S. Nicola in Ancona (Mezzetti, 1955, p. 318, no. 10). This altarpiece is now in the Pinacoteca Comunale, Ancona (repr. Marchini, 1960, p. 84).

CARLO MARATTI, attributed to

282. *The Virgin Appearing to Four Male Saints*

Pen and brown ink, gray wash, over red chalk. 25.0 x 15.0 cm. Lined.

Inscribed in pen and brown ink on recto of old mount, *Carlo Maratti;* in Richardson's hand on the reverse of the old mount, *Study for the Imaculate Conception, the Great Altarpiece of the Chappel of Card. Alder ano Cibo in y Ch of the Madonna del Popolo. The Picture was finish'd 1686. when Carlo was 61 y. old.*

PROVENANCE: Jonathan Richardson, Jr. (Lugt 2170 and 2997); A. P. Story (according to Sotheby's); sale, London, Sotheby's, December 1, 1964, no. 131, repr., purchased by the Metropolitan Museum.

Purchase, 1964, Joseph Pulitzer Bequest
64.295.2

An eighteenth-century owner of this drawing, Jonathan Richardson, Jr., suggested that it is a study by Maratti for the altarpiece of the Cybo chapel in S. Maria del Popolo, Rome (see Nos. 277 and 278 above). However,

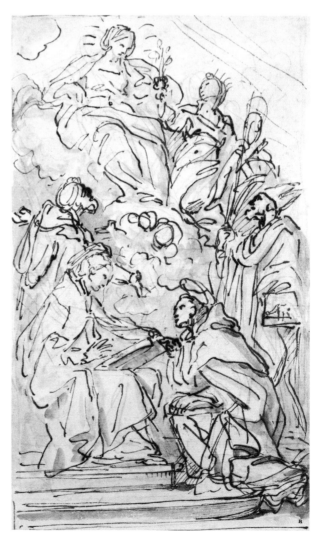

CARLO MARATTI, attributed to (NO. 282)

one of the principal figures in the Cybo composition is St. John the Evangelist, and he is absent here. The four male participants – two prelates standing, another seated, and a monastic saint kneeling – bear no particular similarity to the Doctors of the Church in the altarpiece. In the latter, the Immaculate Virgin appears above, while here she is attended by a kneeling female saint holding up a branch. Furthermore, the drawing does not bear much stylistic resemblance to Maratti's many studies for the Cybo altar, and this sketch may indeed be the work of some close follower of Maratti.

CARLO MARATTI, circle of

283. *Rome and the Tiber Doing Homage to a Pope*

Pen and brown ink, brown wash, heightened with white, over black chalk, on beige paper. 23.4 x 16.0 cm. Lined.

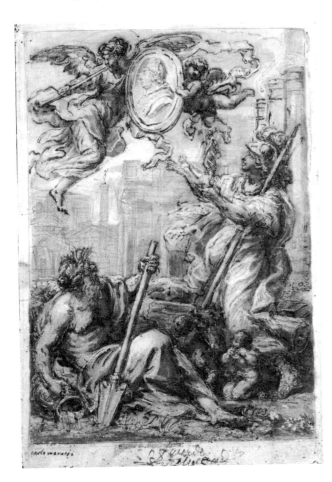

Inscribed in pen and brown ink at lower left, *carlo maratti;* illegible inscription in pen and brown ink at lower center.

PROVENANCE: Janos Scholz, New York; purchased in New York in 1949; transferred from the Department of Prints, 1977.

Purchase, 1949, The Elisha Whittelsey Fund
1977.312

Rome garbed as Minerva and holding a figure of Victory on an orb stands at the right, and the river god Tiber with Romulus and Remus reclines at left. The pope portrayed in the medallion may be Clement XI Albani, one of Maratti's patrons. The sheet appears to be a design for an engraving, but the print does not seem to have been executed. The draughtsmanship, though Marattesque, is somewhat awkward, dry, and impersonal; it is not at present possible to assign the sheet to any specific Maratti pupil or assistant.

FRANCESCO DI MARIA

Naples 1623 – Naples 1690

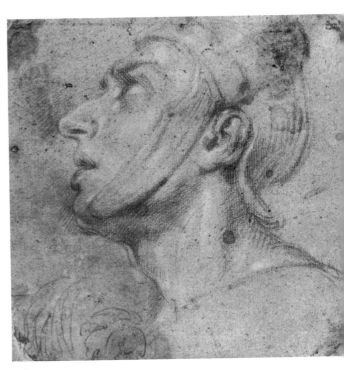

284

216

284. *Head of a Man Wearing a Helmet, Looking to Upper Left*

Red chalk, heightened with a little white. Black chalk studies of arms on verso. 17.7 x 18.5 cm. Several brown stains and small losses; all four corners replaced.

Inscribed in pencil on verso, *f. di M*...[?].

PROVENANCE: Don Sebastien Gabriel de Borbón y Braganza (1811-1875); Don Pedro Alcántara de Borbón y Borbón, Duke of Dúrcal (1862-1892); Dúrcal sale, New York, American Art Galleries, April 10, 1889, part of no. 182, as Francisco de Maria; Henry Walters.

Gift of Henry Walters, 1917
17.236.30

The drawing was given to Francesco di Maria in the Dúrcal collection, and this ascription is supported stylistically by comparison with a very similar red chalk head of a youth in Darmstadt, which came from Mariette's collection with the attribution to Francesco (Vitzthum, 1971, fig. 22).

PAOLO DE MATTEIS

Cilento 1662 – Naples 1728

285. *Flying Figure Appearing before an Enthroned Figure*

Red chalk. 20.3 x 31.0 cm. Lined.

Inscribed in pencil at lower center, ...*matteis* [?]; in pen and brown ink at lower right, *P.M.*

PROVENANCE: Unidentified Neapolitan collector–the paraph *DL* in pen and brown ink at lower left also appears on No. 229 and No. 286; purchased in London in 1965.

BIBLIOGRAPHY: Stampfle and Bean, 1967, no. 104, repr., as Mattia Preti; W. Vitzthum, *Burlington Magazine,* CIX, 1967, p. 253, attributed to P. de Matteis; Bean and Stampfle, 1971, p. 24, mentioned under no. 10 as P. de Matteis.

Purchase, 1965, Rogers Fund
65.111.2

Identified by Walter Vitzthum in 1967 as an exercise by Paolo de Matteis, very much in the manner of Mattia Preti.

285

PAOLO DE MATTEIS

286. *Galatea Triumphant*
VERSO. *Another Study for the Same Figure*

Brush and brown wash, over black chalk (recto); black chalk (verso). 26.7 x 19.8 cm.

Inscribed in pen and brown ink at lower left, *P. Matteis*.

PROVENANCE: Unidentified Neapolitan collector—the paraph *DL* in pen and brown ink at lower right also appears on No. 229 and No. 285; purchased in London in 1968.

BIBLIOGRAPHY: Bean and Stampfle, 1971, no. 10, recto repr.

Purchase, 1968, Rogers Fund
68.172.1

This drawing may be a study for De Matteis's painting the *Triumph of Galatea,* in the Brera, Milan (no. 610). Another chalk and wash study of Galatea and her attendants was sold in London at Christie's, November 26, 1973, no. 290, repr.

GIOVANNI BATTISTA MERANO

Genoa 1632 – Genoa 1698

287. *The Holy Spirit Surrounded by a Wreath of Flowers Held up by Infant Angels*

Pen and brown ink, brown wash, over black chalk. 19.0 x 20.7 cm.

Inscribed in pen and brown ink at lower margin, *Gio Batta Merano.*

PROVENANCE: Prof. John Isaacs; sale, London, Sotheby's, January 28, 1965, no. 174; purchased in London in 1965.

Purchase, 1965, Rogers Fund
65.66.7

The penwork and the facial types of the putti are closely paralleled in a drawing traditionally attributed to G. B. Merano in the Hessisches Landesmuseum, Darmstadt, *God the Father with the Dead Christ* (AE 1794; repr. Newcome, 1972, no. 104). Mary Newcome suggested in 1975 that the present drawing may be related to Merano's decoration over a doorway in the fourth chapel on the right in S. Giovanni Evangelista, Parma.

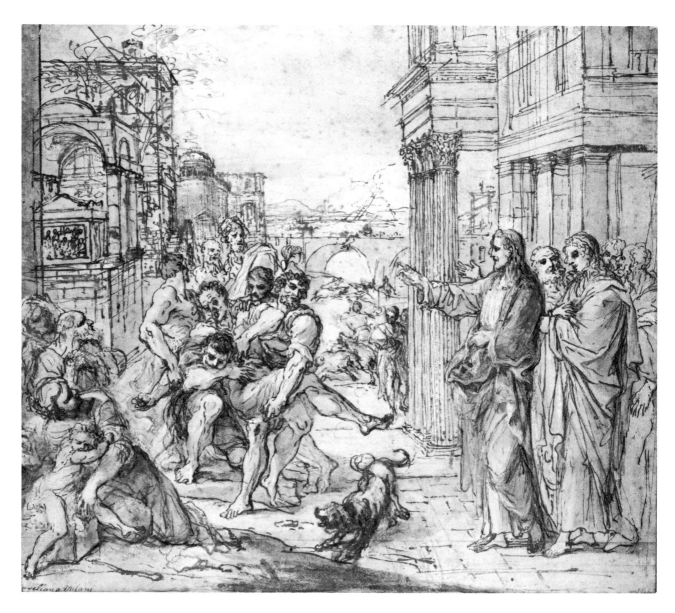

AURELIANO MILANI

Bologna 1675 – Bologna 1749

288. *Christ Healing a Possessed Man*

Pen and brown ink, brown wash, heightened with white, over traces
of black chalk, on light brown paper. 29.8 x 34.9 cm. Lined.

Inscribed in pen and brown ink at lower left, [*A*]*ureliano Milani;*
numbered in red chalk at lower right, *101.*

PROVENANCE: Major A. Merz, Ambleside, Westmoreland (accord-
ing to vendor); purchased in London in 1961.

BIBLIOGRAPHY: Bean and Stampfle, 1971, no. 21, repr.

Purchase, 1961, Rogers Fund
61.130.18

This may well be a preparatory study for a picture
mentioned by Luigi Crespi in a list of works painted by
Aureliano Milani before his departure for Rome in 1719:
"per un altro signore, un Redentore, che libera l'inde-
moniato" (*Vite de' pittori bolognese non descritte nella Felsina
Pittrice,* Rome, 1769, pp. 147-148). The scene represents
Jesus healing the Gerasene demoniac (Luke 8: 26-33); in
the background can be seen the herd of swine, possessed
in its turn by the legion of devils expelled from the man,
racing toward death by drowning in the lake. A local
note is struck by the tabernacle-topped tomb at left,
typically Bolognese in style and suggestive of that of
Egidio Foscherari outside S. Domenico in Bologna.

AURELIANO MILANI

289. *Hilly Landscape with Three Figures*

Red chalk. 28.6 x 43.0 cm. Crease at upper right corner.

Inscribed in pen and brown ink at lower left, *Aur⁰ Milani;* on verso, *Di Aureliano Milani Bolog⁰ 16006* [?]; on old mount, *Di Aureliano Milani Bolognese Pittore in Roma.*

PROVENANCE: Dr. J. R. Wells; Mrs. E. A. Wells (according to Sotheby's); sale, London, Sotheby's, March 27, 1969, no. 37, repr.; purchased in London in 1969.

BIBLIOGRAPHY: Bean and Stampfle, 1971, no. 22, repr.; M. Chiarini, *I disegni italiani di paesaggio dal 1600 al 1750.* Treviso, 1972, p. 77, no. 148, repr.

Purchase, 1969, Rogers Fund
69.293

Similar in style and technique to a red chalk landscape drawing traditionally attributed to Milani in the British Museum (F.f. 3-205).

GIUSEPPE MARIA MITELLI

Bologna 1634 – Bologna 1718

290. *Allegorical Figures of Experience and Time*

Red chalk. 26.1 x 18.3 cm. Lined.

Inscribed in red chalk on tablet held by Experience, *RERUM MAGISTRA;* on pedestal, *PROVERBI/ FIGURATI/ INVEN-TIONE/ DISEGNO ET/ INTAGLIO/ DI ME* [crossed out] *GIUSEPPE Mᵃ/ MITELLI/ PITTORE/ BOLOGN.ˢᵉ/ MDCLXXVII.*

PROVENANCE: Purchased in Florence in 1949; transferred from the Department of Prints, 1977.

Purchase, 1949, The Elisha Whittelsey Fund
1977.313

Study for the title page of the *Proverbi figurati* published in Bologna in 1678 (Bartsch, XIX, pp. 293-300, nos. 67-116, the title page is no. 67). In the etched title page the figures are reversed and the inscription differs in including a dedicatory reference to Francesco Maria de' Medici. The etching is dated 1678, while the drawing seems to be inscribed 1677 (unless the last numeral has been effaced in this somewhat damaged sheet). The Morgan Library possesses red chalk preparatory drawings for fourteen of the forty-eight proverbs illustrated by Mitelli (see Stampfle and Bean, 1967, no. 127).

PIER FRANCESCO MOLA

Coldrerio 1612 – Rome 1666

291. *Caricature of a Seated Man Reading*

Pen and brown ink, brown wash. 24.6 x 18.7 cm.

PROVENANCE: Mathias Komor (Lugt Supp. 1882a); purchased in New York in 1960.

BIBLIOGRAPHY: *Metropolitan Museum of Art Bulletin,* October 1961, p. 46, repr.

Purchase, 1960, Rogers Fund
61.2.2

PIER FRANCESCO MOLA

292. *Artists Drawing and Painting in a Studio*

Pen and brown ink, brown wash. 7.3 x 20.0 cm. Lined.

PROVENANCE: Richard Cosway (Lugt 628); E. A. Wrangham (according to Sotheby's); sale, London, Sotheby's, July 1, 1965, no. 23, purchased by the Metropolitan Museum.

Purchase, 1965, Rogers Fund
65.131.6

PIER FRANCESCO MOLA, circle of

293. *Four Caricatured Heads*

Pen and brown ink. 8.3 x 26.0 cm. Lined.

Inscribed in blue crayon on reverse of old mount, *Guercino*.

PROVENANCE: James Jackson Jarves; Cornelius Vanderbilt.

BIBLIOGRAPHY: *Metropolitan Museum Hand-book,* 1895, no. 298, as Guercino.

Gift of Cornelius Vanderbilt, 1880
80.3.298

These caricatured heads were formerly attributed to Guercino, but J. Q. van Regteren Altena suggested in 1968 that this sheet would be more appropriately classified in the circle of P. F. Mola.

293

294

295

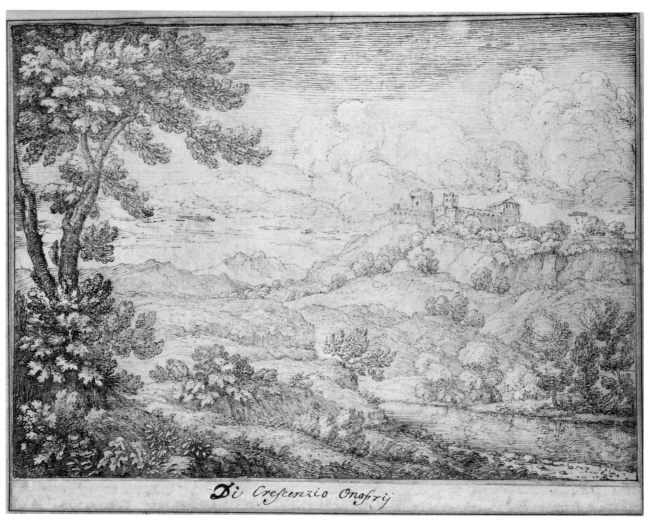

Di Crescenzio Onofrij

224

GIUSEPPE NICOLA NASINI

Castel del Piano, near Grosseto 1657 – Siena 1736

294. *Abraham Dismissing Hagar and Ishmael*

Pen and brown ink, brown wash, heightened with white, over black chalk, on brown paper. 24.3 x 17.4 cm.

PROVENANCE: Purchased on London in 1961.

Purchase, 1961, Rogers Fund
61.130.9

The attribution to Giuseppe Nasini is apparently traditional. In any case the facial types, with their pointed noses, and the heavy, florid drapery are paralleled in drawings traditionally given to Nasini in the British Museum (*Old Testament Scene with a Caravan*, F.f. 3-193) and the Städelsches Kunstinstitut, Frankfurt (*Death of Dido*, no. 4224), as well as in a group of drawings in the National Gallery of Scotland, Edinburgh (*Studies for Pendentives*, and *Scenes from the Legend of Dido*, nos. D 4958-4965).

CRESCENZIO ONOFRI

Rome 1632 – Florence after 1712

295. *Landscape with a Castle on a Hill*

Pen and brown ink. 19.9 x 28.5 cm.

Inscribed in pen and brown ink on strip of paper pasted along lower margin of sheet, *Di Crescenzio Onofrij;* on verso, *Al Sigr Ferdinando Maria Melli Crescentio Onofrij dona l'Anno 1705 Genaio.*

PROVENANCE: Purchased in New York in 1963.

BIBLIOGRAPHY: Stampfle and Bean, 1967, no. 122, repr.; M. Chiarini, *Bollettino d'Arte*, LII, 1, 1967, p. 30; P. Dreyer, in *Stiftung Ratjen*, 1977, mentioned under no. 85.

Purchase, 1963, Rogers Fund
63.222

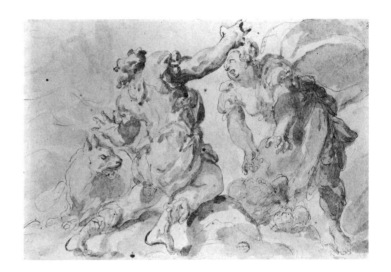

PAOLO PAGANI

Castello Valsolda 1661 – Milan 1716

296. *The Discovery of Romulus and Remus*

Pen and brown ink, brown wash, on brownish paper. 19.4 x 29.1 cm. Several brown spots. Lined.

Numbered in pencil at upper right, 23.

PROVENANCE: James Jackson Jarves; Cornelius Vanderbilt.

BIBLIOGRAPHY: *Metropolitan Museum Hand-book*, 1895, no. 466, as Rubens; J. Bean, *Master Drawings*, XIV, 1, 1976, p. 66, note 4.

Gift of Cornelius Vanderbilt, 1880
80.3.466

The drawing was exhibited in 1895 with an attribution to Rubens, and more recently Walter Hugelshofer has proposed the name of Johann Liss. It is, however, a characteristic example of the draughtsmanship of Paolo Pagani, whose drawings have on occasion been wrongly given to Liss.

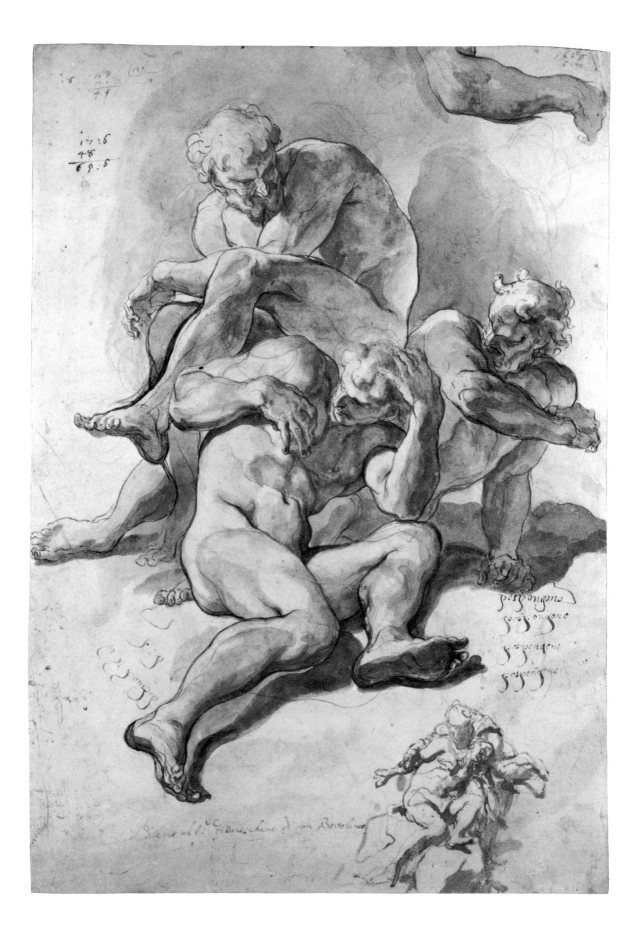

PAOLO PAGANI

297. *Three Men Fighting; Study of a Nude Figure Supported by Another*

Pen and brown ink, brown wash, over black chalk (the three struggling figures), pen and violet wash (the two figures at lower right). Studies of a figure with left arm upraised, of an arm, a leg, and putti with foliage, in pen and brown ink, brown wash, over black chalk, on verso. 41.7 x 28.8 cm.

Inscribed in pen and brown ink at right four times, *pospongono;* other letters and numbers scattered over sheet; inscribed in pen and violet ink at lower margin, *il disegno al S.r Franceschino di San Bortolameo[?]*.

PROVENANCE: Sale, London, Christie's, December 6, 1972, no. 11, repr., purchased by the Metropolitan Museum.

BIBLIOGRAPHY: Bean, 1975-1976, no. 26; J. Bean, *Master Drawings,* XIV, 1, 1976, p. 66, pl. 40.

Purchase, 1972, Rogers Fund
1972.259

ROMOLO PANFI

Florence 1632 – Carmignano 1690

298. *Hilly Landscape with Two Cavaliers and Other Figures in the Foreground*

Brush, black and gray wash. 33.2 x 57.8 cm. Vertical crease at center. Lined.

Inscribed in pen and brown ink at lower margin of old mount, *Romolo Panfi*.

PROVENANCE: Purchased in New York in 1972.

Purchase, 1972, Rogers Fund
1972.134

The attribution to the little-known Romolo Panfi, inscribed in what appears to be an early eighteenth-century hand on the old mount, deserves serious consideration, though Marco Chiarini points out that two drawings ascribed to him in the Uffizi are different in style. In any case, this spacious view looks back to the example of the brush and wash landscapes of Pietro da Cortona, and predicts in some ways the landscape style of the Tuscan Francesco Zuccarelli.

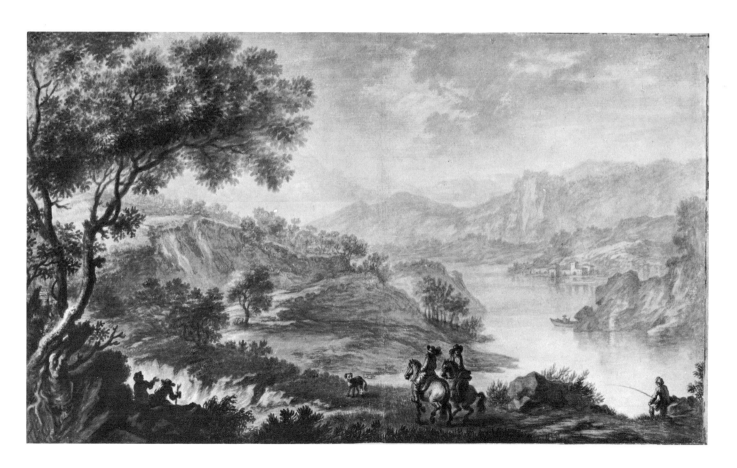

LORENZO PASINELLI

Bologna 1629 – Bologna 1700

299. *Winged Putti with Open Music Books*

Red chalk. 24.9 x 17.8 cm. Repaired losses at left, right, and lower margins. Lined.

Inscribed in pen and brown ink at lower margin, *Lorenzo Pasinelli;* on verso of old mount, *Frammento di Lorenzo Pasinelli/ per l'opera alle stampe intotolata la/Musica.*

PROVENANCE: Cephas G. Thompson.

Gift of Cephas G. Thompson, 1887
87.12.32

In this red chalk drawing of angel-musicians Pasinelli reveals himself the faithful disciple of his first master Simone Cantarini. The old Italian inscription on the reverse of the mount is correct, and these putti were used, differently grouped and reversed, in Ippolito Marracci's etching after Pasinelli, *Concert de musique exécuté par plusieurs anges assis sur un nuage* (Bartsch, XXI, pp. 210-211, no. 1).

GIUSEPPE PASSERI

Rome 1654 – Rome 1714

300. *The Judgment of Solomon*

Pen and brown ink, red chalk, and red wash, heightened with white. 13.2 x 17.7 cm. Lined.

Inscribed in pen and brown ink at lower right, *Passeri.*

PROVENANCE: Cephas G. Thompson.

BIBLIOGRAPHY: *Metropolitan Museum Hand-book,* 1895, no. 773, as G. B. Passeri.

Gift of Cephas G. Thompson, 1887
87.12.103

Dieter Graf very kindly informs me that this drawing is a composition study for a painting by Giuseppe Passeri in the reserves of the Galleria Nazionale d'Arte Antica, Rome (inv. 595; photograph GFN E85612). He further calls attention to two studies for the same subject in the Uffizi (10872 F recto and verso, with an old attribution to Giuseppe Chiari). In the Uffizi studies Solomon is enthroned at the center of the composition and faces forward. Dr. Graf has furthermore identified a group of red chalk figure and drapery studies by Passeri at the Kunstmuseum, Düsseldorf, that are connectible with the painting in Rome, where Solomon is enthroned at the left, as he is in the Metropolitan's drawing. These Düsseldorf drawings will be published in Dr. Graf's forthcoming catalogue of the large groups of drawings by Giuseppe Passeri and Giacinto Calandrucci preserved at Düsseldorf.

300

GIUSEPPE PASSERI

301. *The Nativity*

Pen and brown ink, red chalk, and red wash, heightened with white, on beige paper. 18.9 x 14.0 cm.

PROVENANCE: James Jackson Jarves; Cornelius Vanderbilt.

BIBLIOGRAPHY: *Metropolitan Museum Hand-book*, 1895, no. 215, as Correggio.

Gift of Cornelius Vanderbilt, 1880
80.3.215

The convincing attribution of this drawing to Passeri was made by Anthony Blunt in 1958. Dieter Graf points out that there is a red chalk study in Düsseldorf for a similar vertical Nativity composition (FP 2552). There, the Virgin kneels as here on the right, but St. Joseph stands at left foreground in front of the manger, and his hands are clasped at the top of his staff.

302 v.

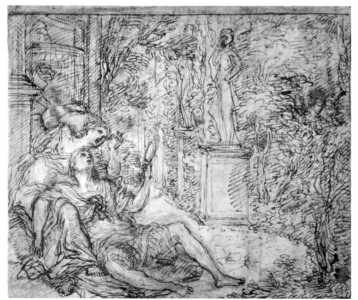

GIUSEPPE PASSERI

302. *The Virgin Immaculate with the Christ Child in Glory*
VERSO. *Rinaldo and Armida*

Pen and brown ink, red chalk, and red wash, heightened with white (recto); pen and brown ink, over red chalk (verso). 22.7 x 18.6 cm.

PROVENANCE: Purchased in London in 1975.

Purchase, 1975, Harry G. Sperling Fund
1975.440

The Christ Child holds a long cross, which he presses down on the head of the serpent below; this motif is derived from Passeri's master Maratti, who seems first to have used it in his *Immaculate Conception* of ca. 1663 in S.

Isidoro Agricola, Rome (repr. *Burlington Magazine*, CI, 1959, p. 64, fig. 25). Passeri himself painted an *Immacolata,* now in S. Tomaso in Parione (before 1686, see Waterhouse, 1976, p. 102; repr. *Antichità Viva,* IX, 1, 1970, p. 9, fig. 16). The Christ Child with his long cross does not appear in this painting, and the Virgin stands alone on a crescent moon with her hands joined in prayer. A drawing by Passeri related to the S. Tomaso in Parione painting is in the Cabinet des Dessins of the Louvre (inv. 3443).

The incident from Tasso's *Gerusalemme Liberata* studied on the verso does not occur in a surviving painting by Passeri, but he made other studies for scenes from this romance—*Rinaldo Reclaimed by his Comrades* (sale, London, Christie's, June 27, 1967, no. 56, repr.), an *Olindo and Sofronia at the Stake* at Holkham Hall (*Old Master Drawings from Holkham,* exhibition catalogue, Agnew, London, 1977, no. 97), and an *Ermenia and the Shepherds* at Windsor Castle (Blunt and Cook, 1960, no. 584).

Dieter Graf courteously points out that there is a red chalk study by Passeri in Düsseldorf (FP 2397) for the composition on the recto of the present drawing, the Virgin with the Christ Child spearing the serpent. He also calls attention to a red chalk study in the Gabinetto Nazionale delle Stampe, Rome (FC 127356) for the Rinaldo and Armida group on the reverse of the Metropolitan sheet, and in addition he has identified several individual figure studies at Düsseldorf for this scene from *Gerusalemme Liberata.*

303. *The Archangels Gabriel, Michael, and Raphael*

Pen and brown ink, red chalk, and red wash, heightened with white. Faint figure studies in red chalk on verso. 24.2 x 15.8 cm.

Inscribed in pen and brown ink at lower right, *L 145* [?].

PROVENANCE: Purchased in London in 1908.

Purchase, 1908, Rogers Fund
08.227.37

The drawing has very recently been identified by Dieter Graf as a study for the altarpiece of the second chapel on the left in S. Caterina a Magnanapoli, Rome; this painting is given in old guidebooks to Fabio della Corgna, but was attributed to Passeri by Dr. Graf. Serena

Romano, who independently recognized the altarpiece as the work of Passeri, pointed out that already in 1765 P.-J. Mariette had accounted for the confusion over authorship by suggesting that Passeri's altarpiece was substituted for an earlier painting by Della Corgna (*Ricerche di Storia dell'Arte,* 6, 1977, p. 161, the painting fig. 9). Mariette thought that the *Three Archangels* was one of Passeri's best pictures and he commissioned a copy of it from Louis Durameau, then a *pensionnaire* at the French Academy in Rome (G. Bottari and S. Ticozzi, *Raccolta di lettere,* V, Milan, 1822, p. 423).

A much freer red chalk study for the three archangels is in the Kunstmuseum, Düsseldorf (FP 2637) and will appear in Graf's soon-to-be-published catalogue of Passeri drawings at Düsseldorf.

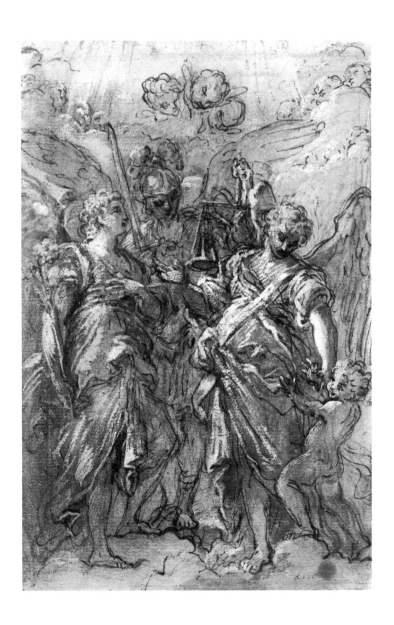

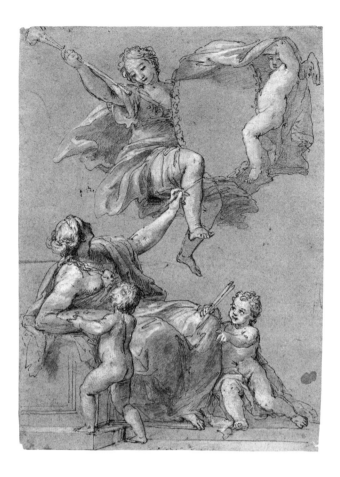

Pietro de Pietri for this engraving are preserved in Berlin (West Berlin, Kupferstichkabinett, KdZ 18227, recto and verso, and KdZ 24645, repr. Dreyer, 1969, nos. 146-147; West Berlin, Kunstbibliothek, Hdz. 6450, recto and verso, and Hdz. 6451, recto and verso, repr. Jacob, 1975, nos. 509-510). None of the preparatory drawings corresponds exactly to the composition as it was engraved by Frezza.

DOMENICO PIOLA

Genoa 1627 – Genoa 1703

305. *The Egyptians Overwhelmed by the Red Sea*

Pen and brown ink, brown wash. 28.9 x 42.3 cm.

Inscribed in pencil on verso, *Nº 15. Beau dessin de Luc Jordane.*

PROVENANCE: Purchased in London in 1964.

BIBLIOGRAPHY: Newcome, 1972, no. 91, repr.

Purchase, 1964, Rogers Fund
64.180.2

Mary Newcome assigned this drawing to the circle of Domenico Piola, suggesting that it might be the work of one of his sons, Antonio Maria or Giovanni Battista, or of his daughter Margherita. Since their styles as draughtsmen are "still undefined," it seems more reasonable to list this drawing under the name of Domenico himself, so characteristic of this minor master are line and facial type. An earlier attribution to *Luc Jordane* is to be rejected, with the comment that the drawings of Piola and Giordano have often in the past been confused.

PIETRO ANTONIO DE PIETRI

Premia 1663 – Rome 1716

304. *Allegorical Composition with Figures of Painting and Fame*

Pen and brown ink, heightened with white, over black chalk, on blue paper. Slight architectural sketches in red chalk on verso. 27.6 x 20.4 cm.

PROVENANCE: Purchased in London in 1972.

BIBLIOGRAPHY: *Drawings by Old Masters. P. & D. Colnaghi and Co.*, exhibition catalogue, London, 1972, no. 28, repr. on cover; Jacob, 1975, p. 111, mentioned under no. 510.

Purchase, 1972, Rogers Fund
1972.173

Design for the title page of a volume that reproduces Francesco Albani's frescoes in the Palazzo Verospi, Rome. This frontispiece, engraved by Giovanni Girolamo Frezza and dated 1704, bears the title *Picturae Francisci Albani in Aede Verospia.* Seven other designs by

306. *St. Jerome in the Wilderness*

Brush and brown wash, heightened with white, over some black chalk, on brownish paper. 39.8 x 26.8 cm. Lined.

PROVENANCE: Purchased in Bournemouth in 1971.

BIBLIOGRAPHY: *Drawings and Watercolors. Alister Mathews*, catalogue no. 77, Bournemouth, 1971, no. 7, repr. as Circle of G. Muziano; Bean, 1972, no. 39.

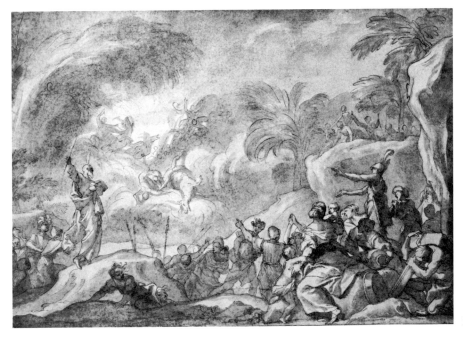

305

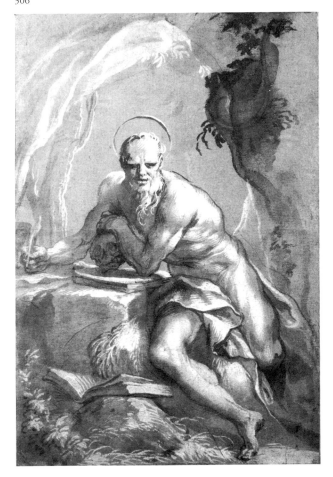

306

DOMENICO PIOLA (NO. 306)

Purchase, 1971, Rogers Fund
1971.67

This good and characteristic example of Piola's
draughtsmanship appeared on the English market with
an attribution to the circle of Girolamo Muziano.
Another drawing by Piola of the penitent Jerome, with
many variations, was sold in Paris at Drouot–Rive
Gauche on June 16, 1976 (no. 61, repr., entitled "Saint
Antoine").

307. *Venus and Cupid in Vulcan's Forge*

Pen and brown ink, brown wash, over black chalk. 18.4 x 27.4 cm.
Some foxing. Lined.

Inscribed in pen and brown ink on reverse of old mount, *Bouché* [sic];
in blue crayon, *Piola P.*

PROVENANCE: James Jackson Jarves; Cornelius Vanderbilt.

BIBLIOGRAPHY: *Metropolitan Museum Hand-book*. 1895, no. 192, as
Pellegro Piola.

Gift of Cornelius Vanderbilt, 1880
80.3.192

308. *Bowman Shooting at a Ball on the Head of a Blindfolded Figure*

Pen and brown ink, brown wash, over black chalk. 26.0 x 38.6 cm. Repaired losses at upper right. Lined.

PROVENANCE: Gustav Grunewald (Lugt Supp. 1155b); purchased in New York in 1947.

Purchase, 1947, Harris Brisbane Dick Fund
47.155.1

DOMENICO PIOLA (NO. 307)

In the nineteenth century the drawing was attributed to Pellegro Piola, elder brother of Domenico, who is rather an unknown quantity as a draughtsman. It seems simpler to list the drawing under the name of the prolific Domenico Piola.

The subject, possibly the representation of a classical myth, has yet to be identified.

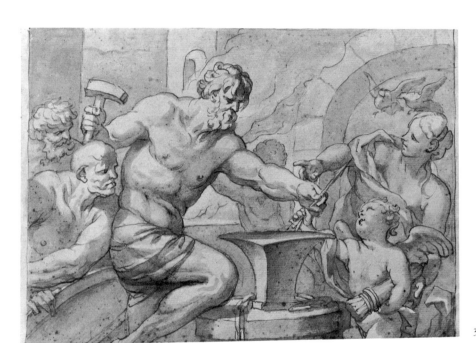

307

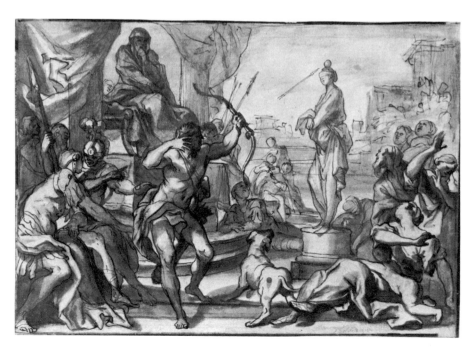

308

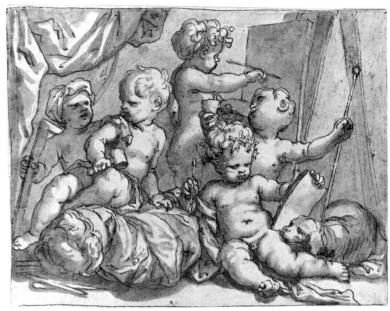

309

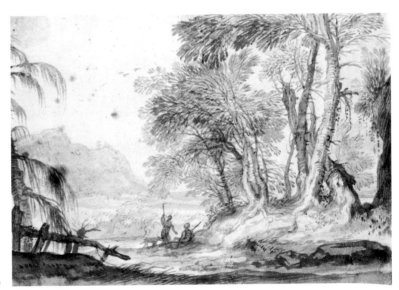

310

DOMENICO PIOLA

309. *Putti with the Attributes of the Arts*

Pen and brown ink, brown wash, over a little black chalk. 14.2 x 18.8
cm.

PROVENANCE: James Jackson Jarves; Cornelius Vanderbilt.

BIBLIOGRAPHY: *Metropolitan Museum Hand-book*, 1895, no. 515, as
François Boucher.

Gift of Cornelius Vanderbilt, 1880
80.3.515

310. *Wooded Landscape with Two Figures*

Pen and brown ink, brown wash. 14.5 x 21.4 cm. Several brown
stains at upper left. Lined.

Inscribed in pen and brown ink on reverse of old mount, *Piola*.

PROVENANCE: Purchased in London in 1968.

Purchase, 1968, Rogers Fund
68.54.1

235

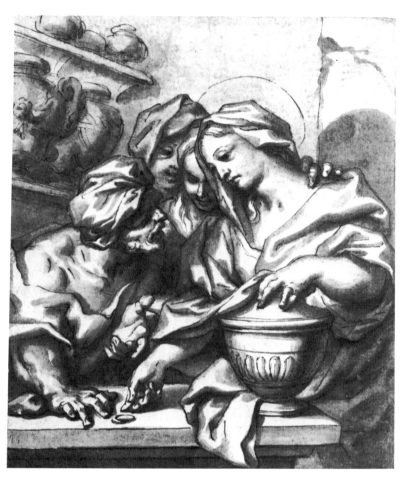

311

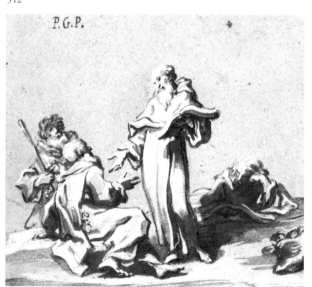

PAOLO GEROLAMO PIOLA

Genoa 1666 – Genoa 1724

311. *Mary Magdalen Purchasing Ointment*

Pen and brown ink, brown wash. 19.7 x 17.0 cm.

PROVENANCE: Sir Thomas Lawrence (Lugt 2445); James Jackson Jarves; Cornelius Vanderbilt.

BIBLIOGRAPHY: *Metropolitan Museum Hand-book,* 1895, no. 471, as Rubens; Newcome, 1977, pp. 38-39, fig. 3.

Gift of Cornelius Vanderbilt, 1880
80.3.471

There is no record of the attribution of this drawing when it was in the collection of Thomas Lawrence, but

PAOLO GEROLAMO PIOLA

James Jackson Jarves attributed it to Rubens. In recent years it has been assigned generically to the Genoese school, then to Domenico Piola, and quite recently and convincingly by Mary Newcome to Domenico's son Paolo Gerolamo who studied another, differently arranged version of the same subject in a black chalk drawing in the Janos Scholz collection (repr. Newcome, 1972, no. 124).

Purchase, 1978, David L. Klein, Jr., Memorial Foundation Gift, Emma Swan Hall Gift, Mr. and Mrs. Carl Selden Gift, Pace Editions, Inc., Gift, Rogers Fund, Mr. and Mrs. David T. Schiff Gift 1978.143

Mary Newcome points out that Paolo Gerolamo was actively involved in sculptural projects, and this figure of Apollo has the air of having been studied for a sculpture complete with base. The drawing appeared on the London market in 1976 with a study for a figure of Janus.

312. *Four Monks Discoursing; One Standing with a Book, the Others Seated or Reclining*

Brush and brown wash, heightened with white, over a little black chalk, on blue-gray paper. 12.8 x 14.9 cm.

Monogram in pen and brown ink at upper left, *P.G.P.*

PROVENANCE: Purchased in New York in 1973.

Purchase, 1973, Rogers Fund
1973.91

Paolo Gerolamo Piola not infrequently monogrammed his own drawings; the letters *P.G.P.,* in the same hand, appear on a *Bacchanal* in the Uffizi (repr. Newcome, 1977, p. 56, fig. 33), on a *Preaching of the Baptist* sold not long ago in London (Sotheby's, November 25, 1970, no. 13), and on a *Pastoral Subject* that was on the London market in 1968 (repr. *Old Master Drawings. Yvonne Tan Bunzl,* exhibition catalogue, London, 1968, no. 47, pl. 8).

313. *Standing Figure of Apollo with a Lyre*

Brush and brown wash, heightened with white, over a little black chalk, on blue paper. Traces of squaring in black chalk. 28.2 x 14.4 cm.

PROVENANCE: Purchased in New York in 1978.

BIBLIOGRAPHY: Newcome, 1977, p. 49, note 82 (with previous bibliography).

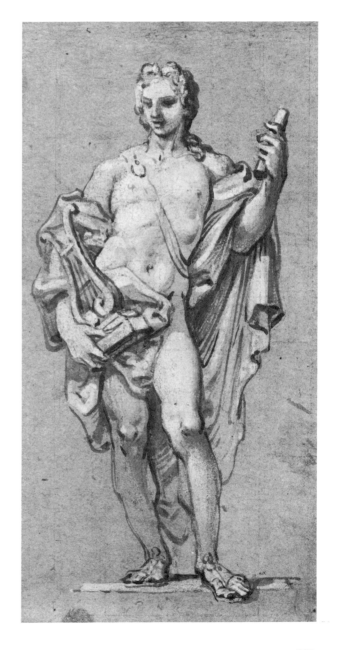

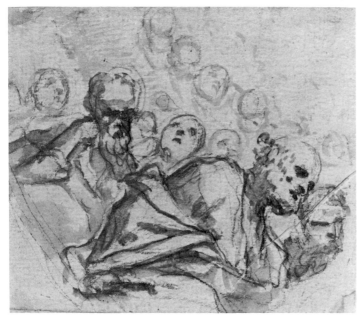

314 v.

MATTIA PRETI

Taverna 1613 – Valletta (Malta) 1699

314. *A Group of Saints and Angels*
VERSO. *Studies of a Male Figure
in a Pendentive*

Red chalk and red wash (recto and verso). 15.1 x 18.1 cm. Lower right corner replaced.

PROVENANCE: Purchased in London in 1970.

BIBLIOGRAPHY: *Disegni bolognesi dal XVI al XVIII secolo. G. and A. Neerman,* exhibition catalogue, Bologna–London, 1968, no. 48, recto repr., as Elisabetta Sirani; *Old Master Drawings and Paintings. Yvonne Tan Bunzl,* exhibition catalogue, London, 1970, no. 42, as Preti; Bean, 1972, no. 42.

Purchase, 1970, Rogers Fund
1970.113.6

Walter Vitzthum associated this sheet with Preti's planning for the decoration of the choir and apse of S. Biagio in Modena, executed 1653-1656. The figures on the recto are studied for the *Paradiso* in the cupola of the choir, while the sketches on the verso are related to the representation of St. Luke in one of the pendentives below the cupola. Other designs for this decorative scheme are preserved in the Museo di Capodimonte, Naples (Vitzthum, 1966, nos. 21, 22).

315. *Seated Bishop with Arms Extended
and Four Attendant Figures*
VERSO. *Head of a Lion and
Perspective Diagrams*

Red chalk and red wash (recto); red chalk (verso); on beige paper. 31.1 x 29.4 cm.

Inscribed on verso in the same red chalk as the drawing, *01 4 / 26 / colori lire 332.*

PROVENANCE: Purchased in London in 1971.

BIBLIOGRAPHY: Bean, 1972, no. 43.

Purchase, 1971, Rogers Fund
1971.221.3

An old copy of the drawing on the recto, with two additional heads in the background, is preserved in the Royal Museum of Fine Arts, Copenhagen, where it is classified as anonymous Italian, seventeenth century.

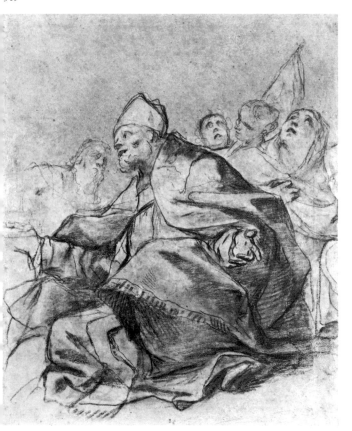

315 v.

ANDREA PROCACCINI

Rome 1671 – San Ildefonso (Spain) 1734

316. *The Death of St. Joseph*

Pen and brown ink, brown wash, over a little black chalk. Lightly squared in black chalk. 18.0 x 10.7 cm.

Inscribed in pen and brown ink at lower margin, *Oncie 55 1/3* [?]; at right margin, *Oncie . . .;* in another hand at lower right, *Andrea Procaccini.*

PROVENANCE: Harry G. Friedman, New York.

Gift of Harry G. Friedman, 1956
56.225.5

The subject, Christ and the Virgin attending the dying St. Joseph, was a popular one in the circle of Maratti. The draughtsmanship here is also clearly Marattesque, and though not much is known of Andrea Procaccini as a draughtsman, the old attribution to him is quite plausible.

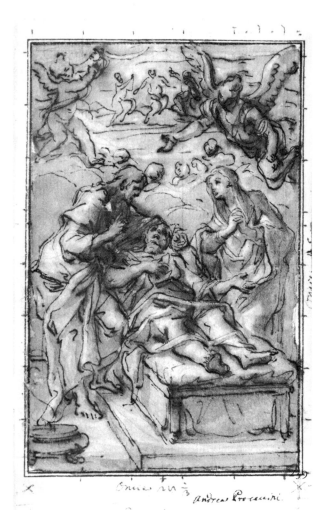

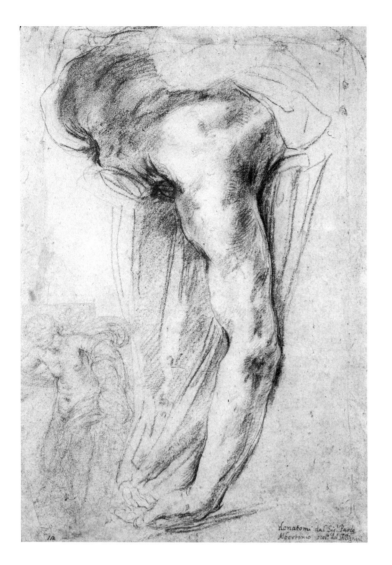

GUIDO RENI

Calvenzano 1575 – Bologna 1642

317. *The Headless Body of Holofernes*

Black chalk on brownish paper. 38.1 x 26.1 cm. A sketch of a female figure in black chalk on blue paper (17.9 x 8.5 cm.) has been pasted down at the lower left of the larger sheet. Lined.

Numbered in pen and brown ink at lower left, *12* [?]; inscribed at lower right, *donatomi dal Sig. Paolo Albertonio scol.º del S. F. Zignani;* at lower margin of old mount, *Guido Reni.*

PROVENANCE: The Roman painter Paolo Albertoni ? (the Paolo Albertonio of the inscription); purchased in London in 1962.

BIBLIOGRAPHY: Stampfle and Bean, 1967, no. 21, repr. (with previous exhibition listing).

Purchase, 1962, Rogers Fund
62.123.1

A study, probably made from life, for the left arm and shoulder of the headless body of Holofernes in *Judith and Holofernes,* a painting in the Spada Gallery, Rome (repr. F. Zeri, *La Galleria Spada in Roma,* Florence, 1954, p. 110, no. 97, pl. 146). Zeri dates the picture, in which Judith stands beside the corpse looking up to heaven and holding the head of Holofernes in her left hand, about 1625-1630. The delicately drawn study of a half-draped female figure at lower left, also by Reni, is a separate sketch that has been pasted by a collector onto the larger sheet.

SEBASTIANO RICCI

Belluno 1659 – Venice 1734

318. *Studies for an Education of the Virgin: St. Anne Teaching the Virgin to Read*

Pen and brown ink, over black chalk. 23.3 x 15.7 cm. Repaired loss at upper right. Lined.

Inscribed in pen and brown ink on reverse of old mount, *disegno distinto | Proviene dalla Raccolta di disegni della Galleria Corniani d'Algarotti in Venezia.*

PROVENANCE: Corniani-Algarotti, Venice; A. de Burlet, Berlin and Basel (according to vendor); purchased in New York in 1967.

BIBLIOGRAPHY: Bean and Stampfle, 1971, no. 8, repr.; Rizzi, 1975, no. 101, repr.

Purchase, 1967, The Florence and Carl Selden Foundation, Inc., Gift 67.15

This charming composition does not occur in any surviving picture by Ricci, but the subject was used in 1732 by Giambattista Tiepolo for his altarpiece in the Chiesa della Fava, Venice.

319. *Allegory with Figures of Hope, Time, and Death*

Pen and brown ink, gray wash, over red and black chalk. 27.3 x 19.5 cm. Lined.

Inscribed in pen and brown ink at lower right, *Seb. Ricci;* on verso, *R. Willett's coll^n WE P 86 N 164.*

PROVENANCE: R. Willett (according to Esdaile's inscription); William Esdaile (Lugt 2617); purchased in Paris in 1967.

BIBLIOGRAPHY: Bean and Stampfle, 1971, no. 6, repr.; Rizzi, 1975, no. 118, repr.

Purchase, 1967, Rogers Fund
67.65

The old French inscription on the mount, *Entre le Temps et la Mort, l'Homme invoque l'Espérance,* gives a satisfactory explanation of the subject. The design was not used in a painting and may have been intended for a book illustration.

318

319

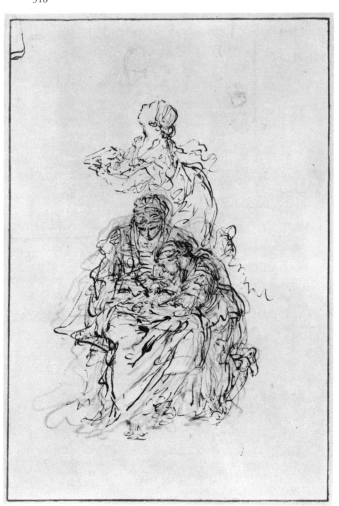

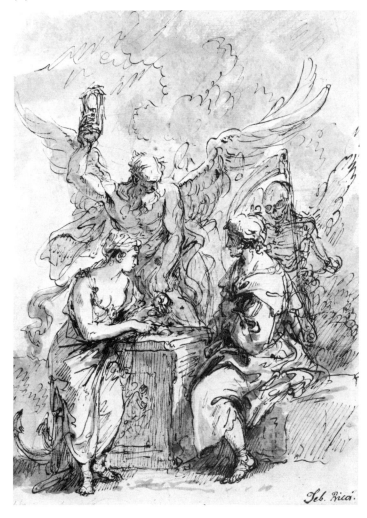

320. *Figure Studies*

Pen and brown ink, gray wash, over red and a little black chalk. 28.2 x 19.0 cm. Lined.

Inscribed in pen and brown ink at lower margin of old mount, *Sebastian Ricci*.

PROVENANCE: John Barnard (Lugt 1419, 1420); Hugh N. Squire, London; purchased in London in 1962.

BIBLIOGRAPHY: Bean and Stampfle, 1971, no. 5, repr. (with previous bibliography); Rizzi, 1975, no. 72, repr.

Purchase, 1962, Gustavus A. Pfeiffer Fund
62.120.6

Similar sheets of figure studies with comparably elegant *mise en pages* are preserved in the Louvre and the British Museum (inv. 14.271 and register no. 1960.4.9.114; repr. Rizzi, 1975, nos. 69 and 71, respectively). None of these figure studies is clearly related to a painting by the artist, and they seem to have been done as graphic exercises in their own right.

GIOVANNI FRANCESCO ROMANELLI

Viterbo ca. 1610 – Viterbo 1662

321. *Aeneas and the Cumaean Sibyl Entering the Infernal Regions*

Pen and brown ink, blue wash, heightened with white, over black chalk, on blue-gray paper. 22.9 x 32.0 cm. Lined.

Inscribed in pen and brown ink on reverse of old mount, *Aeneas...Circe;* in pencil, *Romanelli.*

PROVENANCE: William Esdaile (Lugt 2617); Helen Lowenthal, London; purchased in London in 1977.

Purchase, 1977, Mr. and Mrs. Carl Selden Gift
1977.134

The story of Dido and Aeneas as told in Virgil's *Aeneid* was the subject of a series of eight tapestries produced in the 1630s by the Barberini tapestry manufactory after

cartoons supplied by Romanelli. Six of these cartoons have survived (sale, London, Sotheby's, March 26, 1969, nos. 3-8, repr.), and preparatory drawings for three of the cartoons are preserved in English collections. A design for the *Banquet of Dido* is in the British Museum, one for the *Sacrifice of Dido to Juno* in the Witt Collection, Courtauld Institute of Art, and one for the *Building of Carthage* in the Ashmolean Museum, Oxford (see R. Rubinstein, in *Art at Auction, The Year at Sotheby's & Parke-Bernet, 1968-69,* New York, 1969, pp. 106-119, where the first two drawings are reproduced).

The present design represents an incident drawn from quite another part of the *Aeneid* and would not have

logically formed part of the Dido and Aeneas story (Book VI, as opposed to Books I and IV). It may have been intended for a narrative sequence involving Aeneas's visit to the underworld. A Barberini connection is in any case implied by the bees in formation that appear on the shield held by Aeneas's companion at right (albeit in reversed formation). A drawing by Romanelli in the Albertina represents another incident related by Virgil in Book VI, *Aeneas Plucking the Golden Bough* (Roli, 1969, no. 149, repr.). The Vienna drawing was engraved in reverse by Cornelis Bloemaert (Hollstein, II, p. 76, no. 203). Both drawing and print bear the arms of the Raggi family, which was closely allied to the Barberini. The presence of the arms of Roman families in both the Metropolitan and Albertina drawings makes it unlikely that these scenes from the *Aeneid* could have been associated with Romanelli's late commission from the king of France, a now lost decorative scheme for an "appartamento de' bagni" with representation of "i fatti più illustri dell' Eneide di Virgilio" (Pascoli, 1730, p. 101).

322

323

322. *Five Music-Making Figures*

Pen and brown ink, blue-gray wash. 4.8 x 11.6 cm. Lined.

PROVENANCE: Purchased in London in 1966.

Purchase, 1966, Rogers Fund
66.134.5

The figures are seen in a steep perspective, which suggests that this and the following drawing (No. 323) may have been designs for ornamental friezes painted high on a wall. In both, the facial types are characteristic of Romanelli.

323. *Six Music-Making Figures*

Pen and brown ink, blue-gray wash. 5.3 x 11.6 cm. Lined.

PROVENANCE: Purchased in London in 1966.

Purchase, 1966, Rogers Fund
66.134.6

See No. 322 above.

SALVATOR ROSA
Naples 1615 – Rome 1673

324. *A Large Tree*

Pen and brown ink, on brown paper. 61.5 x 41.8 cm. A number of repaired losses; horizontal crease at center. Lined.

Signed in pen and brown ink at lower left, *Rosa f.*

PROVENANCE: Lord Ronald Sutherland Gower; purchased in London in 1911.

BIBLIOGRAPHY: Mahoney, 1977, I, p. 285, no. 23.5 (with previous bibliography), II, fig. 23.5.

Purchase, 1911, Rogers Fund
11.66.7

This early landscape drawing is exceptional in its size; it fills a double sheet.

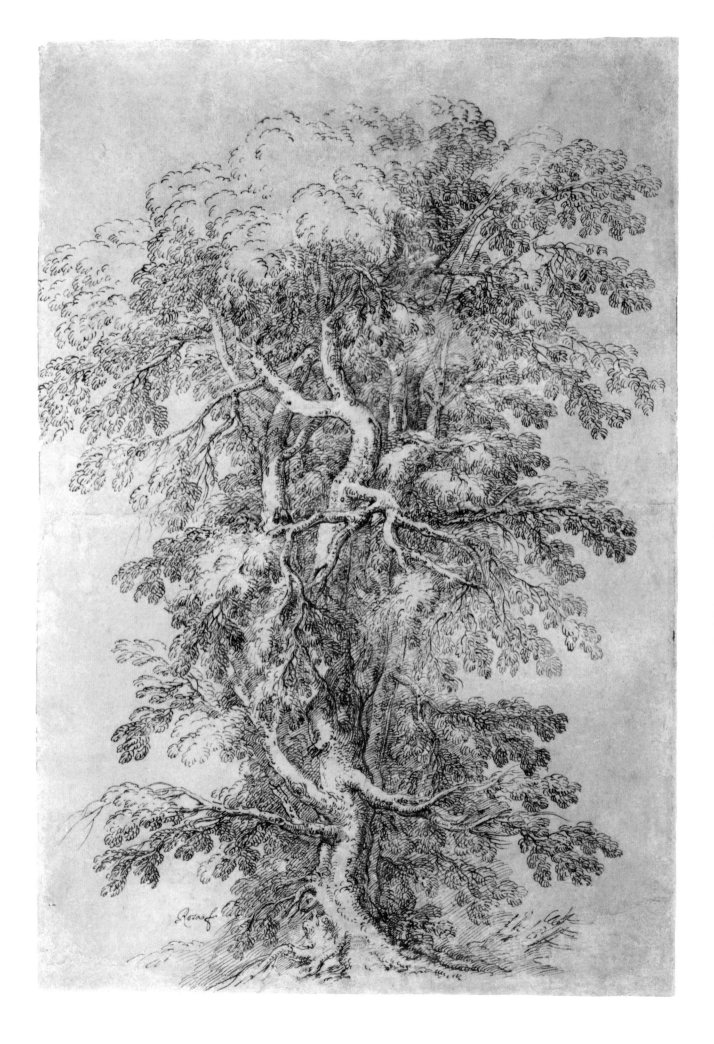

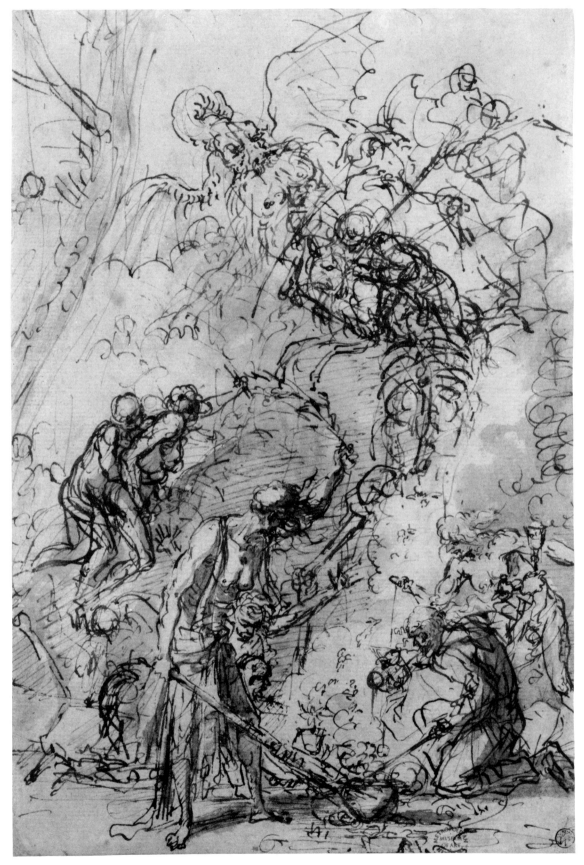

325

SALVATOR ROSA

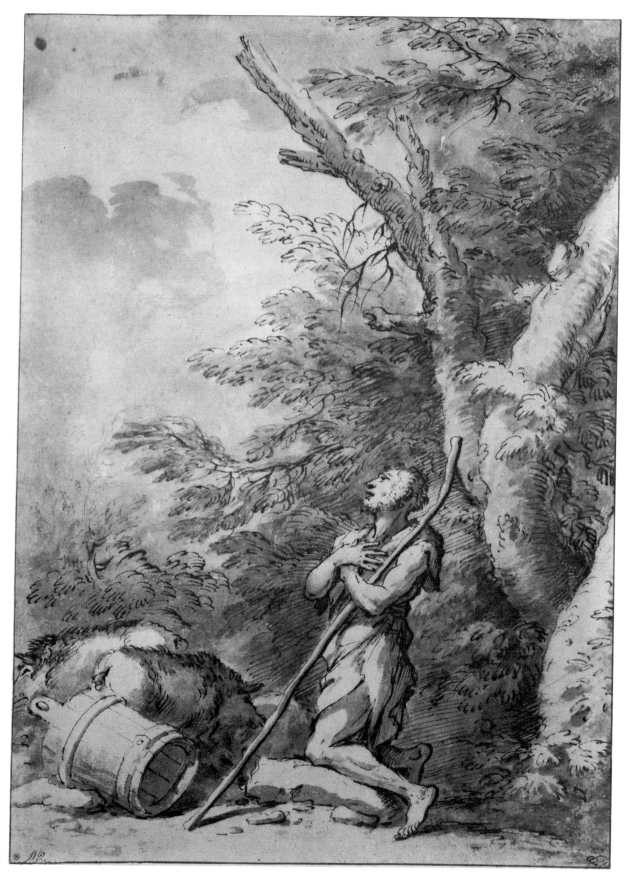

326

SALVATOR ROSA

325. *Witches' Sabbath*

Pen and brown ink, brown wash. 27.2 x 18.4 cm.

PROVENANCE: Sir Charles Greville (Lugt 549); Earl of Warwick (Lugt 2600); J. P. Richter, London; purchased in London in 1912.

BIBLIOGRAPHY: Stampfle and Bean, 1967, no. 105, repr. (with previous bibliography); Mahoney, 1977, I, p. 335, no. 28.4 (with additional bibliography), II, fig. 28.4.

Purchase, 1912, Rogers Fund
12.56.13

Study for the *Witches' Sabbath* in the Corsini collection, Florence, that was no doubt painted during Rosa's Florentine stay, between 1640 and 1649 (repr. Mahoney, 1977, II, fig. 28.4A).

326. *The Prodigal Son Kneeling Repentant among Swine*

Pen and brown ink, brown wash, on brownish paper. 38.7 x 27.8 cm. Lined.

Inscribed in pen and brown ink on the Mariette mount, *SALVATOR ROSA NE . . . LI . . .*; on reverse of mount, *R. Willett's coll[n] 1808 WE; Formerly in the coll of Mariette at Mariette's Sale cost 450 francs.*

PROVENANCE: Pierre-Jean Mariette (Lugt 1852); Mariette sale, Paris, 1775-1776, no. 666; R. Willett (according to Esdaile's inscription on reverse of mount); William Esdaile (Lugt 2617); Alfred A. De Pass (Lugt Supp. 108a); presented by him to the Royal Institution of Cornwall, Truro (Lugt Supp. 2014e); sale, London, Christie's, November 30, 1965, no. 192, repr., purchased by the Metropolitan Museum.

BIBLIOGRAPHY: Stampfle and Bean, 1967, no. 106, repr. (with previous bibliography and exhibition listings); Mahoney, 1977, I, p. 378, no. 34.2, II, fig. 34.2.

Purchase, 1966, Rogers Fund
66.1

Study for the *Prodigal Son Herding Swine,* a painting now in the Hermitage in Leningrad that is generally assigned to the first half of the 1650s (repr. Salerno, 1975, pl. IL). In the painting the middle ground between the kneeling Prodigal and the clump of trees that rises on the right is crowded with animals; these were studied in a pen drawing formerly in the Odescalchi collection (repr. Mahoney, 1977, II, fig. 34.3).

When the present drawing was in William Esdaile's collection it was reproduced in reverse, with a few variations, in a chiaroscuro woodcut by John Skippe dated 1809. An old copy of the drawing is at Princeton (repr. Gibbons, 1977, no. 566).

327. *Turbaned Warrior Holding a Mace*

Pen and brown ink, brown wash, over a little black chalk. 13.2 x 8.2 cm.

PROVENANCE: William Esdaile (Lugt 2617); Prof. Einar Perman, Stockholm; purchased in Stockholm in 1970.

BIBLIOGRAPHY: Bean, 1972, no. 48; Mahoney, 1977, I, p. 440, no. 45.7, II, fig. 45.7.

Purchase, 1970, Rogers Fund
1970.101.12

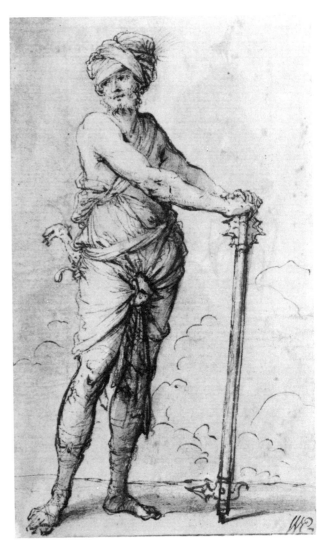

327

SALVATOR ROSA (NO. 327)

Rosa used this figure for one of the sixty-two etchings in the series of *Diverses figures* (Bartsch, XX, p. 281, no. 42), a project on which the artist was at work in 1656. In the etching the figure appears in reverse, and the spiked head of the mace has been omitted. In the drawing, light black chalk indications at the top of the mace suggest that Rosa thought of treating the weapon as a double-headed halberd.

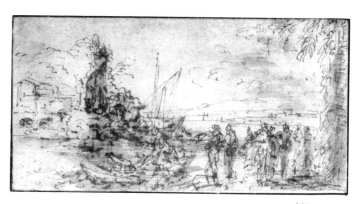

329

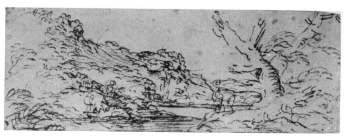

328. *Landscape with Hills and a Lake, Trees in Right Foreground*

Pen and brown ink. 5.3 x 14.5 cm. A number of gray spots.

PROVENANCE: Prof. Einar Perman, Stockholm; purchased in Stockholm in 1970.

BIBLIOGRAPHY: Bean, 1972, no. 47 (with previous bibliography); Mahoney, 1977, I, p. 508, no. 55.10, II, fig. 55.10.

Purchase, 1970, Rogers Fund
1970.101.16

This landscape is assigned by Michael Mahoney to the late 1650s.

329. *Seascape with Sailing Vessels and Figures*

Pen and brown ink, light brown wash. 6.6 x 13.0 cm.

Inscribed in pen and brown ink at lower right of old mount, *S. Rosa;* on verso, *180 2 WE p 80 N 131.*

PROVENANCE: William Esdaile (Lugt 2617); Prof. Einar Perman, Stockholm; purchased in Stockholm in 1970.

BIBLIOGRAPHY: Mahoney, 1977, I, pp. 508-509, no. 55.11, II, fig. 55.11.

Purchase, 1970, Rogers Fund
1970.101.18

Like the landscape above (No. 328), this drawing is dated by Mahoney in the late 1650s.

330. *Two Men Seen Three-Quarter Length*

Pen and brown ink, brown wash. 8.8 x 8.2 cm.

Inscribed in pen and brown ink on verso, *N° 39.*

PROVENANCE: Prof. Einar Perman, Stockholm; purchased in Stockholm in 1970.

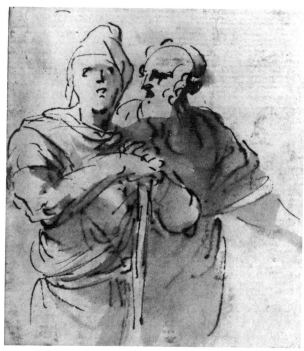

330

BIBLIOGRAPHY: Mahoney, 1977, I, p. 524, no. 60.2, II, fig. 60.2.

Purchase, 1970, Rogers Fund
1970.101.17

Mahoney suggests that this sketch offers an early idea for the two principal figures standing on the left in *St. John the Baptist Preaching in the Wilderness,* a painting formerly in the Walter Chrysler collection and now in the St. Louis Art Museum (repr. Salerno, 1963, pl. XVIII). This picture can be assigned to the end of the 1650s.

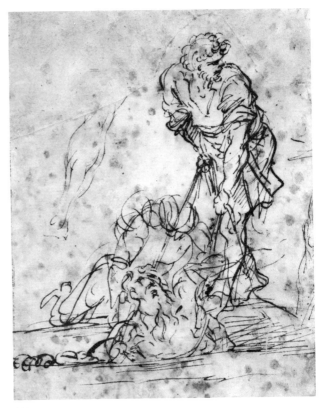

331. *Studies for a Figure Lifted from a Grave or Pit by Cords* VERSO. *Further Study of the Same Figure*

331

Pen and brown ink (recto and verso). 15.7 x 12.4 cm. Upper margin very irregular; upper corners filled in; a number of gray spots.

Inscribed in pen and brown ink on old mount, *Studio di un quadro al Popolo.*

PROVENANCE: John MacGowan, Edinburgh; Sir William Forbes, Pitsligo (sale, January 1804); Mrs. Peter Somervell, Kincardinshire (according to Sotheby's); sale, London, Sotheby's, March 28, 1968, no. 77(vi); purchased in New York in 1969.

BIBLIOGRAPHY: J. Bean, *Master Drawings,* VII, 1, 1969, pp. 56-57, fig. 1; Bean, 1972, no. 46; Mahoney, 1977, I, p. 581, no. 66.7, II, fig. 66.7 (both recto and verso repr.).

Purchase, 1969, Rogers Fund and Walter C. Baker Gift
69.20

Very probably a study for the figure of the prophet in Rosa's *Jeremiah Freed from the Pit,* now in the Musée Condé, Chantilly (repr. Salerno, 1975, pl. LIV). The *Jeremiah* was shown to the Roman public at S. Giovanni Decollato in 1662, and after Rosa's death was placed by his patron Carlo de' Rossi in the church of S. Maria in Montesanto, Piazza del Popolo—thus the old inscription on the mount of this drawing, "un quadro al Popolo." The painting was removed from S. Maria in Montesanto in 1802.

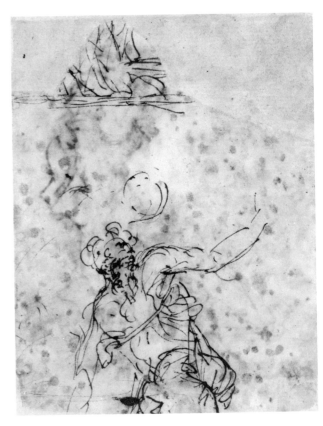

331 v.

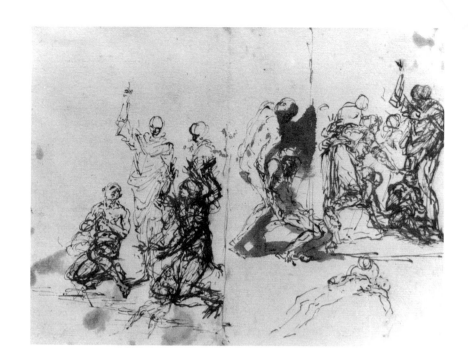

SALVATOR ROSA

332. *The Raising of Lazarus*

Pen and brown ink, brown wash, over a little black chalk. 20.1 x 27.5 cm. A number of brown stains at left. Lined.

Inscribed in pencil on reverse of old mount, *H-19-Salvator Rosa, 1615-1673—Parsons 1929 / 60 drawings, mostly his, all attributed to him.*

PROVENANCE: Dan Fellows Platt (Lugt Supp. 750a and 2066b); purchased in New York in 1938.

BIBLIOGRAPHY: Mahoney, 1977, I, p. 582, no. 66.8 (with previous bibliography), II, fig. 66.8.

Purchase, 1938, Harris Brisbane Dick Fund
38.179.2

These are composition sketches for the *Raising of Lazarus* painted for Carlo de' Rossi about 1662 and now in the Musée Condé, Chantilly (repr. Salerno, 1975, p. LVI).

333. *Studies of Kneeling Figures*

Pen and brown ink, brown wash. 20.2 x 14.1 cm. Lined.

Inscribed in pencil on reverse of old mount, *H-6 S.Rosa/Parsons 1929/ [most]ly his all attributed to him.*

PROVENANCE: Dan Fellows Platt; purchased in New York in 1938.

BIBLIOGRAPHY: Mahoney, 1977, I, p. 592, no. 66.27, II, fig. 66.27.

Purchase, 1938, Harris Brisbane Dick Fund
38.179.1

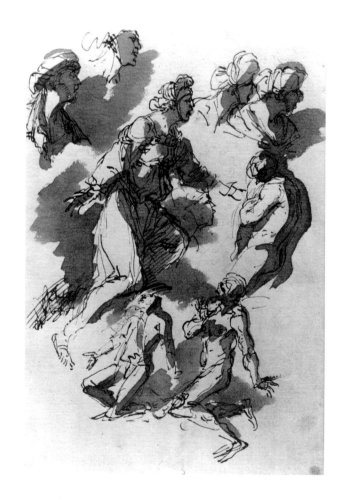

Mahoney points out that the kneeling male figures are studies for Tobit in the *Angel Leaving the House of Tobit* painted for Rosa's patron Carlo de' Rossi and now at the Musée Condé, Chantilly (repr. Salerno, 1975, no. 178). The kneeling female at the center may have also been sketched with the same picture in mind, or for a witness in the related *Raising of Lazarus* composition (see No. 332).

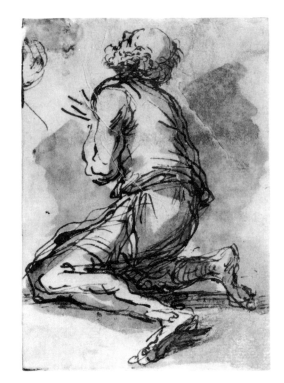

334. *Old Man Kneeling Facing Upper Left*

Pen and brown ink, brown wash. 11.1 x 8.2 cm. Repaired tear at upper right.

Inscribed in pen and brown ink on verso, *N⁰ 14*.

PROVENANCE: Prof. Einar Perman, Stockholm; purchased in Stockholm in 1970.

BIBLIOGRAPHY: Mahoney, 1977, I, p. 594, no. 66.32, II, fig. 66.32.

Purchase, 1970, Rogers Fund
1970.101.15

334

Study for the figure of Tobit in the Chantilly *Angel Leaving the House of Tobit*. See No. 333 above.

335

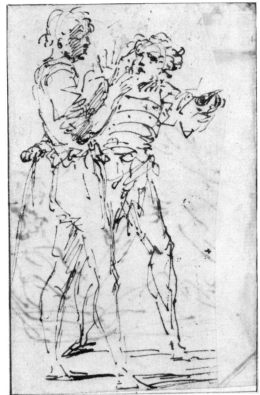

335. *Two Standing Men Gesticulating*

Pen and brown ink. Pen scribbles on verso are indistinctly visible on recto. 13.3 x 7.7 cm. Right margin cut irregularly. Lined.

PROVENANCE: Harry G. Friedman, New York.

BIBLIOGRAPHY: Mahoney, 1977, I, p. 596, no. 66.36, II, fig. 66.36.

Gift of Harry G. Friedman, 1960
60.66.13

On stylistic grounds, Mahoney groups this and the following sketch (No. 336) among the figure studies for the Chantilly biblical scenes which are datable around 1662.

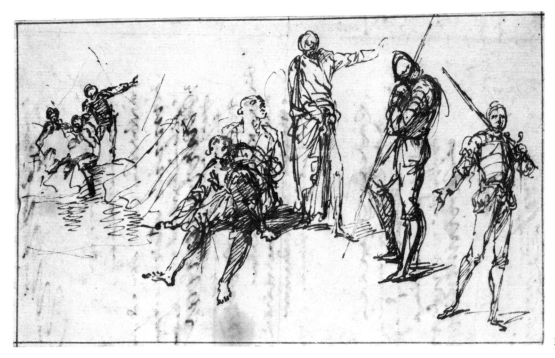

336

SALVATOR ROSA

336. *Two Standing Soldiers and Six Other Figures*

Pen and brown ink. Canceled and illegible pen inscriptions on verso. 11.1 x 19.0 cm. Repaired loss at left.

PROVENANCE: Prof. Einar Perman, Stockholm; purchased in Stockholm in 1970.

BIBLIOGRAPHY: Mahoney, 1977, I, p. 597, no. 66.39, II, fig. 66.39.

Purchase, 1970, Rogers Fund
1970.101.14

See No. 335 above.

337. *The Fall of the Giants*

Pen and brown ink, over charcoal. 26.1 x 19.5 cm. Lined.

PROVENANCE: Purchased in London in 1964.

BIBLIOGRAPHY: Stampfle and Bean, 1967, no. 108, repr.; M. Rotili, *Salvator Rosa, Incisore,* Naples, 1974, p. 230, fig. 106c; Mahoney, 1977, I, p. 620, no. 70.5 (with additional bibliography), II, fig. 70.5.

Purchase, 1964, Rogers Fund
64.197.6

Study for Rosa's large etching the *Fall of the Giants* (Bartsch, XX, p. 276, no. 21), which was completed by July 1663. Mahoney catalogues four further drawings that can be connected with this project; three of them (Rome, Farnesina; Dijon, Musée des Beaux-Arts; London, British Museum) are large designs nearly on the scale of the etching itself, which measures 72.0 x 47.3 cm.

338. *St. Paul, Hermit*

Pen and brown and black ink, brown wash, over black chalk, corrected and heightened in gray gouache. 29.2 x 19.4 cm. Several gray spots at center. Lined.

PROVENANCE: Probably Queen Christina of Sweden; Decio Cardinal Azzolini; Marchese Pompeo Azzolini; Prince Livio Odescalchi and then by descent to Prince Ladislao Odescalchi; first drawing in Odescalchi Album *A* (according to Mahoney); purchased in Berlin in 1976.

BIBLIOGRAPHY: L. Salerno, *Storia dell'arte,* V, 1970, fig. 62; Mahoney, 1977, I, p. 625, no. 70.16, II, fig. 70.16.

Purchase, 1976, Harry G. Sperling Fund
1976.331.1

337

SALVATOR ROSA

338

A study for the *St. Paul, Hermit* now in the Pinacoteca di Brera, Milan (repr. Salerno, 1963, pl. 52). This painting was commissioned from Rosa in Rome by Cardinal Luigi Alessandro Omodei for his chapel in the church of S. Maria della Vittoria, Milan. For this chapel Omodei also commissioned from Rosa an *Assumption of the Virgin,* which is now in the church of St-Thomas-d'Aquin, Paris (repr. Salerno, 1975, no. 156). As a pendant to Rosa's *St. Paul, Hermit,* he commissioned a *St. John the Baptist in the Wilderness* in which the figure of the Baptist was painted by Pier Francesco Mola and the landscape by Gaspar Dughet (repr. R. Cocke, *Pier Francesco Mola,* Oxford, 1972, pl. 127). In these pendants, landscape plays an exceptionally important role. The present drawing, an extraordinary virtuoso performance full of whirlwind *repentirs,* is dated by Mahoney on stylistic grounds to the early 1660s, which is a plausible date for the painting as well.

339. *Studies of a Man's Head in Profile, and of a Standing Male Figure*

Pen and brown ink, pale brown wash. 17.1 x 18.4 cm.

Inscribed in pen and brown ink on verso, *Rob^t Udny coll^n 1803* [WE] *P80. N 100.*

PROVENANCE: Robert Udny (according to Esdaile's inscription on verso); William Esdaile (Lugt 2617); Sir Thomas Lawrence (Lugt 2445); Harry G. Sperling, New York.

BIBLIOGRAPHY: Mahoney, 1977, I, p. 639, no. 73.1, II, fig. 73.1.

Bequest of Harry G. Sperling, 1975
1975.131.47

Michael Mahoney identified these pen sketches as studies for one of the principal conspirators in Rosa's *Oath of Catiline.* The painting was exhibited in Rome in 1663 and found its way to the Martelli collection in Florence, where it is still said to be preserved (repr. Salerno, 1975, no. 180). In the Pitti there is an old copy of the painting, attributed by some to Niccolò Cassana.

339

SALVATOR ROSA

340. *Three Figures around a Globe*

Pen and brown ink, brown wash, over some black chalk. 23.5 x 19.7 cm.

Inscribed in pen and brown ink at lower center, *mi gratto;* at upper right, *scortica;* at upper left, *sueno* [?]

PROVENANCE: Earl Spencer (Lugt 1531); Spencer sale, London, T. Philipe, June 10-17, 1811, no. 685; Prof. Einar Perman; purchased in Stockholm in 1968.

BIBLIOGRAPHY: Mahoney, 1977, I, p. 712, no. 84.7 (with previous bibliography), II, fig. 84.7.

Purchase, 1968, Rogers Fund
68.56

The allegorical subject is unclear, and in the 1811 Spencer sale the drawing was tentatively described as "Three figures—geographers studying the globe." The female figure to the right of the terrestrial globe seems to be tearing off the epidermis of the earth, and, in fact, Rosa's inscription above her reads "scortica" (she flays). The inscription above the figure standing at the upper left is not clear, but the kneeling figure at left is described by an inscription "mi gratto" (I scratch myself). Another drawing for this mysterious composition is in the Musée des Beaux-Arts at Orléans (repr. Mahoney, 1977, II, no. 84.6). No painting of the subject is known.

341. *Witches' Sabbath*
VERSO. *Figures Gathered around a Tree*

Pen and brown ink, brown wash (recto and verso); framing lines in black chalk. 21.8 x 31.7 cm.

Inscribed in pen and brown ink at upper left of recto with a cross within a circle.

PROVENANCE: Probably Queen Christina of Sweden; Decio Cardinal Azzolini; Marchese Pompeo Azzolini; Prince Livio Odescalchi and then by descent to Prince Ladislao Odescalchi; the sixth drawing in the Odescalchi Album *A* (according to Mahoney); purchased in Berlin in 1976.

BIBLIOGRAPHY: Mahoney, 1977, I, pp. 698-699, no. 82.12, II, fig. 82.12 (both recto and verso repr.).

Purchase, 1976, Harry G. Sperling Fund
1976.331.2

The *Witches' Sabbath* on the recto, sketched at an almost delirious speed, can be assigned to the late 1660s; thus it is some twenty years later than the somewhat more staid *Stregoneria* that is a study for a painting in the Corsini collection (see No. 325 above). The present drawing cannot be connected with a picture.

The scene on the verso—a crowd watching with amazement or dismay as a figure chops a tree—is mysterious. Mahoney records the suggestion of Prof. James Bradley of Trinity College, Hartford, that the subject might embody a theme of moral transgression upon primeval innocence: the felling of the tree from which the Argonauts fashioned their ship—an episode used as a symbol of man's corruption of the natural order through the introduction of seafaring.

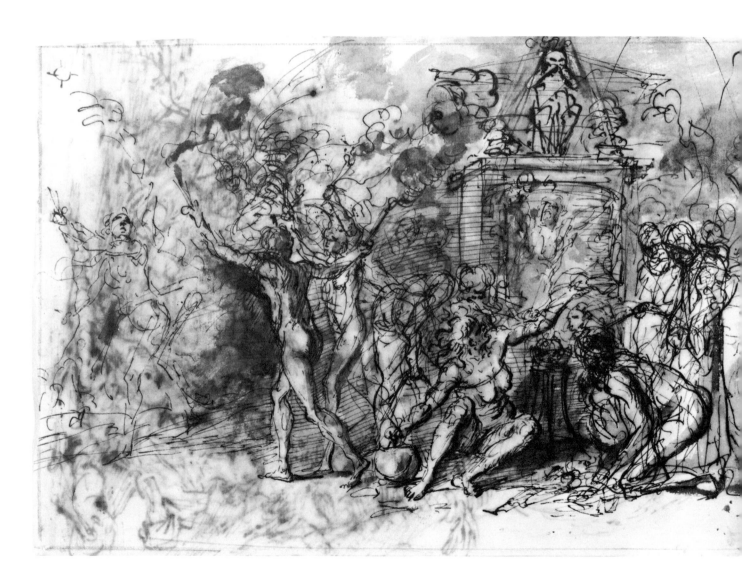

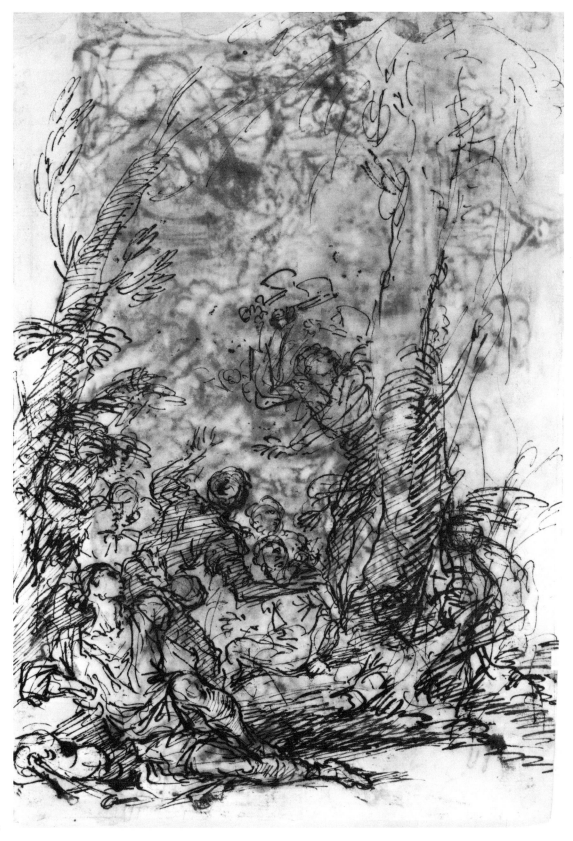

341 v.

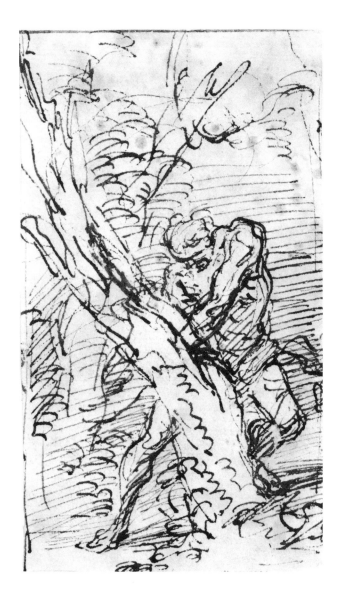

SALVATOR ROSA

342. *Milo of Crotona*

Pen and brown ink. 14.1 x 8.4 cm. Several brown stains at upper right. Lined.

PROVENANCE: Purchased in London in 1966.

BIBLIOGRAPHY: Mahoney, 1977, I, p. 675, no. 79.8 (with previous bibliography), II, fig. 79.8.

Purchase, 1966, Rogers Fund
66.133

Mahoney points out that this drawing is one of a group of four studies for a *Milo of Crotona*, a subject that does not seem to have been actually painted by Rosa. On stylistic grounds Mahoney dates these drawings about 1666.

ANDREA SACCHI

Rome? 1599/1600 – Rome 1661

343. *The Drunkenness of Noah*

Red chalk. 18.6 x 25.9 cm. Repaired losses at left margin.

Inscribed in pen and brown ink at lower left, *Andrea Sacchi.f.¹ 1625.;* numbered at upper left and right, 52.; inscribed on verso, *Coll.ᵉ Lawrence.*

PROVENANCE: Sir Thomas Lawrence ? (according to inscription on verso; there is no trace of the Lawrence mark); purchased in New York in 1977.

BIBLIOGRAPHY: *Old Master Drawings. Armando Neerman,* exhibition catalogue, London, 1975, no. 24, repr.; Harris, 1977, p. 95, under no. 72; Harris, 1978, p. 602, fig. 83.

Purchase, 1977, Harry G. Sperling Fund
1977.168

Finished study for the *Drunkenness of Noah,* a Sacchi composition so popular that eleven versions are recorded. Two of these are dated 1644-1648 by Ann Sutherland Harris on documentary and stylistic grounds. She reproduces three: the versions in the Staatliche Museen in East Berlin, the Kunsthistorisches Museum in Vienna, and the Museo Provinciale in Catanzaro (repr. Harris, 1977, pls. 145, 146, and 147, respectively); she also reproduces a red chalk study for the figures of Noah and Ham at Windsor Castle and lists a red chalk composition sketch in Düsseldorf, which differs in several ways from the painting (Harris, 1977, pl. 144; the Düsseldorf drawing is reproduced in *Master Drawings of the Roman Baroque from the Kunstmuseum Düsseldorf,* exhibition catalogue, London, 1973, no. 139).

344. *Two Warriors, One Standing, The Other Clinging to a Tree*

Pen and brown ink, brown wash, over red chalk, on brownish paper. 23.7 x 15.1 cm. Irregular margin at right made up. Verso rubbed in red chalk for transfer.

Inscribed faintly in red chalk at lower left corner, *S. Rosa.*

PROVENANCE: Purchased in New York in 1969.

BIBLIOGRAPHY: Bean, 1972, no. 49; Harris, 1977, p. 102 under no. 85, fig. 169.

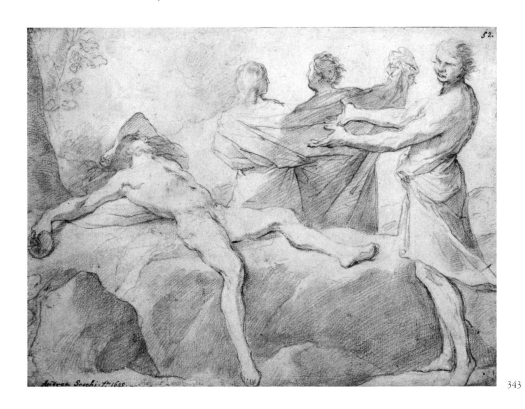

343

Purchase, 1969, Rogers Fund and Mr. and Mrs. Arnold Whitridge Gift
69.21

These two figures appear in a scene from ancient history engraved by Charles Audran (repr. Harris, 1977, pl. 171). The subject was recently described by Ann Sutherland Harris as *Romulus Decorating the Sacred Oak Tree on the Capitol,* while Le Blanc identifies the scene as "Xerxès faisant attacher des couronne et des colliers aux branches d'un arbre" (Le Blanc, I, p. 89, no. 324). The conspicuous presence of camels and emblems of the sun in the engraved composition would seem to give weight to Le Blanc's identification of the subject as Xerxes adorning the plane tree (Herodotus, *History,* VII, 31).

A design for the whole composition is in the Witt Collection, Courtauld Institute, while a study for the kneeling and standing soldiers and the camels' heads, which appear on the left in the engraving, is preserved in the Cabinet des Dessins of the Louvre (repr. Harris, 1977, pls. 168 and 170, respectively). All these drawings are clearly in Sacchi's hand, and identify him as the author of the design engraved by Audran. The print bears only the engraver's name, and Le Blanc lists the design as an invention of Sacchi's pupil, Camassei.

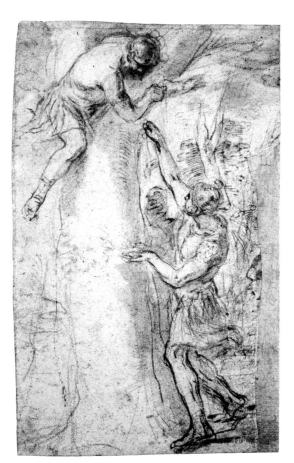

344

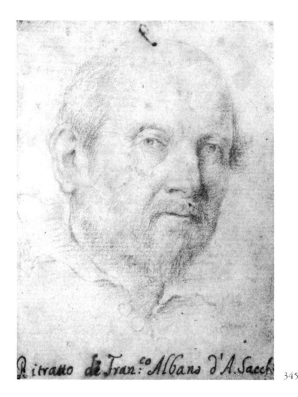

345

ANDREA SACCHI

345. *Portrait of a Man: Francesco Albani?*

Red and black chalk. 9.5 x 7.0 cm.

Inscribed in pen and brown ink at lower margin, *Ritratto di Fran:co Albana d'A. Sacchi;* numbered at upper margin of verso, 9 (this number has bled through to the recto).

PROVENANCE: Sale, London, Sotheby's, March 6, 1973, no. 330, repr.; David Peel, London; purchased in London in 1978.

BIBLIOGRAPHY: *Old Master Drawings. P. and D. Colnaghi and Co.,* exhibition catalogue, London, 1951, no. 9; Harris, 1977, p. 77, mentioned under no. 44; Harris, 1978, p. 601, fig. 84.

Purchase, 1978, Harry G. Sperling Fund
1978.276

This finely executed and penetrating portrait may not represent Francesco Albani, but it seems to be correctly attributed to Andrea Sacchi on stylistic grounds. The prime version of Sacchi's painted portrait of his master Albani, datable 1635, is in the Prado (repr. Harris, 1977, no. 44, pl. 74). The Madrid portrait represents a younger man with larger eyes and more prominent nose. Ann Sutherland Harris, who had originally rejected the present drawing, now accepts it as an autograph work by Sacchi.

ANDREA SACCHI, attributed to

346. *Portrait of Cardinal Antonio Barberini the Younger*

Red chalk. 12.9 x 10.2 cm. Lined.

Inscribed in pen and brown ink at upper right, *A. Sachi* [sic]; on reverse of old mount, *L'eminentissimo Sign.re Sign.re Cardinale Barberini.*

PROVENANCE: John Barnard (Lugt 1419); purchased in London in 1966.

BIBLIOGRAPHY: Harris, 1977, p. 93 under no. 67-2.

Purchase, 1966, Rogers Fund
66.51

For Ann Sutherland Harris, this drawing is not by Sacchi himself, but rather a derivation from Cornelis Bloemaert's engraved portrait of Cardinal Antonio Barberini the Younger in Teti's *Aedes Barberinae* of 1642. It was one of a series of engraved Barberini portraits said by Baldinucci to have been based on drawings by Sacchi. The present drawing is indeed in the same direction as Bloemaert's engraved portrait, though the latter is oval

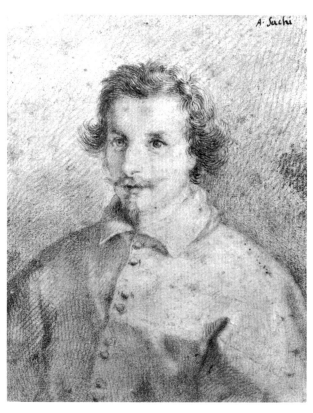

346

in format (repr. Harris, 1977, pl. 139). The quality of the drawing is high, and it does not appear to be a mere copy after the engraving. Furthermore, it is executed with a delicacy and precision that characterize a number of Sacchi's red chalk drawings – thus the old attribution of this portrait to Sacchi should have a considerable weight. The artist is known to have painted at least two portraits of Cardinal Antonio the Younger.

Karl Noehles has suggested that a black chalk oval portrait drawing in West Berlin is Sacchi's study for Bloemaert's engraved representation of Cardinal Francesco Barberini in *Aedes Barberinae* (KdZ 25044; repr. Noehles, 1970, p. 90, fig. 73). The Berlin drawing (which is in the reverse direction from the engraving) is looser in handling than the Metropolitan's portrait of Cardinal Antonio, but they are by no means stylistically incompatible.

ANDREA SACCHI, circle of

347. *Back View of a Seated Male Nude*

Red chalk on beige paper. 39.7 x 26.5 cm. Brown stain at upper left. Lined.

Inscribed in pen and brown ink at lower margin of old mount, *Andrea Sacchi*.

PROVENANCE: Jonathan Richardson, Sr. (Lugt 2184); Prof. John Isaacs; Isaacs sale, London, Sotheby's, February 27, 1964, part of no. 67, purchased by the Metropolitan Museum.

Purchase, 1964, Rogers Fund
64.48.4

A good example of the sort of red chalk academy traditionally associated with Andrea Sacchi and his circle.

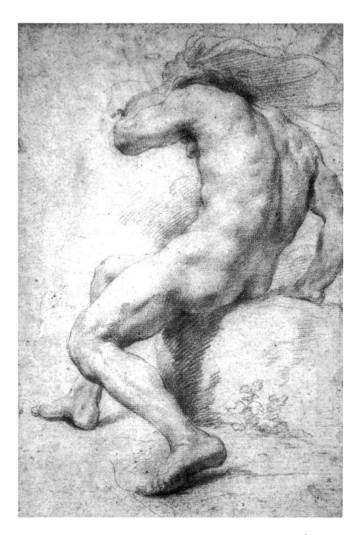

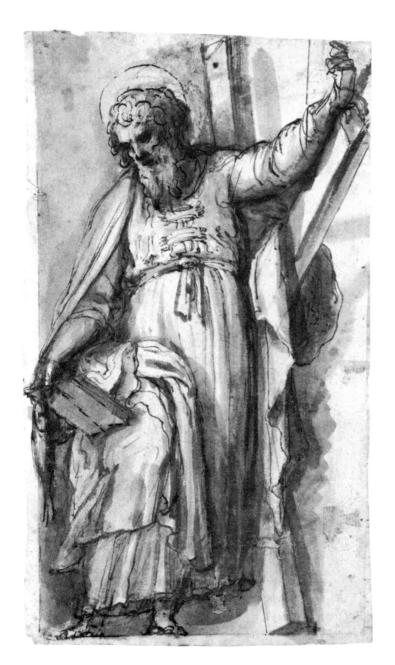

FABRIZIO SANTAFEDE
Naples ca. 1555 – Naples ca. 1630

348. *St. Andrew, Apostle, with Transverse Cross, Book, and Fish*

Pen and brown ink, gray-brown wash, over red chalk. Design for a frame in red chalk on verso. 24.4 x 14.0 cm. Repaired losses at upper margin and at lower right.

Inscribed in pencil on verso, $S^{ta}Fede$.

PROVENANCE: Don Sebastien Gabriel de Borbón y Braganza (1811-1875); Don Pedro Alcántara de Borbón y Borbón, Duke of Dúrcal (1862-1892); Dúrcal sale, New York, American Art Galleries, April 10, 1889, part of no. 220; Henry Walters.

Gift of Henry Walters
17.236.28

The attribution to Santafede is traditional and is not in any way inconsistent with the style of a drawing in the Louvre (*Kneeling Saint,* inv. 9772) and another in Darmstadt (*Artists at Work,* AE 1575, repr. *Stift und Feder,* 1928, no. 37), both attributed to Santafede by Mariette. For comments on Santafede's draughtsmanship, see Vitzthum, Paris, 1967, under no. 7.

IL SASSOFERRATO (Giovanni Battista Salvi)
Sassoferrato 1609 – Rome 1685

349. *The Holy Family with the Infant St. John the Baptist*

Black chalk and a little white chalk, on blue paper. Squared in black chalk. 25.3 x 35.7 cm. Lined.

Inscribed in pen and brown ink at lower margin of old mount, *Sassoferrato;* on reverse of old mount, *... Udny's coll^n 1803 WE. P93. N27.*

PROVENANCE: Robert Udny (Lugt 2248); William Esdaile (Lugt 2617); William Mayor (Lugt 2799); purchased in New York in 1974.

BIBLIOGRAPHY: Bean, 1975-1976, no. 29.

Purchase, 1974, Rogers Fund
1974.73

Squared composition study for a painting on copper of almost exactly the same size as the drawing, formerly in the collection of the Earl of Northbrook, that was sold at

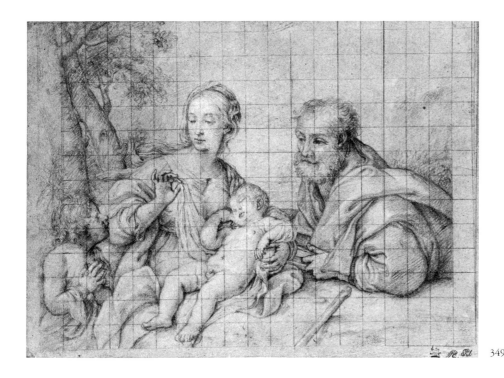

349

Christie's on June 11, 1937, no. 17. The painting, the present whereabouts of which is unknown, was described in J. P. Richter's *A Descriptive Catalogue of the Collection of Pictures Belonging to the Earl of Northbrook,* London, 1889, no. 212.

350. *Studies of Two Flying Putti and of Drapery* VERSO. *Seated Virgin and Child, and Kneeling Child*

Black chalk on blue paper. Recto partially squared in black chalk. 18.0 x 23.8 cm.

PROVENANCE: Harry G. Sperling, New York.

Bequest of Harry G. Sperling
1975.131.48

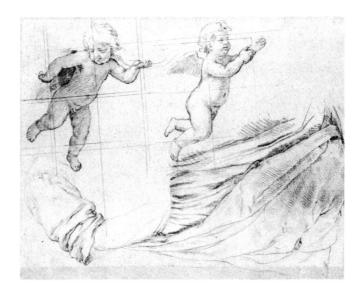

Dean Walker has pointed out that the Virgin and Child with attendant putto on the verso corresponds to the figures in the upper part of Sassoferrato's painting the *Virgin and Child Appearing to St. Francis of Paola,* in the sacristy of S. Francesco de Paola, Rome (repr. Waterhouse, 1976, fig. 69). In the painting the Christ Child holds a disk inscribed with the motto *Charitas.*

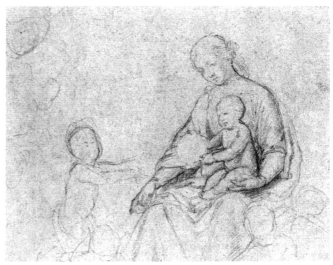

350 v.

BARTOLOMEO SCHEDONI

Modena 1578 – Parma 1615

351. *The Last Supper*

Red, blue, yellow-brown, brown, green, and mauve oil paint on paper, pasted onto canvas. 23.7 x 36.8 cm.

PROVENANCE: F. D. Lycett Green; Lord Derwent (according to vendor); purchased in New York in 1961.

Purchase, 1961, Rogers Fund
61.27

Very possibly a *bozzetto* for Schedoni's *Last Supper* painted for the refectory of the Capuchins at Fontevivo, and now in the Gallery at Parma (no. 132; see V. Moschini, *L'Arte,* XXX, 1927, pp. 145-146). Payment for the transportation of the painting to Fontevivo is recorded in 1608. There are slight differences between the oil sketch and the finished painting, particularly in the physiognomy of Christ. No other such oil sketch on paper by Schedoni has to my knowledge survived, but the vigorous brushwork, the chiaroscuro, and the color scheme seem characteristic of him. The strong influence of the Veneto, and especially of the art of Jacopo Bassano, is apparent here.

Another version of the painting is preserved in the Parma Gallery; this differs in the addition of an architectural background and the continuation of the composition at the bottom to include the lower legs and feet of the apostles in the foreground (no. 905; repr. A. Ghidiglia Quintavalle, *Tesori nascosti della Galleria di Parma,* Parma, 1968, no. 55, fig. 32). A small painting of the *Ultima Cena* in the Viezzoli collection in Genoa differs considerably from the two versions in Parma, and its fragile, mannered forms suggest an earlier date (repr. *Maestri della pittura del Seicento emiliano,* exhibition catalogue, Bologna, 1959, no. 104).

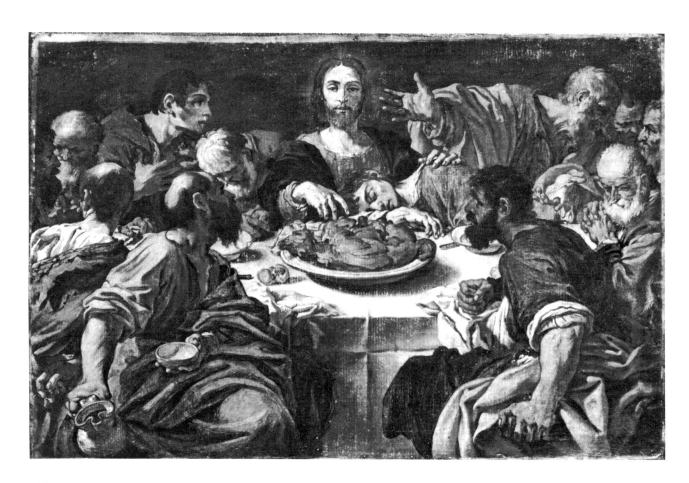

ELISABETTA SIRANI

Bologna 1638 – Bologna 1665

352. *The Finding of Moses*

Brush and brown wash, heightened with white, over black chalk, on gray-blue paper. 49.9 x 33.1 cm. Framing lines in black chalk. Lined.

PROVENANCE: Purchased in New York in 1962.

BIBLIOGRAPHY: Stampfle and Bean, 1967, no. 130, repr.; Roli, 1969, p. 38, no. 49, repr.

Purchase, 1962, Rogers Fund
62.21

GIOVAN GIOSEFFO DAL SOLE

Bologna 1654 – Bologna 1719

353. *Christ and the Canaanite Woman*

Brown and cream oil paint, on a sheet imprinted with a Latin text. 37.5 x 26.4 cm. Lined.

Inscribed in pencil at lower margin of old mount, *Giov Gius dal Sole 1654-1719*.

PROVENANCE: Purchased in Zurich in 1965.

BIBLIOGRAPHY: M. Gregori, in *Kunst des Barok in der Toskana*, Munich, 1976, p. 381, fig. 26; *Sammlung Schloss Fachsenfeld,* 1978, mentioned under no. 41.

Purchase, 1965, Rogers Fund
65.128

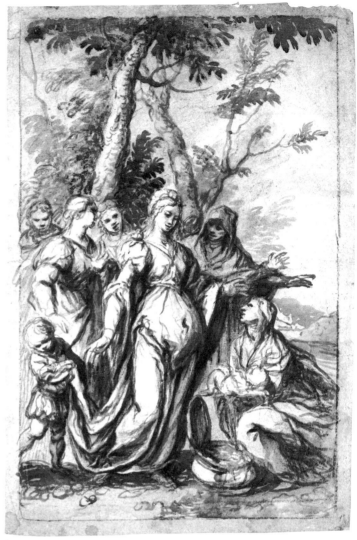

352

Dal Sole often used printed pages as supports for his oil sketches, and when these were fresh the printing was, presumably, almost entirely masked by the pigment. The letters seem to have "bled through" in the course of time. Other examples by Dal Sole of this practice are at Windsor Castle and the Louvre (see Kurz, 1955, pp. 100-101), in the Uffizi (Johnston, 1973, pp. 91-92), the Koenig-Fachsenfeld collection (*Sammlung Schloss Fachsenfeld,* 1978, no. 36, repr.), and in the Pinacoteca Nazionale, Bologna (*The Finding of Moses,* no. 1837). A stylistically similar oil sketch on a printed page is in the Kunsthalle, Hamburg (inv. 21175). It represents a saint in ecstasy supported by an angel and has an old attribution to G. G. dal Sole's pupil Antonio Consetti (Modena 1686-1766).

The subject here has been described as Christ and the Adulteress, but Dr. Christel Thiem is no doubt right in suggesting that the scene represents the Canaanite woman imploring Jesus to exorcize her daughter (Mark 7:24-30). The figures of Christ, with his left arm dramatically extended, and of the kneeling Canaanite are strikingly similar in pose to those in an oil sketch in the Koenig-Fachsenfeld collection (repr. *Sammlung Schloss Fachsenfeld,* 1978, no. 41). This sketch is traditionally and very plausibly attributed to Dal Sole's master, Lorenzo Pasinelli, but Christel Thiem has proposed an alternative – and not very convincing – attribution to Felice Torelli (Verona 1667-Bologna 1748).

Mina Gregori suggests that Dal Sole's composition may have inspired a painting of the same subject by

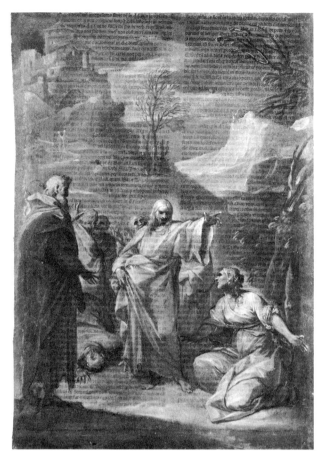

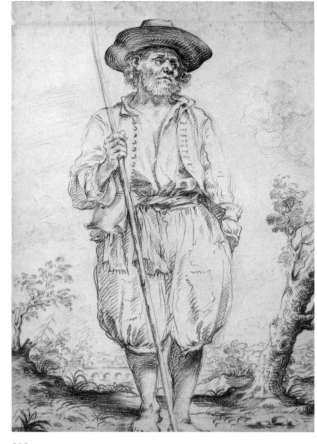

354

GIOVAN GIOSEFFO DAL SOLE (NO. 353)

Giovan Domenico Ferretti in the Oratorio della Madonna, S. Giovanni Valdarno (M. Gregori, *op. cit.,* p. 380, fig. 25).

354. *Standing Countryman Holding a Staff*

Red chalk. 29.1 x 21.0 cm. Repaired tear at upper right. Lined.

Inscribed in pen and brown ink on a piece of paper formerly attached to old mount, *A. di 27 Settimb 1672 | è di Giovan Josepe filio di M⁰ | Antonio M.ᵃ dal Sole d.ᵗᵒ Il Monchino | da li Paesi . . . è un garzone . . . sosia d'un contadino a terra di me | Ales.⁰ Fava.*

PROVENANCE: Alessandro Fava, Bologna; purchased in London in 1962.

BIBLIOGRAPHY: Roli, 1969, p. 45, no. 59, repr. (with previous bibliography).

Purchase, 1962, Rogers Fund
62.132.5

Alessandro Fava's inscription on the old mount is dated September 1672; thus the drawing is quite an early work by Dal Sole. The model is said to have a striking likeness to a peasant on one of Fava's estates.

FRANCESCO SOLIMENA

Canale di Serino 1657 – Barra 1747

355. *The Prophetess Deborah Ordering Barak to Take Arms against Sisera*

Brush and black ink, gray wash, over black chalk. Small black chalk sketch of a nude male figure on verso. 37.9 x 30.3 cm. Horizontal crease near upper margin.

Numbered in brush and gray wash at lower right, *8*; in pen and brown ink on verso, *g [?] 18.*

PROVENANCE: Purchased in London in 1963.

BIBLIOGRAPHY: Bean and Stampfle, 1971, no. 3, repr. (with previous bibliography).

Purchase, 1963, Rogers Fund
63.98.1

Study for a painting by Solimena executed in Naples during the vice-regency of Alois Raimund von Harrach, which extended from 1728 to 1733, and now in the Harrach palace in Vienna (repr. Bologna, 1958, pl. 175). A drawing in the Uffizi (6746 Santarelli; repr. Bologna, 1958, pl. 174), less pictorial and more calligraphic in character, is closer to the picture, and Walter Vitzthum pointed out that the two drawings represent the extreme poles of Solimena's stylistic gamut as a draughtsman. His technique is extraordinarily loose and free in his first sketches, while his finished drawings are elegantly elaborated.

355

FRANCESCO SOLIMENA

356. *The Triumph of David*

Black chalk. Design for a door or window frame on verso. 16.2 x 22.2 cm. Horizontal crease above center.

Numbered in pen and brown ink at lower left, *31*; at lower right, *282* [?].

PROVENANCE: Benno Geiger; sale, London, Sotheby's, December 7-10, 1920, part of no. 305; sale, London, Christie's, June 25, 1974, no. 194, repr.; purchased in London in 1976.

Purchase, 1976, Harry G. Sperling Fund
1976.236

De Dominici records a *Triumph of David* "che entra glorioso a Cavallo con la testa di Golia," painted by Solimena and given to King Philip V of Spain (De Dominici, 1742, III, p. 593). Such a painting cannot presently be traced in Spain, but a version of the subject, corresponding in many ways to the drawn composition, was in the A. Geri sale, Settignano, April 25–May 2, 1930, no. 31, repr., mistakenly described as "Incontro di Salomone con la Regina di Saba."

357. *Allegorical Figure of Study*

Pen and brown ink, gray wash, over black chalk. 14.5 x 19.7 cm. Spots of blue and red pigment at right; all four corners cut away. Lined.

PROVENANCE: Prof. John Isaacs; sale, London, Sotheby's, January 28, 1965, part of no. 162, as Italian school, seventeenth century; purchased in London in 1965.

Purchase, 1965, Rogers Fund
65.66.11

This drawing, certainly very close in style to Solimena if not by the master himself, was formerly described as a representation of John the Evangelist. Lawrence Turčić has supplied the correct identification. The figure is *Studio* with his attributes: a book, a lamp, and a cock.

358. *The Continence of Scipio*

Pen and brown ink, gray wash, over black chalk. 42.0 x 56.6 cm. Upper left corner made up. Lined.

PROVENANCE: Purchased in London in 1971.

BIBLIOGRAPHY: Bean, 1972, no. 51.

Purchase, 1971, Rogers Fund
1971.222.3

The *Continence of Scipio* is also the subject of a Solimen-esque black chalk drawing in the Royal Museum of Fine Arts, Copenhagen ("Collection de Solimène," II, 17; Gernsheim photo no. 73750). There are differences between the two composition studies; for example, in the Copenhagen version the fiancée kneels, and the *repoussoir* figure in the right foreground holding a vase is omitted. No painting is known, but the frieze-like grouping of the massive figures is very similar to that in the *Dido Receiving Aeneas* in the National Gallery, London (no. 6397), which also includes a very similar half-figure in the foreground. The London picture is generally dated in the 1720s.

De Domenici does not mention the *Continence of Scipio* as a subject treated by Solimena in a painting, and the hopes elicited by an etching of this subject by Karl Mathias Ernst (1758-1830) entitled "La Continence de Scipion l'Africain, d'après le tableau original de Fr. Solimène qui se trouve dans la Galerie Royale de Munic

357

[*sic*]" prove to be illusory. The etching reproduces a composition by Sebastiano Ricci, the best version of which is in the English Royal Collection (repr. Daniels, 1976, pl. III). The painting engraved by Ernst is no longer in the Bavarian State Collections.

358

FRANCESCO SOLIMENA, attributed to

359. *Draped Female Figure Reclining by a Globe, and a Study of Her Head*

Black chalk, heightened with white, on brownish paper. 29.3 x 37.8 cm. Upper margin irregular and made up; the head study at upper left may have been originally attached to the upper margin at right, then pasted to the present sheet. Lined.

Inscribed on the Mariette mount within a cartouche, *FRANCISCUS SOLIMENA.*

PROVENANCE: Pierre-Jean Mariette (Lugt 2097); not identifiable in catalogue of 1775-1776 Mariette sale; purchased in London in 1970.

Purchase, 1970, Rogers Fund
1970.242.1

This drawing appears at first glance to be the work of a French artist of the seventeenth century, very close to Simon Vouet. It is included here with the attribution to Solimena that was supplied by P.-J. Mariette, who knew Neapolitan drawings remarkably well, and had a particular *penchant* for the elegant draughtsmanship of Solimena. It is to be hoped that the illustration of this drawing may elicit a new attribution or a confirmation of Mariette's identification.

TANZIO DA VARALLO (Antonio d'Enrico)

Riale di Alagna ca. 1580 – Novara? 1635

360. *Priest with Upraised Arms Wearing a Two-Horned Tiara*

Red chalk on red-washed paper. 21.7 x 12.9 cm. Several brown stains.

PROVENANCE: Walter C. Baker, New York.

BIBLIOGRAPHY: Virch, 1962, no. 30.

Bequest of Walter C. Baker, 1972
1972.118.17

Claus Virch reported that the correct attribution to Tanzio is due to Janos Scholz; the drawing had formerly been ascribed to the young Watteau.

PIETRO TESTA

Lucca 1612 – Rome 1650

361. *The Triumph of Galatea*

Pen and brown ink, over black chalk, on blue paper. Squared in black chalk. 27.1 x 37.9 cm. Brown stains at lower left and right; repaired loss at upper left.

PROVENANCE: Purchased in London in 1968.

Purchase, 1968, Rogers Fund
68.54.3

Composition study for Testa's painting the *Triumph of Galatea,* formerly in the Galleria Civica at Lucca (repr. *L'Arte,* XXIV, 1921, p. 14, fig. 5). There are a number of variations between drawing and painting.

362. *The Presentation of the Virgin in the Temple*
VERSO. *Another Design for the Same Composition*

Pen and brown ink, brown wash, on beige paper (recto); pen and brown ink (verso). 36.7 x 26.2 cm. Repaired losses at lower left.

Inscribed in pen and brown ink at lower left of recto, *P Testa;* at upper left of verso in the artist's hand, *più sù;* at upper margin of verso in another hand, *Orig⁶ di Pietro Testa. Il dipinto è in Roma nella Chiesa dei Lucchesi.*

PROVENANCE: Thomas Hudson (Lugt 2432); Uvedale Price (Lugt 2048); Price sale, London, Sotheby's, May 3-4, 1854, no. 240, as Testa, "The Saviour received at the Gates of the Temple"; Major S. V. Christie-Miller, Clarendon Park, Salisbury; purchased in London in 1971.

361

362

PIETRO TESTA (NO. 362)

BIBLIOGRAPHY: Bean, 1972, no. 52; H. Brigstocke, *Paragone*, XXVII, 321, 1976, pp. 21-22, pl. 41 (recto), pl. 42 (verso).

Purchase, 1971, Rogers Fund
1971.241

As the old inscription on the verso correctly suggests, both the recto and the verso offer composition designs for the *Presentation of the Virgin in the Temple*, Testa's most important altarpiece, painted for the church of S. Croce dei Lucchesi, Rome, and now in the Hermi-

362 v.

tage, Leningrad (repr. *Paragone*, XXVII, 321, 1976, fig. 39). Both designs differ in detail from the painting, but the drawing on the verso comes closer to, and is in the same direction as, the composition of the altarpiece. Before the rediscovery of this double-faced sheet, Ann Sutherland Harris had identified two drawings in the Teyler Museum at Haarlem as studies for the Leningrad picture (D31 and D32, the former repr. *Paragone*, XVIII, 213, 1967, fig. 57b; the latter repr. *Paragone*, XXVII, 321, 1976, fig. 40).

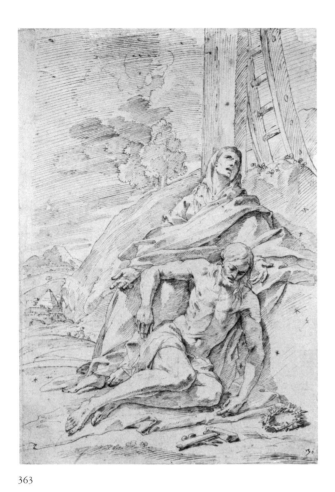

363

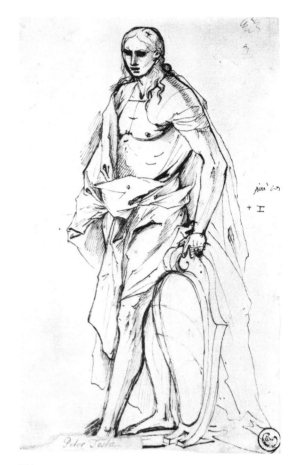

364

PIETRO TESTA

363. *The Virgin Lamenting over the Dead Christ*

Pen and brown ink, on beige paper. 32.5 x 23.0 cm. Lined.

Numbered in pen and dark brown ink at lower right, *30*; inscribed in pencil on reverse of old mount, *Pietro Testa*.

PROVENANCE: Purchased in London in 1964.

Purchase, 1964, Rogers Fund
64.38.2

364. *Standing Male Figure Supporting a Shield*

Pen and brown ink, over a little black chalk, on beige paper. 23.3 x 14.5 cm. Lower margin irregular and made up. Lined.

Inscribed in pen and brown ink in the artist's hand at right margin center, *più . . . / +I*; in another hand at lower margin, *Peter Testa*.

PROVENANCE: Richard Cosway (Lugt 628); E. A. Wrangham (according to Sotheby's); sale, London, Sotheby's, July 8, 1964, no. 18; purchased in London in 1964.

BIBLIOGRAPHY: E. Cropper, *Grafica,* 1-4, 1977, repr. p. 92, fig. 7.

Purchase, 1964, Rogers Fund
64.201

In the British Museum there is another study for the same youthful standing male figure wearing armored shoulder plates; there the band across the shield bears the motto [LI]BERTAS (1946-7-13-810). This figure appears standing at the right in a composition representing the Virgin enthroned and attended by saints, which is studied in a drawing at the Teyler Museum, Haarlem (D28; repr. Van Regteren Altena, 1966, fig. 107), and in another at Darmstadt (AE 1746; repr. *Stift und Feder,* 1928, no. 16). The inscription *Libertas,* motto of Testa's native Lucca, also appears on the shield held by the same standing male figure in the Haarlem composition

sketch. Elizabeth Cropper suggests that this figure is St. Martin of Tours, to whom the cathedral in Lucca is dedicated. The presence of a panther in the foreground of both the Darmstadt and Haarlem composition studies is another local reference, for this animal is emblematic of Lucca. No painting by Testa that can be associated with these four drawings is recorded.

365. *Nude Youth Running*
VERSO. *Standing Draped Old Man with Left Hand Upraised*

Black chalk on gray paper. 34.5 x 23.0 cm.

Inscribed in pen and brown ink at lower right on recto, *Pietro Testa;* on verso at lower left, *Testa.*

PROVENANCE: Purchased in London in 1965.

BIBLIOGRAPHY: A. S. Harris, *Paragone,* XVIII, 213, 1967, p. 52, note 27, pl. 49 (recto), pl. 50 (verso).

Purchase, 1965, Rogers Fund
65.131.8

Ann Sutherland Harris has pointed out that both the running youth on the recto of this sheet and the standing old man on the verso correspond (in reverse, of course) to figures just right of center in Testa's etching *The Death of Sinorix,* and that these chalk figure studies were no doubt made in preparation for the print (Bartsch, XX, p. 220, no. 19). Composition studies for the etching are preserved in the Kupferstichkabinett, West Berlin, in the British Museum, London, in the Pierpont Morgan Library, New York, and in the National Museum, Stockholm (see Stampfle and Bean, 1967, under no. 84).

365 v.

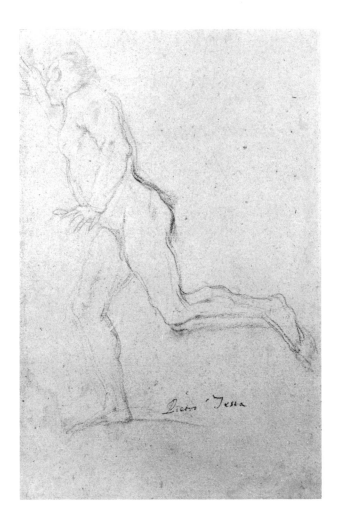

366

367

278

366. *Allegory of Penance and Death*

Pen and brown ink, over a little black chalk. 13.6 x 35.7 cm.

Inscribed in pen and brown ink at top center in the artist's hand, *qui un tantino di carnevale.*

PROVENANCE: Richard Cosway (Lugt 629); C. R. Rudolf, London (according to vendor); purchased in London in 1973.

Purchase, 1973, Rogers Fund
1973.117

In the right foreground a priest goes about the Ash Wednesday ceremony of the imposition of ashes, while belated carnival revellers are seen in the background. At left, Death, gesticulating toward a common grave, underlines the mortality of human flesh.

367. *A Seated Female Figure Surrounded by Nude Infants*

Pen and brown ink, some black ink, gray wash, on brownish paper. 18.5 x 25.7 cm. A number of repaired losses. Lined.

Illegible and partly effaced inscription in pen and brown ink, in the artist's hand, at lower margin beginning, *la carità....*

PROVENANCE: Sir Robert Mond (Lugt Supp. 2813a); purchased in London in 1959; transferred from the Department of Prints, 1977.

BIBLIOGRAPHY: Borenius and Wittkower, 1937, p. 61, no. 248, pl. XLIII; Stampfle and Bean, 1967, under no. 83.

Purchase, 1959, The Elisha Whittelsey Fund
1977.314

Study for Testa's etching usually called *Charity* (Bartsch, XX, p. 222, no. 27). The composition is reversed in the etching, and there are slight variations. An impression of this rare print is preserved in the Metropolitan Museum. Testa also engraved a similar but larger and vertically composed *Charity* (Bartsch, XX, p. 223, no. 28), a preparatory drawing for which is in the Pierpont Morgan Library (repr. Stampfle and Bean, 1967, no. 83).

ALESSANDRO TIARINI
Bologna 1577 – Bologna 1668

368. *Travelers on a Road*

Pen and brown ink, brown wash, over a little black chalk. 18.6 x 12.7 cm. Lined.

Inscribed in pen and brown ink at lower margin of old mount, *Anibale Caracci.*

PROVENANCE: Purchased in London in 1967.

Purchase, 1967, Rogers Fund
67.95.5

The sharp-nosed facial types and the wiry pen contour lines seem characteristic of Tiarini.

369. *Allegory of the Trinitarian Order*

Pen and brown ink, brown wash, over red chalk. Squared in red chalk. Arched framing lines above in pen and brown ink. 20.7 x 16.6 cm.

Inscribed in pencil on verso, *Tiarini*.

PROVENANCE: Lionel Lucas (Lugt Supp. 1733a); Claude Lucas; Lucas sale, London, Christie's, December 9, 1949, part of no. 102; purchased in London in 1961.

Purchase, 1961, Rogers Fund
61.130.17

In the right foreground stand two members of the Order of the Most Holy Trinity for the Redemption of Captives (identifiable by the cross on the long scapular) negotiating with a turbaned oriental for the release of Christian prisoners. The group on the altar in the middle ground, an angel in glory wearing the Trinitarian habit and flanked by kneeling captives, refers to the vision of St. John of Matha, one of the founders of the Trinitarian order (for this subject see a drawing by Calandrucci, No.

74 of this inventory). The relief on the altar, representing two religious kneeling before a stag with a cross on its breast, is a reference to a vision of St. Felix of Valois, reputedly the co-founder of the order. Above, the Holy Trinity crowns the Blessed Virgin who, as Our Lady of Good Remedy, is principal patroness of the Trinitarians. The female saints kneeling on clouds at left and right are not identified by attributes.

370. *Seated Male Nude Facing Right*

Red chalk on beige paper. 29.2 x 18.4 cm. Vertical tear repaired at center, and horizontal tear repaired at upper left. Lined.

Inscribed in pen and brown ink at lower margin, *Originale del/Tiarini* [the lower part of the last word cut off]; in pencil on reverse of old mount, *Marquis of Aberdeen Collection*.

PROVENANCE: Marquess of Aberdeen (according to inscription on old mount); purchased in New York in 1961.

Purchase, 1961, The Elisha Whittelsey Fund
61.215.2

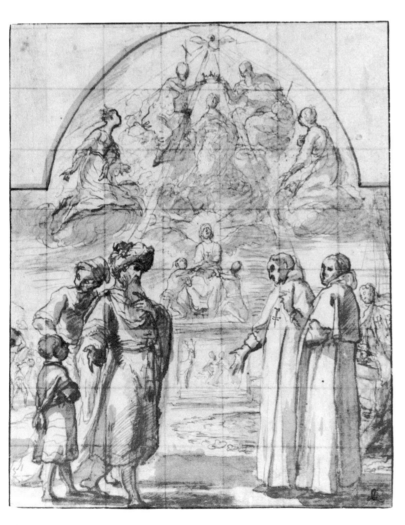

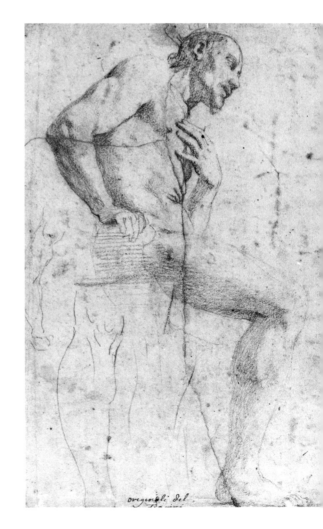

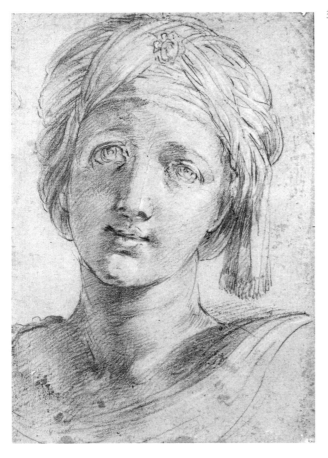

ALESSANDRO TIARINI

371. *Head of a Young Woman Wearing a Turban*

Red chalk, a little black and white chalk, on blue paper. 26.4 x 18.6 cm. Small loss at upper right margin. Lined.

Inscribed in pen and brown ink on reverse of old mount, *Alessandro Tiarini*.

PROVENANCE: Robert Udny (Lugt 2248, stamped in gold on old mount); Sir Thomas Lawrence (Lugt 2445); purchased in London in 1966.

Purchase, 1966, Rogers Fund
66.56.2

The traditional attribution is confirmed by comparison with a group of black chalk head studies by Tiarini in the Louvre, in which the features are indicated in much the same fashion as here (inv. 9045 a-d from Mariette's collection). Lawrence Turčić points out that a black chalk head of a youth in a turban in the Royal Collection at Windsor Castle could be added to this group because of the strong similarity of facial indications (Kurz, 1955, no. 725, as anonymous Bolognese).

FLAMINIO TORRI

Bologna 1621 – Modena 1661

372. *The Virgin Appearing to St. Jerome* VERSO. *Head of a Young Woman with Braided Hair*

Red chalk on brownish paper. 39.9 x 14.0 cm.

PROVENANCE: A.-P.-E. Gasc (Lugt 1131); Charles Gasc (Lugt 544); Sir Robert Mond (Lugt Supp. 2813a); purchased in New York in 1960.

BIBLIOGRAPHY: Borenius and Wittkower, 1937, p. 63, no. 257, pl. XLVI; Kurz, 1955, p. 139 under no. 543, repr. p. 140, fig. 104; Detroit, 1965, no. 117, repr.

Purchase, 1960, Rogers Fund
61.3

Preparatory study for the left half of a painting by Torri representing the Virgin and Child with the Baptist, Sts. Jerome, Charles Borromeo, and Nicholas of Tolentino, formerly in the church of the Carità at Bologna (Malvasia, 1686, p. 139, lines 8 ff.). Kurz reproduced a *bozzetto* or smaller version of the composition in the Galleria Estense, Modena; in this painting Carlo Borromeo stands at the left and Jerome is seated at the center. A red chalk study for the Virgin and Child who appear at the top of the composition is in the Koenig-Fachsenfeld collection (repr. *Unbekannte Handzeichnungen alter Meister, 15.-18. Jahrhundert, Sammlung Freiherr Koenig-Fachsenfeld,* exhibition catalogue, Staatsgalerie, Stuttgart, 1967, no. 51); this appears to be superior in quality to an almost identical drawing at Windsor published by Kurz.

372 v. (detail)

FLAMINIO TORRI

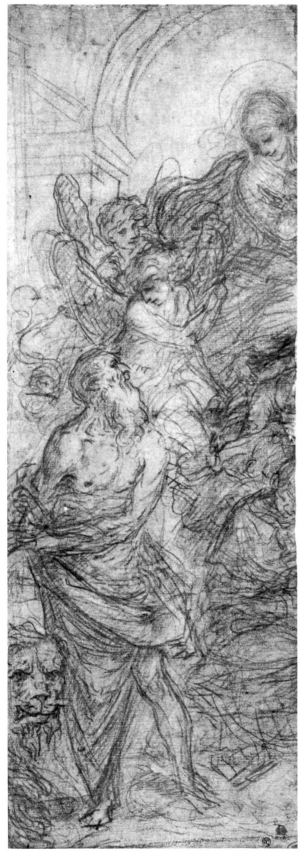

372

ALESSANDRO TURCHI

Verona 1578 – Rome 1649

373. *Allegory of the Immaculate Conception with the Fall of Man*

Pen and brown ink, brown wash, over a little black chalk. 53.9 x 29.2 cm. Lined.

PROVENANCE: Purchased in London in 1971.

BIBLIOGRAPHY: E. Schleier, *Master Drawings,* IX, 2, 1971, p. 150, no. 16b (with previous bibliography); Bean, 1972, no. 55.

Purchase, 1971, Rogers Fund
1971.64.2

COSIMO ULIVELLI

Florence 1625 – Florence 1704

374. *Truth Removing Blinders from the Eyes of Ignorance*

Red chalk and red wash, heightened with a little white, on beige paper. Red chalk designs for frames on verso. 26.0 x 22.9 cm.

Inscribed in red chalk at lower left, *M. Corneille f;* in pen and brown ink on verso, *Ulivelli.*

PROVENANCE: Harry G. Sperling, New York.

BIBLIOGRAPHY: J. P. Cooney, *Master Drawings,* XI, 4, 1973, pp. 379-383, pl. 36.

Bequest of Harry G. Sperling, 1975
1975.131.54

J. Patrick Cooney has pointed out that the composition here derives from the ceiling fresco representing *La cecità della mente umana illuminata dalla Verità,* painted by Ulivelli's master, Volterrano, in the Palazzo della Gherardesca, Florence, in the early 1650s, when Ulivelli was probably working in his teacher's studio.

OTTAVIO VANNINI

Florence 1585 – Florence 1643

376. *Half-Figure of a Male Nude with Arms behind Back*

Red chalk on beige paper. 32.9 x 27.4 cm. A few brown stains at lower left; upper left and right corners replaced.

Inscribed in pen and brown ink on old mount, *Di Ottavio Vannini.*

PROVENANCE: Purchased in London in 1967.

Purchase, 1967, Rogers Fund
67.195

COSIMO ULIVELLI

375. *Martyrdom of Two Female Saints*

Brush and gray wash, heightened with white gouache, over black chalk, on beige paper. 41.6 x 25.7 cm. Lined.

Inscribed in pen and brown ink at lower margin of old mount, *Cosimo Ulivelli;* on reverse of old mount in Jonathan Richardson, Jr.'s, hand, *Cosimo Ulivelli, born in Florence, about 1622, was Disciple of Baldassare Franceschini, the/Volterrano; and hath left innumerable Fine Works in the Churches, Convents, Palaces and Pri/vate Houses of his native city, and elsewhere. Orlandi.*

PROVENANCE: Jonathan Richardson, Jr. (Lugt 2170 and 2997b); purchased in New York in 1962.

BIBLIOGRAPHY: J. P. Cooney, *Master Drawings,* XI, 4, 1973, p. 382, pl. 37.

Purchase, 1962, Rogers Fund
62.61

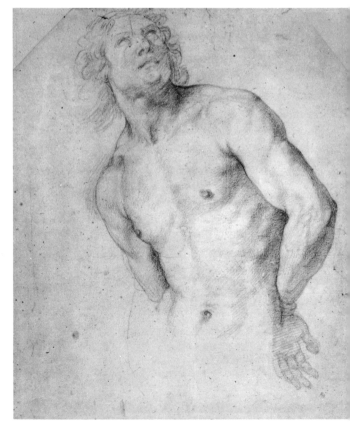

ANONYMOUS TUSCAN (?) ARTIST,
first half of the 17th century

377. *The Swearing In of a Knight of the Tuscan Order of St. Stephen ?*

Pen and brown ink, brown wash, over red and black chalk. Squared in black chalk. 31.9 x 25.3 cm. Arched top. Lined.

Inscribed in pen and brown ink at lower margin, *Domenich.º*

PROVENANCE: Purchased in London in 1964.

Purchase, 1964, Rogers Fund
64.180.3

The draughtsmanship here seems distinctively Tuscan, but the artist responsible for this charming narrative scene has yet to be identified.

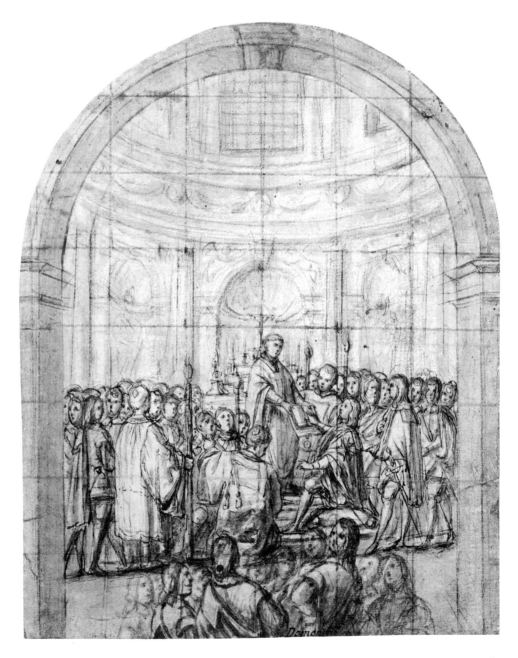

ANONYMOUS ROMAN (?) ARTIST,
end of the 17th century

378. *Study for a Ceiling Decoration: Coronation of the Virgin*

Red chalk, brush and brown wash, heightened with white, on brownish paper. Red chalk study of a female head on verso. 45.9 x 37.2 cm. Vertical and horizontal creases at center; a number of water stains.

Inscribed in pencil at lower left, *Cati 104* [?]; on verso, *Ciroferri*.

PROVENANCE: Don Sebastien Gabriel de Borbón y Braganza (1811-1875); Don Pedro Alcántara de Borbón y Borbón, Duke of Dúrcal (1862-1892); Dúrcal sale, New York, American Art Galleries, April 10, 1889, no. 250, as Ciro Ferri; Henry Walters.

Gift of Henry Walters, 1917
17.236.4

This ceiling design figured in the Dúrcal sale under the name of Ciro Ferri, an attribution based on an oldish inscription on the reverse of the sheet. Ferri's name can be excluded. The artist, still to be identified, must have been someone strongly influenced by the example of Gaulli.

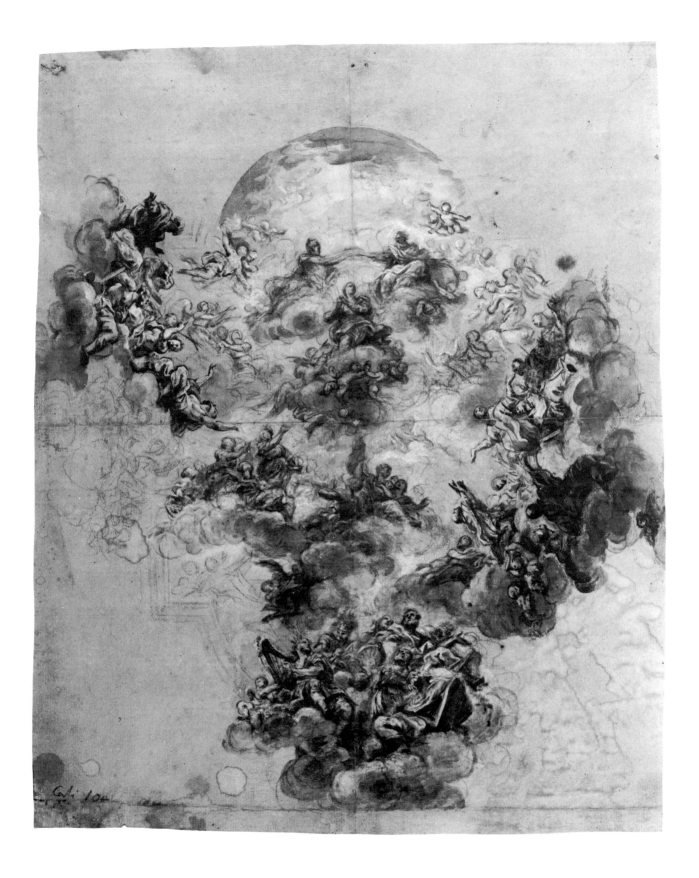

Addendum

PIETRO DA CORTONA

142* *The Virgin and Child with St. Martina*

Pen and brown ink, brown wash, over black chalk. 24.5 x 31.5 cm. Spots of red wash at upper left.

Inscribed in pen and brown ink at lower right, *n...* and *P. de Corto...* (rest of inscriptions cut off).

PROVENANCE: Benjamin Sonnenberg, New York.

BIBLIOGRAPHY: Stampfle and Bean, 1967, no. 65, repr. (with previous bibliography).

Bequest of Benjamin Sonnenberg, 1978

St. Martina receives from the Infant Jesus the palm branch of martyrdom, and in her left hand she holds the long, curved, two-pronged fork which is said to have been one of the instruments of her martyrdom. Cortona often painted this devotional subject and the drawing comes closest to a small painting belonging to Mr. and Mrs. Harold M. Landon in New York that has often been exhibited at the Metropolitan Museum (G. Briganti, *Pietro da Cortona,* Florence, 1962, p. 242, no. 103).

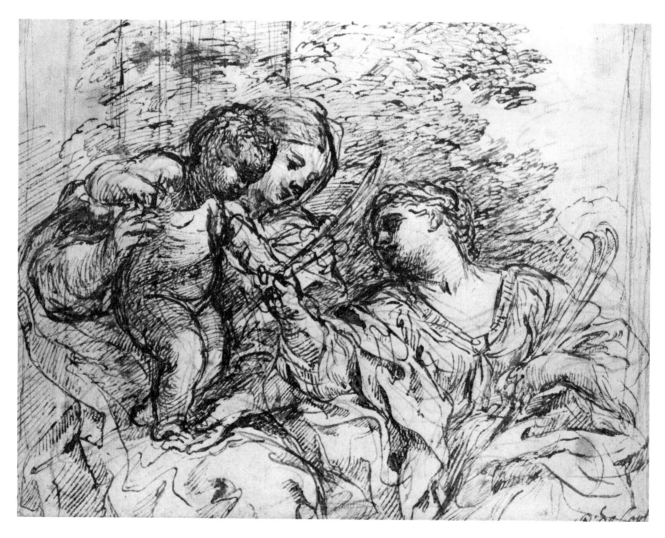

Index of Former Owners

Aberdeen, Marquess of:
220 (Garzi), 370 (Tiarini)

Albergati, Count:
71 (Burrini)

Albertoni, Paolo:
317 (Reni)

Angeloni, Francesco:
102, 103 (Annibale Carracci)

Argoutinsky-Dologoroukoff, Prince
Wladimir Nikolaevitch:
270 (Maratti)

Azzolini, Decio Cardinal:
338, 341 (Rosa)

Azzolini, Marchese Pompeo:
338, 341 (Rosa)

Baer, Curtis O.:
176 (Ferri)

Baker, Walter C.:
57 (Baglione), 98 (Annibale Carracci),
117 (Giovanni Benedetto Castiglione),
136, 137, 139 (Cortona), 185 (Baldas-
sare Franceschini), 248 (Guercino), 360
(Tanzio da Varallo).

Banks, Thomas:
78 (Canini)

Barboza, Antonio:
223 (Gaulli)

Barker, Gilbert:
135 (Cortona)

Barnard, John:
226 (Gaulli), 320 (Ricci), 346 (Sacchi)

Bates, William:
179 (Foggini), 219 (Garzi)

Bauer, Dr. Jacob:
240 (Guercino)

Benoit, Alexandre:
270 (Maratti)

Biron, Marquis de:
254, 255 (Guercino imitator)

Borbón y Borbón, Don Pedro Alcántara
de, see Dúrcal, Duke of

Borbón y Braganza, Don Sebastien Gabriel de:
164 (Falcone), 181 (Fracanzano), 198,
199, 200, 201, 202, 203, 204, 205,
206, 207, 208, 209, 210, 211, 212,

213, 214, 215, 216 (Gargiulo), 233
(Giordano), 284 (Francesco di Maria),
348 (Santafede), 378 (Anonymous)

Borthwick, Hon. Mrs. J.:
110 (Cassana)

Boutin:
104 (Annibale Carracci)

Bouverie, Hon. Edward:
107 (Annibale Carracci), 171 (Ferri),
244, 245, 247 (Guercino)

Brackley, D. E.:
235 (Guercino)

Branson, A.:
132 (Ciarpi), 174 (Ferri), 258 (Lan-
franco)

Bruce, Hon. Robert:
176 (Ferri)

Bucknall, P. G. A.:
76 (Canini)

Burlet, A. de:
318 (Ricci)

Byam Shaw, J.:
175 (Ferri)

Campello, Count Lanfranco di:
132 (Ciarpi), 174 (Ferri), 222 (Gaulli),
258 (Lanfranco)

Cantacuzène, J.:
184 (Baldassare Franceschini)

Carpio e Helice, Marchese del (Don
Gaspar Méndez de Haro y Guzmán):
162, 163 (Falcone)

Chapin, Edwin S.:
63 (Della Bella)

Christie-Miller, Major S. V.:
362 (Testa)

Christina, Queen of Sweden:
338, 341 (Rosa)

Chuberé, M.:
71 (Burrini)

Cooke, Hereward Lester:
278 (Maratti)

Corniani-Algarotti:
318 (Ricci)

Cosway, Richard:
292 (Mola), 364, 366 (Testa)

Crozat, Pierre:
95, 102, 103, 105 (Annibale Carracci),
128 (Cerano)

Delany, Dr. Barry:
62 (Della Bella), 226 (Gaulli)

De Pass, Alfred A.:
326 (Rosa)

Derwent, Lord:
351 (Schedoni)

Dimsdale, Thomas:
97 (Annibale Carracci)

Disney, Mr.:
267 (Luti)

Donnadieu, A.:
253 (Guercino imitator)

"Double-Numbering" collector:
145 (Cortona)

Drake, Sir William Richard:
115 (Giovanni Benedetto Castiglione)

Drawing Shop, The:
189 (Marcantonio Franceschini)

Duits, Carel Emil:
79 (Canini)

Duke, L. G.:
140 (Cortona)

Dúrcal, Duke of (Don Pedro Alcántara de
Borbón y Borbón):
164 (Falcone), 181 (Fracanzano), 198,
199, 200, 201, 202, 203, 204, 205,
206, 207, 208, 209, 210, 211, 212,
213, 214, 215, 216 (Gargiulo), 233
(Giordano), 284 (Francesco di Maria),
348 (Santafede), 378 (Anonymous)

Egerton, Lord Francis, see Ellesmere

Ellesmere, 1st Earl of (Lord Francis Eger-
ton):
93 (Agostino Carracci), 95, 96, 97,
104, 105 (Annibale Carracci)

Esdaile, William:
113, 114 (Francesco Castiglione), 319
(Ricci), 321 (Romanelli), 326, 327,
329, 339 (Rosa), 349 (Sassoferrato)

Fagan ?:
141 (Cortona)

Fava, Alessandro:
354 (Dal Sole)

Felstiner, Mary Lowenthal:
77 (Canini)

Forbes, Sir William:
331 (Rosa)

Formi, Francesco:
247 (Guercino)

Friedman, Harry G.:
55 (Baglione), 251 (Guercino), 268 (Luti), 316 (Procaccini), 335 (Rosa)

Fries, Count Moriz von:
90 (Carpioni), 95, 105 (Annibale Carracci)

Gabburri, F. M. N.:
183 (Baldassare Franceschini)

Gainsborough, 1st Earl of:
238 (Guercino)

Gasc, A.-P.-E.:
372 (Torri)

Gasc, Charles:
252 (Guercino imitator), 372 (Torri)

Geiger, Benno:
356 (Solimena)

Gelosi, Commendatore:
253 (Guercino imitator)

Gennari, Casa:
247 (Guercino)

Gower, Lord Ronald Sutherland:
107 (Annibale Carracci), 324 (Rosa)

Greville, Sir Charles:
73 (Cagnacci), 161 (Faccini), 249 (Guercino), 325 (Rosa)

Grunewald, Gustav:
308 (Domenico Piola)

Harewood, Earl of:
136 (Cortona)

Haro y Guzmán, Don Gaspar Méndez de, see Carpio e Helice, Marchese del

Harrison, Helen Elizabeth:
135 (Cortona)

Haumont, Georges:
64 (Bernini)

Hibbert, George:
140 (Cortona)

Hibbert, Nathaniel:
140 (Cortona)

Holland-Martin, Edward:
137 (Cortona)

Hollis, Thomas Brand:
267 (Luti)

Hone, Nathaniel:
146 (Cortona)

Houlditch, Richard:
272 (Maratti)

Huart, P. ?:
60 (Bassetti)

Hudson, Thomas:
161 (Faccini), 244 (Guercino), 270 (Maratti), 362 (Testa)

Hutchinson, David:
154 (Creti)

Hyde, James Hazen:
158 (Pietro Dandini)

Ingram, Sir Bruce S.:
130 (Cerquozzi)

Isaacs, Prof. John:
81 (Cantagallina), 138, 145, 146 (Cortona), 227 (Gherardini), 287 (Merano), 347 (Sacchi), 357 (Solimena)

Jarves, James Jackson (later in the collection of Cornelius Vanderbilt):
2, 3, 4, 5, 6, 7, 8, 9, 10, 11, 12, 13, 14, 15, 16, 17, 18, 19, 20, 21, 22, 23, 24, 25, 26, 27, 28, 29, 30, 31, 32, 33, 34, 35, 36, 37, 38, 39, 40, 41, 42, 43, 44, 45, 46, 47, 48, 49, 50, 51, 52, 53 (Allegrini), 69, 70 (Boschi), 83, 84 (Cantarini), 86 (Canuti), 120 (Giovanni Benedetto Castiglione), 142 (Cortona), 152 (Creti), 155 (Damini), 159 (Discepoli), 177 (Ferri), 194 (Marcantonio Franceschini), 243, 250, 252 (Guercino), 256 (Lana), 293 (Mola), 296 (Pagani), 301 (Passeri), 307, 309 (Domenico Piola), 311 (Paolo Gerolamo Piola)

Knapton, George:
110 (Cassana)

Knowles, Sir James:
122, 123 (Giovanni Benedetto Castiglione), 154 (Creti), 241 (Guercino)

Knowles, W. Pitcairn:
257 (Lanfranco)

Knutsford, 1st Viscount (Sir Henry Thurston Holland):
140 (Cortona)

Komor, Mathias:
134 (Cortona), 185 (Baldassare Franceschini), 291 (Mola)

Krautheimer, Mrs. Richard:
88, 89 (Giovanni Battista Carlone), 188 (Baldassare Franceschini)

Lagoy, Marquis de:
75 (Camassei), 90 (Carpioni), 96, 97, 104 (Annibale Carracci)

Lawrence, Sir Thomas:
93 (Agostino Carracci), 95, 96, 97, 104, 105 (Annibale Carracci), 110 (Cassana), 146 (Cortona), 311 (Paolo Gerolamo Piola), 339 (Rosa), 343 (Sacchi), 371 (Tiarini)

Lely, Sir Peter:
99 (Annibale Carracci), 161 (Faccini), 235 (Guercino)

Lempereur, Jean-Denis:
241 (Guercino)

Levis, Howard C.:
77 (Canini)

Lowenthal, Alexander:
77 (Canini)

Lowenthal, Helen:
321 (Romanelli)

Lowry, Walter:
259 (Lanfranco)

Lucas, Claude:
101 (Annibale Carracci), 109 (Ludovico Carracci), 369 (Tiarini)

Lucas, Lady:
242 (Guercino)

Lucas, Lionel:
101 (Annibale Carracci), 109 (Ludovico Carracci), 369 (Tiarini)

Lycett Green, F. D.:
351 (Schedoni)

MacDonald:
240 (Guercino)

MacGowan, John:
331 (Rosa)

McMahon, Dr. A. P.:
102 (Annibale Carracci), 247 (Guercino)

McMahon, Mrs. A. P.:
102 (Annibale Carracci), 247 (Guercino)

Maggiori, Alessandro:
229 (Giordano)

Malvasia, Count:
105 (Annibale Carracci)

Mariette, Pierre-Jean:
71 (Burrini), 75 (Camassei), 93 (Agos-

tino Carracci), 95, 105 (Annibale Carracci), 226 (Gaulli), 279 (Maratti), 326 (Rosa), 359 (Solimena)

Mayor, William:
136 (Cortona), 277 (Maratti), 349 (Sassoferrato)

Merz, Major A.:
288 (Milani)

Mignard, Pierre:
102, 103 (Annibale Carracci)

Mond, Sir Robert:
235 (Guercino), 367 (Testa), 372 (Torri)

Morritt, J. B. S.:
125 (Cavedone)

Nathan of Churt, Lord:
226 (Gaulli)

Newman, Victor Winthrop:
102 (Annibale Carracci)

Northwick, John, Lord:
245, 251 (Guercino), 275 (Maratti)

Occhiali, Carlo degli:
95 (Annibale Carracci)

Odescalchi, Prince Ladislao:
338, 341 (Rosa)

Odeșcalchi, Prince Livio:
338, 341 (Rosa)

Oppenheimer, Henry:
136 (Cortona), 275 (Maratti)

Ottley, William Young:
239 (Guercino)

Pacini, Giuseppe:
116 (Giovanni Benedetto Castiglione)

Palumbo, Peter:
224 (Gaulli)

Parker, Sir Karl:
271 (Maratti)

Peart, Dr. Edward:
183 (Baldassare Franceschini)

Peel, David:
345 (Sacchi)

Pembroke, Earls of:
99 (Annibale Carracci), 126 (Cavedone), 193 (Marcantonio Franceschini)

Perman, Prof. Einar:
128 (Cerano), 327, 328, 329, 330, 334, 336, 340 (Rosa)

Philip V, King of Spain:
261 (Lanfranco)

Platt, Dan Fellows:
246 (Guercino), 332, 333 (Rosa)

Pouncey, Philip:
261 (Lanfranco)

Poynter, Ambrose:
78 (Canini)

Prachoff, Adrien:
57 (Baglione)

Pratt Institute:
198, 199 (Gargiulo)

Price, Uvedale:
362 (Testa)

Rayner-Wood, Mrs. A. D.:
137 (Cortona)

"Reliable Venetian Hand" (Lugt Supp. 3005 c-d):
113, 114 (Francesco Castiglione)

Renaud, François:
123 (Giovanni Benedetto Castiglione)

Resta, Padre Sebastiano:
129 (Cerano)

Reynolds, Sir Joshua:
78, 79 (Canini), 125 (Cavedone), 136 (Cortona), 183 (Baldassare Franceschini), 195 (Marcantonio Franceschini), 270 (Maratti)

Richardson, Jonathan, Sr.:
107 (Annibale Carracci), 125 (Cavedone), 129 (Cerano), 161 (Faccini), 347 (Sacchi)

Richardson, Jonathan, Jr.:
72 (Burrini), 179 (Foggini), 239 (Guercino), 282 (Maratti), 375 (Ulivelli)

Richter, J. P.:
244, 249 (Guercino), 325 (Rosa)

Royal Institution of Cornwall:
326 (Rosa)

Rudolf, C. R.:
277 (Maratti), 366 (Testa)

Russell, A. G. B.:
238 (Guercino)

Russell, William:
154 (Creti), 236 (Guercino)

Rust, David:
179 (Foggini)

Sack, Baron C.:
128 (Cerano)

Sack, Baron Jean-Gabriel:
128 (Cerano)

Sartoris, C. S.:
76 (Canini)

Schmid, Anton:
90 (Carpioni), 134 (Cortona)

Scholz, Janos:
265 (Luffoli), 283 (Maratti)

Skippe, John:
137 (Cortona)

Somers, John, Lord:
129 (Cerano)

Somervell, Mrs. Peter:
331 (Rosa)

Sonnenberg, Benjamin:
142* (Cortona)

Sonnenschein, Hugo:
133 (Commodi)

Spencer, Earl:
62 (Della Bella), 73 (Cagnacci), 281 (Maratti), 340 (Rosa)

Sperling, Harry G.:
58 (Balassi), 81 (Cantagallina), 94 (Agostino Carracci), 112 (Valerio Castello), 121 (Giovanni Benedetto Castiglione), 191, 192 (Marcantonio Franceschini), 264 (Leoni), 339 (Rosa), 350 (Sassoferrato), 374 (Ulivelli)

Springell, Dr. Francis:
115 (Giovanni Benedetto Castiglione)

Squire, Hugh N.:
73 (Cagnacci), 101, 103 (Annibale Carracci), 320 (Ricci)

Steiner, John and Alice:
80 (Cantagallina)

Story, A. P.:
282 (Maratti)

Sutherland, 6th Duke of:
93 (Agostino Carracci), 95, 96, 97, 104, 105 (Annibale Carracci)

Tessin, Count Carl-Gustav:
128 (Cerano)

Thompson, Cephas G.:
65 (Bernini), 66 (Biscaino), 85 (Cantarini), 106 (Annibale Carracci), 157 (Cesare Dandini), 197 (Gabbiani), 218 (Garzi), 260 (Lanfranco), 266 (Luti), 299 (Pasinelli), 300 (Passeri)

Udny, Robert:
60 (Bassetti), 339 (Rosa), 349 (Sassoferrato), 371 (Tiarini)

Uilenbroek, Gosuinus:
1 (Albani)

Vallardi, Giuseppe:
68 (Bombelli), 116 (Giovanni Benedetto Castiglione), 159 (Discepoli)

Vanderbilt, Cornelius, *see* Jarves, James Jackson

Wagstaff, Samuel:
 154 (Creti)

Walters, Henry:
 164 (Falcone), 181 (Francanzano), 200,
 201, 202, 203, 204, 205, 206, 207,
 208, 209, 210, 211, 212, 213, 214,
 215, 216 (Gargiulo), 233 (Giordano),
 284 (Francesco di Maria), 348 (San-
 tafede), 378 (Anonymous)

Warwick, Earl of:
 73 (Cagnacci), 161 (Faccini), 249
 (Guercino), 325 (Rosa)

Wells, Dr. J. R.:
 289 (Milani)

Wells, Mrs. E. A.:
 289 (Milani)

West, Benjamin:
 113, 114 (Francesco Castiglione)

Wien, Rudolf:
 170 (De Ferrari)

Willett, R.:
 319 (Ricci), 326 (Rosa)

Winckler, J. G. H.:
 59 (Baldi)

Winter, Carl:
 130 (Cerquozzi)

Wrangham, E. A.:
 292 (Mola), 364 (Testa)

Wunsch, Eric:
 79 (Canini), 156 (Cesare Dandini), 261
 (Lanfranco)

Wurzbach-Tannenberg, Dr. A. Ritter von:
 134 (Cortona), 257 (Lanfranco)

Zoomer, Jan Pietersz.:
 266 (Luti)

Lugt 474, "pseudo Crozat":
 161 (Faccini)

Lugt 1156, unidentified:
 108 (Ludovico Carracci)

Lugt 2508, unidentified:
 75 (Camassei)

Lugt 2951, Crozat?:
 123 (Giovanni Benedetto Castiglione),
 130 (Cerquozzi)

Lugt Supp. 416a, unidentified English col-
lector:
 234 (Grimaldi)

D. F., unidentified:
 148 (Giuseppe Maria Crespi)

DL (paraph), unidentified Neapolitan col-
lector:
 229 (Giordano), 285, 286 (Matteis)

J. I. K., unidentified:
 90 (Carpioni)

ACC. NO.	THIS INVENTORY	ACC. NO.	THIS INVENTORY	ACC. NO.	THIS INVENTORY	ACC. NO.	THIS INVENTORY
80.3.5	39	80.3.275	29	87.12.113	65	19.76.14	99
80.3.7	17	80.3.280	250	87.12.120	218	19.76.16	126
80.3.8	37	80.3.284	20	87.12.123	157	36.101.2	275
80.3.20	38	80.3.285	10	08.227.7	111	37.165.99	254
80.3.23	28	80.3.287	35	08.227.12	219	37.165.108	255
80.3.24	27	80.3.292	252	08.227.22	122	38.179.1	333
80.3.27	40	80.3.294	243	08.227.23	123	38.179.2	332
80.3.52	142	80.3.298	293	08.227.24	113	38.179.4	246
80.3.66	52	80.3.311	47	08.227.25	114	45.36	78
80.3.67	9	80.3.313	83	08.227.29	236	47.155.1	308
80.3.84	19	80.3.315	7	08.227.30	241	50.56	109
80.3.85	13	80.3.319	51	08.227.37	303	55.628.8	169
80.3.87	16	80.3.326	8	11.66.6	107	56.219.4	259
80.3.89	18	80.3.327	34	11.66.7	324	56.225.5	316
80.3.98	15	80.3.331	84	12.56.11	244	59.208.93	158
80.3.99	4	80.3.333	159	12.56.12	249	60.66.1	55
80.3.100	26	80.3.339	86	12.56.13	325	60.66.9	251
80.3.102	11	80.3.369	152	17.97.17	253	60.66.13	335
80.3.103	32	80.3.458	120	17.236.4	378	61.2.1	134
80.3.112	36	80.3.459	43	17.236.6	205	61.2.2	291
80.3.113	33	80.3.461	44	17.236.7	203	61.3	372
80.3.119	69	80.3.463	30	17.236.8	206	61.6	185
80.3.120	70	80.3.466	296	17.236.9	214	61.27	351
80.3.138	2	80.3.471	311	17.236.10	202	61.52	179
80.3.143	50	80.3.509	41	17.236.11	210	61.72	57
80.3.152	256	80.3.515	309	17.236.12	201	61.123.4	71
80.3.168	194	80.3.519	45	17.236.13	211	61.129.1	140
80.3.182	155	80.3.530	22	17.236.14	212	61.130.9	294
80.3.192	307	80.3.535	42	17.236.19	164	61.130.13	227
80.3.215	301	80.3.536	48	17.236.21	233	61.130.17	369
80.3.238	3	80.3.538	49	17.236.24	207	61.130.18	288
80.3.251	46	80.3.539	6	17.236.28	348	61.131.1	62
80.3.252	14	80.3.554	31	17.236.30	284	61.142	217
80.3.254	21	87.12.20	197	17.236.31	215	61.143	124
80.3.256	5	87.12.25	66	17.236.32	209	61.156	189
80.3.257	25	87.12.32	299	17.236.36	208	61.162.2	1
80.3.259	23	87.12.64	260	17.236.39	204	61.169	272
80.3.266	177	87.12.79	266	17.236.44	200	61.174	180
80.3.267	24	87.12.83	106	17.236.48	216	61.178.1	223
80.3.269	53	87.12.102	85	17.236.49	181	61.212.2	279
80.3.273	12	87.12.103	300	17.236.51	213	61.215.1	220

ACC. NO.	THIS INVENTORY	ACC. NO.	THIS INVENTORY	ACC. NO.	THIS INVENTORY	ACC. NO.	THIS INVENTORY
61.215.2	370	64.136.5	199	66.137	270	1970.168	237
61.256	59	64.136.7	198	67.15	318	1970.242.1	359
62.21	352	64.180.2	305	67.65	319	1970.244.1	156
62.61	375	64.180.3	377	67.95.1	153	1970.258	148
62.119.1	67	64.197.3	145	67.95.2	91	1970.282	183
62.119.2	141	64.197.4	146	67.95.5	368	1970.294.1	88
62.119.3	165	64.197.5	187	67.95.9	167	1970.294.2	89
62.119.11	168	64.197.6	337	67.95.10	280	1971.58	154
62.120.1	103	64.201	364	67.97	128	1971.64.2	373
62.120.2	101	64.223	72	67.99	232	1971.66.2	133
62.120.6	320	64.284	166	67.195	376	1971.67	306
62.120.9	73	64.295.1	273	67.205	170	1971.130	79
62.121.1	116	64.295.2	282	68.38	171	1971.146	143
62.123.1	317	65.66.2	54	68.39	60	1971.221.1	242
62.126	115	65.66.3	132	68.51	257	1971.221.3	315
62.129.1	229	65.66.4	174	68.54.1	310	1971.222.1	196
62.129.2	231	65.66.6	258	68.54.3	361	1971.222.3	358
62.129.4	173	65.66.7	287	68.56	340	1971.241	362
62.130.2	193	65.66.11	357	68.68	235	1972.118.17	360
62.132.5	354	65.111.1	108	68.106.1	225	1972.133.1	93
62.133	276	65.111.2	285	68.123.2	261	1972.133.2	95
62.137	278	65.112.4	119	68.171	238	1972.133.3	97
62.149	175	65.128	353	68.172.1	286	1972.133.4	104
62.204.1	234	65.131.2	222	68.172.2	240	1972.134	298
62.204.3	100	65.131.6	292	68.193	87	1972.137.1	96
62.237	56	65.131.8	365	69.1	82	1972.137.2	105
63.18	277	65.137	75	69.20	331	1972.173	304
63.37	239	65.176	118	69.21	344	1972.259	297
63.75.2	245	65.206	274	69.115	184	1972.271	80
63.76.4	230	66.1	326	69.126.1	90	1973.12	125
63.89	190	66.9	172	69.169	267	1973.71	162
63.91.2	263	66.14	195	69.172	182	1973.72	163
63.98.1	355	66.35	188	69.293	289	1973.91	312
63.98.2	281	66.49	61	1970.15	102	1973.117	366
63.103.1	110	66.51	346	1970.40	247	1973.126	77
63.103.2	226	66.53.1	262	1970.101.12	327	1973.265	64
63.118	176	66.53.3	271	1970.101.14	336	1974.73	349
63.222	295	66.54.2	221	1970.101.15	334	1974.270	178
64.13	127	66.56.2	371	1970.101.16	328	1975.120	186
64.14	268	66.133	342	1970.101.17	330	1975.123	63
64.38.2	363	66.134.1a-c	144	1970.101.18	329	1975.130	160
64.48.2	138	66.134.4	129	1970.108	269	1975.131.3	58
64.48.4	347	66.134.5	322	1970.113.1	76	1975.131.15	81
64.50	135	66.134.6	323	1970.113.3	92	1975.131.16	94
64.132.1	161	66.135	131	1970.113.6	314	1975.131.17	112

ACC. NO.	THIS INVENTORY	ACC. NO.	THIS INVENTORY	ACC. NO.	THIS INVENTORY	ACC. NO.	THIS INVENTORY
1975.131.18	121	1975.190	130	1976.331.1	338	1977.311	265
1975.131.26	191	1975.440	302	1976.331.2	341	1977.312	283
1975.131.27	192	1976.57.1	149	1977.13	224	1977.313	290
1975.131.34	264	1976.57.2	150	1977.127	228	1977.314	367
1975.131.47	339	1976.57.3	151	1977.128	74	1978.133	147
1975.131.48	350	1976.187.2	68	1977.134	321	1978.143	313
1975.131.54	374	1976.236	356	1977.168	343	1978.276	345

Index of Artists

Albani, Francesco	1	Canuti, Domenico Maria	86	Dal Sole, Giovan Gioseffo, *see* Sole	
Allegrini, Francesco	2-53	Carlone, Giovanni Andrea	87	Damini, Pietro	155
Anonymous Roman (?) artist	378	Carlone, Giovanni Battista	88, 89	Dandini, Cesare	156, 157
Anonymous Tuscan (?) artist	377	Carpioni, Giulio	90-92	Dandini, Pietro	158
Antonio d'Enrico, *see* Tanzio		Carracci, Agostino	93, 94	De Ferrari, Gregorio, *see* Ferrari	
Baciccio, *see* Gaulli		Carracci, Annibale	95-107	Della Bella, Stefano, *see* Bella	
Baglione, Giovanni	54-57	Carracci, Ludovico	108, 109	De Matteis, Paolo, *see* Matteis	
Balassi, Mario	58	Cassana, Giovanni Agostino or Giovanni Battista	110	Di Maria, Francesco, *see* Maria	
Baldi, Lazzaro	59	Castello, Valerio	111, 112	Discepoli, Giovanni Battista	159
Barbieri, Giovanni Francesco, *see* Guercino		Castiglione, Francesco	113, 114	Faccini, Pietro	160, 161
Bassetti, Marcantonio	60	Castiglione, Giovanni Benedetto	115-119	Falcone, Aniello	162-164
Beinaschi, Giovanni Battista	61	Castiglione, Giovanni Benedetto, circle of	120-123	Ferrari, Gregorio de	165-170
Bella, Stefano della	62, 63	Caula, Sigismondo	124	Ferri, Ciro	171-177
Bernini, Gian Lorenzo	64	Cavedone, Giacomo	125, 126	Fidani, Orazio	178
Bernini, Gian Lorenzo, school of	65	Celesti, Andrea	127	Foggini, Giovanni Battista	179, 180
Berrettini, Pietro, *see* Cortona		Cerano (Giovanni Battista Crespi)	128, 129	Fracanzano, Francesco	181
Biscaino, Bartolomeo	66	Cerquozzi, Michelangelo	130	Franceschini, Baldassare	182-188
Bocchi, Faustino	67	Chiari, Giuseppe	131	Franceschini, Marcantonio	189-195
Bombelli, Sebastiano	68	Ciarpi, Baccio	132	Gabbiani, Anton Domenico	196, 197
Boschi, Fabrizio	69, 70	Commodi, Andrea	133	Gargiulo, Domenico, called Micco Spadaro	198-216
Burrini, Gian Antonio	71, 72	Cortona, Pietro da (Pietro Berrettini)	134-146, 142*	Garzi, Luigi	217-221
Cagnacci, Guido	73	Crespi, Daniele	147	Gaulli, Giovanni Battista, called Baciccio	222-226
Calandrucci, Giacinto	74	Crespi, Giovanni Battista, *see* Cerano		Gherardini, Alessandro	227
Camassei, Andrea	75	Crespi, Giuseppe Maria	148-151	Giordano, Luca	228-233
Canini, Giovanni Angelo	76-79	Creti, Donato	152-154	Grimaldi, Giovanni Francesco	234
Cantagallina, Remigio	80, 81			Guercino (Giovanni Francesco Barbieri)	235-251
Cantarini, Simone	82-85				

Guercino, imitator of	252-255	Panfi, Romolo	298	Santafede, Fabrizio	348
Lana, Ludovico	256	Pasinelli, Lorenzo	299	Sassoferrato (Giovanni Battista Salvi)	349, 350
Lanfranco, Giovanni	257-262	Passeri, Giuseppe	300-303	Schedoni, Bartolomeo	351
Leoni, Ottavio	263, 264	Pietri, Pietro Antonio de	304	Sirani, Elisabetta	352
Luffoli, Giovanni Maria	265	Piola, Domenico	305-310	Spadaro, Micco, *see* Gargiulo	
Luti, Benedetto	266-269	Piola, Paolo Gerolamo	311-313	Sole, Giovan Gioseffo dal	353, 354
Maratti, Carlo	270-282	Preti, Mattia	314, 315	Solimena, Francesco	355-359
Maratti, Carlo, circle of	283	Procaccini, Andrea	316	Tanzio da Varallo (Antonio d'Enrico)	360
Maria, Francesco di	284	Reni, Guido	317	Testa, Pietro	361-367
Matteis, Paolo de	285, 286	Ricci, Sebastiano	318-320	Tiarini, Alessandro	368-371
Merano, Giovanni Battista	287	Roman (?) anonymous artist, *see* Anonymous Roman		Torri, Flaminio	372
Milani, Aureliano	288, 289			Turchi, Alessandro	373
Mitelli, Giuseppe Maria	290	Romanelli, Giovanni Francesco	321-323	Tuscan (?) anonymous artist, *see* Anonymous Tuscan	
Mola, Pier Francesco	291-293	Rosa, Salvator	324-342		
Nasini, Giuseppe Nicola	294	Sacchi, Andrea	343-346	Ulivelli, Cosimo	374, 375
Onofri, Crescenzio	295	Sacchi, Andrea, circle of	347	Vannini, Ottavio	376
Pagani, Paolo	296, 297	Salvi, Giovanni Battista, *see* Sassoferrato		Volterrano, *see* Franceschini, Baldassare	

Published by The Metropolitan Museum of Art, New York
Bradford D. Kelleher, Publisher
John P. O'Neill, Editor in Chief
Anne M. Preuss, Editor
Peter Oldenburg, Designer

Composed by Finn Typographic Service
Printed by The Meriden Gravure Company
Bound by American Book-Stratford Press